AMERICAN
CORPORATE
IDENTITY
2009

AMERICAN
CORPORATE
IDENTITY
2009

DAVID E. CARTER
SUZANNA MW STEPHENS

COLLINS DESIGN

An Imprint of HarperCollins*Publishers*

HarperCollins books may be purchased for educational, business, or sales promotional use.
For information, please write: Special Markets Department, HarperCollins*Publishers*,
10 East 53rd Street, New York, NY 10022.

First Edition

First published in 2008 by:
Collins Design
An Imprint of HarperCollins*Publishers*
10 East 53rd Street
New York, NY 10022
Tel: (212) 207-7000
Fax: (212) 207-7654
collinsdesign@harpercollins.com
www.harpercollins.com

Distributed throughout the world by:
HarperCollins*Publishers*
10 East 53rd Street
New York, NY 10022
Fax: (212) 207-7654

Book and competition design by:

Designs
on *You!*

Suzanna and Anthony Stephens

Cover design by:
Mark Groves, Ad Harvest.biz

Library of Congress Control Number: 2007930307

ISBN: 978-0-06-162674-6

Produced by Crescent Hill Books, Louisville, KY.

Printed in China by Everbest Printing Company.

First Printing, 2008

Table of Contents

Brooke Brimm—Agency Manager/Partner
Culture Advertising Design
www.culture-ad.com _____

Brooke Brimm is Agency Manager and a partner for Culture Advertising Design. She received her Master's degree in Professional Counseling and spent eight years in the field of Behavioral Science before joining Culture in 2005.

With extensive project management and account liaison experience coupled with a unique understanding of clients and business communication issues, Brooke brings creativity, insight, and human behavior expertise to her work as a primary brand and account coordinator.

She has been involved in the development and delivery of several campaigns for companies and organizations ranging from Colomer U.S.A. (ethnic hair care industry) to the Kenya Tourist Board (travel & tourism industry). She has produced television and radio advertisements for Georgia's Anti-Litter Campaign and video for African Pride's in-store promotional infomercial. Brooke supervises all production management for print advertisement photography shoots facilitated by Culture A.D. She has under girded all of the agencies PR efforts and brand maintenance.

She also authors an ezine/newsletter, "Love's Gumbo," in which she discusses women's love of themselves, their mates, and their families. Her writings will be culminated into a forthcoming book.

Craig Brimm—Creative Director/Founder & CEO
Culture Advertising Design
www.culture-ad.com _____

Craig Brimm is Creative Director and founder of Culture Advertising in Atlanta, Georgia. Over the past fifteen years his work has included television, video, radio, and print advertising for an extensive client list including Ford Motor Company, The Atlanta Football Classic, Levi's, Coca-Cola, Wachovia, Kenya Tourist Board, Procter and Gamble, Tylenol, Atlanta Metropolitan College, Bermuda Board of Tourism, and package design for SoftSheen Carson, Luster Products, and Colomer U.S.A. among others.

Craig's approach to design is moving brands ahead through relevent concepts and visuals. Craig says "Today's society is moving so fast and we receive messages so quickly and frequently, that it is essential for brands to evolve so they do not fall victim to circumstance."

Before founding Culture Advertising Design in 2001, Craig worked at agencies such as Roy Advertising, J. Walter Thompson, Nomenudum, and MLT Creative. He now leads an award-winning design team that has been honored with multiple American Graphic Design Awards, and has been named one of Step Inside Design's 100, Graphic Design USA's "One to Watch" in 2006, and was a featured design firm in the Adobe Creative Suite 3 Designer Guide.

David E. Carter—Founder of ACI . . . and other things
www.sanibelfilmschool.com _____

A noted authority on the subjects of graphic design, logo design, and corporate branding, Dave produced his first book on logo design in 1972, and has since created more than 100 books in those fields. He is the biggest-selling editor/author in the history of graphics books.

Dave has a varied background which includes founding an advertising agency that quickly qualified for AAAA membership. Soon after, he won his first Clio Award; he would go on to be honored by the Clios ten more times. He also worked in television, writing and producing 700 commercials. After he founded a TV production company in 1982, his work appeared on PBS and *The Tonight Show Starring Johnny Carson*. He won seven Emmy Awards for work he wrote and/or produced.

A graduate of the University of Kentucky, Dave also received a master's degree in advertising from the Ohio University School of Journalism. In 1998, he graduated from the three-year OPM (Owner/President Management) program at the Harvard Business School.

Deciding that his lifelong accomplishments have earned him a place in the sun, Dave now resides in Sanibel, Florida (beach front!) and spends his "free" time developing documentaries on socially-relevant and humorous topics—sometimes within the same film.

David Lemley—President
Lemley Design Company
www.lemleydesign.com

David Lemley is the President of Lemley Design. With over twenty years experience in retail brand design, he is recognized and respected for his holistic and wholly original approach to retail. He combines big picture consulting, brand identity, brand strategy and development with comprehensive marketing communication elements for consumer facing brands. He possesses a rare combination of business savvy and a bold artistic vision that has helped create brands, identities, and branded communication systems for some of the most recognized and beloved brands in the world including Starbucks, Home Depot and Nike.

David is an alumnus of both the Art Institute of Seattle and University of Washington School of Architecture. He has been a visiting professor at several colleges and universities and continues to speak at branding and design conferences.

David is a past multiple winner of the American Corporate Identity competition.

Anthony Stephens—Principal
Designs on You!

Anthony Stephens began his career in the field of visual creativity as staff photographer for Creativity 29, an annual international advertising/design competition. It became quickly evident that his talent was multi-faceted and he was approached to contribute to book layout with subsequent work being published by Harper Design International and Collins Design. Endowed with a natural eye for design, over the next nine years Tony broadened his graphics portfolio with a large variety of print media including, but not limited to, logos, stationery, brochures, and t-shirts.

Other professional achievements encompass the position of Creativity Awards judge, principal at Designs on You!, owner of American Corporate Identity, as well as co-editor of "Boutique Offices: Small Spaces Big on Creativity" to be published by Collins Design and distributed by HarperCollins *Publishers* in spring 2009.

Suzanna MW Stephens—Principal/Senior Designer
Designs on You!

Suzanna MW Stephens has been principal of Designs on You! for over fifteen years. An ever-evolving creative studio, Designs on You! offers graphic design and editorial services but has also created and sold original jewelry, one-of-a-kind garments, personal stationery packages, handmade books, and various fiber arts. Suzanna specializes in book design and layout with over seventy-five volumes in her portfolio, many published by Collins Design.

She and business-partner/husband, Anthony, are co-owners of American Corporate Identity, an annual graphics competition entering its 25th edition; London Books, producer of corporate history and anniversary books; the semi-annual, international Logo competition; and share seven children ages 7 - 25.

In 1993, Suzanna received her BFA in Graphic Design, graduating from Marshall University summa cum laude. (The extra tassel on her cap seemed important at the time, but not a single client has asked about her grade point average since.) She's sometimes invited to guest lecture to design classes at Marshall University, and recently taught a Graphics of Communication course there.

Thomas White Jr.—Creative Director
Maple Creative
www.maplecreative.com

Thomas White is a veteran graphic designer whose past work experience spans the retail, banking, advertising and marketing agency sectors. He is currently Creative Director for Maple Creative in Charleston, West Virginia.

Thomas applies his talents to a variety of deliverables for clients including identity development, advertisements, marketing, publications, corporate collateral, and web development. While his work has been recognized with awards from The American Advertising Federation and the Public Relations Society of America, he judges his professional accomplishments not on awards, but rather on repeat business and referrals from satisfied customers.

Thomas earned his BFA in Graphic Design from Marshall University. He and his wife, Tara, reside in St. Albans, West Virginia, with their two children.

COMPLETE CORPORATE IDENTITY PROGRAMS

California Coastal
Cleanup Day

Saturday, September 15, 2007 - 9 am to Noon

 1 800 COAST 4U or
www.coast4u.org

CLIENT
 California Coastal
 Commission
CREATIVE FIRM
 Axion Design
 axiondesign.com
DESIGNERS
 Axion Design Team,
 Goodby,
 Silverstein & Partners

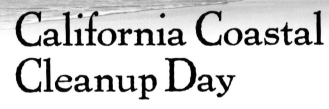

California Coastal
Cleanup Day

Saturday, September 15, 2007 - 9 am to Noon

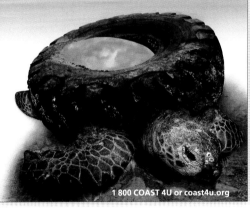

 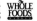 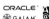 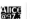 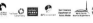 1 800 COAST 4U or coast4u.org

California Coastal
Cleanup Day

Saturday, September 15, 2007 - 9 am to Noon

 1 800 COAST 4U or www.coast4u.org

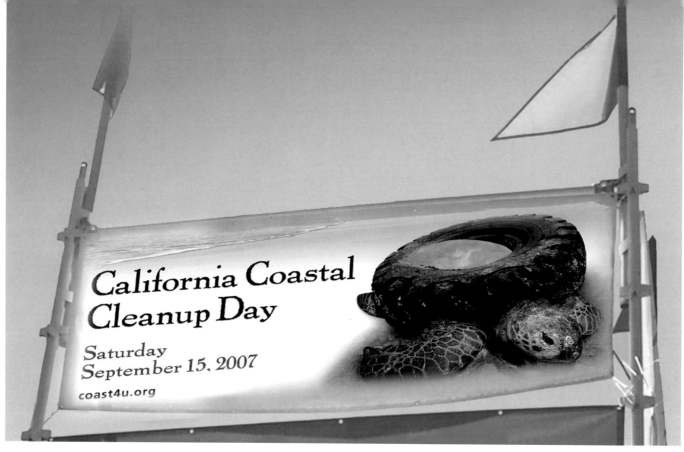

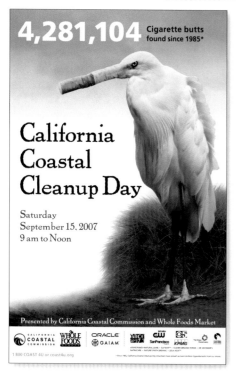

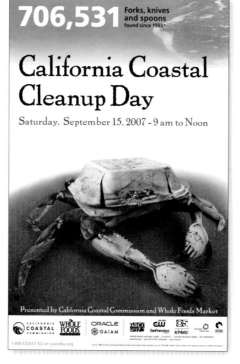

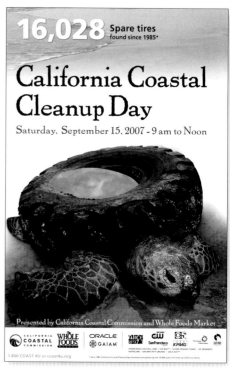

(CONTINUED)
CLIENT
 California Coastal Commission
CREATIVE FIRM
 Axion Design
 axiondesign.com

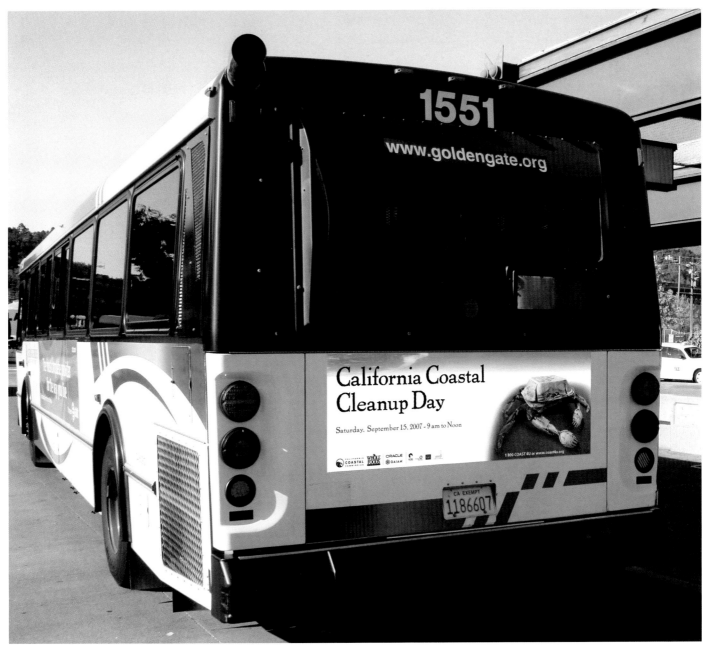

CLIENT
ASV Incorporated
CREATIVE FIRM
Franke + Fiorella
www.frankefiorella.com
CREATIVE DIRECTOR
Craig Franke
DESIGNER
Todd Monge

James Olson
Director of Product Development
218.327.3434
jolson@asvi.com

A.S.V., Inc.
840 Lily Lane
PO Box 5160
Grand Rapids, MN 55744
800.346.5954 Main
218.326.5291 Fax

A.S.V., Inc.
840 Lily Lane
PO Box 5160
Grand Rapids, MN 55744

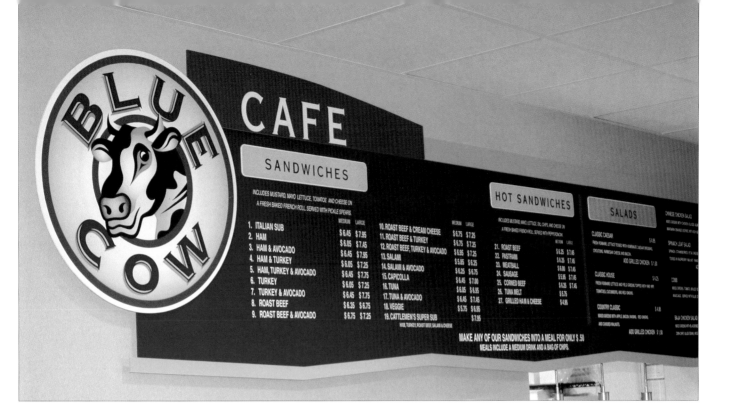

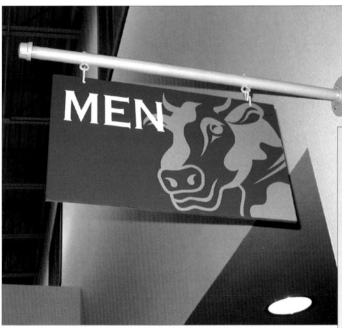

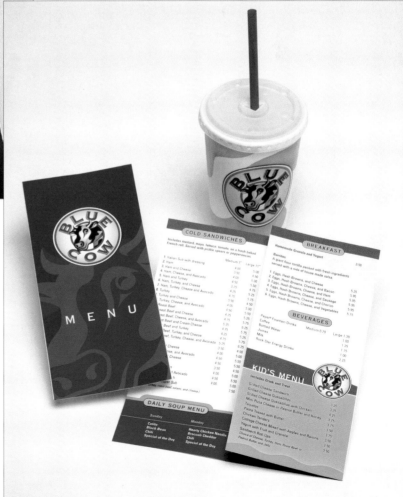

CLIENT
Blue Cow
CREATIVE FIRM
Vince Rini Design
vincerinidesign.com
DESIGNER
Vinci Rini

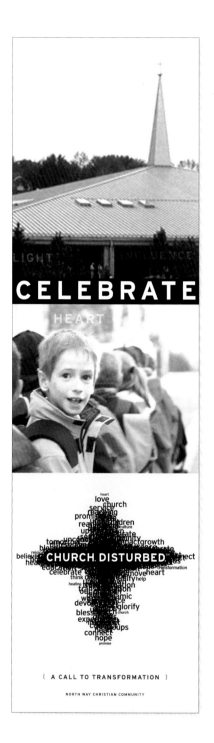

KNOW YOUR NEIGHBOR.

WALLS ARE MAN MADE.

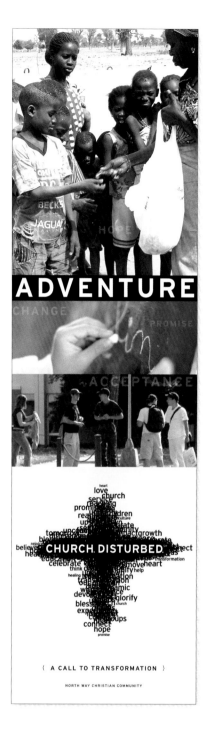

WHERE IS THE CHURCH?

HAVE A PURPOSE.

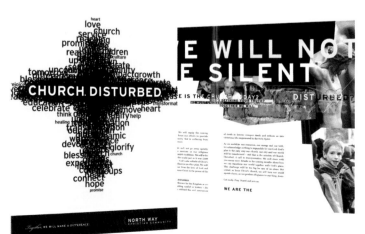

CLIENT
Northway Community Church
CREATIVE FIRM
FSC Marketing Communications
www.fscmc.com
CREATIVE DIRECTOR
Bryan Brunsell
DESIGNER
Tim Frost

CLAYTON'S

CLAYTON'S

REAL PEOPLE REAL COFFEE REAL SIMPLE

—

WE INVITE YOU
TO CELEBRATE
WITH US
AT OUR GRAND
OPENING PARTY

TUESDAY
DECEMBER 4TH
4-6 P.M.

OUR NEW
LOCATION IS
1016 H STREET

DOWNTOWN
MODESTO
522-7811

CLAYTON'S

REAL PEOPLE REAL COFFEE REAL SIMPLE

—

WE ARE OPEN!
6-4 M-F

FRESH BAKED PASTRIES
& SAVORIES

LOOSE LEAF TEAS

COMMERCIAL BREWING
EQUIPMENT

OFFICE COFFEE SERVICE &
CATERING AVAILABLE

1016 H STREET
DOWNTOWN MODESTO

209-522-7811
WWW.CLAYTONCOFFEE.CO

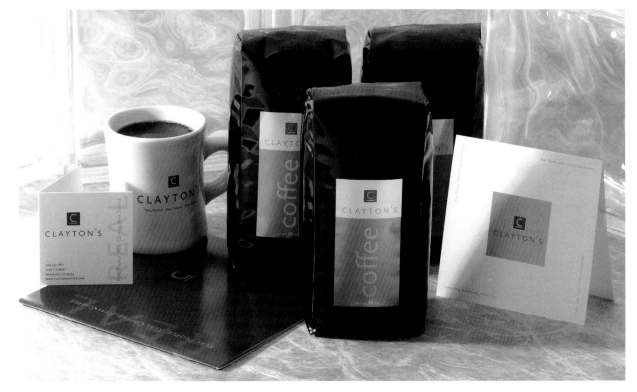

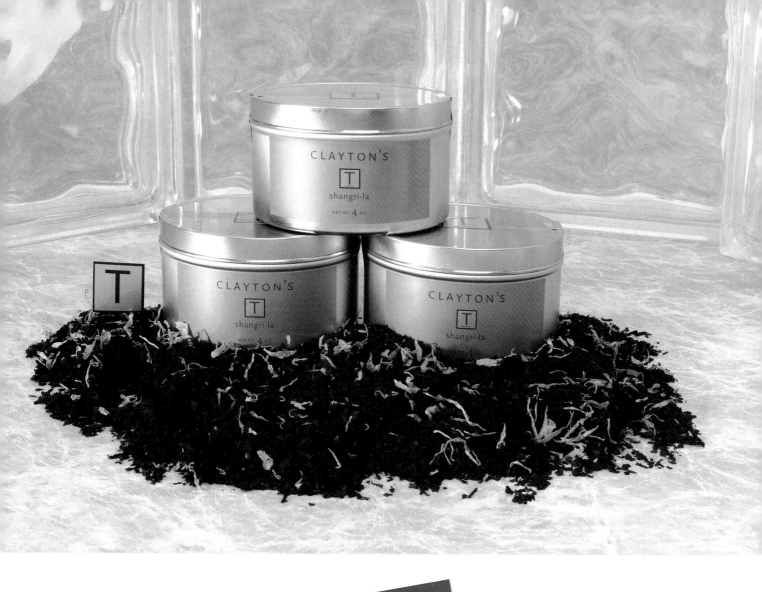

CLIENT
Clayton's Restaurant & Coffee
CREATIVE FIRM
Marcia Herrmann Design
www.her2man2.com

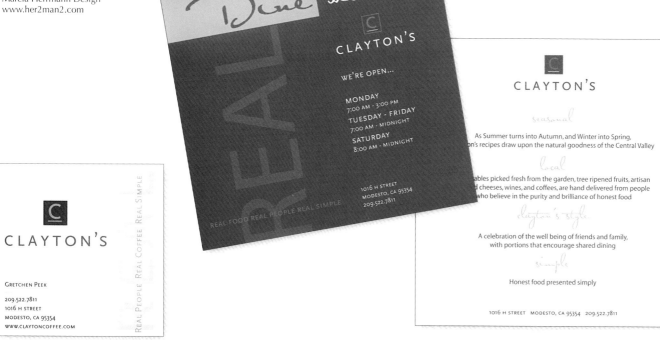

Covenant
House
Opening Doors for Homeless Youth

CLIENT
 Covenant House
CREATIVE FIRM
 Verse Group
 versegroup.com
CREATIVE DIRECTORS
 Michael Thibodeau, Sylvia Chu
DESIGNERS
 Marina Binns, Marco Acevedo

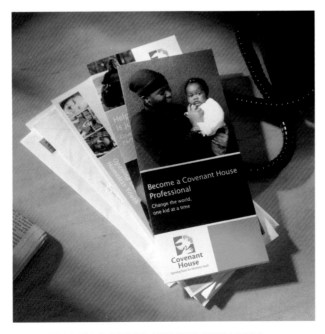

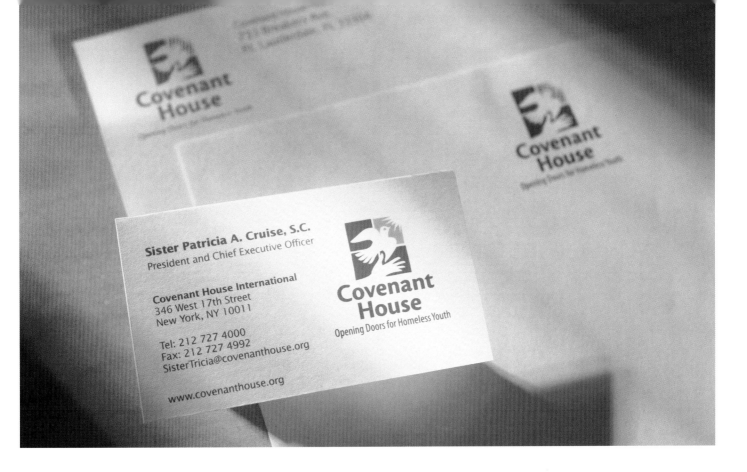

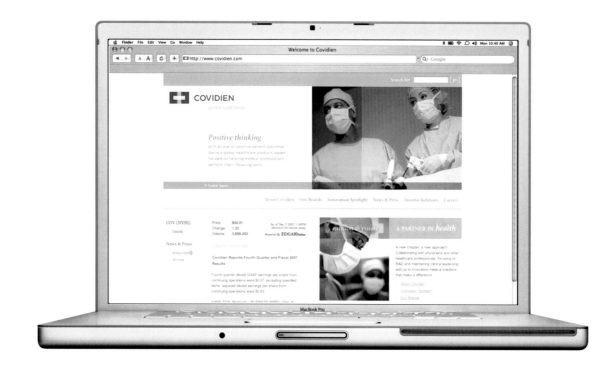

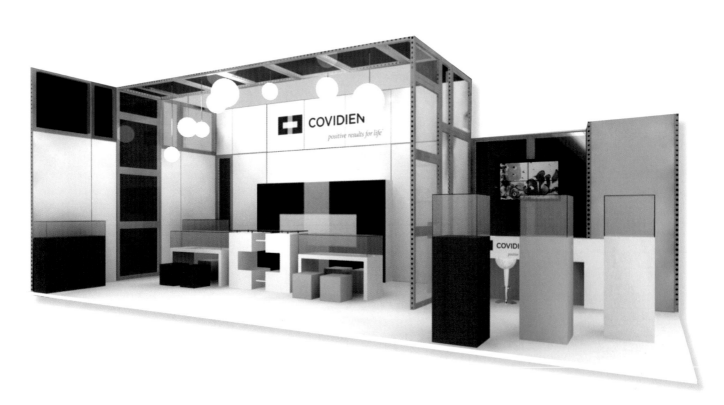

CLIENT
Covidien
CREATIVE FIRM
Interbrand New York
www.interbrand.com
CREATIVE DIRECTOR
Craig Stout
DESIGNER
Dan Dyksen

CLIENT
Days Inn
CREATIVE FIRM
Verse Group
versegroup.com
CREATIVE DIRECTORS
Michael Thibodeau, Silvia Chu
DESIGNERS
Marina Binns, Doris Dell, Marco Acevedo

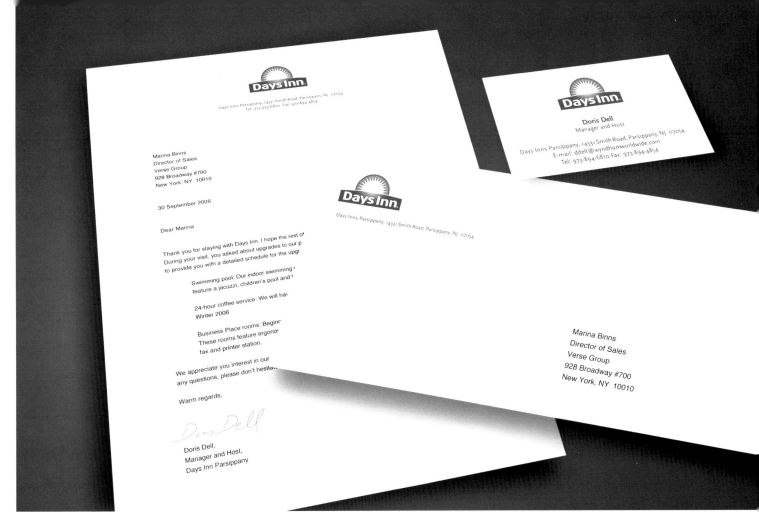

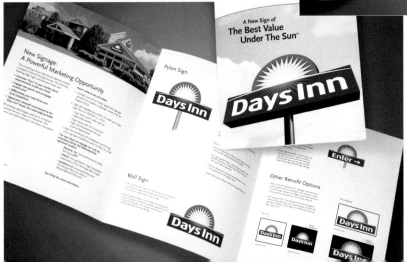

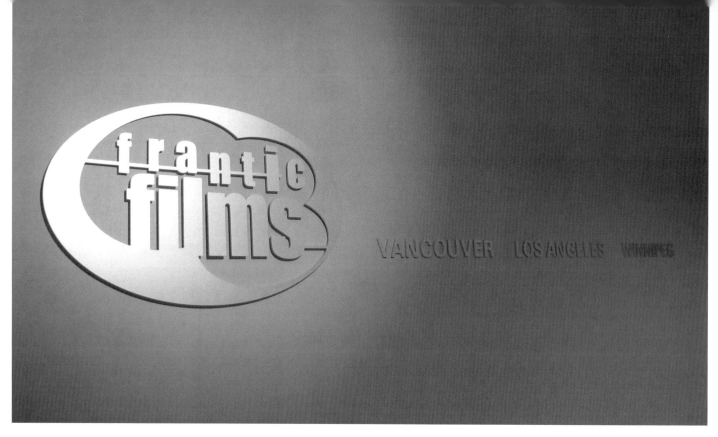

CLIENT
 Frantic Films
CREATIVE FIRM
 Velocity Design Works
 www.velocitydesignworks.com

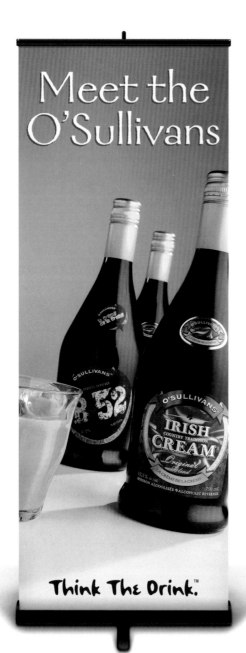

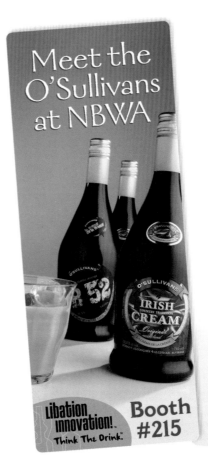

CLIENT
Geloso Beverages Inc.
CREATIVE FIRM
Icon Graphics Inc.
www.thinkfeelchoose.com

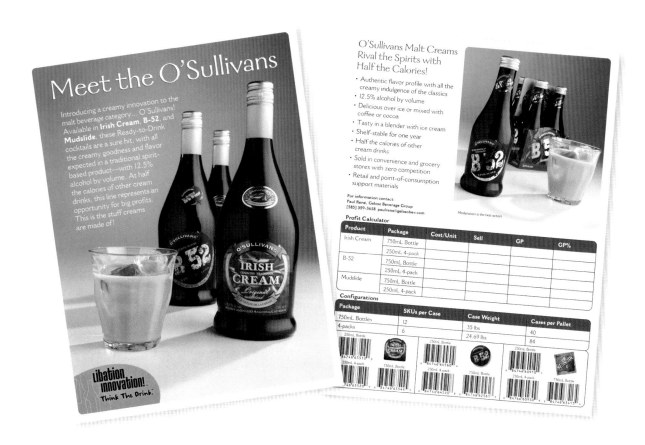

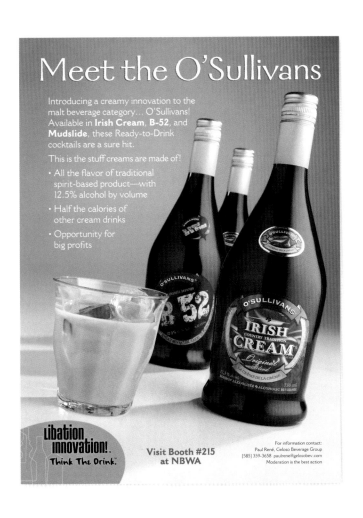

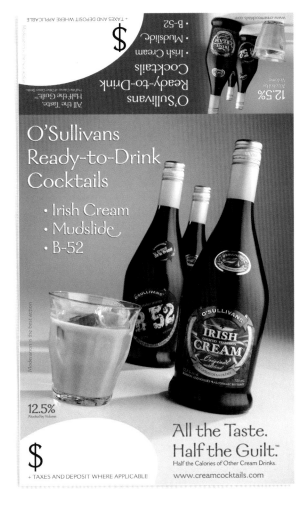

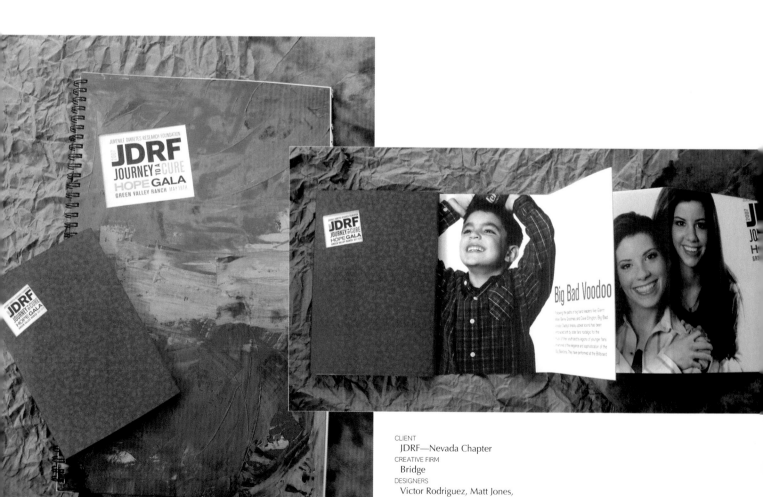

CLIENT
JDRF—Nevada Chapter
CREATIVE FIRM
Bridge
DESIGNERS
Victor Rodriguez, Matt Jones,
Patty Mar, Chris Smith

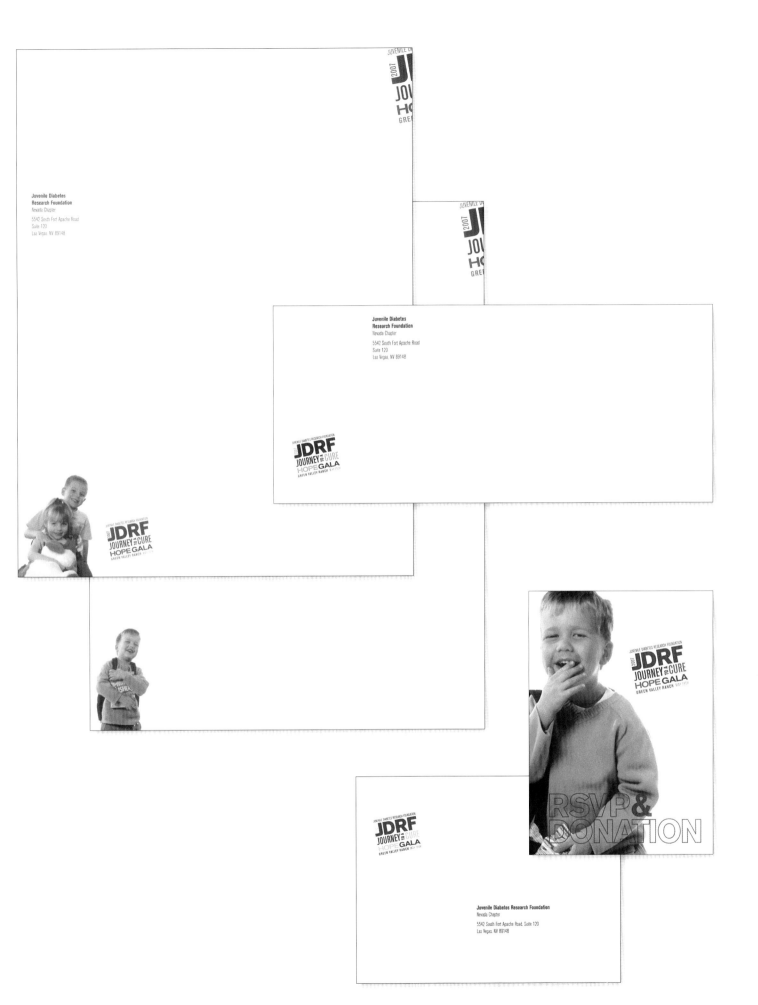

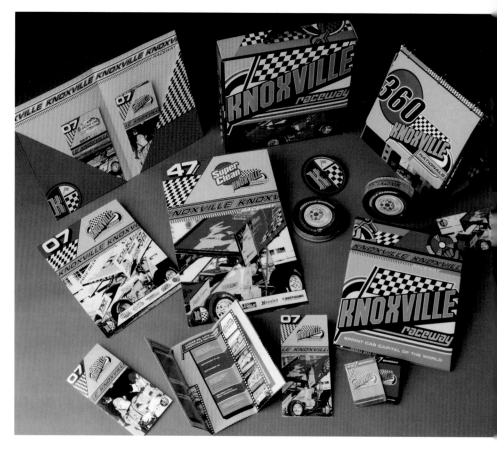

CLIENT
Knoxville Raceway
CREATIVE FIRM
Sayles Graphic Design
www.saylesdesign.com
DESIGNER
John Sayles

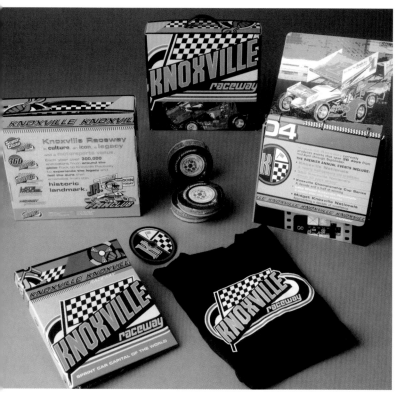

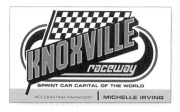

1000 NORTH LINCOLN STREET
P.O. BOX 347
KNOXVILLE, IOWA 50138
PHONE 641.842.5431
OR 641.842.3220
FAX 614.842.2899

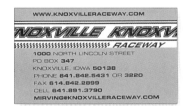

WWW.KNOXVILLERACEWAY.COM

WWW.KNOXVILLERACEWAY.COM

1000 NORTH LINCOLN STREET
PO BOX 347
KNOXVILLE, IOWA 50138
PHONE 641.842.5431 OR 3220
FAX 614.842.2899
CELL 641.891.3790
MIRVING@KNOXVILLERACEWAY.COM

1000 NORTH LINCOLN STREET
P.O. BOX 347
KNOXVILLE, IOWA 50138

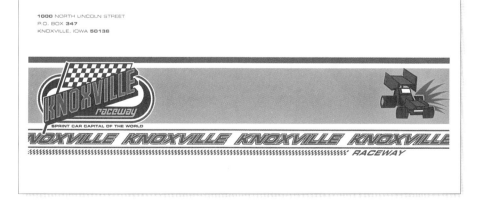

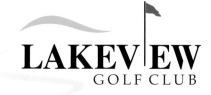

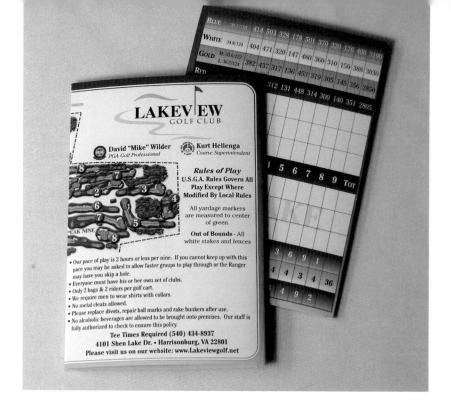

CLIENT
Lakeview Golf Club
CREATIVE FIRM
Seran Design
DESIGNER
Sang Yoon

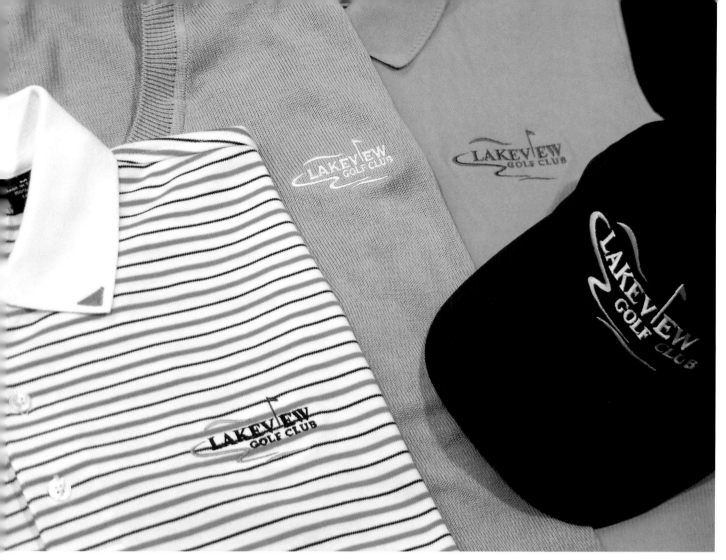

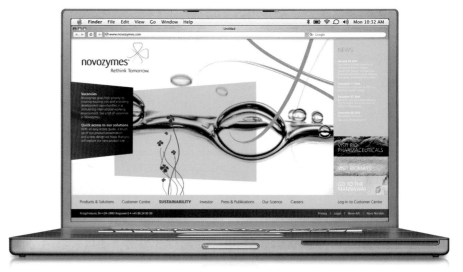

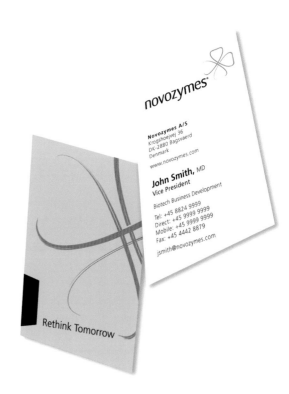

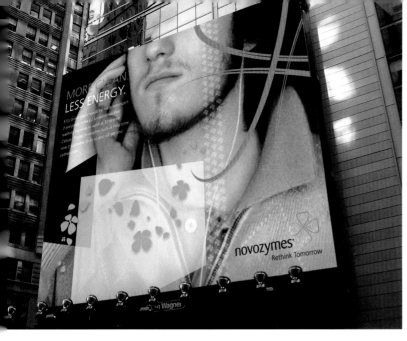

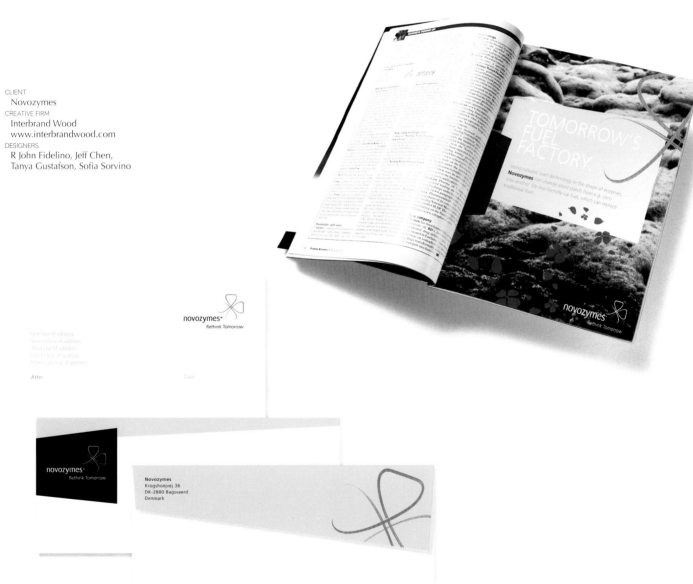

CLIENT
Novozymes
CREATIVE FIRM
Interbrand Wood
www.interbrandwood.com
DESIGNERS
R John Fidelino, Jeff Chen,
Tanya Gustafson, Sofia Sorvino

CLIENT
 Pittsburgh Downtown Partnership
CREATIVE FIRM
 FSC Marketing Communications
 www.fscmc.com
CREATIVE DIRECTOR
 Bryan Brunsell
ART DIRECTORS
 Lisa Sabol, Tim Frost

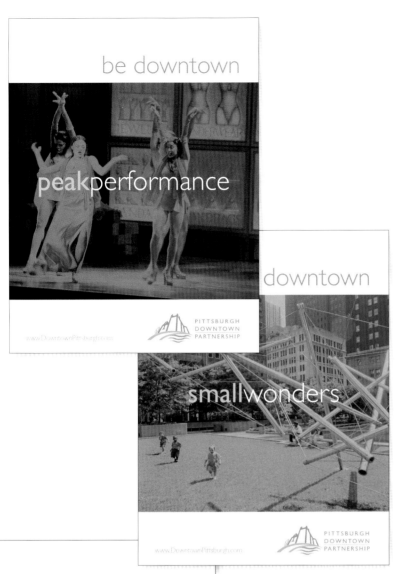

be downtown

peakperformance

www.DowntownPittsburgh.com

PITTSBURGH
DOWNTOWN
PARTNERSHIP

downtown

smallwonders

www.DowntownPittsburgh.com

PITTSBURGH
DOWNTOWN
PARTNERSHIP

be downtown

lookup

www.DowntownPittsburgh.com

PITTSBURGH
DOWNTOWN
PARTNERSHIP

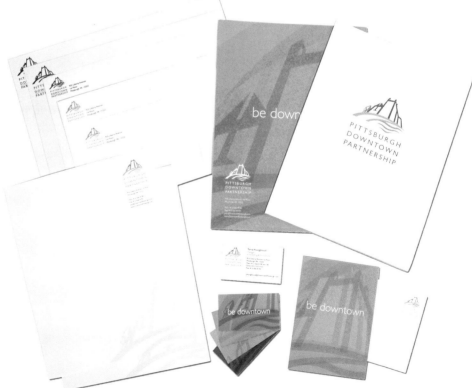

CLIENT
Teens for Safe Cosmetics
CREATIVE FIRM
Axion Design
axiondesign.com
DESIGNERS
Axion Design Team

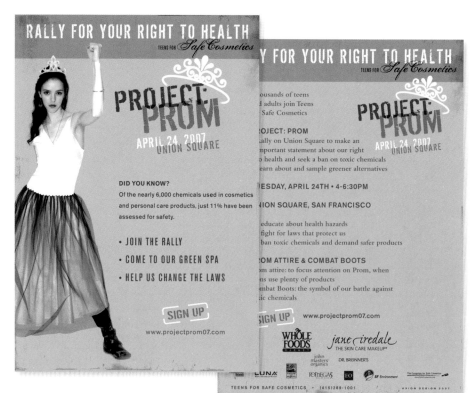

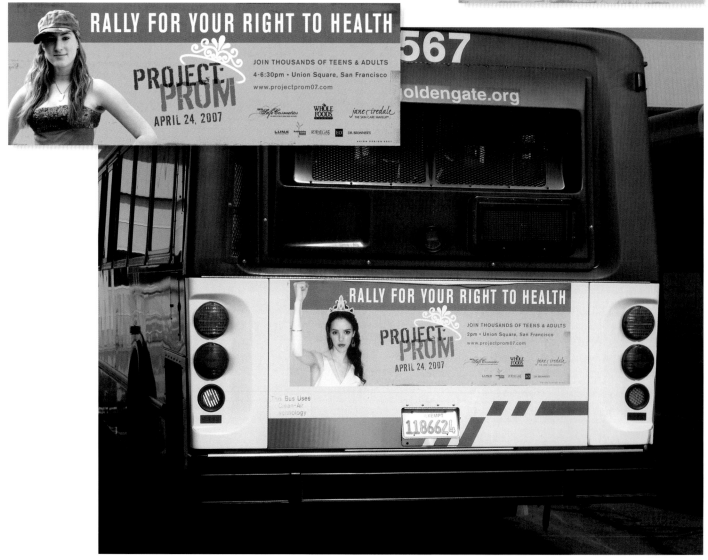

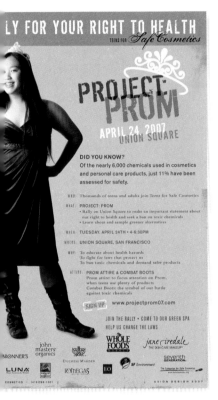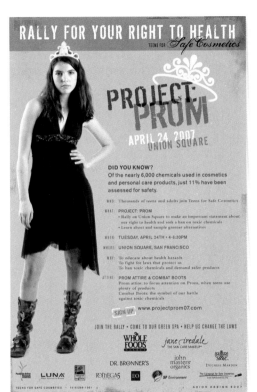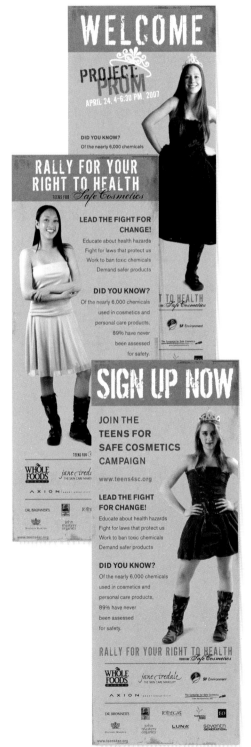

slice

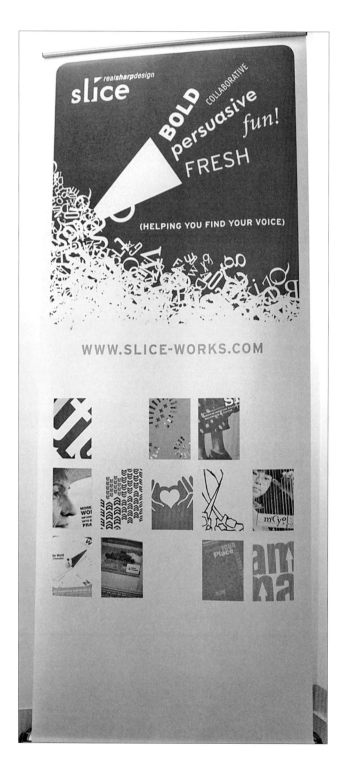

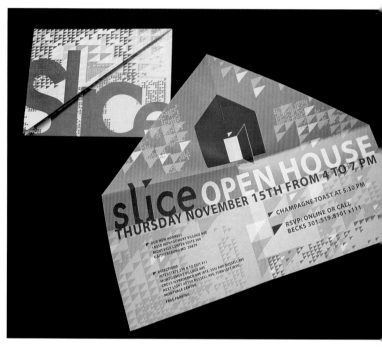

CLIENT
Slice
CREATIVE FIRM
Slice
www.slice-works.com
CREATIVES
Dick Rabil, Elizabeth Imber, Kevin Richards Natalie Taylor, Juana Merlo

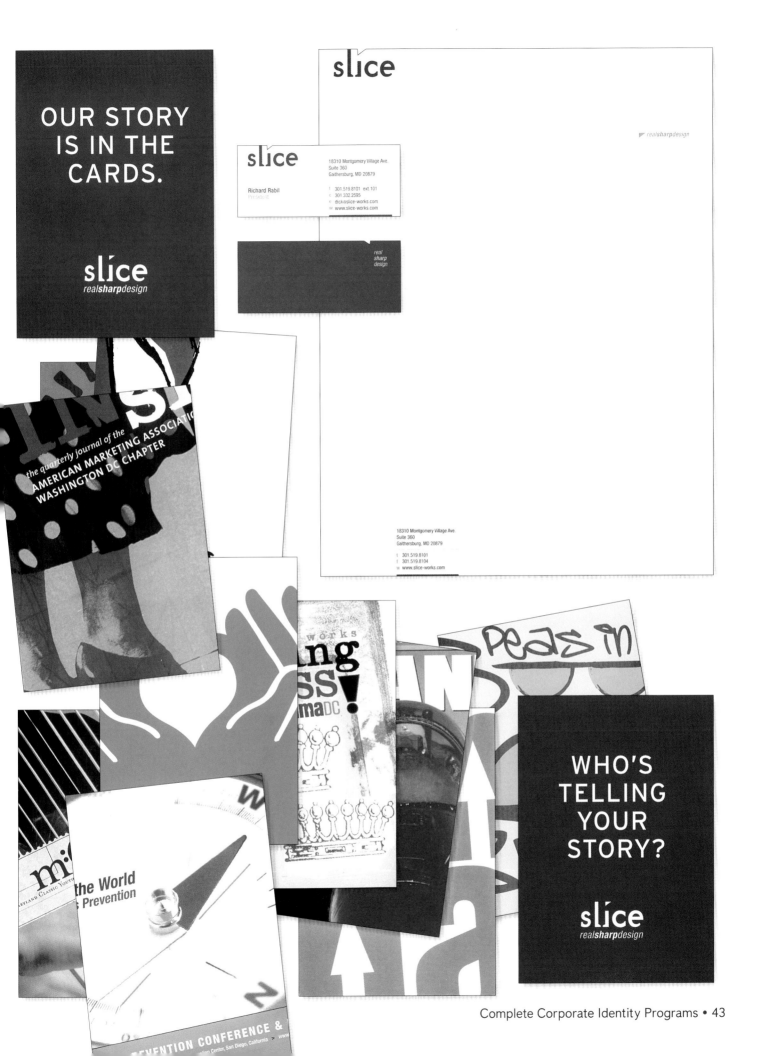

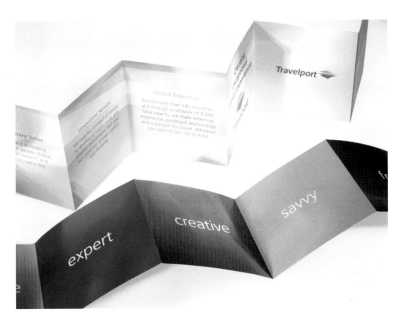

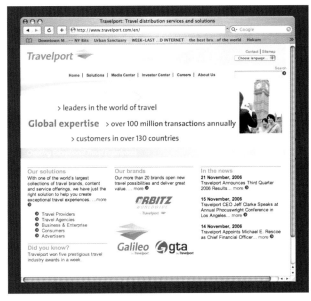

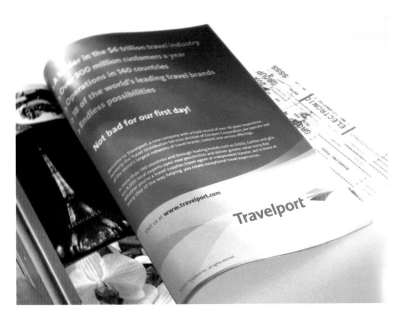

CLIENT
Travelport
CREATIVE FIRM
Verse Group
versegroup.com
CREATIVE DIRECTORS
Michael Thibodeau, Sylvia Chu
DESIGNERS
Michael Thibodeau, Doris Dell

ATTENTION JJC ALUMNI

Help Preserve *Your* Community College

On April 1st, there will be a referendum question on the ballot to increase the Joliet Junior College Operations and Maintenance Fund by 2-cents. This is crucial for repairing, replacing, and preserving 30-year-old buildings, systems, and their components.

The cost to you is just *Pennies a Day*. $10 a year on a home valued at $150,000.

Joliet Junior College has met the educational needs of the community for a century. Help preserve one of the community's most valuable assets.

For more information visit: www.jjc.edu/referendum

CLIENT
Joliet Junior College Alumni Association
CREATIVE FIRM
Bullet Communications, Inc.
www.BulletCommunications.com
DESIGNER
Tim Scott Kump

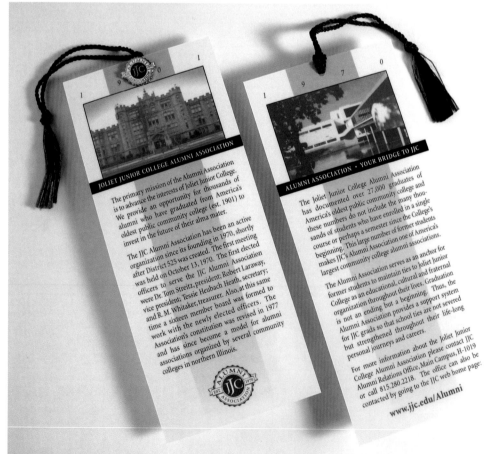

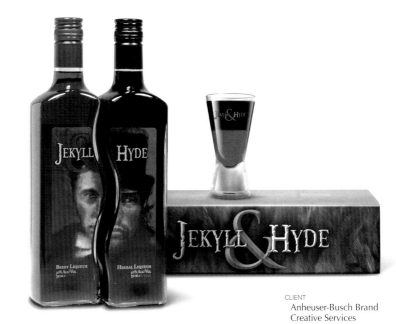

CLIENT
Wallace Church, Inc.
CREATIVE FIRM
Wallace Church, Inc.
www.wallacechurch.com
CREATIVE DIECTOR, DESIGNER
Stan Church

CLIENT
Linens-N-Things
CREATIVE FIRM
FAI Design Group
www.faidesigngroup.com
CREATIVE DIRECTOR
Marion Fraternale
ART DIRECTOR
Robert Scully
DESIGNERS
Robert Scully, Derek Hunter, Uriel Rivera
ILLUSTRATORS
Uriel Riverea, Robert Scully

CLIENT
Anheuser-Busch Brand
Creative Services
CREATIVE FIRM
Deutsch Design Works
www.ddw.com
CREATIVE DIRECTOR
Barry Deutsch
ART DIRECTOR
Mike Kunisaki
DESIGNER
Eric Pino

CLIENT
TriVita
CREATIVE FIRM
Hornall Anderson Design Works
www.hadw.com
DESIGNERS
Larry Anderson, Kathleen Gibson,
Jay Hilburn, Chang Ling Wu

CLIENT
Seafarer Baking Company
CREATIVE FIRM
Sabingrafik, Inc.
http://tracy.sabin.com
ILLUSTRATOR,DESIGNER
Tracy Sabin

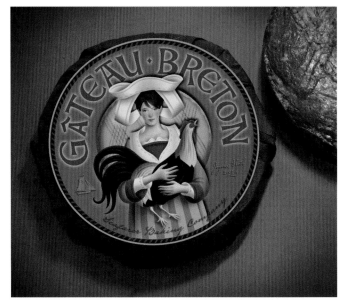

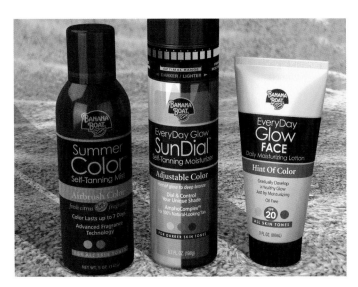

CLIENT
Playtex
CREATIVE FIRM
R.Bird
www.rbird.com
DESIGNERS
Marivi Chong, Joseph Favata, Kevin Lenahan

CLIENT
Chocolaterre
CREATIVE FIRM
McDill Design
www.mcdilldesign.com
DIRECTOR
Michael Dillon
DESIGNER
Dave Burkle

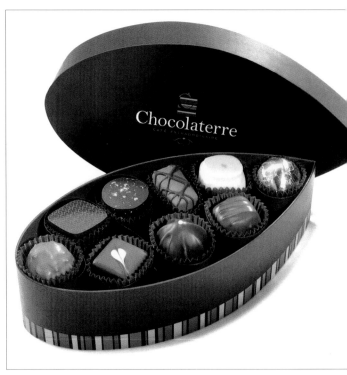

CLIENT
Colomer USA
CREATIVE FIRM
Culture Advertising Design
www.culture-ad.com
ART DIRECTOR
Craig Brimm

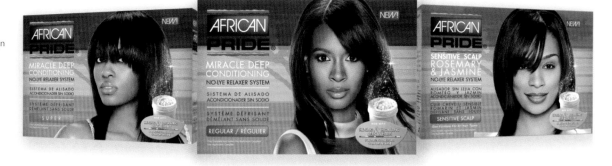

CLIENT
Panos Brands
CREATIVE FIRM
Wallace Church, Inc.
www.wallacechurch.com
CREATIVE DIRECTOR
Stan Church
DESIGN DIRECTOR
Marco Escalante
DESIGNER
Maritess Manaluz

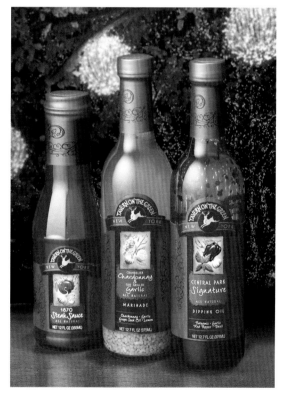

CLIENT
Tavern on the Green
CREATIVE FIRM
Dixon Schwabl
dixonschwabl.com
DESIGNERS
Kari Petsche,
Kara Painting,
Dana Denberg

CLIENT
Odyssey Lifestyle
CREATIVE FIRM
Brand, Ltd.
brandltd.com
DESIGNERS
Virginia Martino. Sandy Schiff

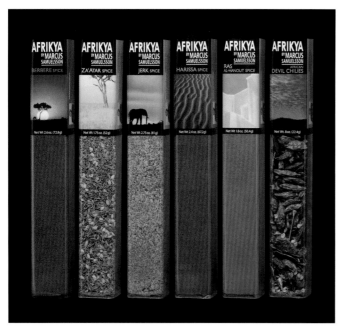

CLIENT
Marcus Samuelsson
CREATIVE FIRM
Silver Creative Group
silvercreativegroup.com
DESIGNER
Donna Bonato

CLIENT
Annie's Inc.
CREATIVE FIRM
Deutsch Design Works
www.ddw.com
CREATIVE DIRECTOR
Barry Deutsch
DESIGNER
Kate Greene

CLIENT
Bella Tunno
CREATIVE FIRM
Kelly Brewster Design
DESIGNER
Kelly Brewster

CLIENT
Lincoln Snacks
Company
CREATIVE FIRM
Haugaard Creative
Group
www.haugaard.com
DESIGNER
José Parado

50

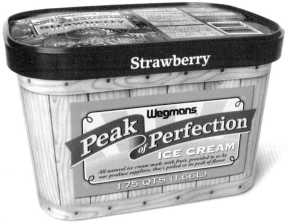

CLIENT
Wegmans Food Markets
CREATIVE FIRM
Icon Graphics inc.
www.thinkfeelchoose.com

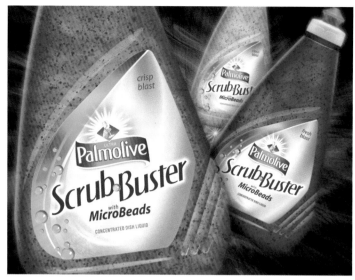

CLIENT
Colgate-Palmolive Company
CREATIVE FIRM
Zunda Group, LLC
www.zundagroup.com
DESIGNERS
Charles Zunda, Gary Esosito,
Dan Price, Lorraine Casscles

CLIENT
S.C. Johnson & Son, Inc.
CREATIVE FIRM
The Weber Group, Inc.
www.thewebergroupinc.com
DESIGNERS
Anthony Weber, Martin Defatte

CLIENT
Robinson Home Products
CREATIVE FIRM
Michael Orr + Associates, Inc.
michaelorrassociates.com
DESIGNERS
Michael R. Orr, Thomas Freeland

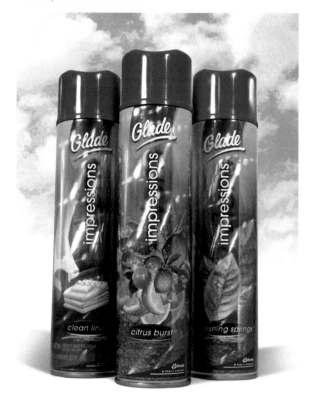

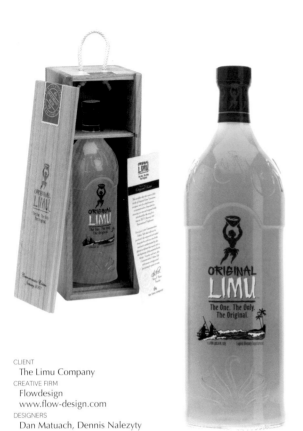

CLIENT
The Limu Company
CREATIVE FIRM
Flowdesign
www.flow-design.com
DESIGNERS
Dan Matuach, Dennis Nalezyty

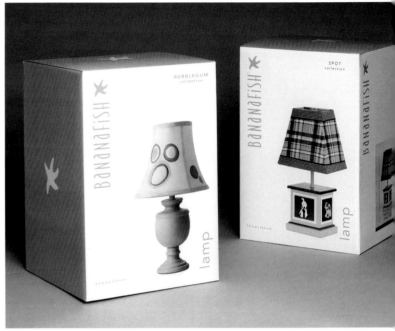

CLIENT
Bananafish for the Betesh Group
CREATIVE FIRM
Design Trends
tree52@optonline.net
CREATIVE DIRECTOR
David Un
DESIGNERS
Tree Trapanese, Ann Kim, Tom Connors
PHOTOGRAPHERS
Mayo Studios, Robert Lin

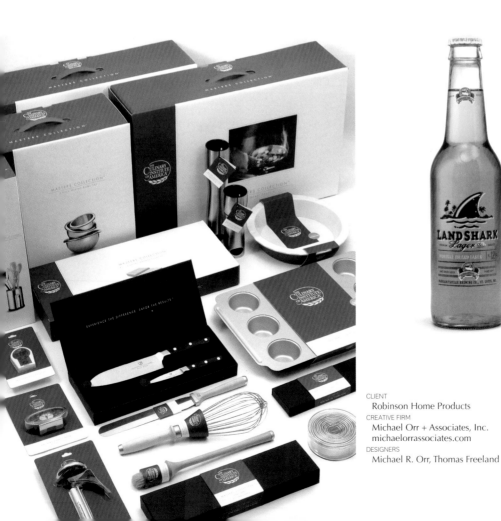

CLIENT
Robinson Home Products
CREATIVE FIRM
Michael Orr + Associates, Inc.
michaelorrassociates.com
DESIGNERS
Michael R. Orr, Thomas Freeland

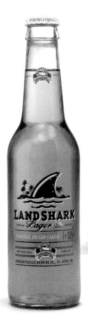

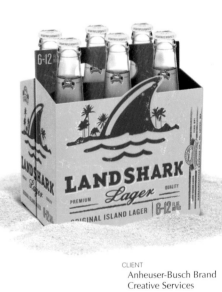

CLIENT
Anheuser-Busch Brand
Creative Services
CREATIVE FIRM
Deutsch Design Works
www.ddw.com
CREATIVE DIRECTOR
Barry Deutsch
ART DIRECTOR
Mike Kunisaki
DESIGNER
Nancy Andre

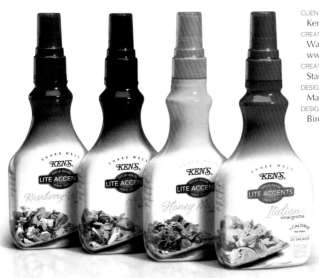

CLIENT
Ken's Foods Inc.
CREATIVE FIRM
Wallace Church, Inc.
www.wallacechurch.com
CREATIVE DIRECTOR
Stan Church
DESIGN DIRECTOR
Marco Escalante
DESIGNER
Bird Tubkam

CLIENT
Conroy Foods
CREATIVE FIRM
FSC Marketing Communications
www.fscmc.com
ART DIRECTOR
Lisa Sabol
CREATIVE DIRECTOR, DESIGNER
Bryan Brunsell

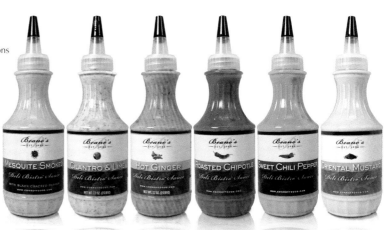

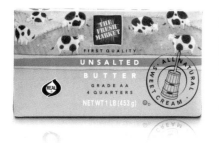 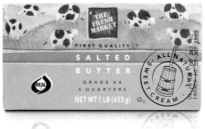

CLIENT
The Fresh Market
CREATIVE FIRM
Daymon Worldwide Design
www.daymonworldwidedesign.com
DESIGNERS
Jane Atwell, Joanne Sena Hines,
Jupiter Images

CLIENT
The Dial Corporation
CREATIVE FIRM
Wallace Church, Inc.
www.wallacechurch.com
CREATIVE DIRECTOR
Stan Church

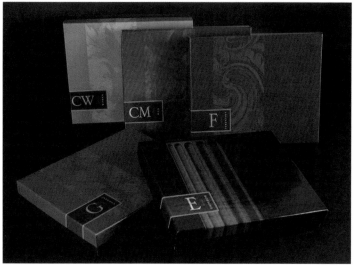

CLIENT
Caesars Palace Las Vegas
CREATIVE FIRM
eurie creative
www.euriecreative.com
DESIGNERS
Victor Rodriguez,
Alex Frazier, Joe Cotrupe

CLIENT
Anheuser-Busch Brand
Creative Services
CREATIVE FIRM
Deutsch Design Works
www.ddw.com
CREATIVE DIRECTOR
Barry Deutsch
ART DIRECTOR
Mike Kunisaki
DESIGNER
Jason Abreau

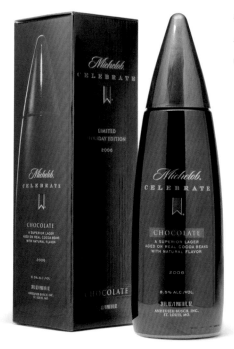

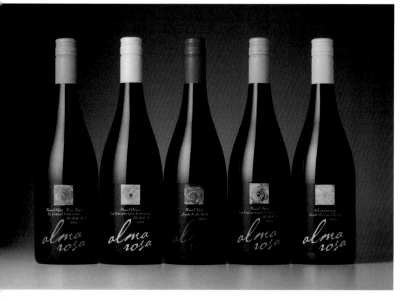

CLIENT
Alma Rosa Winery
CREATIVE FIRM
Mark Oliver, Inc.
www.markoliverinc.com
CREATIVE DIRECTOR
Mark Oliver
DESIGNER
Parry Driskel
ILLUSTRATOR
Leslie Wu

CLIENT
Agro Farma, Inc.
CREATIVE FIRM
Zunda Group, LLC
www.zundagroup.com
DESIGNERS
Charles Zunda, Edward Moeller

CLIENT
Wyatt Zier
CREATIVE FIRM
Wallace Church, Inc.
www.wallacechurch.com
CREATIVE DIRECTOR
Stan Church
DESIGN DIRECTOR, DESIGNER
Marco Escalante

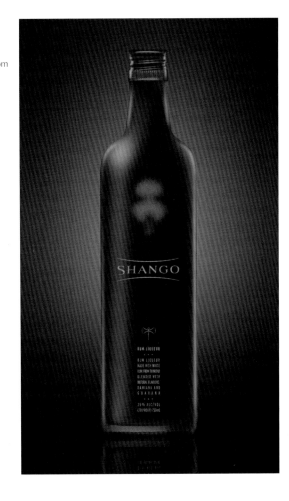

CLIENT
Bed Bath & Beyond
CREATIVE FIRM
FAI Design Group
www.faidesigngroup.com
CREATIVE DIRECTOR
Allison Schwartz
ART DIRECTOR, DESIGNER, ILLUSTRATOR
Robert Scully

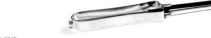

CLIENT
Anheuser-Busch Brand
Creative Services
CREATIVE FIRM
Deutsch Design Works
www.ddw.com
CREATIVE DIRECTOR
Barry Deutsch
DESIGNERS
Mike Kunisaki, Eric Pino

CLIENT
Luna Roasters Gourmet
Coffee & Tea
CREATIVE FIRM
Evenson Design Group
www.evensondesign.com
CREATIVE DIRECTOR
Stan Evenson
DESIGNER, ILLUSTRATOR
Mark Sojka

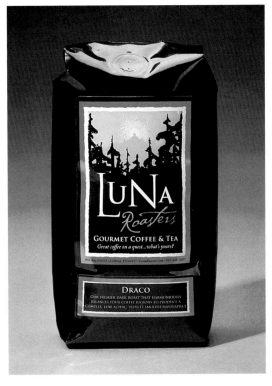

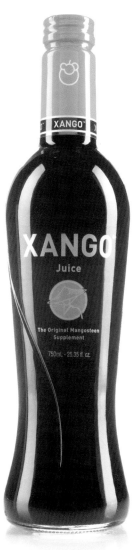

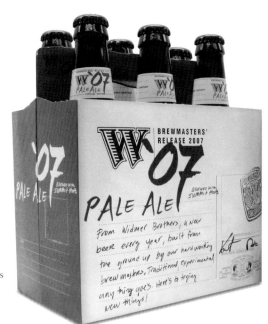

CLIENT
Widmer Brothers Brewery
CREATIVE FIRM
Hornall Anderson Design Works
www.hadw.com
DESIGNERS
Larry Anderson, Bruce Stigler,
Jay Hilburn, Vu Nguyen

CLIENT
Xango
CREATIVE FIRM
Flowdesign
www.flow-design.com
DESIGNERS
Dan Matuach,
Dennis Nalezyty

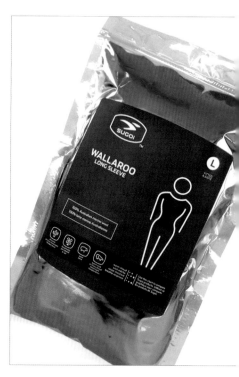

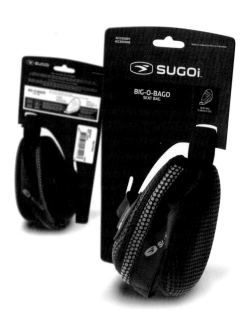

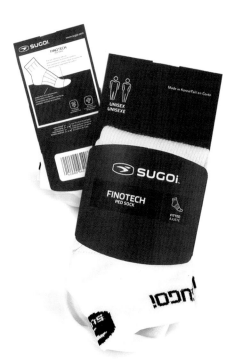

JUDGE'S WORK
CLIENT
Sugoi
CREATIVE FIRM
Lemley Design
www.lemleydesign.com
DESIGNERS
David Lemley,
Pat Snavely,
Coventry Jankowski,
Amber Hahto,
Jeremy Wheat

CLIENT
The Fresh Market
CREATIVE FIRM
Daymon Worldwide Design
www.daymonworldwidedesign.com
DESIGNERS
Jane Atwell,
Joanne Sena Hines

CLIENT
Nino Salvaggio International Marketplace
CREATIVE FIRM
Goldforest
www.goldforest.com
CREATIVE DIRECTOR
Lauren Gold
ART DIRECTOR
Bibiana Pulido
DESIGNER
Carolyn Rodi
ILLUSTRATOR
Roger Xavier

CLIENT
Wyeast Laboratories
CREATIVE FIRM
Funk/Levis & Associates
funklevis.com
DESIGNER
Jason Anderson

CLIENT
Deutsch Design Works
CREATIVE FIRM
Anheuer-Busch Brand
Creative Services
www.ddw.com
CREATIVE DIRECTOR
Barry Deutsch
ART DIRECTOR
Mike Kunisaki
DESIGNER
Didem Carissimo

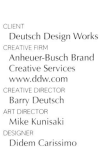

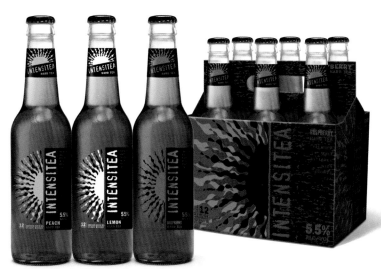

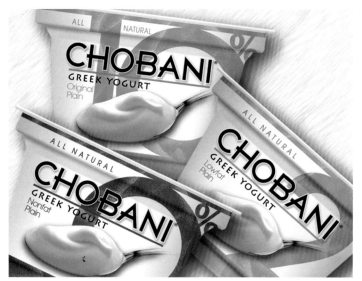

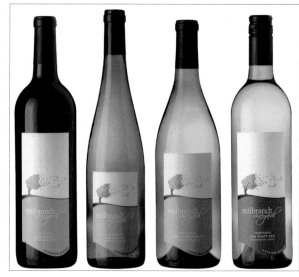

CLIENT
Agro Farma, Inc.
CREATIVE FIRM
Zunda Group, LLC
www.zundagroup.com
DESIGNERS
Charles Zunda, Edward Moeller

CLIENT
Milbrandt Vineyards
CREATIVE FIRM
Image Ink Studio
imageink.com
DESIGNERS
Tom Hession-Herzog,
Chris McInerney

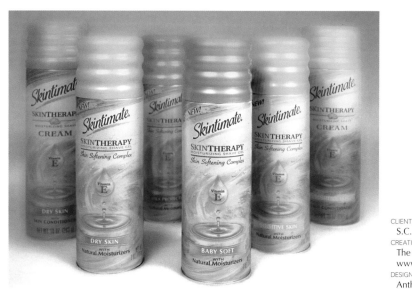

CLIENT
S.C. Johnson & Son, Inc.
CREATIVE FIRM
The Weber Group, Inc.
www.thewebergroupinc.com
DESIGNERS
Anthony Weber, Shad Smith,
Scott Schreiber, Steve Westfall

CLIENT
Bananafish for the Betesh Group
CREATIVE FIRM
Design Trends
tree52@optonline.net
CREATIVE DIRECTOR
David Un
DESIGNERS
Tree Trapanese,
Ann Kim, Tom Connors
PHOTOGRAPHER
Mayo Studios, Robert Lin

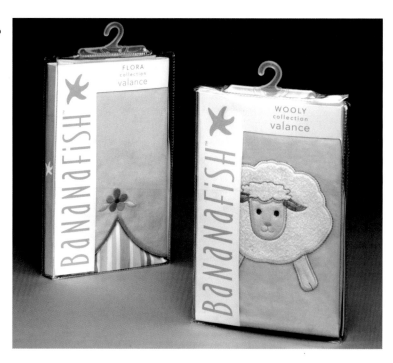

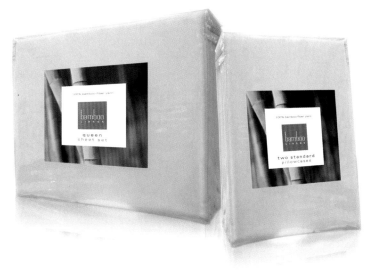

CLIENT
Bed Bath & Beyond
CREATIVE FIRM
FAI Design Group
www.faidesigngroup.com
CREATIVE DIRECTOR
Allison Schwartz
ART DIRECTOR, DESIGNER
Robert Scully

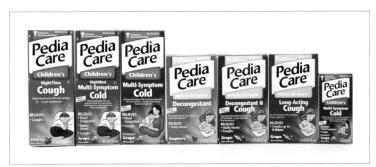

CLIENT
Pfizer
CREATIVE FIRM
The Bailey Group
www.baileygp.com
DESIGNERS
Dave Fiedler, Gary LaCroix,
Ann Malone, Eric Yeager,
Christian Williamson

CLIENT
GSC Gourmet
CREATIVE FIRM
Sellier Design
sellierdesign.com
DESIGNERS
Pauline Pellicer, Brahndi Asadi

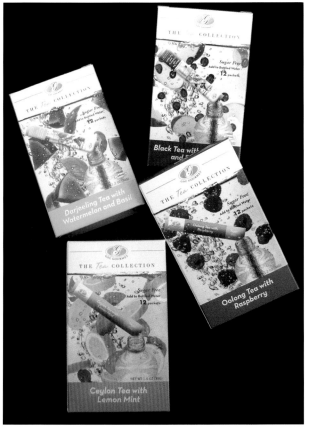

CLIENT
Topco Corporation
CREATIVE FIRM
Design Resource Center
www.drcchicago.com
DESIGNERS
John Norman, Eric Timm

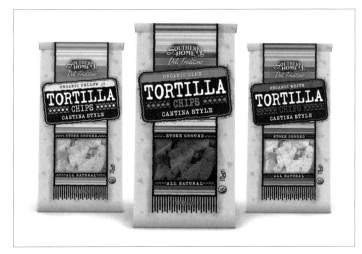

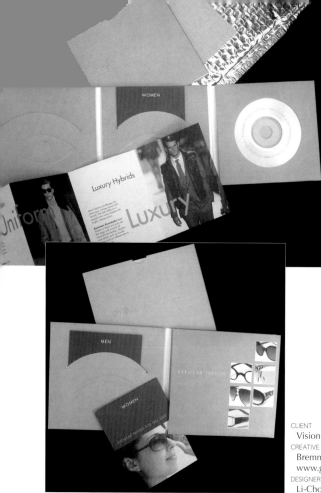

CLIENT
Tahitian Noni
CREATIVE FIRM
Hornall Anderson Design Works
www.hadw.com
DESIGNERS
Lisa Cerveny, Jana Nishi,
Belinda Bowling, Leo Raymundo

CLIENT
Vision Council of America
CREATIVE FIRM
Bremmer & Goris Communications
www.goris.com
DESIGNERS
Li-Chow, Miki Lo

CLIENT
AquaDeco
CREATIVE FIRM
Flowdesign
www.flow-design.com
DESIGNERS
Dan Matauch,
Dennis Nalezyty

CLIENT
Anheuser-Busch Brand Creative Services
CREATIVE FIRM
Deutsch Design Works
www.ddw.com
CREATIVE DIRECTOR
Barry Deutsch
ART DIRECTOR
Mike Kunisaki
DESIGNER
Gregg Perin

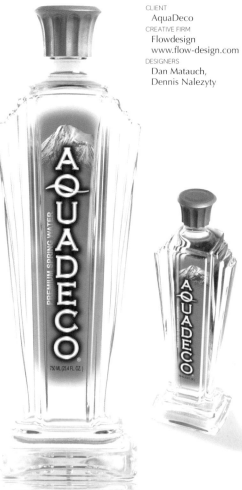

CLIENT
Hansen's Beverages
CREATIVE FIRM
Flowdesign
www.flow-design.com
DESIGNERS
Dan Matauch, Dennis Nalezyty

CLIENT
Rio Blanco Spirits, LLC
CREATIVE FIRM
Deutsch Design Works
www.ddw.com
CREATIVE DIRECTOR
Barry Deutsch
DESIGNER
Jason Abreu

CLIENT
Microsoft Corporation
CREATIVE FIRM
Hornall Anderson Design Works
www.hadw.com
DESIGNERS
Jack Anderson, Andrew Wicklund,
David Bates, Elmer dela Cruz,
Jacob Carter, Peter Anderson, Chris Freed

CLIENT
Dr. Weil
CREATIVE FIRM
FAI Design Group
www.faidesigngroup.com
CREATIVE DIRECTOR
Marion Fraternale
ART DIRECTOR, DESIGNER
Robert Scully
PHOTOGRAPHER
Colin Cooke

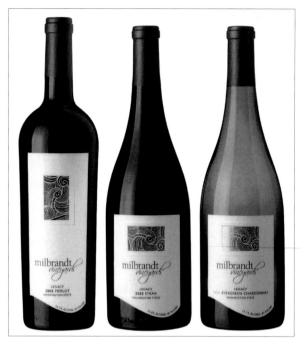

CLIENT
Milbrandt Vineyards
CREATIVE FIRM
Image Ink Studio
imageink.com
DESIGNERS
Tom Hession-Herzog, Chris McInerney

CLIENT
BTS
CREATIVE FIRM
Sellier Design
sellierdesign.com
DESIGNER
Pauline Pellicer

CLIENT
The Fresh Market
CREATIVE FIRM
Daymon Worldwide Design
www.daymonworldwidedesign.com
DESIGNERS
Jane Atwell, Joanne Sean Hines, Studio Zoo

CLIENT
S.C. Johnson & Son, Inc.
CREATIVE FIRM
The Weber Group, Inc.
www.thewebergroupinc.com
DESIGNERS
Anthony Weber, Steve Westfall,
Shad Smith, Scott Schrieber

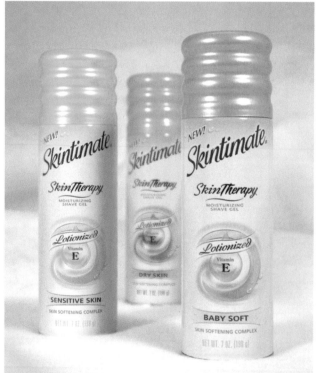

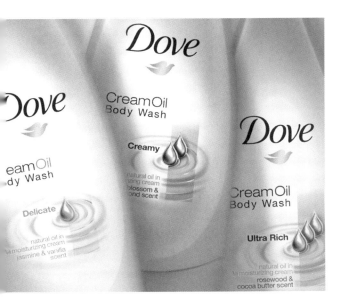

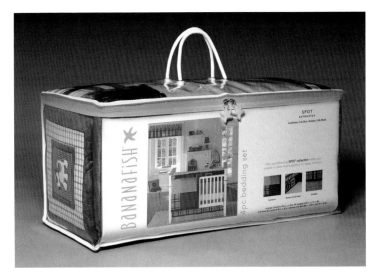

CLIENT
Unilever Home & Personal Care - USA
CREATIVE FIRM
Zunda Group, LLC
www.zundagroup.com
DESIGNERS
Charles Zunda, Gary Esposito,
Lauren Millar, Matthew Okin

CLIENT
Bananafish for the Betesh Group
CREATIVE FIRM
Design Trends
tree52@optonline.net
CREATIVE DIRECTOR
David Un
DESIGNERS
Tree Trapanese, Ann Kim, Tom Connor
PHOTOGRAPHER
Mayo Studios, Robert Lin

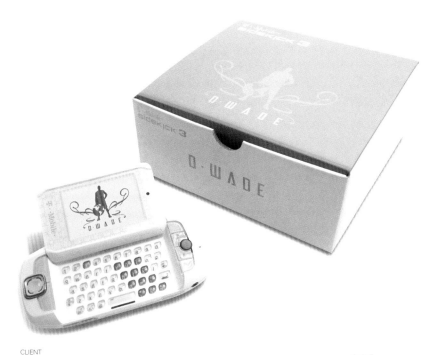

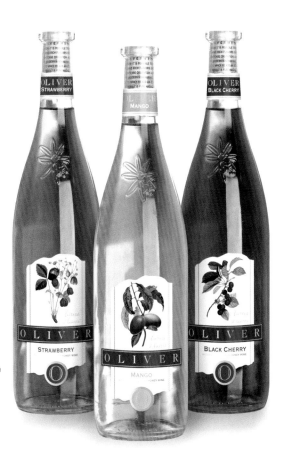

CLIENT
T-Mobile
CREATIVE FIRM
Hornall Anderson Design Works
www.hadw.com
DESIGNERS
Mark Popich, Ethan Keller,
Andrew Well, Jon Graeff,
Rachel Lancaster

CLIENT
Oliver Winery
CREATIVE FIRM
Flowdesign
www.flow-design.com
DESIGNERS
Dan Matauch,
Dennis Nalezyty,
Allison Tinsley

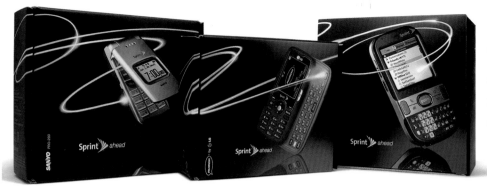

CLIENT
Sprint
CREATIVE FIRM
Deutsch Design Works
www.ddw.com
CREATIVE DIRECTOR
Barry Deutsch
DESIGN DIRECTOR
Erika Krieger
DESIGNER
Eric Pino

CLIENT
Anheuser-Busch Brand Creative Services
CREATIVE FIRM
Deutsch Design Works
www.ddw.com
CREATIVE DIRECTOR
Barry Deutsch
ART DIRECTOR
Mike Kunisaki
DESIGNER
Eric Pino

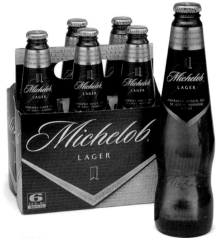

CLIENT
Anheuser-Busch Brand Creative Services
CREATIVE FIRM
Deutsch Design Works
www.ddw.com
CREATIVE DIRECTOR
Barry Deutsch
ART DIRECTOR
Mike Kunisaki

CLIENT
Biowave
CREATIVE FIRM
Taylor Design
taylordesign.com
DESIGNER
Steve Habersaug

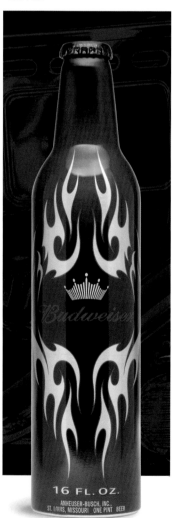

TAGS, BAGS, LABELS, & BOXES

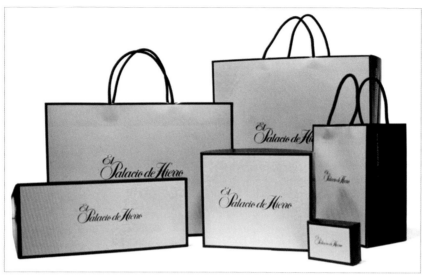

CLIENT
El Palacio de Hierro
CREATIVE FIRM
Alexander Isley Inc.
www.alexanderisley.com
CREATIVE DIRECTOR
Alexander Isley
MANAGING DIRECTOR
Aline Hilford
ART DIRECTOR
Tara Benyei

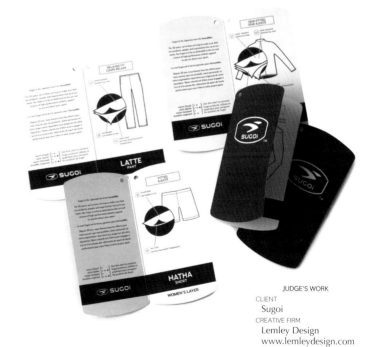

JUDGE'S WORK
CLIENT
Sugoi
CREATIVE FIRM
Lemley Design
www.lemleydesign.com
DESIGNERS
David Lemley,
Pat Snavely,
Coventry Jankowski,
Amber Hahto,
Jeremy Wheat

CLIENT
Strikke Designs
CREATIVE FIRM
Peggy Lauritsen Design Group
www.pldg.com
ART DIRECTOR, DESIGNER
Laura Dokken

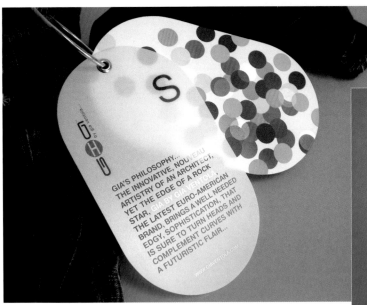

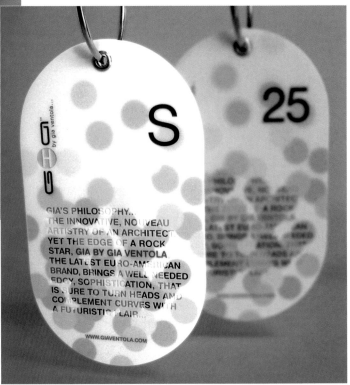

CLIENT
Platinum Holdings, Inc./Gia Ventola
CREATIVE FIRM
Helena Seo Design
www.helenaseo.com
CREATIVE DIRECTOR, DESIGNER
Helena Seo

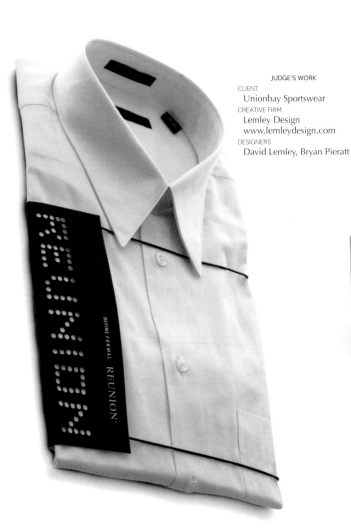

JUDGE'S WORK
CLIENT
Unionbay Sportswear
CREATIVE FIRM
Lemley Design
www.lemleydesign.com
DESIGNERS
David Lemley, Bryan Pieratt

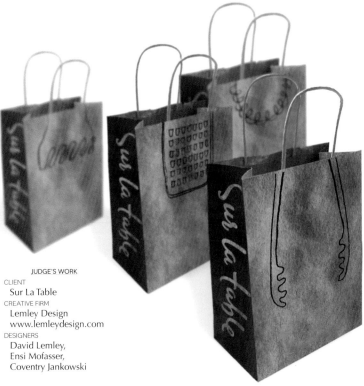

JUDGE'S WORK
CLIENT
Sur La Table
CREATIVE FIRM
Lemley Design
www.lemleydesign.com
DESIGNERS
David Lemley,
Ensi Mofasser,
Coventry Jankowski

BUSINESS CARDS

CLIENT
Green Lion International
CREATIVE FIRM
Seth Joseph & Co., LLC
www.sethjoseph.com
DESIGNER
Seth J. Katzen

CLIENT
Teach To Fish
CREATIVE FIRM
Brohard Design Inc.
www.brohard.com
DESIGNER
William Brohard

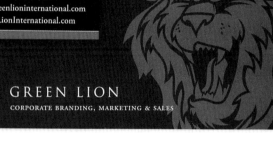

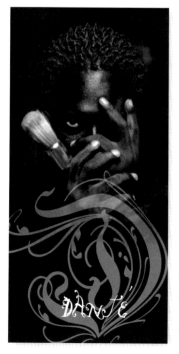

CLIENT
The Campus Theatre
CREATIVE FIRM
MFDI
DESIGNER
Mark Fertig

JUDGE'S WORK
CLIENT
Dante Yarbourgh Fine Artist
CREATIVE FIRM
Culture Advertising Design
www.culture-ad.com
ART DIRECTOR
Craig Brimm

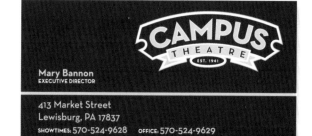

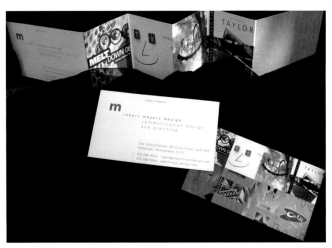

CLIENT
Robert Meyers Design
CREATIVE FIRM
Robert Meyers Design
robertmeyersdesign.com
DESIGNER
Robert Meyers

Suzan Blackman
designer

imag'in

514.883.6606
info@imagincards.com

410, Wickham
Saint-Lambert, QC
J4R 2B3

www.imagincards.com

CLIENT
Imag'in Greeting Cards
CREATIVE FIRM
Marqium
www.marqium.com
DESIGNER
Fadi Yaacoub

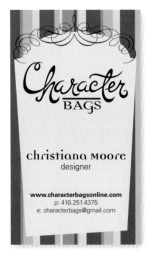

CLIENT
Character Bags
CREATIVE FIRM
Kalico Design
www.kalicodesign.com
CREATIVE DIRECTOR, DESIGNER
Kimberly Dow

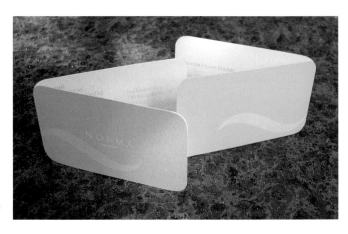

CLIENT
Norma Foster Maddy
CREATIVE FIRM
Marcia Herrmann Design
www.her2man2.com

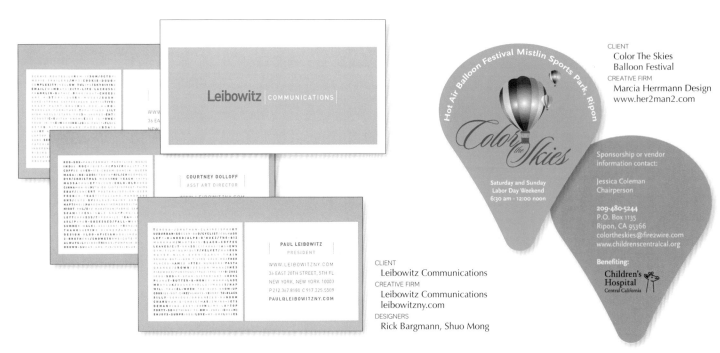

CLIENT
Leibowitz Communications
CREATIVE FIRM
Leibowitz Communications
leibowitzny.com
DESIGNERS
Rick Bargmann, Shuo Mong

CLIENT
Color The Skies
Balloon Festival
CREATIVE FIRM
Marcia Herrmann Design
www.her2man2.com

CLIENT
Hoopla Headquarters
CREATIVE FIRM
Hoopla Headquarters
www.hooplahq.com
DESIGNER
Ivy Oliver

CLIENT
James Atkins Photography
CREATIVE FIRM
Octavo Designs
www.8vodesigns.com
DESIGNER
Sue Hough

CLIENT
Genevieve Bond
CREATIVE FIRM
TrueBlue
www.trueblue.us
DESIGNERS
Ria Fisher,
James Lawton

CLIENT
Platinum Holdings, Inc./
Gia Ventola
CREATIVE FIRM
Helena Seo Design
www.helenaseo.com
CREATIVE DIRECTOR, DESIGNER
Helena Seo

CLIENT
Vision Swirl
CREATIVE FIRM
Roskelly Inc.
ww.roskelly.com
DESIGNER
Thomas C. Roskelly

CLIENT
Mary Marsh
CREATIVE FIRM
Hausman Design
www.hausmandesign.com
DESIGNER
Joan Hausman

CLIENT
Sellier Design
CREATIVE FIRM
Sellier Design
www.sellierdesign.com
DESIGNER
Pauline Pellicer

CLIENT
The Genius Organization
CREATIVE FIRM
BBM&D
bbmd-inc.com
DESIGNER
Barbara Brown

CLIENT
Sales Concepts
CREATIVE FIRM
Crawford Design
www.crawford-design.com
DESIGNER
Alison Crawford

CLIENT
Michael Christopher Salon
CREATIVE FIRM
Crawford Design
www.crawford-design.com
DESIGNER
Alison Crawford

CLIENT
Chip Shot Photo
CREATIVE FIRM
Eye 2 Eye Graphics
www.eye2eyegraphics.com
DESIGNER
Nancy Owyang

MOORPARK COLLEGE

HUMANITIES/VISUAL AND COMMUNICATION ARTS
Moorpark College
7075 Campus Road
Moorpark, CA 93021
www.moorparkcollege.edu
805 378 1400

MOORPARK COLLEGE

7075 Campus Road
Moorpark, CA 93021

CLIENT
Moorpark College
CREATIVE FIRM
BBM&D
bbmd-inc.com
DESIGNERS
Mia Bortolussi, Suzette Brown

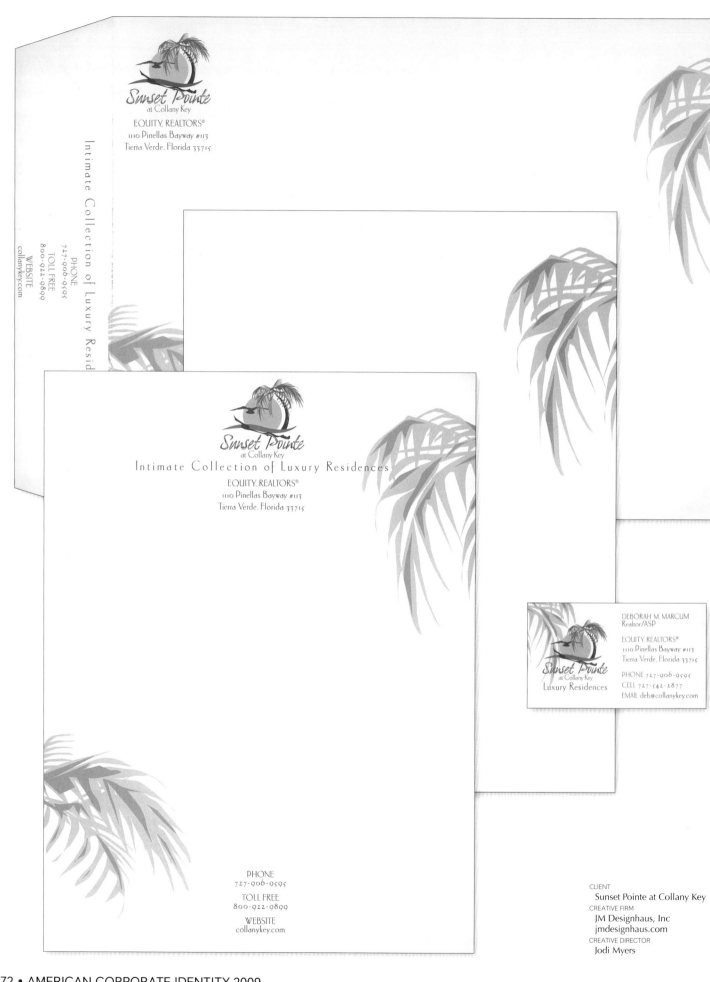

Sunset Pointe
at Collany Key

EQUITY. REALTORS®
1110 Pinellas Bayway #113
Tierra Verde, Florida 33715

Intimate Collection of Luxury Resid

PHONE
727·906·9595
TOLL FREE
800·922·9899
WEBSITE
collanykey.com

Sunset Pointe
at Collany Key
Intimate Collection of Luxury Residences

EQUITY. REALTORS®
1110 Pinellas Bayway #113
Tierra Verde, Florida 33715

PHONE
727·906·9595
TOLL FREE
800·922·9899
WEBSITE
collanykey.com

DEBORAH M. MARCUM
Realtor/ASP

EQUITY. REALTORS®
1110 Pinellas Bayway #113
Tierra Verde, Florida 33715

PHONE 727·906·9595
CELL 727·542·2877
EMAIL deb@collanykey.com

Sunset Pointe
at Collany Key
Luxury Residences

CLIENT
Sunset Pointe at Collany Key
CREATIVE FIRM
JM Designhaus, Inc
jmdesignhaus.com
CREATIVE DIRECTOR
Jodi Myers

COSTA LADERA

CORPORATE OFFICE
402 WEST BROADWAY, SUITE 400
SAN DIEGO, CALIFORNIA 92101
TOLL FREE 1.888.815.9880
TEL 619.446.5605 ▪ FAX 619.595.3150

COSTALADERA.COM

LIVE. BREATHE. BAJA

CORPORATE OFFICE: 402 WEST BROADWAY, SUITE 400 ▪ SAN DIEGO, CA 92101 ▪ TOLL-FREE 1.888.815.9880 ▪ TEL 619.446.5605 ▪ FAX 619.595.3150 ▪ **COSTALADERA.COM**

Visit our Discovery & Sales Center located on the Scenic Coastal Highway 1 at KM 100, Ensenada B.C. Mexico

LIVE. BREATHE. BAJA.

COSTA LADERA

CORPORATE OFFICE
402 WEST BROADWAY, SUITE 400
SAN DIEGO, CALIFORNIA 92101

CLIENT
Baja 1000 Development Group LLC
CREATIVE FIRM
Phinney Bischoff Design House
www.pbdh.com
DESIGNERS
Dean Hart, David Cole

LIFELIKE
BOTANICALS

we create your vision
commercial • residential

LIFELIKE
BOTANICALS

we create your vision
commercial • residential

303 Orville Wright Court, Las Vegas, NV 89119 P: 702.795.0010 F: 702.260.8888 lifelikebotanicals.com

LIFELIKE
BOTANICALS

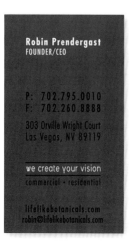

Robin Prendergast
FOUNDER/CEO

P: 702.795.0010
F: 702.260.8888

303 Orville Wright Court
Las Vegas, NV 89119

we create your vision
commercial • residential

lifelikebotanicals.com
robin@lifelikebotanicals.com

CLIENT
Lifelike Botanicals
CREATIVE FIRM
Brand, Ltd.
brandltd.com
DESIGNERS
Virginia Martino,
Sandy Schiff

COACHING ♥ CONSULTING

10453 DONNA BELLA STREET
DES MOINES, IOWA 50325

515.253.0646
FAX 515.252.7773
NAN@VALENTINECOACHING.COM
WWW.VALENTINECOACHING.COM

10453 DONNA BELLA STREET
DES MOINES, IOWA 50325

ENHANCING THE WELL-BEING AND EFFECTIVENESS OF PEOPLE IN THE WORKPLACE

CLIENT
Nan Valentine
CREATIVE FIRM
Sayles Graphic Design
www.saylesdesign.com
DESIGNER
John Sayles

ORFILA

GLASS
DESIGN

E ernie@orfilaglass.com

595 Tyrone Street
El Cajon, CA 92020

P 619.249.9454
F 619.442.7427

WWW.ORFILAGLASS.COM

ERNIE ORFILA

E ernie@orfilaglass.com

595 Tyrone Street
El Cajon, CA 92020

P 619.249.9454
F 619.442.7427

WWW.ORFILAGLASS.COM

595 Tyrone Street
El Cajon, CA 92020

ORFILA

GLASS
DESIGN

CLIENT
Orfila Glass Design
CREATIVE FIRM
Viadesign
www.viadesign.com
DESIGNER
Arcelia Contraras

1556 Ocean Ave, Suite 12
Bohemia, NY 11716

PHONE 631·563·5009
FAX 631·563·4695

EMAIL info@agencyaccess.com
WEB agencyaccess.com

agencyaccess

Keith Gentile
kgentile@agencyaccess.com

PHONE 631·563·5009
FAX 631·563·4695
WEB agencyaccess.com

1556 Ocean Ave, Suite 12
Bohemia, NY 11716

agencyaccess

Create Connections

agencyaccess

1556 Ocean Ave, Suite 12
Bohemia, NY 11716

PHONE 631·563·5009
FAX 631·563·4695

EMAIL info@agencyaccess.com
WEB agencyaccess.com

CLIENT
Agency Access
CREATIVE FIRM
Matthew Schwartz
Design Studio
www.ms-ds.com
DESIGNER
Matthew Schwartz

The Campus Theatre, *LTD* ✦ 413 Market Street ✦ Lewisburg, PA 17837 ✦ SHOWTIMES: 570-524-9628 ✦ OFFICE: 570-524-9629 ✦ campustheatre.org

CLIENT
The Campus Theatre
CREATIVE FIRM
MFDI
DESIGNER
Mark Fertig

The Willington Companies

WILLINGTON NAMEPLATE | WILLINGTON POWERPRINT | NEW ENGLAND LABEL

The
Willington
Companies

W^C

WILLINGTON NAMEPLATE

WILLINGTON POWERPRINT

NEW ENGLAND LABEL

W^C NEW ENGLAND LABEL INC.
1213 US Route 302-Berlin
Barre, VT 05641

W^C WILLINGTON NAMEPLATE INC.
11 Middle River Drive
Stafford Springs, CT 06076

1213 US Route 302-Berlin • Barre, VT 05641 • phone

enhancing the value of yo

WILLINGTON NAMEPLATE

Jeff Morrissey
ACCOUNT EXECUTIVE

11 Middle River Drive
Stafford Springs, CT 06076
phone: (877) 967 - 4743 ext.3003
fax: (877) 892 - 2966
jmorrissey@wnpinc.com
www.wnpinc.com

W^C

WILLINGTON
NAMEPLATE WILLINGTON
POWERPRINT NEW ENGLAND
LABEL

CLIENT
Willington Companies
CREATIVE FIRM
Fathom
www.fathom.net
ART DIRECTOR
Brent Robertson
DESIGNER
Anthony Acock
COPYWRITER
Louisa Handle

**NASP 2008
ANNUAL
CONVENTION** | Marriott and Sheraton
New Orleans Hotels
New Orleans, LA
February 6–9, 2008

NATIONAL
ASSOCIATION OF SCHOOL
PSYCHOLOGISTS

4340 East West Highway, Suite 402
Bethesda, MD 20814

**NASP 2008
ANNUAL CONVENTION**

Marriott and Sheraton New Orleans Hotels
New Orleans, LA
February 6–9, 2008

NATIONAL
ASSOCIATION OF SCHOOL
PSYCHOLOGISTS

4340 East West Highway, Suite 402
Bethesda, MD 20814
(301) 657-0270
(301) 657-0275, fax
(301) 657-4155, TTY

CLIENT
National Association of School Psychologists
CREATIVE FIRM
Octavo Designs
www.8vodesigns.com
DESIGNER
Sue Hough

liz halsted | 1606 highland dr | hastings | ne | 68901 | p 402.469.5369 lhalsted strikkedesigns.com | www.strikkedesigns.com

CLIENT
Strikke Designs
CREATIVE FIRM
Peggy Lauritsen Design Group
www.pldg.net
ART DIRECTOR, DESIGNER
Laura Dokken

nancy lauritsen

18645 highland ave | deephaven | mn | 55391

p 612.296.6885
nlauritsen strikkedesigns.com
www.strikkedesigns.com

Steve Tartaglione
Founder/President

630.664.6805
steve@clutterbear.com

Clutter Bear Records 2048 N. Western Ave. #3F
Chicago, IL 60647 www.clutterbear.com

Clutter Bear Records 2048 N. Western Ave. #3F Chicago, IL 60647
630.664.6805 info@clutterbear.com www.clutterbear.com

CLIENT
Clutter Bear Records
CREATIVE FIRM
Intelligent Fish Studio
briandanaher.com
ART DIRECTOR, DESIGNER
Brian Danaher

LIFETIME SOLUTIONS

753 Boston Post Rd.
Guilford, Connecticut 06437

BESIDE YOU AT EVERY TURN

753 Boston Post Rd. | Guilford, Connecticut 06437 | www.LTScare.com | P: 203.458.5990

VNA COMMUNITY
HEALTHCARE

Susan Faris
RN, MPH, CHCE P: 203.458.4200
President | CEO F: 203.458.4390
 E: sfaris@vna-commh.org

Shawn Clark, Executive Assistant P: 203.458.4202
753 Boston Post Rd. | Guilford, CT 06437 | www.ConnecticutHomecare.com

BESIDE YOU AT EVERY TURN

CLIENT
 Visiting Nurses Association
CREATIVE FIRM
 Fathom
 www.fathom.net
DESIGNER
 Anthony Acock

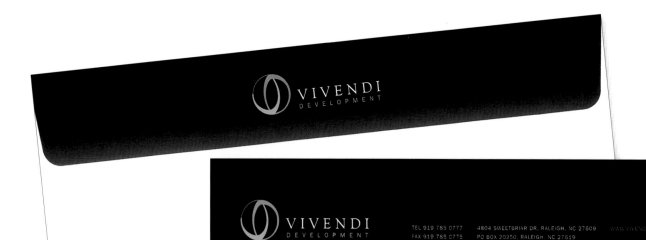

KEITH B. PERRY
MANAGING DIRECTOR

TEL 919 785 0777 4804 SWEETBRIAR DR, RALEIGH, NC 27609
FAX 919 785 0775 PO BOX 20250, RALEIGH, NC 27619
KPERRY@VIVENDIDEVELOPMENT.COM

CLIENT
Vivendi Development
CREATIVE FIRM
Helena Seo Design
www.helenaseo.com
CREATIVE DIRECTOR, DESIGNER
Helena Seo

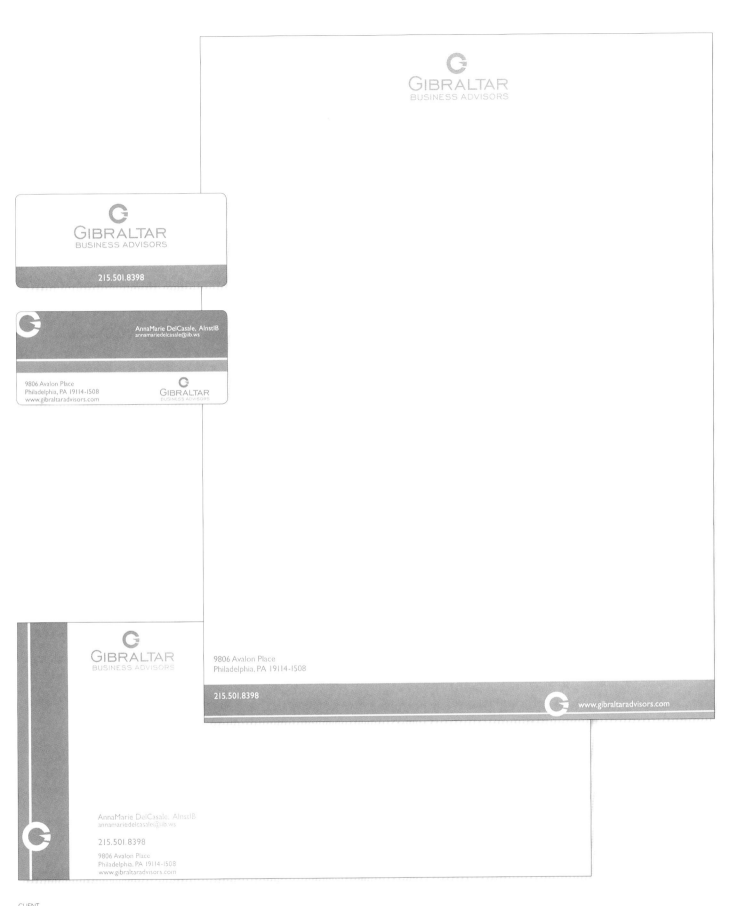

CLIENT
Gibraltar Business Advisors
CREATIVE FIRM
Bondepus Graphic Design
bondepus.com
DESIGNERS
Gary Epis, Amy Bond

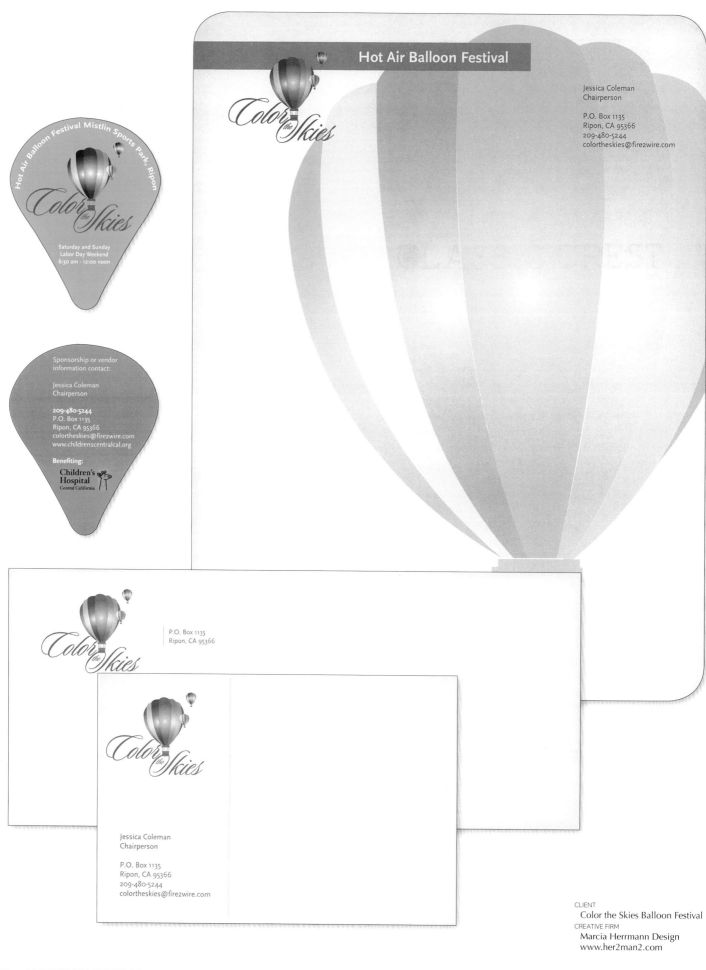

CLIENT
Color the Skies Balloon Festival
CREATIVE FIRM
Marcia Herrmann Design
www.her2man2.com

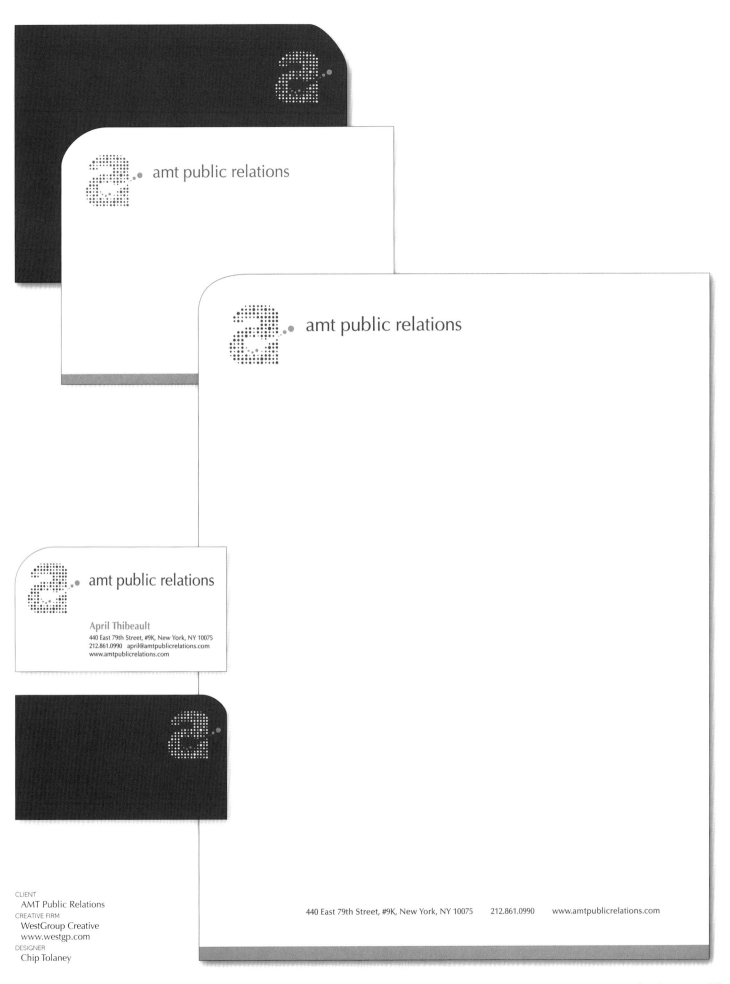

amt public relations

amt public relations

amt public relations

April Thibeault
440 East 79th Street, #9K, New York, NY 10075
212.861.0990 april@amtpublicrelations.com
www.amtpublicrelations.com

440 East 79th Street, #9K, New York, NY 10075 212.861.0990 www.amtpublicrelations.com

CLIENT
 AMT Public Relations
CREATIVE FIRM
 WestGroup Creative
 www.westgp.com
DESIGNER
 Chip Tolaney

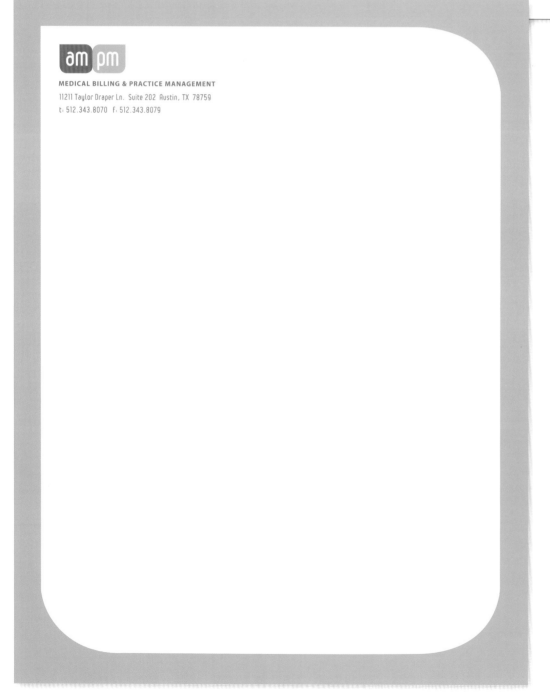

MEDICAL BILLING & PRACTICE MANAGEMENT

11211 Taylor Draper Ln. Suite #202 Austin, TX 78759

MEDICAL BILLING & PRACTICE MANAGEMENT

11211 Taylor Draper Ln. Suite 202 Austin, TX 78759
t: 512.343.8070 f: 512.343.8079

MEDICAL BILLING & PRACTICE MANAGEMENT

Kathy Campbell
President, CEO

11211 Taylor Draper Ln. Suite 202
Austin, TX 78759

t: 512.674.9001
c: 512.965.1641 f: 512.343.8079
e: kathycampbell@ampm-inc.com

www.ampm-inc.com

CLIENT
AMPM Medical Billing
and Practice Management
CREATIVE FIRM
Hoopla Headquarters
www.hooplahq.com
DESIGNER
Ivy Oliver

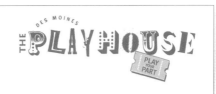

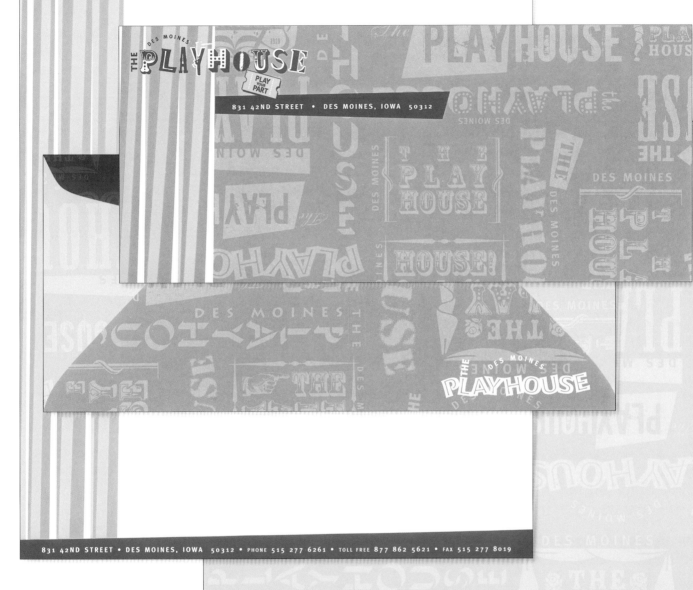

CLIENT
Des Moines Playhouse
CREATIVE FIRM
Sayles Graphic Design
www.saylesdesign.com
DESIGNER
John Sayles

Invest well. Manage well. Live well.

AMA

{ Ask Me Anything }

CONVERGENT | WEALTH
ADVISORS

AKA { Also Known As }

CONVERGENT | WEALTH
ADVISORS

CONVERGENT | WEALTH
ADVISORS

Kathleen F. Freed
DIRECTOR
Kathy.Freed@ConvergentWealth.com

Radnor Financial Center
150 North Radnor Chester Road
Suite C100
Radnor, PA 19087-5260
www.ConvergentWealth.com

OFFICE 610.254.6800
DIRECT 610.254.6808
FAX 610.254.0241
MOBILE 610.256.4926

CONVERGENT | WEALTH
ADVISORS

CLIENT
Convergent Wealth Advisors
CREATIVE FIRM
Grafik Marketing
Communications
www.grafik.com
DESIGNERS
Judy Kirpich,
Kristin Moore,
Michael Mateos,
Chris Hong

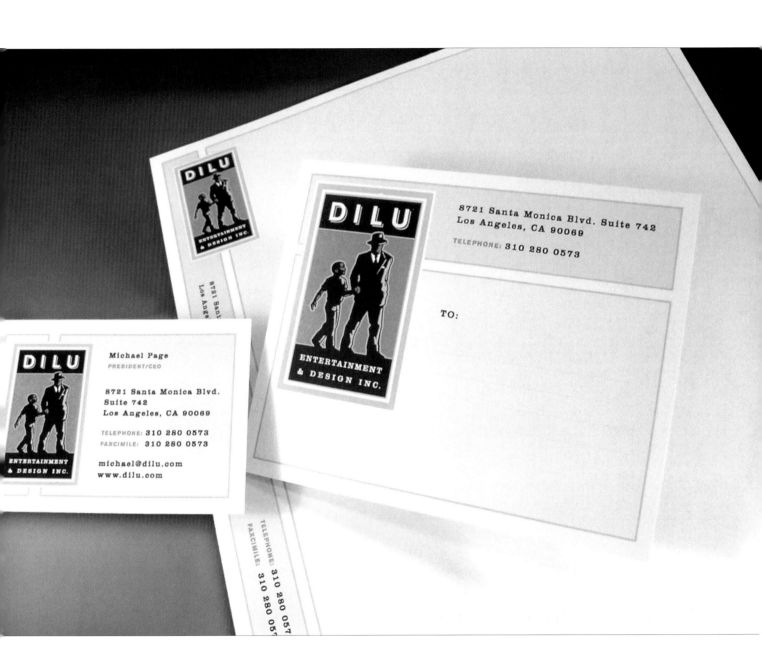

CLIENT
 Dilu Entertainment
CREATIVE FIRM
 Evenson Design Group
 www.evensondesign.com
CREATIVE DIRECTOR
 Stan Evenson
DESIGNER
 Mark Sojka
ILLUSTRATOR
 Wayne Watford

{ INTERSECTION } INTERSECTION LLC 10 Saugatuck Avenue Westport, CT 06880 o 203.557.4945 www.intersectionr3.com

{ INTERSECTION }
www.intersectionr3.com fig.1

Andy Lipman

INTERSECTION LLC

10 Saugatuck Avenue Westport. CT 06880
o 203.557.4945 c 203.515.7623
alipman@intersectionr3.com ACS

{ INTERSECTION } INTERSECTION LLC 10 Saugatuck Avenue Westport, CT 06880

CLIENT
 Intersection LLC
CREATIVE FIRM
 Curio Design LLC
 curiodesign.com
DESIGNERS
 Carrie Chatterson,
 Tamiko Hershey

P.O. Box 3608 Saratoga, CA 95070

State License #B651592
Bonded & Insured

CLIENT
 Heritage Construction
CREATIVE FIRM
 Hellbent Marketing
 www.hellbentmarketing.com
DESIGNERS
 Deb Shea, Shanan Valente

P.O. Box 3608 Saratoga, California 95070 t. 408.867.6881 f. 408.741.1099 www.heritageconstruct.com
State License #B651592 Bonded & Insured

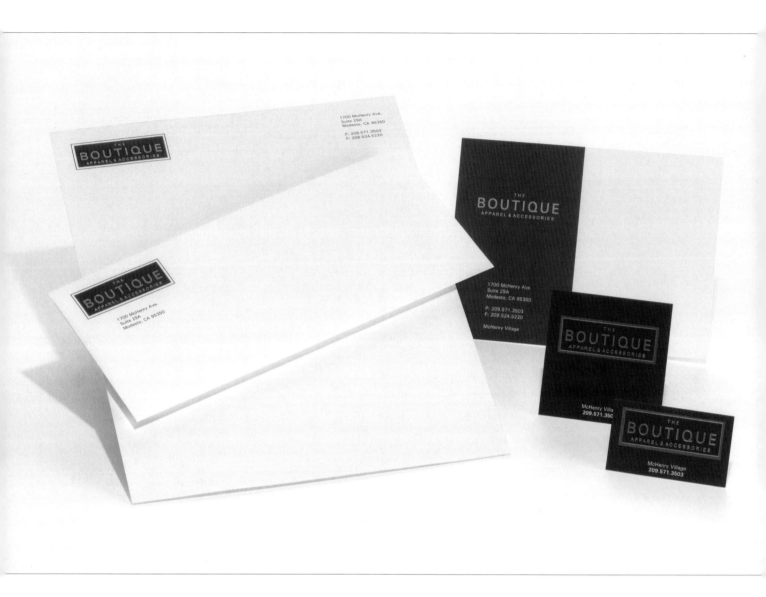

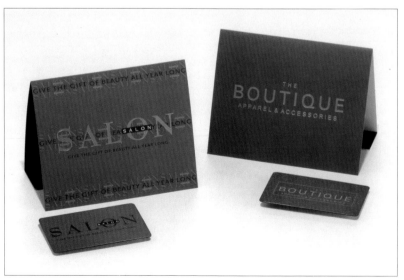

CLIENT
The Boutique
Apparel & Accessories
CREATIVE FIRM
Marcia Herrmann Design
www.her2man2.com

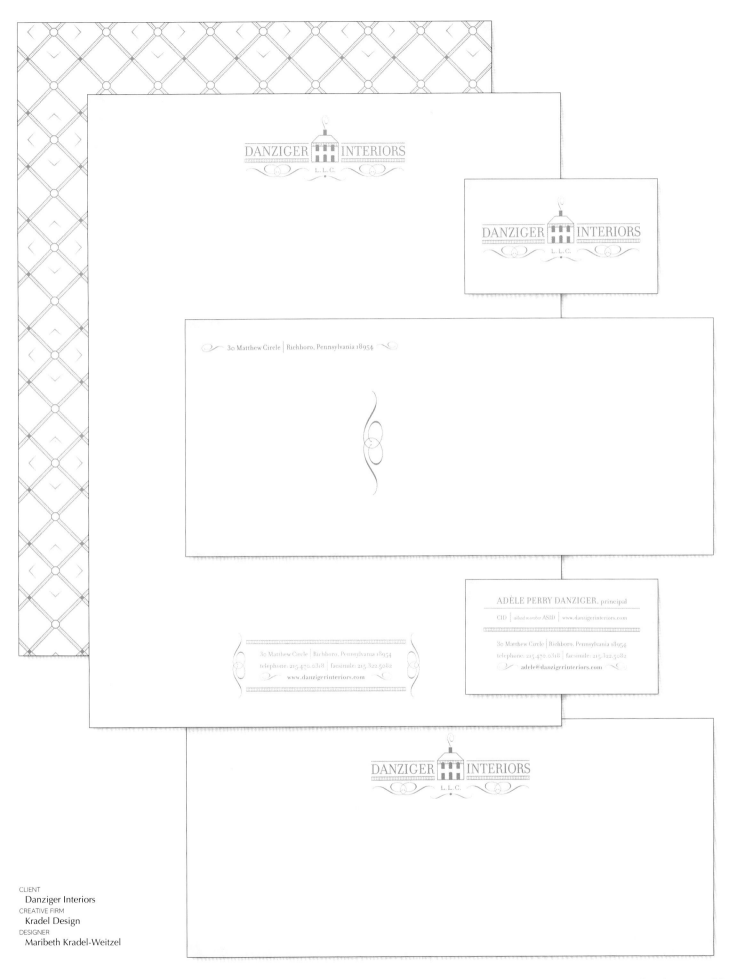

DANZIGER **⌂** INTERIORS
L.L.C.

DANZIGER **⌂** INTERIORS
L.L.C.

30 Matthew Circle │ Richboro, Pennsylvania 18954

30 Matthew Circle │ Richboro, Pennsylvania 18954
telephone: 215.470.0318 │ facsimile: 215.322.5082
www.danzigerinteriors.com

ADÈLE PERRY DANZIGER, principal

CID │ *allied member* ASID │ www.danzigerinteriors.com

30 Matthew Circle │ Richboro, Pennsylvania 18954
telephone: 215.470.0318 │ facsimile: 215.322.5082
adele@danzigerinteriors.com

DANZIGER **⌂** INTERIORS
L.L.C.

CLIENT
 Danziger Interiors
CREATIVE FIRM
 Kradel Design
DESIGNER
 Maribeth Kradel-Weitzel

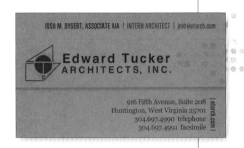

JUDGE'S WORK

CLIENT
Edward Tucker Architects, Inc.

CREATIVE FIRM
Maple Creative
maplecreative.com

DESIGNERS
Thomas White, Clayton Ray

COPYWRITERS
Justin Hylbert,
Phoebe Patton Randolph,
Edward W. Tucker

PETER RAIMONDI
President

6241 PGA Blvd
Suite 104 - 205
Palm Beach Gardens, FL 33418

P (561) 630-4600 • C (617) 733-3277 • F (561) 630-9788

praimondi@banyanpartners.net

WWW.BANYANPARTNERS.NET

6241 PGA Blvd, Suite 104 - 205, Palm Beach Gardens, FL 33418

P (561) 630-4600 • C (617) 733-3277 • F (561) 630-9788

WWW.BANYANPARTNERS.NET

CLIENT
Banyan Partners, LLC
CREATIVE FIRM
Seth Joseph & Co., LLC
www.sethjoseph.com
DESIGNERS
Seth J. Katzen,
Yumiko Shibata

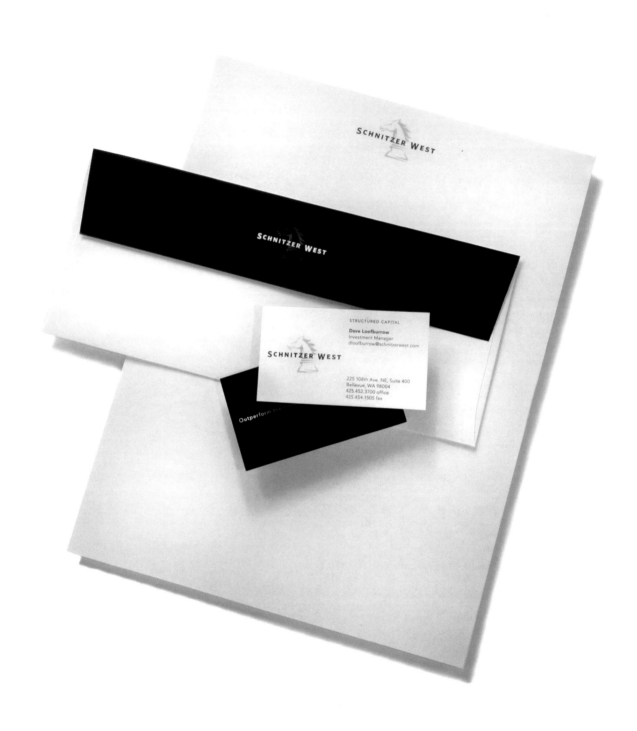

CLIENT
 Schnitzer West
CREATIVE FIRM
 Hornall Anderson Design Works
 www.hadw.com
DESIGNERS
 John Anicker, Larry Anderson,
 Jay Hilburn, Yuri Shvets,
 Andrew Wicklund,
 Bruce Branson-Meyer

CLIENT
 TrueBlue
CREATIVE FIRM
 TrueBlue
 www.trueblue.us
DESIGNERS
 Ria Fisher, James Lawton

ACPS
Alexandria City Public Schools

2008 FAMILY INVOLVEMENT RALLY

FOSTERING TRUSTFUL RELATIONSHIPS BETWEEN FAMILIES & SCHOOLS

DATE: SATURDAY, NOVEMBER 3, 2007 ■ PLACE: GEORGE WASHINGTON MIDDLE SCHOOL
1005 MOUNT VERNON AVENUE, GYM, ALEXANDRIA, VA 22301 ■ TIME: 8:30 A.M. - 12:00 NOON

FAMILY RALLY HIGHLIGHTS: Free New Clothing Give-away ■ Fun Activities ■ Free Refreshments ■ Free School Supplies ■

Free Bus Transportation ■ Exciting Student Entertainment ■ Schools & Community Organizations Represented

CLIENT
Alexandria City Public Schools
CREATIVE FIRM
RCW Communication Design Inc.
www.rcwinc.com
DESIGNERS
Michele Thomas, Anna Blazejcyk,
Rodney C. Williams

CLIENT
JCC of the Greater Palm Beaches
CREATIVE FIRM
Seth Joseph & Co., LLC
www.sethjoseph.com
DESIGNER
Seth J. Katzen, Jason White

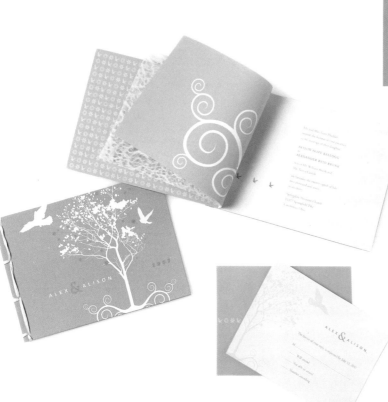

CLIENT
Alex & Alison Brunk
CREATIVE FIRM
Curio Design LLC
DESIGNER
Carrie Chatterson

CLIENT
FSC Marketing Communications
CREATIVE FIRM
FSC Marketing Communications
www.fscmc.com
ART DIRECTOR, COPYWRITER, ILLUSTRATOR
Bryan Brunsell

Some people like sensible gifts for the holidays.

CLIENT
Oh Frenzy! Advertising Agency
CREATIVE FIRM
Oh Frenzy! Advertising Agency
www.ohfranzy.com
DESIGNERS
Charlie Honold, Tara Langley

CLIENT
Dunkin' Donuts
CREATIVE FIRM
Berry Design Inc.
berrydesign.com
ART DIRECTOR
Bob Berry
DESIGNER
Chip Waller

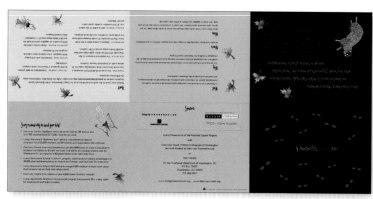

CLIENT
Discovery Creek
CREATIVE FIRM
Crabtree + Company
www.crabtreecompany.com
DESIGNERS
Susan Angrisani, Lisa Suchy,
William Weinheimer, Tamera Finn

CLIENT
U.S. Xpress
CREATIVE FIRM
TrueBlue
www.trueblue.com
DESIGNERS
Ria Fisher, James Lawton

CLIENT
Caesars Palace Las Vegas
CREATIVE FIRM
eurie creative
www.euriecreative.com
DESIGNERS
Victor Rodriguez, Alex Frazier

CLIENT
Union Hospital
CREATIVE FIRM
MillerWhite, LLC
www.millerwhite.com
DESIGNER
Jenny Hoffeditz

Jack Taylor has been retired from the
day-to-day management of the company for
a number of years, having passed those reins
to me. He and I are the only two people to
hold the titles of Chairman and Chief Executive
Officer of the company. My sister, Jo Ann
Taylor Kindle, is President of the company's
charitable foundation. And a third generation
is on the way up. My daughter, Chrissy, and
Jo Ann's daughter, Carolyn, are also actively
involved in the management of the company.

CLIENT
Enterprise Rent-a-Car
CREATIVE FIRM
ProWolfe Partners
www.prowolfe.com
DESIGNERS
Doug Wolfe,
Ben Franklin

CLIENT
Preti Flaherty
CREATIVE FIRM
Right Hat, LLC
www.righthat.com
DESIGNER
Charlyne Fabi

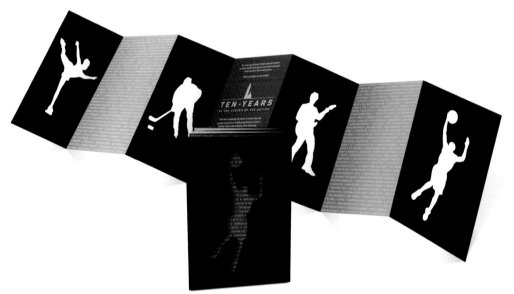

CLIENT
Verizon Center
CREATIVE FIRM
Levine & Associates
www.levinedc.com
DESIGNER
Greg Sitzmann
COPYWRITER
Tierney Sadler

CLIENT
Sewickley Academy
CREATIVE FIRM
Third Planet Communications
www.reinnov8.com
DESIGNER
Richard A. Hooper

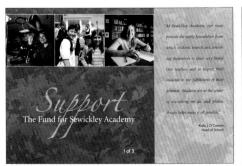

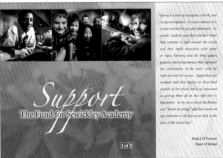

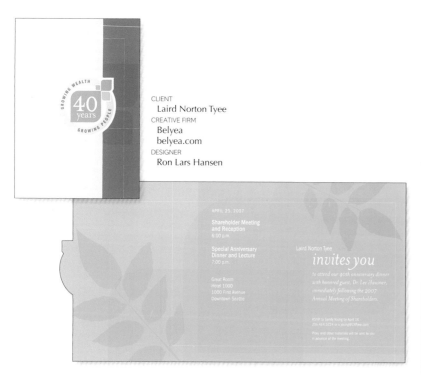

CLIENT
Laird Norton Tyee
CREATIVE FIRM
Belyea
belyea.com
DESIGNER
Ron Lars Hansen

CLIENT
Lomangino Studio Inc.
CREATIVE FIRM
Lomangino Studio Inc.
www.lomangino.com
DESIGNERS
Betsy Martin, Mary Frances Hansford

CLIENT
Tom Fowler, Inc./TFI Envision Inc.
CREATIVE FIRM
Tom Fowler, Inc./TFI Envision Inc.
www.tfienvision.com
DESIGNER
Elizabeth P. Ball

CLIENT
David Laub M.D.
CREATIVE FIRM
Marcia Herrmann Design
www.her2man2.com

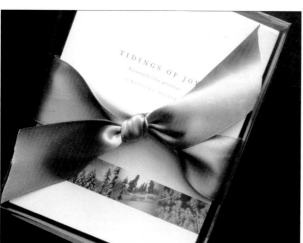

CLIENT
Caesars Palace Las Vegas
CREATIVE FIRM
eurie creative
www.euriecreative.com
DESIGNERS
Victor Rodriguez, Alex Frazier

CLIENT
Pat Sloan Design
CREATIVE FIRM
Pat Sloan Design
DESIGNER
Pat Sloan

CLIENT
Caesars Palace Las Vegas
CREATIVE FIRM
eurie creative
www.euriecreative.com
DESIGNERS
Alex Frazier, Mike Enriquez

CLIENT
Guiding Eyes for the Blind
CREATIVE FIRM
Tom Fowler, Inc./TFI Envision Inc.
www.tfienvision.com
DESIGNERS
Elizabeth P. Ball, Mary Ellen Butkus,
Brien O'Reilly

CLIENT
True Blue
CREATIVE FIRM
True Blue
www.trueblue.us
DESIGNERS
Ria Fisher,
Jessie Hunt
PHOTOGRAPHER
Liz Russel

CLIENT
Caesars Palace Las Vegas
CREATIVE FIRM
eurie creative
www.euriecreative.com
DESIGNERS
Victor Rodriquez, Alex Frazier, Mike Enriquez

CLIENT
Vicki and Michael Meloney
CREATIVE FIRM
Latrice Graphic Design
DESIGNER
Vicki L. Meloney

CLIENT
SGDP
CREATIVE FIRM
SGDP
www.sgdp.com
DESIGNER
Mick Pavlik
COPYWRITERS
Karl Gromelski, Steve Batterson

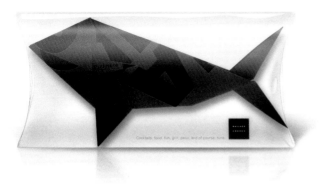
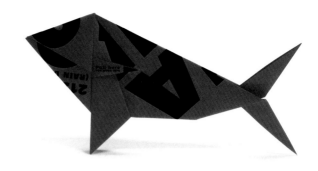

CLIENT
Wallace Church, Inc.
CREATIVE FIRM
Wallace Church, Inc.
www.wallacechurch.com
CREATIVE DIRECTOR
Stan Church

CLIENT
Hornall Anderson Design Works
CREATIVE FIRM
Hornall Anderson Design Works
www.hadw.com
DESIGNERS
Lisa Cerveny, Jana Nishi, Michael Connors,
Belinda Bowling, Andrew Wicklund, Hans Krebs
COPYWRITER
Pamela Mason Davey

CLIENT
Rochester Philharmonic Orchestra
CREATIVE FIRM
Dixon Schwabl
dixonschwabl.com
DESIGNERS
Corinne Clar, Charles Benoit

CLIENT
Tom Fowler, Inc./TFI Envision Inc.
CREATIVE FIRM
Tom Fowler, Inc./TFI Envision Inc.
www.tfienvision.com
DESIGNER
Elizabeth P. Ball

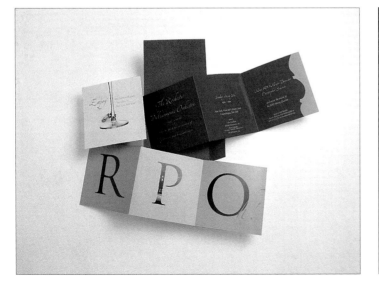

CLIENT
Citi Private Bank
CREATIVE FIRM
Curio Design LLC
curiodesign.com
DESIGNER
Tamiko Hershey

CLIENT
The Advertising Federation of Fargo-Moorehead
CREATIVE FIRM
Sayles Graphic Design
www.saylesdesign.com
DESIGNER
John Sayles

CLIENT
Sunbury Textile Mills
CREATIVE FIRM
Sire Advertising
www.sireadvertising.com
DESIGNERS
Shawn Felty, Jessica Varner

CLIENT
DCM
CREATIVE FIRM
Gee + Chung Design
www.geechungdesign.com
DESIGNERS
Earl Gee, Fani Chung

CLIENT
Kansas City Advertising Federation
CREATIVE FIRM
Sayles Graphic Design
www.saylesdesign.com
DESIGNER
John Sayles

Please celebrate with us as
AMBER LINEA MOREEN & SEAN MICHAEL O'CONNOR
Join in marriage Saturday. July twenty second. two thousand six at five o'clock in the evening
320 Ranch, Big Sky Montana
reception to follow

CLIENT
Sean O'Connor
CREATIVE FIRM
Studio Picotee
www.studiopicotee.com
DESIGNER
Heather Landers

CLIENT
Robert Meyers Design
CREATIVE FIRM
Robert Meyers Design
robertmeyersdesign.com
DESIGNER
Robert Meyers

CLIENT
Public Relations Society of America
CREATIVE FIRM
Dixon Schwabl
dixonschwabl.com
DESIGNERS
Tim Coyne, Kathy Phelps

CLIENT
Stacey Lewis & Kostiya Peki
CREATIVE FIRM
Latrice Graphic Design
DESIGNER
Vicki L. Meloney

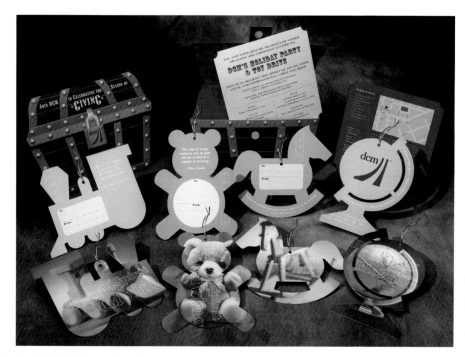

CLIENT
DCM
CREATIVE FIRM
Gee + Chung Design
www.geechungdesign.com
DESIGNERS
Earl Gee, Fani Chung

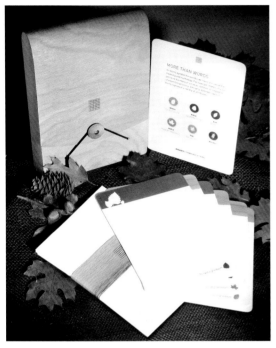

CLIENT
Brady Communications
CREATIVE FIRM
Brady Communications
www.bradycommunications.com
CREATIVE DIRECTOR, DESIGNER
John Brady
DESIGNERS
Keri Allison, Corey Tiani
COPYWRITER
Lia Osle
PRODUCTION SPECIALIST
Dave Cameron

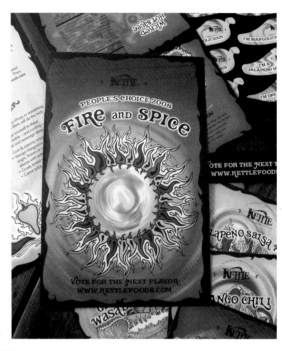

CLIENT
Kettle Foods
CREATIVE FIRM
Defteling Design
www.defteling.com
DESIGNERS
Alex Wijnen, Marc Wijnen

CLIENT
Mike Salisbury Communications
CREATIVE FIRM
Mike Salisbury Communications
www.mikesalisbury.net
DESIGNER
Mike Salisbury

CLIENT
Tom Fowler, Inc./TFI Envision Inc.
CREATIVE FIRM
Tom Fowler, Inc./TFI Envision Inc.
www.tfienvision.com
DESIGNER
Elizabeth P. Ball

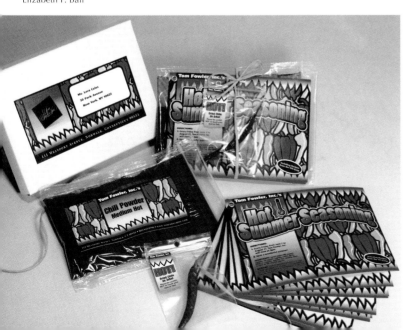

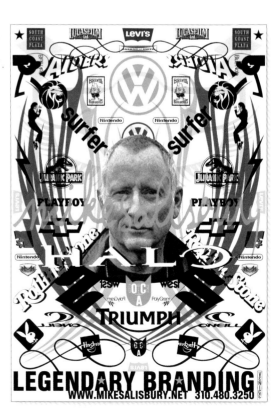

JUDGE'S WORK

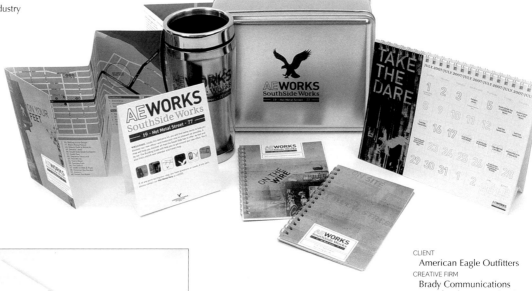

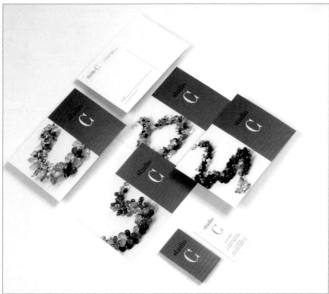

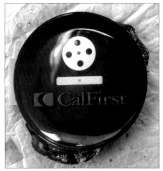

CLIENT
Cal First Leasing
CREATIVE FIRM
Viadesign
www.viadesign.com
DESIGNERS
Scott Pacheco, Stephan Donche

CLIENT
Corning Museum of Glass
CREATIVE FIRM
Michael Orr + Associates, Inc.
michaelorrassociates.com
DESIGNERS
Michael R. Orr, Thomas Freeland

CLIENT
Image Ink Studio
CREATIVE FIRM
Image Ink Studio
imageink.com
DESIGNERS
Tom Hession-Herzog,
Chris McInerney

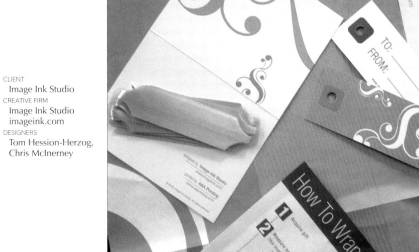

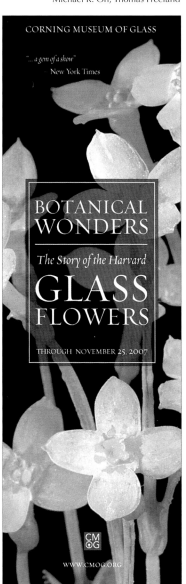

CLIENT
Empire Valuation Consultants
CREATIVE FIRM
Pisarkiewicz Mazur & Co., Inc.
designpm.com
DESIGNERS
Mary F. Pisarkiewicz, Justin Grundfast,
Julie Lange

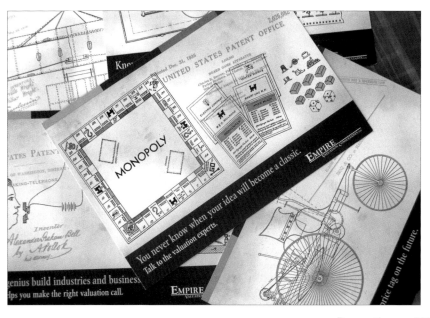

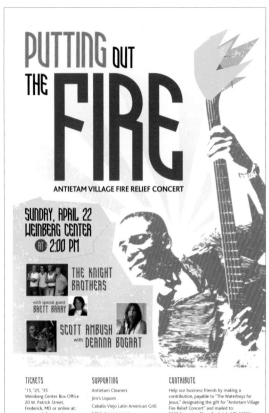

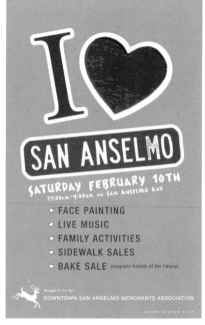

CLIENT
Downtown San Anselmo
Merchants Association
CREATIVE FIRM
Axion Design
axiondesign.com
DESIGNERS
Axion Design Team

CLIENT
EAT Advertising & Design
CREATIVE FIRM
EAT Advertising & Design
www.eatinc.com
DESIGNERS
Patrice Jobe, DeAnne Dodd, Rachel Eilts

CLIENT
Danny Knight
CREATIVE FIRM
Octavo Design
www.8vodesigns.com
DESIGNERS
Mark Burrier, Sue Hough

CLIENT
Bremmer & Goris Communications
CREATIVE FIRM
Bremmer & Goris Communications
www.goris.com
DESIGNERS
Li-Chou, Miki Lo

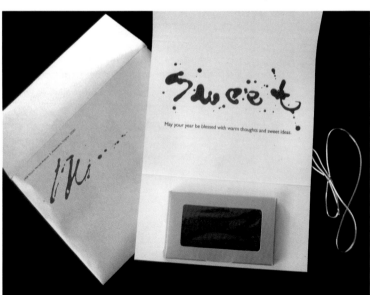

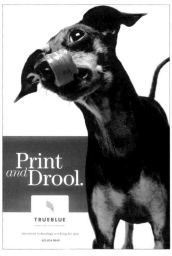

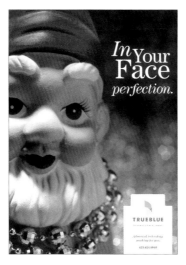

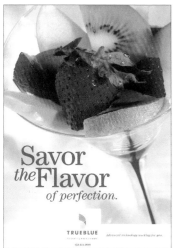

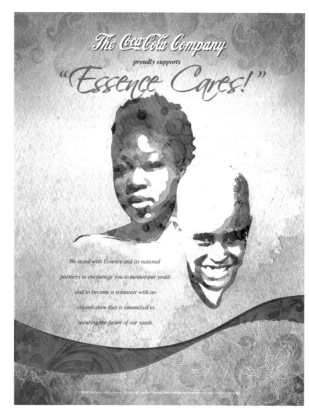

CLIENT
TrueBlue
CREATIVE FIRM
TrueBlue
www.trueblue.com
DESIGNER
Ria Fisher
PHOTOGRAPHER
Liz Russell

JUDGE'S WORK
CLIENT
Kenya Tourist Board,
Africa American Travel
CREATIVE FIRM
Culture Advertising Design
www.culture-ad.com
ART DIRECTOR
Craig Brimm
COPYWRITER
Brooke Brimm

JUDGE'S WORK
CLIENT
Coca-Cola
CREATIVE FIRM
Culture Advertising Design
www.culture-ad.com
ART DIRECTOR
Craig Brimm
COPYWRITER
Brooke Brimm

CLIENT
CVS
CREATIVE FIRM
Tom Fowler, Inc./TFI Envision Inc.
www.tfienvision.com
DESIGNERS
Elizabeth P. Ball, Brien O'Reilly

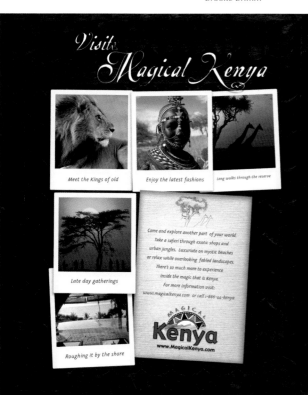

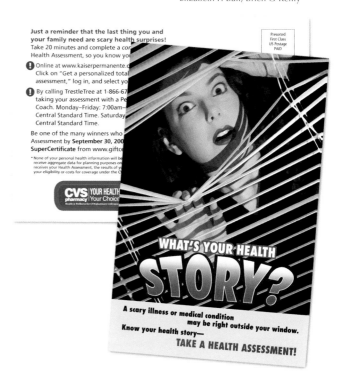

CLIENT
Ben Hannam
CREATIVE FIRM
Hannam Designs
www.benhannam.com
DESIGNER
Ben Hannam
COPYWRITER
Michele Domenech

CLIENT
Bud Frankel
CREATIVE FIRM
Simple Design
simpledesign.com
DESIGNER
Robert Mitchell

JUDGE'S WORK
CLIENT
District of Columbia Service Initiative
CREATIVE FIRM
Culture Advertising Design
www.culture-ad.com
ART DIRECTOR
Craig Brimm

CLIENT
Geloso Beverages, Inc.
CREATIVE FIRM
Icon Graphics Inc.
www.thinkfeelchose.com

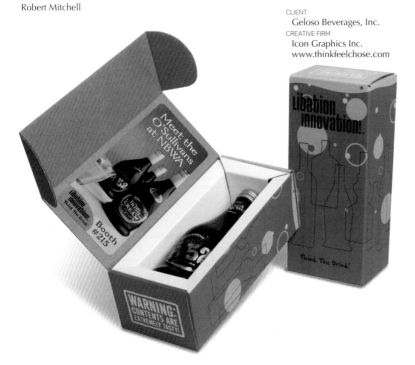

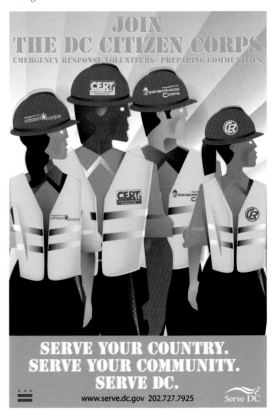

CLIENT
EYA-National Park Seminary Property
CREATIVE FIRM
Grafik Marketing Communications
www.grafik.com
DESIGNERS
John Vitrovich, Hal Swetnam

CLIENT
Greenfield Belser
CREATIVE FIRM
Greenfield Belser
gbltd.com
DESIGNERS
Burkey Belser, Mark Ledgerwood

CLIENT
Triton Ink
CREATIVE FIRM
eurie creative
www.euriecreative.com
DESIGNERS
Victor Rodriguez, Alex Frazier

CLIENT
National Endowment for the Humanities
CREATIVE FIRM
Crabtree + Company
www.crabtreecompany.com
DESIGNERS
Susan Angrisani, Lisa Suchy, Rod Vera,
Forrest Dunnavant, Rob Harlow

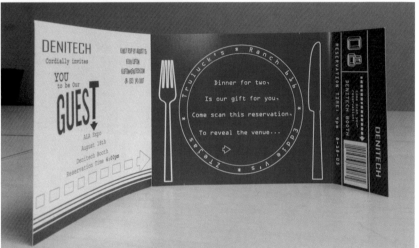

CLIENT
Denitech
CREATIVE FIRM
Hoopla Headquarters
www.hooplahq.com
DESIGNER
Ivy Oliver
COPYWRITERS
Ivy Oliver, Angela Oliver
PHOTOGRAPHER
Eric Hegwer

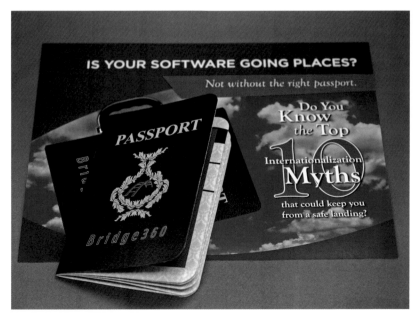

CLIENT
Bridge 360
CREATIVE FIRM
Hoopla Headquarters
www.hooplahq.com
DESIGNER
Ivy Oliver
COPYWRITER
Stacy Stroud
PHOTOGRAPHER
Eric Heawer

CLIENT
Adler Theatre
CREATIVE FIRM
Oh Frenzy! Advertising Agency
www.ohfrenzy.com
DESIGNERS
Charlie Honold, Tara Langley

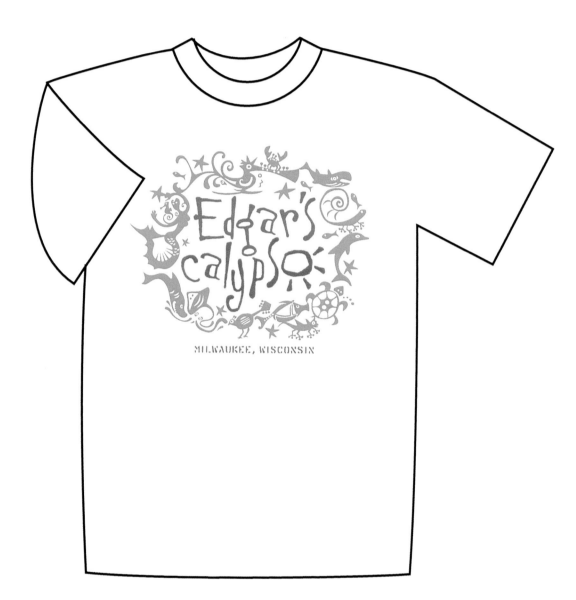

CLIENT
Edgar's Calypso
CREATIVE FIRM
McDill Design
www.mcdilldesign.com
DIRECTOR
Michael Dillon
DESIGNER
Dave Burkle

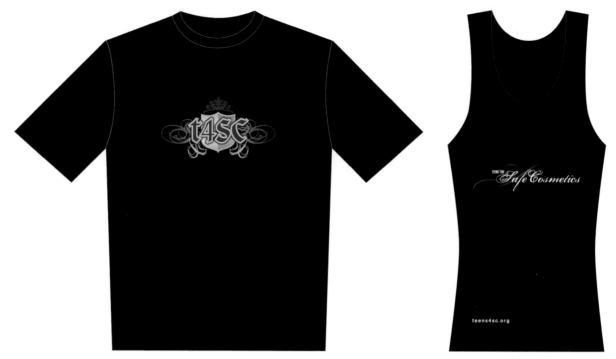

CLIENT
Teens for Safe Cosmetics
CREATIVE FIRM
Axion Design
axiondesign.com
DESIGNERS
Axion Design Team

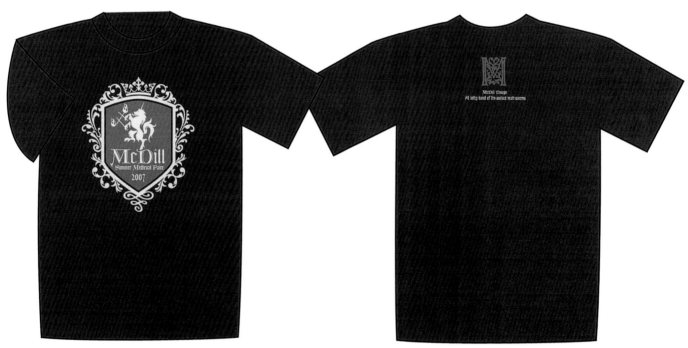

CLIENT
McDill Design
CREATIVE FIRM
McDill Design
www.mcdilldesign.com
DIRECTOR
Michael Dillon
DESIGNER
Dave Burkle

Rhythms
Cafe & Bar

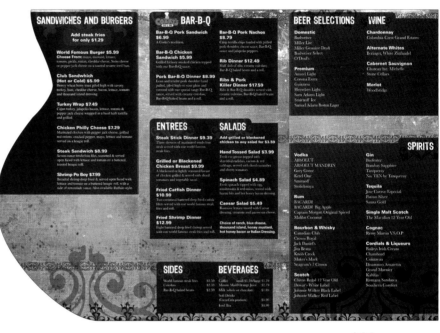

SANDWICHES AND BURGERS

Add steak fries for only $1.29

World Famous Burger $5.99
Choose From: mayo, mustard, lettuce, tomato, pickle, onion, cheddar cheese, Swiss cheese or pepper jack cheese on a toasted sesame seed bun.

Club Sandwich (Hot or Cold) $5.99
Honey wheat berry toast piled high with savory turkey, ham, cheddar cheese, bacon, lettuce, tomato and thousand island dressing.

Turkey Wrap $7.49
Cajun turkey, jalapeño bacon, lettuce, tomato & pepper jack cheese wrapped in a basil herb tortilla and grilled.

Chicken Philly Cheese $7.29
Marinated chicken with pepper jack cheese, grilled red onions, cracked pepper, mayo, lettuce and tomato served on a hoagie roll.

Steak Sandwich $8.99
Seven ounce tenderloin filet, seasoned & served open faced with lettuce and tomato on a buttered, toasted hoagie roll.

Shrimp Po Boy $7.99
Breaded shrimp deep fried & served open faced with lettuce and tomato on a buttered hoagie roll, with a side of remoulade sauce. Also available Buffalo style.

BAR-B-Q

Bar-B-Q Pork Sandwich $6.99
A Cooke's tradition.

Bar-B-Q Chicken Sandwich $5.99
Grilled hickory smoked chicken topped with our Bar-B-Q sauce.

Pork Bar-B-Q Dinner $8.99
Lean and tender pork shoulder hand pulled, piled high on your plate and covered with our special tangy Bar-B-Q sauce, served with creamy coleslaw, Bar-B-Q baked beans and a roll.

Bar-B-Q Pork Nachos $8.79
Crisp tortilla chips loaded with pulled pork shoulder, cheese sauce, Bar-B-Q sauce and jalapeño peppers.

Rib Dinner $12.49
Half slab of ribs, creamy coleslaw, Bar-B-Q baked beans and a roll.

Ribs & Pork Killer Dinner $17.59
Ribs & Bar-B-Q shoulder served with creamy coleslaw, Bar-B-Q baked beans and a roll.

ENTREES

Steak Stick Dinner $9.39
Three skewers of marinated tenderloin steak served with our world famous steak fries.

Grilled or Blackened Chicken Breast $9.99
A blackened or lightly seasoned breast of chicken grilled & served with diced tomatoes and vegetable medley.

Fried Catfish Dinner $10.99
Two cornmeal battered deep fried catfish fillets served with our world famous steak fries and roll.

Fried Shrimp Dinner $12.99
Eight battered deep fried shrimp served with our world famous steak fries and roll.

SALADS

Add grilled or blackened chicken to any salad for $3.59

Hand Tossed Salad $3.99
Fresh cut greens topped with shredded radishes, carrots & red cabbage, served with sliced cucumber and cherry tomatoes.

Spinach Salad $4.89
Fresh spinach topped with egg, mushrooms & red onions, served with bacon bits and hot honey bacon dressing.

Caesar Salad $5.49
Romaine lettuce tossed with Caesar dressing, croutons and parmesan cheese.

Choice of ranch, blue cheese, thousand island, honey mustard, hot honey bacon or Italian Dressing.

SIDES

World famous steak fries	$2.59
Coleslaw	$2.59
Bar-B-Q baked beans	$2.59

BEVERAGES

Coffee small $1.59/large $1.79	
Minute Maid Orange Juice	$2.19
Milk whole or chocolate	$1.89
Soft Drinks	
Coca-Cola products	$1.90
Iced Tea	$1.90

BEER SELECTIONS

Domestic
Budweiser
Miller Lite
Miller Genuine Draft
Budweiser Select
O'Doul's

Premium
Amstel Light
Corona Extra
Guinness
Heineken Light
Sam Adams Light
Smirnoff Ice
Samuel Adams Boston Lager

WINE

Chardonnay
Columbia Crest Grand Estates

Alternate Whites
Beringer, White Zinfandel

Cabernet Sauvignon
Chateau Ste. Michelle
Stone Cellars

Merlot
Woodbridge

SPIRITS

Vodka
ABSOLUT
ABSOLUT MANDRIN
Grey Goose
Ketel One
Smirnoff
Stolichnaya

Rum
BACARDI
BACARDI Big Apple
Captain Morgan Original Spiced
Malibu Coconut

Bourbon & Whisky
Canadian Club
Crown Royal
Jack Daniel's
Jim Beam
Knob Creek
Maker's Mark
Seagram's 7 Crown

Scotch
Chivas Regal 12 Year Old
Dewar's White Label
Johnnie Walker Black Label
Johnnie Walker Red Label

Gin
Beefeater
Bombay Sapphire
Tanqueray
No. TEN by Tanqueray

Tequila
Jose Cuervo Especial
Patron Silver
Sauza Gold

Single Malt Scotch
The Macallan 12 Year Old

Cognac
Remy Martin V.S.O.P.

Cordials & Liqueurs
Baileys Irish Cream
Chambord
Cointreau
Disaronno Amaretto
Grand Marnier
Kahlúa
Romana Sambuca
Southern Comfort

CLIENT
(on behalf of IMI for)
Delaware North
CREATIVE FIRM
Sellier Design
sellierdesign.com
DESIGNER
Julie Cofer

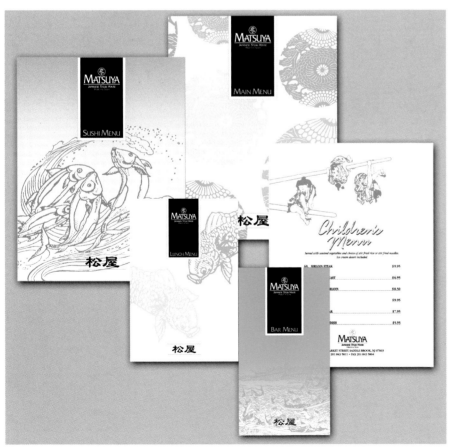

MATSUYA
SUSHI MENU

MATSUYA
MAIN MENU

MATSUYA
LUNCH MENU

MATSUYA
BAR MENU

松屋

Children's Menu

Served with sautéed vegetables and choice of stir fried rice or stir fried noodles. Ice cream desert included.

6 oz. SIRLOIN STEAK	$9.95
...AST	$6.95
...RLOIN	$8.50
...	$9.95
...K	$7.95
...DISH	$5.95

MATSUYA
...RKET STREET SADDLE BROOK, NJ 07663
201 843 5811 • FAX 201 843 5864

CLIENT
Matsuya Restaurant
CREATIVE FIRM
Stephen Longo Design Associates
DESIGNER
Stephen Longo

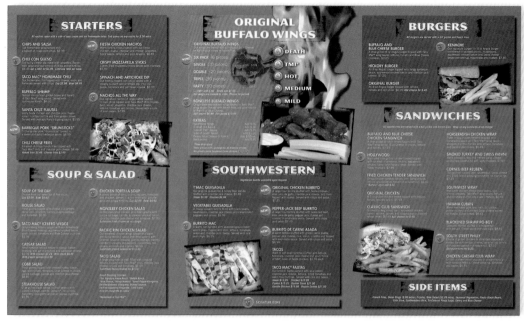

CLIENT
Taco Mac
CREATIVE FIRM
Sellier Design
sellierdesign.com
DESIGNER
Pauline Pellicer

CLIENT
Odyssey Las Vegas
CREATIVE FIRM
Brand, Ltd.
brandltd.com
DESIGNERS
Virginia Martino, Anne Bonds

CLIENT
(on behalf of IMI for)
Delaware North Companies
CREATIVE FIRM
Sellier Design
sellierdesign.com
DESIGNER
Pauline Pellicer

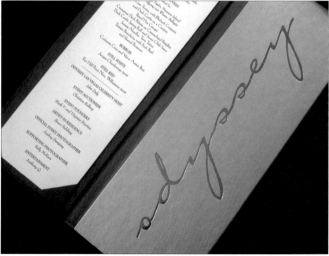

BROCHURES

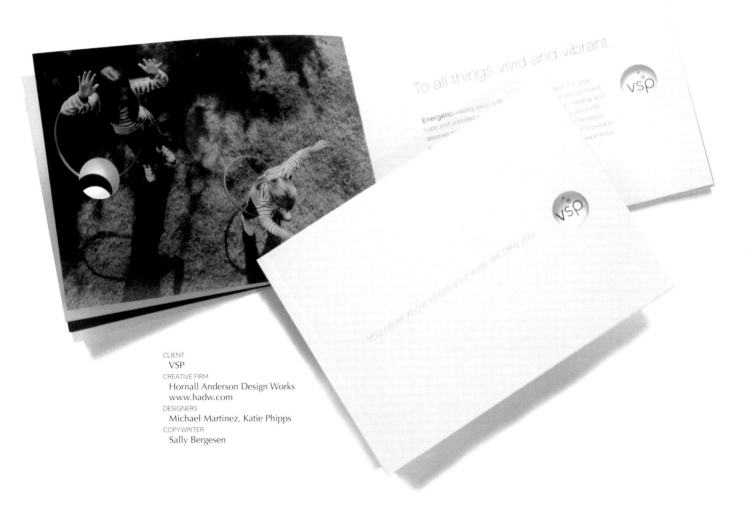

To all things vivid and vibrant.

Energetic: Healthy vision is lik...
hope, and unbridled ...
deserves ...

You never know where your eyes will take you

CLIENT
VSP
CREATIVE FIRM
Hornall Anderson Design Works
www.hadw.com
DESIGNERS
Michael Martinez, Katie Phipps
COPYWRITER
Sally Bergesen

Embrace your dream. Live it here.

CLOVERWOOD

What sets Cloverwood apart is an embracing community spirit nurtured by the friendly, welcoming people who live here. With so many community events to choose from and so many ways to get involved, making new friends and enjoying old friends couldn't be easier. Some Cloverwood residents have been pleasantly surprised to learn that long-time friends and colleagues are now their new neighbors.

At Cloverwood, there is always something interesting to do. Whether it's a ... self ... dinner party, lecture, or musical performance, ... ing in at your own pace will seem limitless. ... opportunities for self-expression, growth, ... style.

... deally blends privacy and convenience. ... ere's easy access to the outstanding culture, ... g events that make the Rochester area so ... of town will land you in the heart of the ... resque countryside, wineries, and Upstate

... plified to assure plenty of time to do as you ... of home ownership are a thing of the past. ... cleaning, and even the cooking to us – you

...ntials of happiness are: ... to love, and something to hope for." ...an K. Chalmers

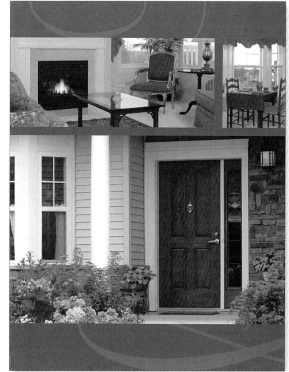

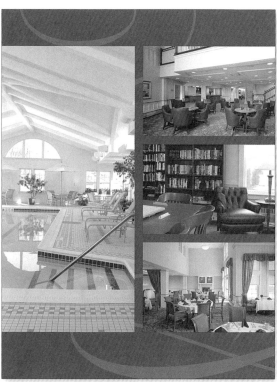

CLIENT
Cloverwood
CREATIVE FIRM
Dixon Schwabl
DixonSchwabl.com
DESIGNERS
Wendy Moffett, Dana Denberg

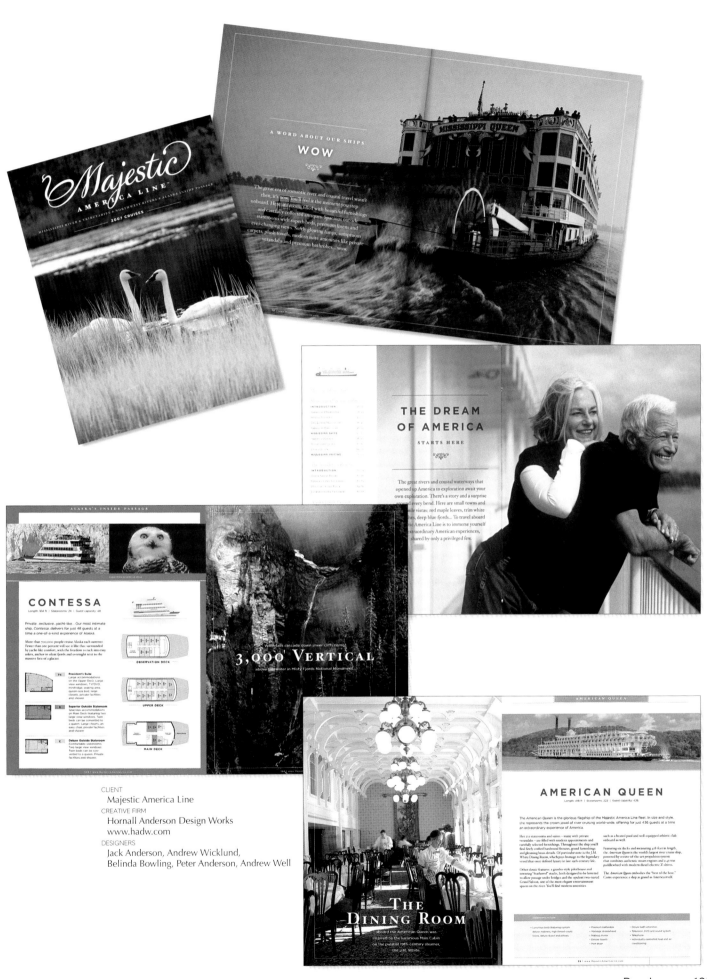

CLIENT
Majestic America Line
CREATIVE FIRM
Hornall Anderson Design Works
www.hadw.com
DESIGNERS
Jack Anderson, Andrew Wicklund,
Belinda Bowling, Peter Anderson, Andrew Well

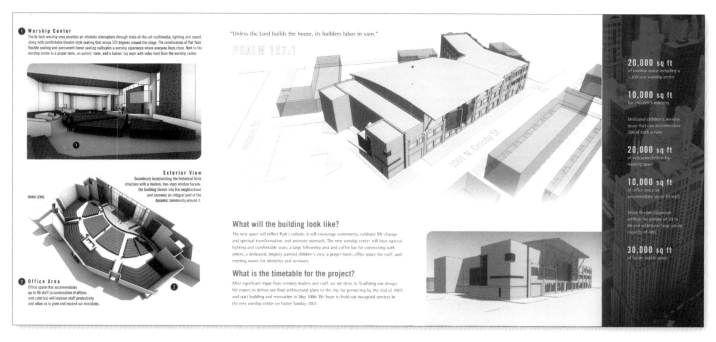

CLIENT
Park Community Church
CREATIVE FIRM
Christopher Gorz Design
www.studiochris.com
DESIGNER
Christopher Gorz

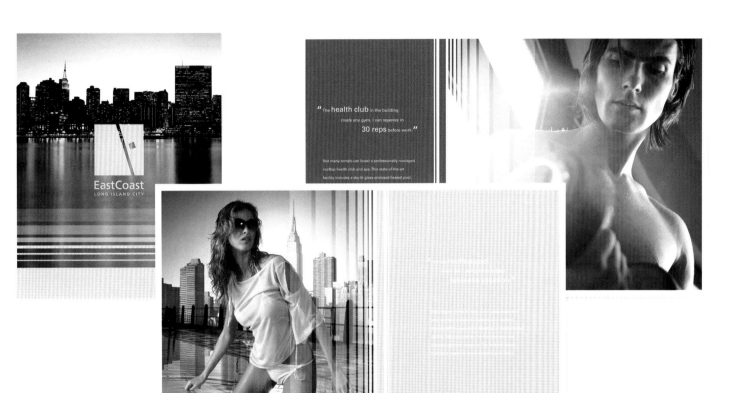

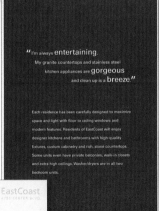

CLIENT
 Rockrose Development Corp.
CREATIVE FIRM
 Silver Creative Group
 silvercreativegroup.com
DESIGNERS
 Suzanne Petrow, Paul Zullo

CLIENT
Stamford Center for the Arts
CREATIVE FIRM
Taylor Design
taylordesign.com
DESIGNER
Vaughn Fendev

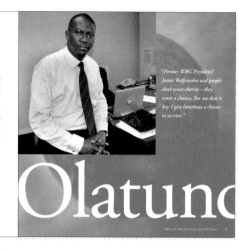

Olatunde Akande
A Venture Capitalist for Nigeria

"[Former WBG President] James Wolfensohn said people don't want charity—they want a chance. For me that is key: I give businesses a chance to survive."

Olatun

CLIENT
International Finance Corporation
CREATIVE FIRM
Schum & Associates
www.schum.com
ART DIRECTOR, PRODUCER, DESIGNER
Ephraim Schum

CHINA

Wenfang Chen
Training a New Generation of Bankers

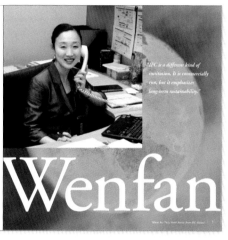

"IFC is a different kind of institution. It is commercially run, but it emphasizes long-term sustainability."

Wenfan

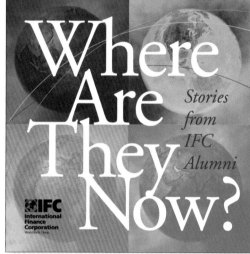

Where Are They Now?

Stories from IFC Alumni

🌐 **IFC**
International
Finance
Corporation
World Bank Group

MOROCCO

Jalal Charaf
The Trials of Bureaucracy

"IFC creates an environment where you can listen, talk, and learn."

Jalal Ch

BOSNIA

Sanela Pasic
A New Bridge in a Divided Land

"At IFC, it doesn't matter where you come from or what your culture is, but rather that you work professionally and benefit from each other's differences."

Sanela P

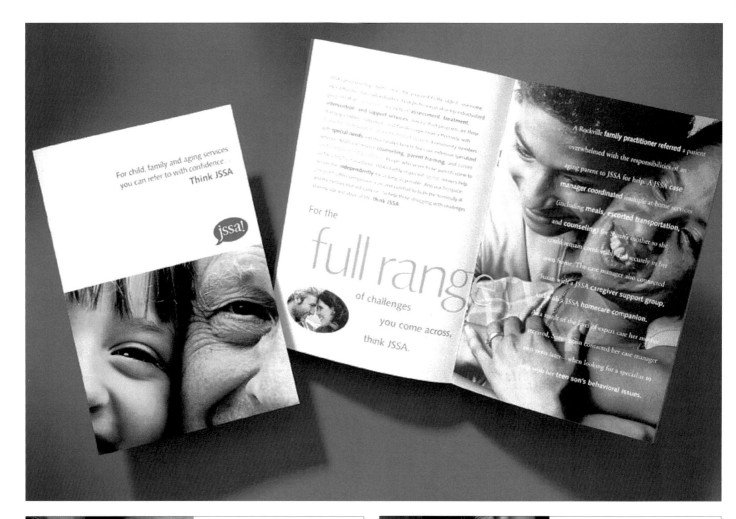

CLIENT
 Jewish Social Services Agency
CREATIVE FIRM
 Beth Singer Design
 info@bethsingerdesign.com
PRINCIPAL
 Beth Singer
DESIGNER
 Sucha Snidvongs

CLIENT
Kreamer Feed
CREATIVE FIRM
Sire Advertising
www.sireadvertising.com
DESIGNERS
**Shawn Felty, Sumer Buttorff,
Jessica Varner**

CLIENT
Spa Elegance
CREATIVE FIRM
Third Planet Communications
www.reinnov8.com
DESIGNER
Richard A. Hooper

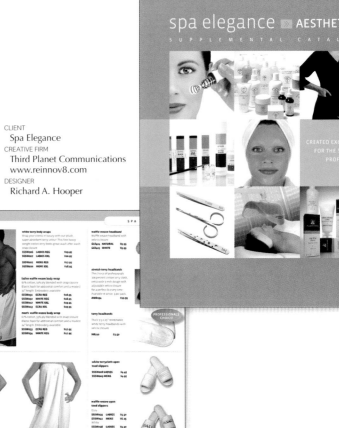

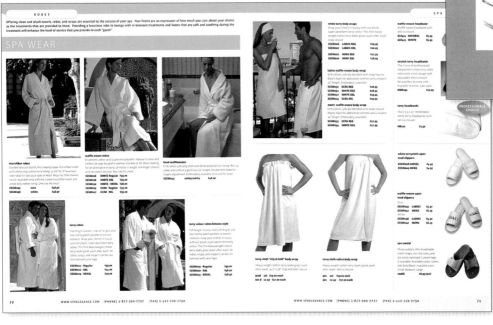

CLIENT
PMMI
CREATIVE FIRM
Brohard Design Inc.
www.brohard.com
DESIGNER
William Brohard

SALES LEADERSHIP ROUNDTABLE
Gain Insight. Work Smarter. Execute Faster.

IT LEADERSHIP EXCHANGE
Gain Insight. Work Smarter. Execute Faster.

HR EXECUTIVE FORUM
Gain Insight. Work Smarter. Execute Faster.

CLIENT
Corporate Executive Board
CREATIVE FIRM
The Design Channel
www.thedesignchannel.com
DESIGNERS
David Franek, Tara Dethemendy,
George Abe

CORPORATE LEGAL EXCHANGE
Gain Insight. Work Smarter. Execute Faster.

FINANCE LEADERSHIP EXCHANGE
Gain Insight. Work Smarter. Execute Faster.

CLIENT
The Commons/Premiera Care Communities
CREATIVE FIRM
Marcia Herrmann Design
www.her2man2.com

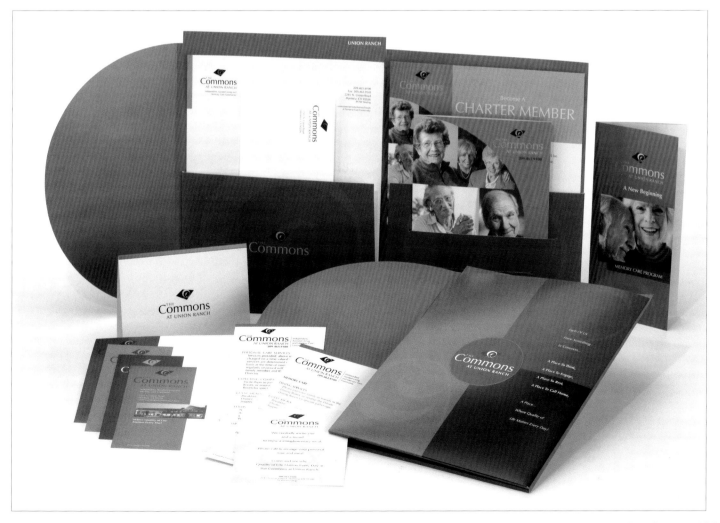

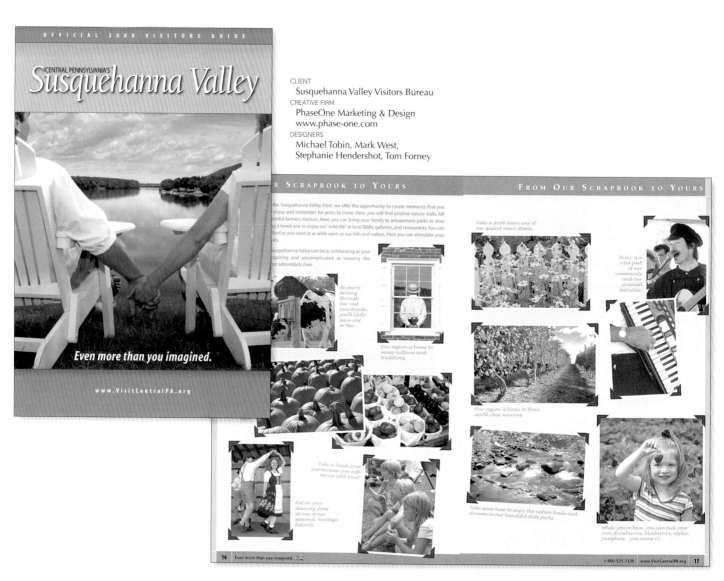

CLIENT
Susquehanna Valley Visitors Bureau
CREATIVE FIRM
PhaseOne Marketing & Design
www.phase-one.com
DESIGNERS
Michael Tobin, Mark West,
Stephanie Hendershot, Tom Forney

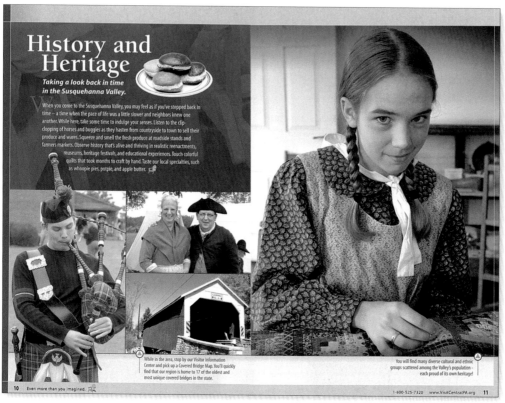

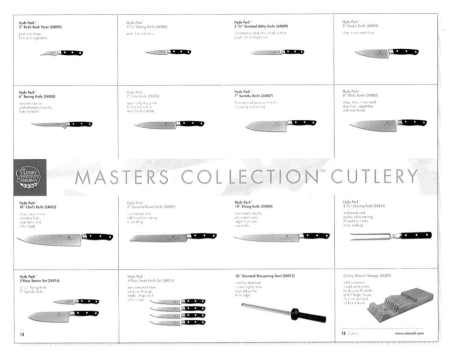

CLIENT
Robinson Home Products

CREATIVE FIRM
Michael Orr + Associates, Inc.
michaelorrassociates.com
DESIGNERS
Michael R. Orr, Thomas Freeland

We can take you there.

Dream big. The great States await, and one airline is dedicated to making your journey simply unforgettable. Which is why, as a member of the Star Alliance® network, reaching over 800 destinations in 152 countries, United proudly offers unparalleled access around the globe. So no matter where you're starting from, when you're headed to the U.S., United is, above and beyond, the best way to fly. Once you're here, we can take you from state to state and coast to coast with routes to hundreds of destinations nationwide.

Experience what makes America one of the best destinations on the planet. This United Destinations Guide features some of the best places to go and things to do throughout the country. Discover even more at SeeAmerica.org, the U.S. travel industry's official website, including information about festivals, attractions, hotels, restaurants and shopping. Plus, find a wealth of planning tools, from maps to suggested itineraries to weather reports at your fingertips. Visit SeeAmerica.org today.

United (States), made easy.

✈ UNITED

A STAR ALLIANCE MEMBER ✦

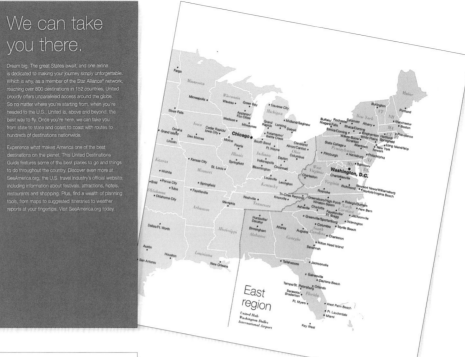

East region

United Hub
Washington Dulles
International Airport

Los Angeles
California

They call it "the City of Angels." That might be a slight exaggeration. But, in this town, fiction is king. From Santa Monica to Hollywood to Beverly Hills, celebrities mingle among the rest of us, and image is everything.

Beyond the stars
Los Angeles is the ideal city for following your passions. So take a quick trip coast to coast or to destinations throughout the nation from one of our two West Coast hubs. United, United Express, p.s.℠ and Ted offer over 200 nonstop flights daily. See united.com for details.

See Los Angeles

A life less ordinary
Beverly Hills is no place for restraint. Give in to your inner power shopper among Rodeo Drive's high-end boutiques and hip lunch spots. Check out the scene on the famous Sunset Boulevard.

The secrets of the silver screen
Go behind the scenes in the land of movie magic at Paramount or Warner Bros. studios. Don't miss the famous Hollywood sign, and, while in "Tinseltown," be star-struck on a celebrity homes tour.

Denver
Colorado

"The Mile High City" is nestled at the base of the Rocky Mountains. One of the largest cities in the entire region, Denver is known for having all the perks of a premier destination, plus the perfect escape right outside its back door.

The sky's the limit
From here, the country stretches as far as the eye can see. One airline will take you almost anywhere you set your sights. Together, United, United Express and Ted offer over 450 daily nonstop flights from Denver to over 90 destinations across the country. See united.com for details.

The call of the wild
In addition to Denver's city parks and golf courses, the Rocky Mountains are a short drive from the city, offering snowboarding, hiking, and many more outdoor activities.

Pennies from Heaven
Tour the U.S. Mint to see how coins are made. This great historic site has been producing U.S. coins for 100 years.

A mile high, a mile long
The 16th Street Mall is a mile-long pedestrian promenade of restaurants, major retailers and entertainment in the heart of downtown. Just hop aboard a free shuttle available at any corner.

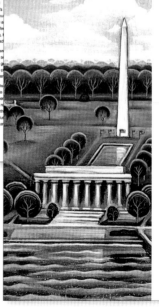

Washington, D.C.

A tale of two cities, D.C. is more than the center of American history and politics. It's also the core of the American experience. United proudly welcomes you to the nation's capital city.

A destination for everyone
While Washington, D.C. is the focal point of U.S. culture, it's also our East Coast hub. From here, you can fly across the continent or throughout the country with over 150 daily nonstop flights on United, United Express and Ted. See united.com for details.

Take a trip to D.C.

On top of Capitol Hill
The magnificent dome of America's Capitol shines from the middle of the city's four quarters. Take a free, guided tour to see where U.S. policy has been established for over 200 years.

Inside the White House
From the "haunted" Lincoln Bedroom to the Oval Office, the home of the U.S. President is a must-see for any visitor to Washington, D.C. Stroll through the city squares surrounding the grand estate, or arrange a group tour in advance.

See the Smithsonian
With more than a dozen museums and the National Zoo, the Smithsonian Institute is the world's largest museum complex. Explore family favorites like the National Air and Space Museum and the National Museum of Natural History as well as the National Portrait Gallery.

Stroll through Georgetown
Wandering through historic Georgetown is like stepping into our 19th century past. Lush scenery, exquisite boutiques, fine restaurants and charming row houses line the streets of this breathtaking old town.

(Inter)national flavor
Washington, D.C. attracts visitors from all over the world, and this global influence is reflected in the wide variety of cuisines available in the city. Feast on Atlantic seafood, nosh next to Capitol Hill power-lunchers, try a spicy Ethiopian dish, or venture to Chinatown for an authentic Asian experience.

For more information visit
seeamerica.org 26

CLIENT
Cooley Godward
CREATIVE FIRM
Greenfield Belser
gbltd.com
DESIGNERS
Burkey Belser, Mark Ledgerwood

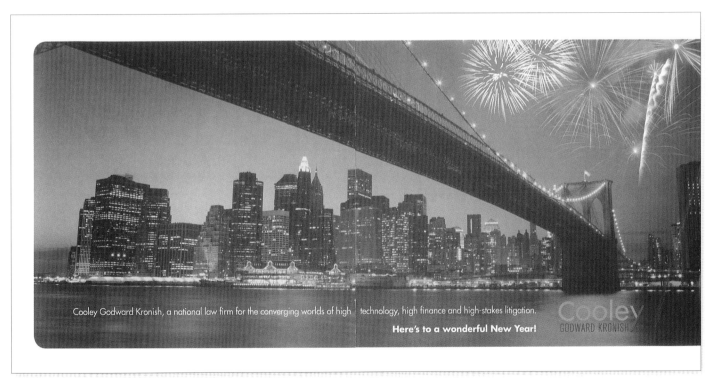

CLIENT
Sunset Pointe at Collany Key
CREATIVE FIRM
JM DesignHaus, Inc.
jmdesignhaus.com
CREATIVE DIRECTOR
Jodi Myers

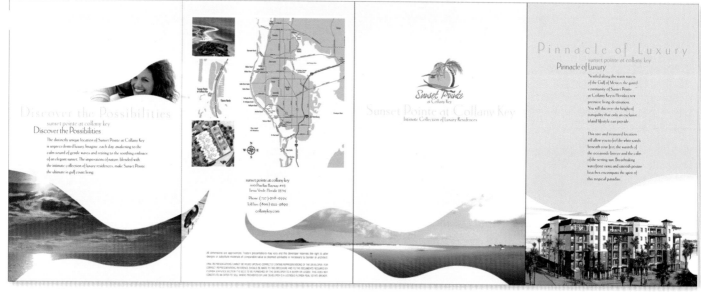

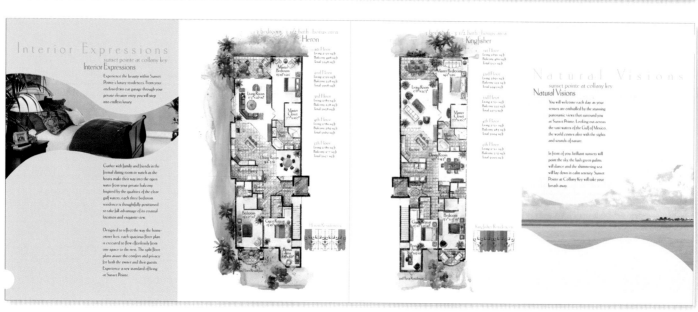

WELCOME
TO MERRILL GARDENS

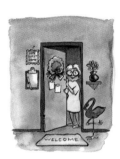

A ONE OF A KIND RETIREMENT COMMUNITY

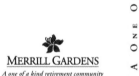

MERRILL GARDENS
A one of a kind retirement community

CLIENT
Merrill Gardens
CREATIVE FIRM
Higgins Design
www.jhigginsdesign.com
DESIGNER
Jane Higgins
ILLUSTRATOR
Sam Day

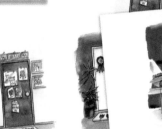

WELCOME *to you*

Merrill Gardens' communities offer
apartments with generous living space, as well
as a choice of floor plans to suit your needs.
There's no buy-in required. And your month
to month fee includes many of the comforts
of home:

• Convenient Anytime Dining*
• Scheduled Transportation
• Weekly housekeeping
 and linen services
• A Variety of Activities
• 24-hour staff

We welcome all
the personal touches
that make a house a home, including
your small pet. Many communities even
provide garden areas outdoors.

Enjoy a leisurely stroll along our nearby
walking paths. Celebrate a special occasion with
your family in our private dining room. Get
together with friends in our spacious living and
dining areas.

WELCOME TO MERRILL GARDENS,
A ONE OF A KIND RETIREMENT
COMMUNITY. IT'S A PLACE WHERE
YOU ARE ABSOLUTELY FREE TO BE
YOURSELF. YOU CAN ENJOY ALL
THE PLEASURES OF INDEPENDENT
LIVING, OR THE QUIET COMFORTS
OF ASSISTED LIVING CARE. AT
MERRILL GARDENS, THE DOOR
IS ALWAYS OPEN FOR CREATING A
LIFESTYLE THAT'S RICH, REWARDING
AND ONE OF A KIND. JUST LIKE YOU.

THE FAMILY THAT OWNS AND
OPERATES MERRILL GARDENS HAS
BEEN IN BUSINESS FOR MORE THAN
100 YEARS. WE ARE ABSOLUTELY
DEDICATED TO PROVIDING A
QUALITY LIVING ENVIRONMENT
THAT'S MINDFUL OF YOUR SECURITY
AND RESPECTFUL OF YOUR NEEDS.

A ONE OF A KIND RETIREMENT COMMUNITY

W HOME

dedicated to making your life here at
ns feel full and enriching. They'll help
hanges that may accompany your new
ply offer the encouragement you need
st of this new phase in your life.

schedule of activities includes
m crafts and musical performances,
programs and more. We'll even
card game or two!

rill Gardens community has access
churches and medical services.
se who want to venture off the
our scheduled transportation
sy to get where you want to go.

married couple, recently single
n, we think you'll find
place to call home.

ONLY *at* MERRILL GARDENS

ANYTIME DINING℠ At Merrill Gardens,
you're free to build your meals around your
schedule, instead of the other way around. With
our convenient Anytime Dining program, we
serve up nutritious meals from early morning
until early evening. A meal
plan is included in your
monthly fee.

ACTIVE LIVING℠
Active Living is designed to
improve our residents' overall
health and well-being by
providing a variety of physical
activities for all fitness levels.

CONNECTIONS℠
Merrill Gardens offers a
revolutionary way for seniors to use
computers – Merrill Gardens Connections.
An easy to use program that allows instant access
to e-mail and the internet exclusively for our
communities. Best of all, it's FREE!

PERSONALIZED CARE To meet your
changing needs, Merrill Gardens offers a
personalized Assisted Living care program.* In
addition to the comfort of knowing that a familiar
face is around 24 hours a day, our staff is trained
to help with the activities of daily living, such as
assistance with medication needs and offering
reminders about important appointments.

*The Merrill
Gardens Guarantee
You'll love living
here...or your
money back!*

60-DAY GUARANTEE If after 60 days
you're not completely satisfied we'll refund
your rent. With a 60-Day Guarantee, you've
got nothing to lose – and every happiness
to gain, guaranteed.

THE HISTORY OF FirstEnergy

10-Year Anniversary
1997 - 2007

When Ben Franklin tapped **electricity** from a rain cloud more than 250 years ago, he could hardly have imagined that the mysterious "electric fluid" he collected in a glass jar would become the basis of a **power industry** that revolutionized **industrial production**, **transportation**, and the **lifestyle** of Americans. An industry with roots in the 19th century, electric utilities created new jobs for Americans and made their lives safer, **cleaner**, and more **comfortable**.

PART II:

CENTERIOR

The Cleveland Electric Illuminating Company, now referred to as
The Illuminating Company, is intimately tied to the City of Cleveland's
industrial history.

Cleveland's Illuminating Company

THE HISTORY OF FirstEnergy

The Bruce
Mansfield Plant

RECOLLECTIONS

Continuing a Family Tradition

OHIO EDISON

THE HISTORY OF FirstEnergy

On September 16, 1996, **Ohio Edison** announced its plan to merge with **Centerior Energy** to form **FirstEnergy**, headquartered in **Akron, Ohio**, with Will Holland as CEO. The merger, completed on November 7, 1997, created a larger company positioned to compete in a changing electricity marketplace.

CLIENT
FirstEnergy
CREATIVE FIRM
Herip Design Associates, Inc.
heripdesign.com
DESIGNERS
Walter M. Herip, John R. Menter,
Jen Hollo Crabtree

Your provider for premier arena surfaces, design and construction.

EQUESTRIAN SURFACES

CLIENT
Attwood Equestrian Surfaces
CREATIVE FIRM
Zero Gravity Design Group
www.zerogny.com
DESIGNERS
Jennifer Mariotti, Chuck Killorin

Welcome
to the ultimate ride.

Whether you ride professionally or for pleasure, choosing a surface for your arena is an important decision. Attwood Equestrian Surfaces offers a full range of arena surface products, as well as the experience and knowledge to guide you through the process.

The next step in footing.

Attwood Equestrian Surfaces' premier arena footings are all-weather, dust-free and require no watering. Our footing provides a consistent, stable surface with viscoelastic rebound that greatly reduces concussion. Our surfaces are specifically designed and formulated for horse safety and injury reduction.

Water the grass, not the sand.

Attwood Equestrian Surfaces never require watering! And a dust-free arena means a healthier environment — for both you and your horse.

Our history.

Attwood Equestrian Surfaces has been building quality riding arenas for over fifteen years. We are innovators of equine surfaces and Equation® is the original dust-free footing. Our background in chemistry, construction, and manufacturing enables us to research and create carefully balanced products that perform consistently in any climate.

We understand the needs of each discipline. Our clients range from nationally recognized competitors to the private discerning rider. We know it's essential to provide meticulously engineered surfaces that benefit the horse and the rider. Using advances in technology and our continuous innovation, we remain at the forefront of footing development.

Our products.

Attwood Equestrian Surfaces is the original manufacturer of polymer-coated footing in the USA. Our footings are engineered from meticulously selected sand, blended with micro poly-fibers and coated with a viscoelastic polymer.

All of our polymer-coated footings are:

- Dust-free
- Non-tacky
- Consistent
- Need no watering
- Low-maintenance
- Tuned for different disciplines
- Manufactured from premium raw materials
- Appropriate for indoor and outdoor applications
- Rebuffed concussion with viscoelastic rebound
- Freeze-resistant and stable over a wide temperature range

Equation™

The original dust-free footing was developed over 15 years ago and early installations remain dust-free today. Today's Equation incorporates the latest advances in footing technology. Equation is installed to a depth of 4 inches over a carefully graded compacted base.

Terra 2000™

This superb product is the result of Attwood Equestrian Surfaces' continuous investment in research and development. Terra 2000 incorporates premium materials which enhance viscoelastic rebound and minimize concussion.

Pinnacle™

This ultimate riding surface combines the latest in technology and our 15 years of footing experience. Pinnacle is engineered with additional premium materials to bring you the optimum in shear strength, minimal concussion and maximum viscoelastic rebound. Pinnacle is laser graded to a uniform depth of five inches over a carefully graded compacted base.

Ameritrack™

This complete race track system is specifically designed and formulated for horse safety and injury reduction. Ameritrack is engineered with a free-draining base and all-weather cushion. It incorporates a vertical drainage system which eliminates movement of the cushion to the rail and results in a consistent, no bias track. The characteristics of the surface are minimal kick-back, low concussion and optimal viscoelastic rebound.

Minimal harrowing is needed to maintain consistency and track appearance. With Ameritrack, watering for dust control, leveling and re-establishing the grade of the slope are not required.

Our low maintenance footings require only periodic dragging to keep them in excellent condition.

About the surfaces.

Our products are formulated from meticulously selected sand, viscoelastic polymers and microfibers. Our dust-free footing system does not require watering and, when used indoors, will not freeze. In outdoor applications the water-repellent nature of the polymer ensures fast drainage. It won't "mist" with water so the arena can be used even after heavy rainfall, unlike conventional footings which can become sloppy and muddy with excess moisture.

In comparison to traditional arenas, maintenance is significantly reduced. To maintain the arena involves only light harrowing and manure removal.

2007 — 2008 BEALL CONCERT HALL

CHAMBER MUSIC SERIES | Reconnecting WITH Intimacy

O UNIVERSITY OF OREGON

40 years

CLIENT
 University of Oregon—School of Music
CREATIVE FIRM
 Defteling Design
 www.defteling.com
DESIGNER
 Alex Wijnen

Waverly Consort

SUNDAY | NOV. 25 | 3 P.M.
MICHAEL JAFFE *DIRECTOR*

Each season the thirteen-member ensemble of singers and players tours The Christmas Story, a program combining solemn and festive music, processions and simple gestures, to dramatize the Biblical narrative as conveyed by music manuscripts and illuminated miniatures of the Middle Ages. Since its premiere at New York's Metropolitan Museum of Art in 1980, this seasonal offering has become a favorite of audiences throughout North America.

"No other group approaches the style and verve of the Waverly Consort."
— TIME MAGAZINE

2007 — 2008 CHAMBER MUSIC SERIES TICKETS 682.5000

Mozart Piano Quartet

THURSDAY | MARCH 6 | 8 P.M.

Founded in 1997, the Mozart Piano Quartet has been establishing an impressive career. It has been ensemble-in-residence at the Festival for Romantic Chamber Music in Leipzig/Halle, Germany, with appearances at festivals and concert series throughout Europe, Australia, and the U.S.

"Sweetly romantic and gorgeously lyrical...altogether dazzling"
— FANFARE

2007 — 2008 CHAMBER MUSIC SERIES

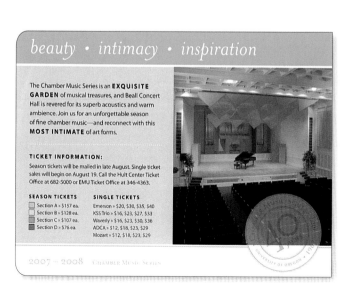

beauty · intimacy · inspiration

The Chamber Music Series is an **EXQUISITE GARDEN** of musical treasures, and Beall Concert Hall is revered for its superb acoustics and warm ambience. Join us for an unforgettable season of fine chamber music—and reconnect with this **MOST INTIMATE** of art forms.

TICKET INFORMATION:
Season tickets will be mailed in late August. Single ticket sales will begin on August 19. Call the Hult Center Ticket Office at 682-5000 or EMU Ticket Office at 346-4363.

SEASON TICKETS
☐ Section A » $157 ea.
☐ Section B » $128 ea.
☐ Section C » $107 ea.
☐ Section D » $76 ea.

SINGLE TICKETS
Emerson » $20, $30, $35, $40
KSS Trio » $16, $23, $27, $33
Waverly » $16, $23, $30, $36
ADCA » $12, $18, $23, $29
Mozart » $12, $18, $23, $29

2007 — 2008 CHAMBER MUSIC SERIES

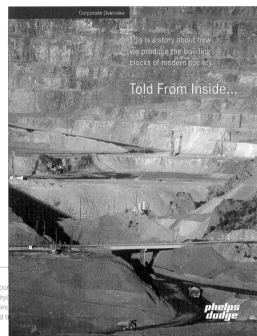

This is a story about how we produce the building blocks of modern society.

Told From Inside...

phelps dodge

CLIENT
Phelps Dodge
CREATIVE FIRM
Pro Wolfe Partners
www.prowolfe.com
DESIGNERS
Doug Wolfe, Kristin Ritchie

Looking Ahead

The success of our company has long depended on our ability to look ahead 10 and even 20 or more years, beyond the obvious and into places, processes and technologies hidden from individuals who lack vision and specialized t

Supporting Community

At Phelps Dodge, we believe in giving back to the communities in which we work and live. Our community involvement program supports quality of life through partnerships, in-kind donations and financial contributions. We focus on building mutual trust.

Our goal is to be a leader in our communities, creating collaboration among multiple partner organizations and serving as a catalyst for positive change. We direct resources to organizations, programs and partnerships that are aligned with our core values - safety, trust, accountability, teamwork, confidence and doing what's right.

Phelps Dodge employees also take an active role in making our communities better places to live and work. Gifts of time and talent are invaluable to community organizations working to improve education, increase safety, protect the environment or promote cultural understanding and diversity.

Every year, Phelps Dodge employees help improve the quality of life by volunteering for company-sponsored projects focused on education, safety, the environment and community development. Our employees lend their hands and their hearts to projects such as rebuilding facilities lost to natural disasters, serving as volunteer emergency service workers and tutoring school children in reading.

We've had nearly two centuries of community involvement and investment. We will continue to build upon our tradition of community involvement.

Phelps Dodge wants Fund to strengthen organizations and families in the communities in which it does business. The company's charitable giving program have five areas of focus - education, community safety and wellness, the environment, community development, and arts and culture.

CORPORATE OVERVIEW

PHELPS DODGE CORPORATION

FindWhere™
License to Locate

precision **tracking**
& location-based
services

CLIENT
Teydo
CREATIVE FIRM
Phoenix Creative Group
www.phoenixcreativegroup.com
DESIGNERS
Nicole Kassolis, Sean Mullins

› Today's highest-sensitivity & proven technology—provides location data even in the toughest tracking environments

› Advanced GPS & wireless coverage make precise real-life tracking affordable

› Extended operating power facilitates efficient recovery (e.g., standby: up to one year battery life)

› 24/7 online access allows you to review updates on your computer or mobile device

Convenient self-evaluation report automatically checks its signal strength and remaining battery life every 24 hours to confirm its Health Status.

iFind 3000

Ultra Sensitive, Industrial-Grade
Tracking that Works in Conditions
Where Other Devices Fail

Locate Anything...Anytime
Customize features to capture the exact data you need. Capabilities include:

• **Intelligent Motion-based Reporting**
• **Arrival/Departure Alerts**
• **Speed & Altitude Monitoring**
• **Start/Stop Movement Reporting**
• **Automatic Data Storage and Forwarding to Cover Any Wireless Service Gap**
• **Geo-fencing Using Virtual Perimeters**

iFind 3000's ultra-sensitive GPS can operate accurately in conditions that defeats all others. Now, indoor and inner-city tracking is within your reach.

Additionally, iFind 3000 takes full advantage of cost-effective data communication plans where available, or otherwise transfer over to universal text messaging—providing you the highest-possible service level.

The iFind 3000 can be managed online to set parameters for report frequency, geo-fencing, and customized alerts to serve your tracking needs.

When your job depends on tracking the location of people and assets through challenging environments—precisely, reliably, and undetected—FindWhere's iFind 3000 remains accurate. From indoor or outdoor transport, to enclosed or open placement, iFind 3000 is your *license to locate*.

FindWhere™
License to Locate

Back **your investigations** with the advanced satellite technology **used by today's** highest-level security agencies

FindWhere™

Supporting more than 18,000 users and over 200,000 mobile tracking devices

Convenient.
Easy-to-use.
Precise.

Need to track subjects precisely despite traffic congestion or bad weather? Need to be in more than one place at a time? Need another set of eyes? Nothing answers your needs better—or more easily—than FindWhere.

FindWhere offers best-in-class products and services for private investigation, parental supervision, insurance, personal safety and general tracking purposes.

It's easy to customize FindWhere's features to fit your schedule, your procedures, and your specific tracking objective. Real-time response gives you an up-to-the-minute report on the location of your subject or asset and geo-fencing capabilities let you set virtual perimeters that alert you the moment they're crossed.

Just conceal the mobile tracking device inside any asset or vehicle—in the glove box, under the seat, in the trunk or even *underneath* the vehicle. FindWhere takes care of the rest, giving you an omniscient scope and aerial perspective, so you don't miss a thing.

No matter how high the stakes or tough the assignment, count on FindWhere to track anything, anywhere, and anytime.

Cut physical surveillance time by 75%
It's so easy to use and so accurate—private investigators report it cuts average physical surveillance time from 8 hrs down to just 2 hrs.

FindWhere succeeds where other tracking devices fail
Our water-resistant devices withstand scorching heat and below-zero temperatures, urban canyons, enclosed or lower-level areas, and operate under trees or even indoors.

Track multiple targets simultaneously
From one user account, track more than one target by simply adding multiple FindWhere devices. Private investigators find they can track 10+ targets at the same time.

Depend on accurate, worry-free reliability
Since 2002, FindWhere's accuracy and dependability have won a loyal following among law enforcement agencies and private investigators around the world.

GOVERNMENT & PEOPLE

Brookland

Residents of the Brookland neighborhood successfully challenged the government to keep a new highway from going through their homes.

Who could have benefited from a new highway through Washington, D.C.?

Do you think it was a good or bad thing that this highway wasn't built?

What topics are important in your neighborhood? Traffic? Trees? Safety?

Draw a picket sign to protest or support something in your neighborhood:

A picket sign can show your opinion on an important issue.

Pennsylvania Avenue

Pennsylvania Avenue is often called America's main street.

Look up at the colorful banners or watch the video screen to see how both visitors and residents of Washington, D.C., have used Pennsylvania Avenue to join together for celebrations or protests.

Pennsylvania Avenue and the people who use it have changed in appearance over time. What are some differences you notice?

Identify three types of transportation people have used on this street.

1. _____ 2. _____ 3. _____

(answer: horseback, walking, trolley cars, or tractor)

You're the reporter! Fill-in the blanks of this important newscast to America:

Boy, was it _____ today in the nation's capital!
(ADJECTIVE/DESCRIBE)

_____ people joined together to _____ on
(NUMBER) (VERB/ACTION)

Pennsylvania Avenue to _____ the election of the new
(VERB/ACTION)

President of the United States, _____.
(NAME OF YOUR CHOICE!)

CLIENT
National Building Museum
CREATIVE FIRM
Pensaré Design Group
www.pensaredesign.com
CREATIVE DIRECTOR
Mary Ellen Vehlow
DESIGNER
Amy E. Billingham

Happy Holidays

Orchard Fresh Gifts

CLIENT
The Limoneira Company
CREATIVE FIRM
BBM&D
bbmd-inc.com
DESIGNERS
Keir Dubois, Suzette Brown,
Barbara Brown

Avocados

SPICE UP THE SEASON

Limoneira takes special pride in managing the quality of our coffee from seed to cup. Our offering includes Guara specialty Espresso and Italian Roast gourmet coffee from Brazil paired with delicious gourmet chocolates. Spice up your colleagues' mornings with this aromatic sampling of Limoneira's unique Brazilian-grown coffee. Your Coffee Gift Box includes a 12 oz. bag of Italian roast (dark brown), a 12 oz. bag of Espresso Roast (medium brown) and sumptuous chocolates.

Item# F5064
Price $54.95
Shipping
Weight: 6 lbs

CALIFORNIA PISTACHIOS

Pistachios, the top selling nuts in the United States, are not only delicious - they also have great health benefits, confirmed by the U.S. FDA and a Harvard research study. Our 2 lb offering, hand selected from the best for your holiday gift giving, ensures that you don't have to sacrifice great taste for health. Enjoy in holiday recipes such as elegant brie and pistachio appetizers, apricot pistachio stuffing, or dried apricot pistachio biscotti. Limoneira pistachios-orchard fresh, healthy and delicious.

Item# F5066 Price $29.95 Shipping Weight: 3 lbs

Gus Gunderson
Ever since he was a young man, Gus has loved working the land. He has pursued that passion in his 17 years with Limoneira by supervising production on over 7200 acres of rich agricultural soil. Gus is particularly proud to be a part of Limoneira's long history of work in advancing sustainable agriculture, a growing movement which helps to preserve topsoil and groundwater, improve the economic and social quality in rural communities and improve the living and working conditions for farm laborers.

HOLIDAY SPORTS FAN'S DELIGHT

Family and friends love to gather together and root for their favorite teams during the holiday season, and we offer the perfect gift to help get into the spirit. 4 creamy Hass avocados, 4 Premium lemons and 2 Persian limes provide the ingredients for holiday snacking, great dips and refreshing drinks. We include 2 guacamole seasoning packs to make the festivities sparkle as well as a selection of classic Merck Old World miniature sports ornaments.

Item# F5056
Price $34.95
Shipping
Weight: 7 lbs

HOLIDAY SPORTS FAN'S DELIGHT (LARGE)

This is the same wonderful offering as shown above, but we've added even more delicious fruit, bringing the total to 6 avocados, 3 Premium lemons, 3 limes, 3 guacamole seasoning packs, gourmet recipes and a selection of classic Merck Old World miniature sports ornaments.

Item# F5055
Price $49.95
Shipping Weight: 11 lbs

CALIFORNIA FRUIT GIFT BOX: PRIDE OF HERITAGE VALLEY

Give the gift of taste and health this season with a great variety package of 4 large Hass avocados, 4 crisp Valencia oranges and 4 Premium Lemons. Perfect for those special holiday recipes or just great for healthy nutritious snacking.

Item#: F5067
Price: $31.95
Shipping Weight: 8 lbs

GOURMET'S NEW CHRISTMAS HOLIDAY ROMANCE: BLOOD ORANGES

Add romance to your holiday table or gift list with the dramatic difference of Moro Blood Oranges. Uniquely sweet with a dark red interior, Moro Blood Oranges are less acidic than juice oranges, making this citrus ideal for cocktails as well as a great addition to holiday salads, sauces, sorbets, granitas and compotes. Showcase this delicious fruit with our gourmet recipes, included in this package with 14 blood oranges.

Item: F2062
Price: $34.95
Shipping
Weight: 11 lbs

CHRISTMAS CITRUS TASTE OF TRADITION

Hand-picked for sweetness and color, these ripe, fresh mandarins will evoke, at the first taste, cozy Christmas gatherings around the hearth. A delightful Christmas postcard book, a fun Christmas puzzle and your choice of one of five specialty Christmas citrus ornaments. These are included with 20 California sun ripened mandarins. Perfect for everything from stocking stuffers to business gifts.

Item# F4058
Price $49.95
Shipping Weight: 9 lbs

A TASTE OF HISTORY: CITRUS CRATE ART

Colorful souvenirs of a bygone era, lithographic citrus packing labels once decorated every wooden crate of lemons and oranges Limoneira shipped over the last two centuries. This holiday or business gift includes 12 crate art labels for Limoneira which were patented in 1927. These reflected the company's location in Santa Paula; a snowy-bearded Santa Claus, carrying a bagful of lemons and Paula, a curly blond-haired senorita with a lace fan and shawl. Included with the now famous Santa Label is a fun Santa Surfer ornament for a California twist on the holidays. These are paired with a selection of 10 juicy Persian limes, 8 navel oranges, and 10 Premium lemons, and make a unique gift for business associates or friends and family.

Item# F4040
Price $49.95
Shipping
Weight: 16 lbs

SANTA CRATE LABEL CALIFORNIA CHRISTMAS GIFT BOX

Fruit Crate art symbolizes the history and heritage of California Citrus. Max Schmidt, a native of Germany and founder of Schmidt Lithographers of Los Angeles, developed new crate labels for Limoneira which were patented in 1927. These reflected the company's location in Santa Paula, a snowy-bearded Santa Claus, carrying a bagful of lemons and Paula, a curly blond-haired senorita with a lace fan and shawl. Included with the now famous Santa Label is a fun Santa Surfer ornament for a California twist on the holidays. These are paired with a selection of 10 juicy Persian limes, 8 navel oranges, and 10 Premium lemons.

Item# F4057
Price $59.95
Shipping Weight: 15 lbs

ORCHARD FRESH GOURMET HOLIDAY FRUIT GIFT BASKET

When your friends, family or business colleagues open this beautiful basket, they will find the best from Limoneira's orchard. The 4 large Hass avocados (and the 4 great guacamole spice packs) are a perfect complement for hors d'oeuvres. The 4 Blood oranges provide great makings for juices and cocktails. 4 vibrant yellow Premium lemons, 4 Sweet Meyer Lemons and a 12 oz. jar of silky Heritage Valley honey provide holiday bakers with a great incentive to create wonders. The pistachios, almonds, cashews and walnuts (all in 8 oz. packs) offer tempting snacks by the fire.

Item# F2063
Price $69.95
Shipping Weight: 18 lbs

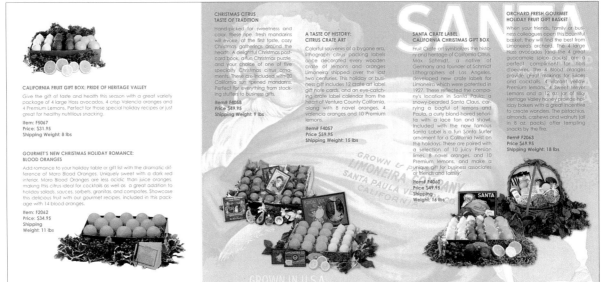

THE UNIVERSITY'S
LOCATION CAN'T
BE BEAT. FROM
THE BLUFF, YOU
CAN SEE THE
WILLAMETTE
RIVER AND
DOWNTOWN,
ONLY MINUTES
AWAY. LOOK TO
THE RIGHT TO
SEE THE HILLS
OF FOREST PARK,
AND ON THE LEFT
IN THE DISTANCE
ARE THE SLOPES
OF MT. HOOD.

Alisabeth Bush '10

PACIFIC NORTHWEST

THE UNIVERSITY OF PORTLAND
Oregon's Catholic University

WHAT TO KNOW

THE UNIVERSITY OF PORTLAND

PACIFIC NORTHWEST

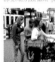

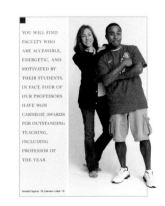

YOU WILL FIND
FACULTY WHO
ARE ACCESSIBLE,
ENERGETIC, AND
MOTIVATED BY
THEIR STUDENTS.
IN FACT, FOUR OF
OUR PROFESSORS
HAVE WON
CARNEGIE AWARDS
FOR OUTSTANDING
TEACHING,
INCLUDING
PROFESSOR OF
THE YEAR.

THE UNIVERSITY OF PORTLAND

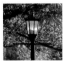

CLIENT
 University of Portland
CREATIVE FIRM
 Lightner Design
PROJECT & CREATIVE DIRECTOR
 Rachel Barry-Arquit, University of Portland
ART DIRECTOR, DESIGNER
 Connie Lightner, Lightner Design
PHOTOGRAPHERS
 Jerome Hart, various
PRINTER
 Bridgetown Printing

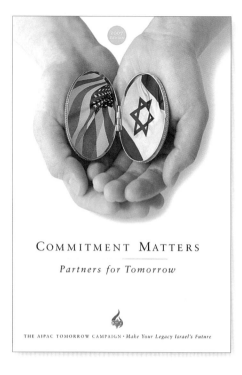

COMMITMENT MATTERS

Partners for Tomorrow

THE AIPAC TOMORROW CAMPAIGN • *Make Your Legacy Israel's Future*

"THE MOST IMPORTANT THING IS PASSING THIS
LEGACY ON TO MY CHILDREN. BY ENDOWING
AIPAC WITH THIS FINANCIAL CONTRIBUTION OUT
OF MY ESTATE, IT IS MY HOPE THAT THEY WILL
UNDERSTAND MY COMMITMENT AND BE INSPIRED
TO PARTICIPATE AS WELL."

– ALISA ABECASSIS

INSPIRING FUTURE GENERATIONS

Alisa Abecassis • Los Angeles, CA

As a single mother, I felt it was very important that my children understand not only why I give so much of my time and energy to AIPAC now, but that I am equally committed to the future of AIPAC. Participating in *The AIPAC Tomorrow Campaign* is a statement of that commitment and sends a clear message to them—our future leaders—that AIPAC's vital work must continue. It is my hope that it will inspire their commitment and involvement as well.

I have only been involved with AIPAC since October 2004, but I have become very active both in my hometown of Los Angeles and at the national level. What really struck a chord with me was the chance to do something more than just write a check to a worthy cause. AIPAC provides the opportunity and the tools for my voice to be heard, allowing me to actively engage in something that promotes and strengthens Israel's relationship with the United States.

The world is a very volatile place and we can never take for granted America's support for Israel. It is crucial to ensure that AIPAC has the financial wherewithal to continue its work with the U.S. government in the future. By making this endowment commitment, we can ensure that the funds will be there and that future generations—my children and the children of other pro-Israel advocates—will have an AIPAC going forward so their voices will also be heard."

AIPAC PARTNERS FOR TOMORROW • *Making Their Legacy Israel's Future*

11

DEMONSTRATING COMMITMENT

Chaya & Howard Friedman • Baltimore, MD

Strengthening the U.S.–Israel relationship is very important to us and is a vital part of our commitment to being Jewish. The threats from Iran and elsewhere in the world require us to provide for a strong AIPAC. That will ensure America can continue its favorable foreign policy and Israel will be secure for decades to come.

Our endowment also counters the possibility of changes within the Jewish community: Will future generations have the same passion we have for AIPAC's work? Will they understand the importance of the U.S.–Israel relationship like we do?

Like so many, the Holocaust was a very personal tragedy for our families. Those who survived and came to this country, like my father, built new lives from the opportunities that America gave them. As an American, I now have a responsibility to work for the issues that are dear to American values, and the support of Israel is one of those issues. What better way can I show my patriotism to America and my support for my fellow Jews?

It is inspiring to connect with and be involved with thousands of like-minded people demonstrating their commitment to Israel and the Jewish people by lobbying hard for a bill. It is exciting when your conversations and your information have helped a member of Congress vote for legislation that will impact Israel's security. We are leaving half of our *AIPAC Tomorrow* gift to the American Israel Education Foundation to support AIPAC's educational work, and the other half directly to AIPAC, because we believe that its capacity to effectively lobby must be endowed.

Most people our age don't think about legacy and endowment gifts yet, but maybe it's time they do. In its almost 60 years of existence, Israel has been in constant peril from the enemies around it. We need to ensure for our children and grandchildren, and generations to come that the Jewish people and Israel stay strong. In making our gift, we're doing our part to assure that it does."

AIPAC PARTNERS FOR TOMORROW • *Making Their Legacy Israel's Future*

20

"IN ITS ALMOST 60 YEARS OF EXISTENCE, ISRAEL
HAS BEEN IN CONSTANT PERIL FROM THE ENEMIES
AROUND IT. WE NEED TO ENSURE FOR OUR CHILDREN
AND GRANDCHILDREN, AND GENERATIONS TO COME
THAT THE JEWISH PEOPLE AND ISRAEL STAY STRONG."

– CHAYA & HOWARD FRIEDMAN

"WE WANT AIPAC TO CONTINUE DOING ITS GREAT JOB
EDUCATING THE U.S. CONGRESS ABOUT ISSUES
AFFECTING ISRAEL AND THE UNITED STATES. THE
INCOME FROM OUR GIFT WILL HELP KEEP AIPAC
GOING THROUGH MANY, MANY YEARS AHEAD."

– LOIS & DICK ENGLAND

Israel is at the heart of our relationship...it's been a part of who we are ever since we made our first trip there 30 years ago. Israel's survival is so important to us, and helping to ensure the solid relationship between the United States government and Israel is fundamental to her security.

One of AIPAC's most important activities is bringing representatives from both sides of the aisle to Israel. You can talk about the needs and role of Israel until you're blue in the face. But until somebody actually sees it and hears firsthand from people in the know there, they don't understand the challenges. Once they go—whether they're Jewish or not—it changes their life and understanding of the relationship forever.

Our job is to ensure this invaluable educational work continues. For me, as a board member, it is so motivating to work alongside such a dedicated group of people. I get to work side-by-side with our community's most talented and experienced leaders. They could do whatever they want, and they believe their time and energy is best spent with AIPAC. They really take ownership of this responsibility because they know Israel's security is at stake.

Moving forward we will face increasing challenges and will need to build new alliances, engage more activists. If you believe in Israel, if you believe in the United States, there's not a better way to spend your time and money than to invest it in AIPAC's work.

Although we believe that we have passed on our commitment to our family because they're involved now, we still want to make sure AIPAC has the resources in place to continue what we're doing going forward for many, many years to come. This gift puts an exclamation point on our beliefs and it feels great to be able to do so in it."

AIPAC PARTNERS FOR TOMORROW • *Making Their Legacy Israel's Future*

13

CLIENT
American Israel Public Affairs Committee
CREATIVE FIRM
Beth Singer Design
info@bethsingerdesign.com
PRINCIPAL
Beth Singer
DESIGNER
Sucha Snidvongs

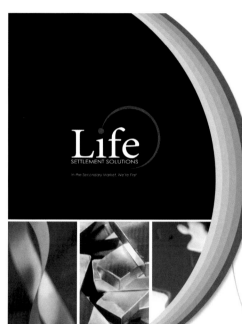

**Identifying Candidates
& The Life Settlement Process**

flexibility

Once the client and their advisors determine that a life settlement is an appropriate course of action, policies considered for purchase generally must meet these eligibility requirements:

• Minimum age of 65 with most common ages between 75-85;
• Various types of policies qualify; refer to the most current pricing guidelines for details;
• There is no maximum on face amount; the minimum face amount is $250,000;
• Life expectancy of the insured is between two years and 17 years where the insured does not have any terminal illness;
• The policy must be beyond any carrier or statutory contestability period; and
• Policy written by U.S. life insurance company rated "BB" or better by S&P.

The process is somewhat detailed. A high-level summary consists of the following:

• A completed case file consisting of properly executed client authorizations, medical information, life expectancy reports, inforce policy illustrations and an application for a life settlement is submitted to Life Settlement Solutions for evaluation.
• If the policy and insured meet our purchasing criteria, Life Settlement Solutions extends a pricing offer for the policy.
• The client and their advisors evaluate the pricing offer. If the policy owner accepts the pricing offer, Life Settlement Solutions issues a contract closing package for completion and properly executed signatures.
• Policy owner properly completes and signs closing package and returns to Life Settlement Solutions and policy values are verified by the insurance carrier.
• Change of policy ownership is executed with the insurance carrier, funds are released to the policy owner and compensation is paid to the distribution firm. Depending upon the transaction, escrow services and contract rescission time periods can affect the timing of payments.
• Because funding is provided solely by institutional financing entities, Life Settlement Solutions does not provide customer information to (and does not re-sell policies to) individual investors or purchasers.

A Powerful Financial Planning Tool Has Emerged

value

Advantages of Life Settlements

opportunity

Candidates for Life Settlements

innovation

CLIENT
Life Settlement Solutions
CREATIVE FIRM
Design Group West
www.dgwest.com
DESIGNERS
Jim Naegeli, Megan Boyer,
Sasha Govorova

PARSONS

Parsons Transportation
People and power to
move the world.

We know how important it is for communities to
spread their wings. We also know the challenges
involved. From Miami to Abu Dhabi, Parsons brings
clients the added benefit of the best lessons
learned from more than $145 billion in airport
construction worldwide.

Our expertise in every aspect of the process, including
safety, efficiency and state-of-the-art technology, and
our reputation for working to meet our clients' needs are
how we tip the scale. When you go from being just another
city to becoming a gateway to the world, it helps to have
people that you trust to help you make a safe, smooth
transition. We're ready to fly.

ROAD AND HIGHWAY

What happens
when teamwork
mirrors
technology?

Southeast Corridor Transportation Expansion (T-REX) Project; Denver, CO

CLIENT
Parsons
CREATIVE FIRM
SGDP
www.sgdp.com
ART DIRECTOR, DESIGNER
Albena Ivanova
COPYWRITER
Steve Batterson

TRANSPORTATION CONSUMER SERVICES

How can global
thinking change
your world?

Connecting people is about offering them better
ways to stay in touch, from point a to point b and
beyond. Which is why Parsons offers your clients
online and communications access on the move.

The world moves pretty quickly, but with Parsons,
you can be sure that you and your clients stay connected.
We implement Internet in Motion — broadband wireless
infrastructures that allow train, ferry and bus passengers to
access the Internet — using Wi-Fi–enabled laptops or PDAs
while they travel. We also keep you in step with the latest
digital communications services, including entertainment,
location-based advertising, safety and security, and
operational applications like on-board ticketing. It's all done
with the customer in mind to add maximum value to the
transportation world.

communications network
consistent bandwidth
mobile Internet access
broadband wireless Internet access

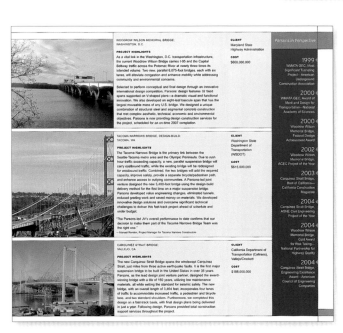

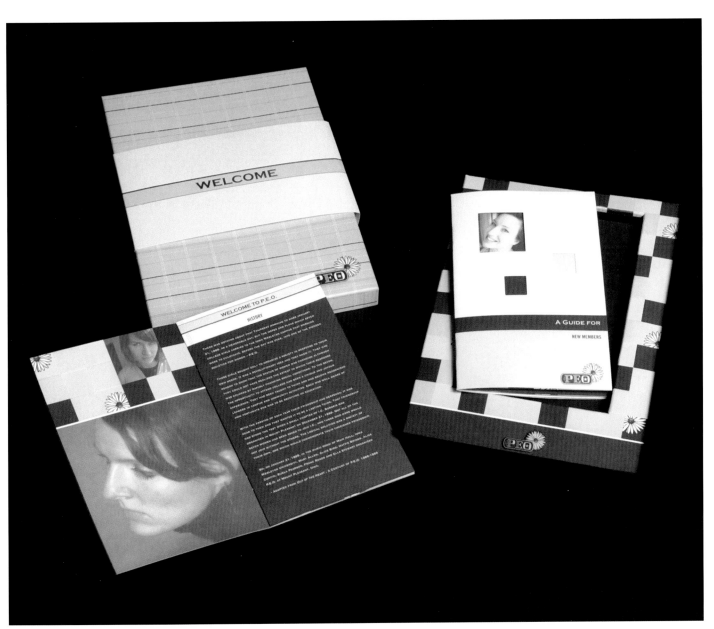

CLIENT
P.E.O. Sisterhood
CREATIVE FIRM
Sayles Graphic Design
www.saylesdesign.com
DESIGNER
John Sayles

10260

KOROGARD®
WALL PROTECTION SYSTEMS

08

Handrails • Chair Rails • Crash Rails • Bumper Rails • Corner Guards • Thermoformed Products
Protective Wallcoverings • Traffic Series Decorative Wallcoverings **KOROGARD.COM**

CLIENT
Korogard Wall Protection Systems
CREATIVE FIRM
Sire Advertising
www.sireadvertising.com
DESIGNERS
Shawn Felty, Sumer Buttorff,
Amanda Lenig

08
New Products

Korogard has expanded our product collection to offer a new breadth of design solutions including Bellagard's sophisticated new sculpted wall panels. We've also expanded our popular Korowood™ chair rails to include the BW30 and BW50 and released the modern HW7P wood and HS50 aluminum handrails. Korogard also offers the stainless steel CS5F and CS55 and the aluminum CS45 crash rails. For those of you who want metal and wood, combine the two with Korogard's new HS50!

Above: BellaLucent Handrail

Sculpted Wall Panels

- Ideal for interiors requiring a distinct design appearance while providing abrasion resistance
- Select from a colorful array of film finishes, paint colors, and multidimensional pattern options
- Available in several hundred unique wall panel options
- Standard panel size measures 48" x 96"

HS50 Handrail

- 4-1/2" aluminum handrail
- Handrail available in three powder coated textures: Black, Silver, and Silver Stratum
- Available with rounded or oval top grip
- Top grips available in Red Oak, Maple, Cherry, Ash, Poplar, and Eucalyptus in three standard finishes: Clear Varnish, Red Oak Stain, and Cherry Stain; or stained to match your specification
- FSC Certified Wood available upon request
- Made to order (Handrails 10' in length or greater may have splices)

HW7P Handrail

- 1-1/2" handrail with rounded full grip; stainless steel ends and mounting brackets
- Handrail available in Red Oak, Maple, Cherry, Ash, Poplar, and Eucalyptus in three standard finishes: Clear Varnish, Red Oak Stain, and Cherry Stain; or stained to match your specification
- Ends and mounting brackets available in three powder coated textures: Black, Silver, and Silver Stratum
- FSC Certified Wood available upon request

BW30 Chair Rail

- 2-1/8" solid wood chair rail with integrated flexible bumper
- Vinyl insert available in black
- Chair rail available in Red Oak, Maple, Cherry, Ash, Poplar, and Eucalyptus with three standard finishes: Clear Varnish, Red Oak Stain, and Cherry Stain; or stained to match your specification
- FSC Certified Wood available upon request

BW50 Chair Rail

- 3" solid wood chair rail with integrated flexible bumper
- Vinyl insert available in black
- Chair rail available in Red Oak, Maple, Cherry, Ash, Poplar, and Eucalyptus with three standard finishes: Clear Varnish, Red Oak Stain, and Cherry Stain; or stained to match your specification
- FSC Certified Wood available upon request

10

11

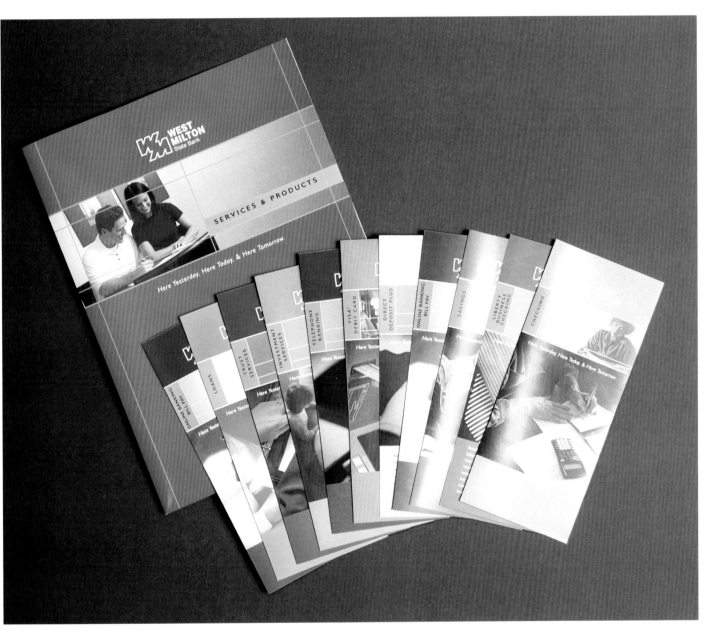

CLIENT
West Milton State Bank
CREATIVE FIRM
PhaseOne Marketing & Design
www.phase-one.com
DESIGNERS
Michael Tobin, Josie Fertig

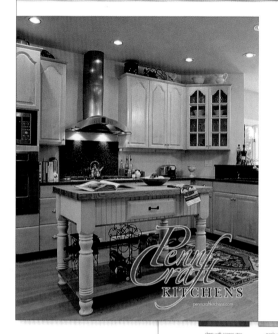

design
solutions CATALOG

CLIENT
Penn Craft Kitchens
CREATIVE FIRM
Sire Advertising
www.sireadvertising.com
DESIGNERS
Shawn Felty, Jordan Chappell,
Sumer Buttorff

premium

penncraftkitchens.com

cherry with cognac stain maple with honey stain oak

camden 836

cherry with mocha stain maple with muslin stain oak

premium series construction

The construction of the Premium Series is what sets this collection apart from other cabinetry options. With tough, durable plywood cases and solid wood drawers, the Premium Series includes additional features as part of the standard construction. Weight-bearing, bottom-mounted steel drawer slides provide superior durability. Penn Craft's Premium Series designs are constructed from the finest materials and built for dependability and durability.

10

11

choice

penncraftkitchens.com

woodhaven 578

cherry with walnut stain maple with chestnut stain shown in arctic white

ridgeview 579

cherry with cognac stain maple with honey stain and pewter glazing shown in bisque

choice series construction

Constructed with durable melamine cases, Choice Series cabinets offer single-piece tops for added strength and stability and finely tooled dowel joints for a snug fit. Bottom mounted, epoxy-coated drawer slides make opening and closing drawers a smooth and simple process. Hinges allow adjustments in every direction while opening a full 110 degrees with guaranteed dependability. Stain resistant interiors and shelves wipe clean with a damp cloth.

16

5

CLIENT
Spa Elegance
CREATIVE FIRM
Third Planet Communications
www.reinnov8.com
DESIGNER
Richard A. Hooper

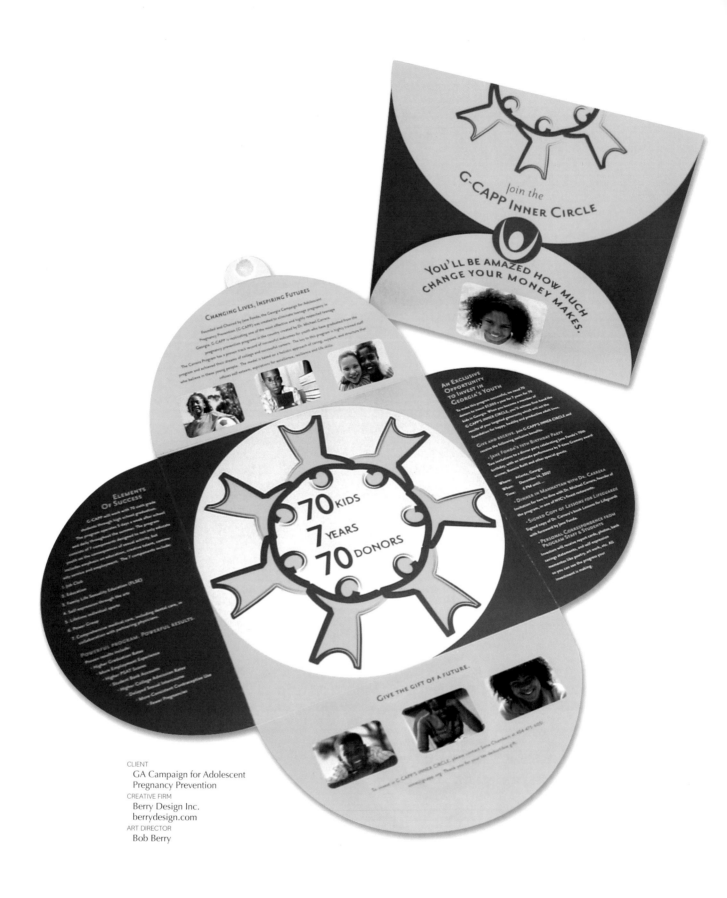

CLIENT
GA Campaign for Adolescent
Pregnancy Prevention
CREATIVE FIRM
Berry Design Inc.
berrydesign.com
ART DIRECTOR
Bob Berry

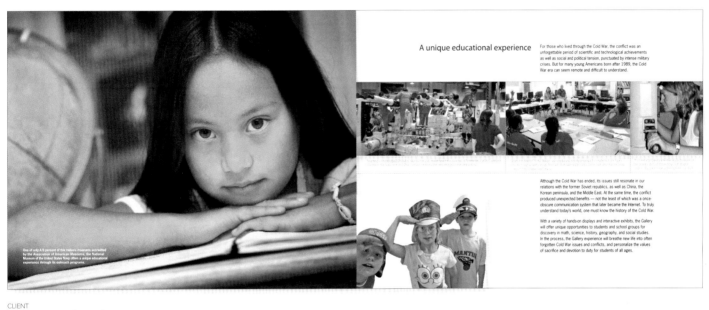

CLIENT
Naval Historical Foundation
CREATIVE FIRM
Slice
www.slice-works.com
ART DIRECTOR
Richard Rabil
DESIGNER
Juana Merlo
PHOTOGRAPHY
Jonathan Hamill

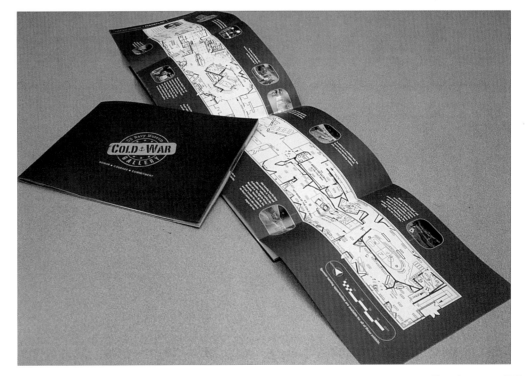

CLIENT
Bennett Homes
CREATIVE FIRM
Image Ink Studio
imageink.com
DESIGNER
Tom Hession-Herzog

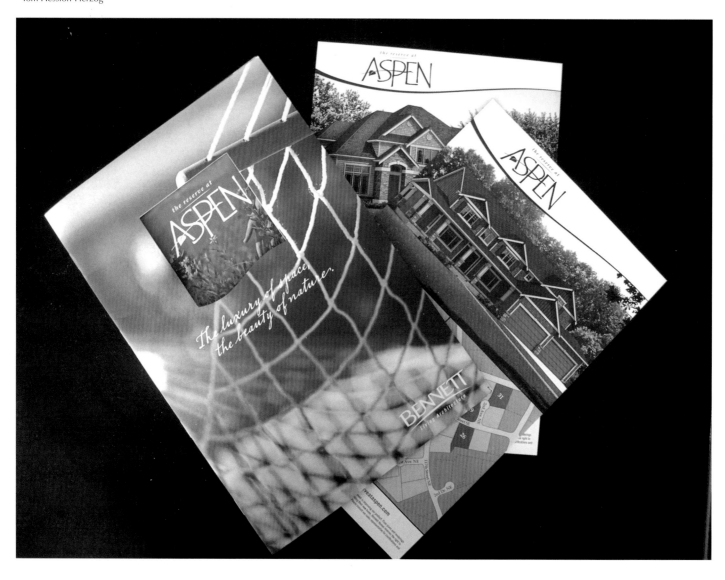

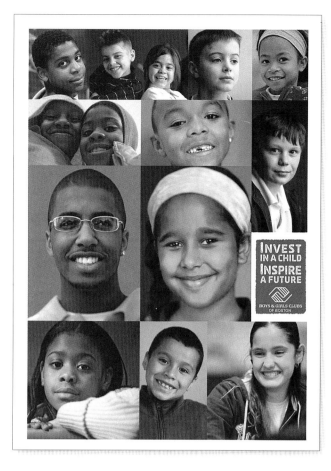

CLIENT
Boys & Girls Club of Boston
CREATIVE FIRM
Gill Fishman Associates
gill@gillfishmandesign.com
DESIGNER
Tammy Torrey

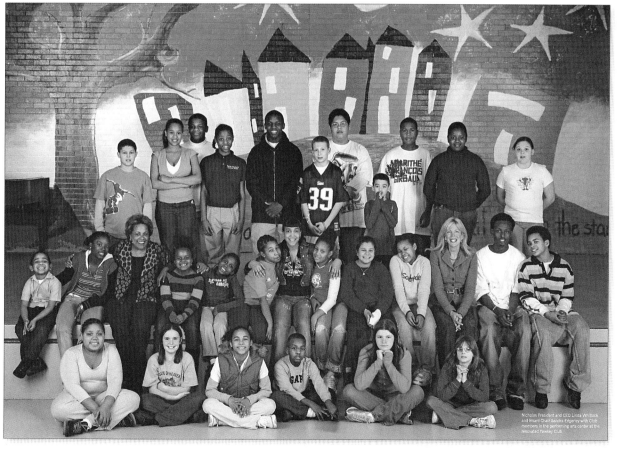

Nicholas President and CEO Linda Whitlock and Board Chair Sandra Edgerley with Club members in the performing arts center at the renovated Yawkey Club.

CLIENT
Community School
CREATIVE FIRM
Kiku Obata + Company
www.kikuobata.com
DESIGNERS
Amy Knopf, Igor Karash,
Carole Jerome

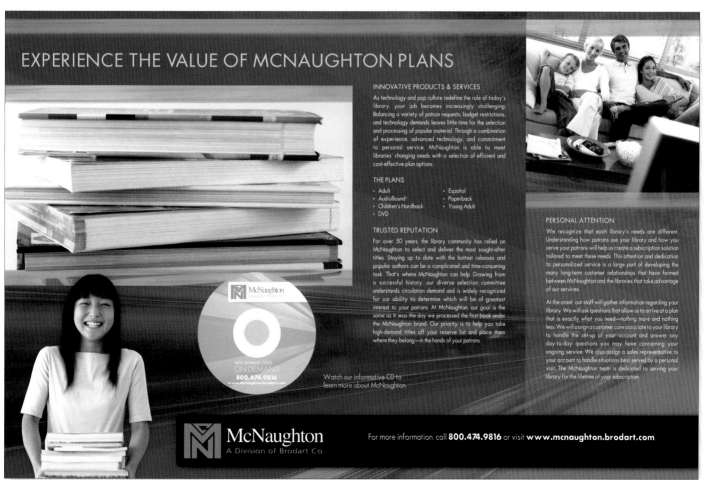

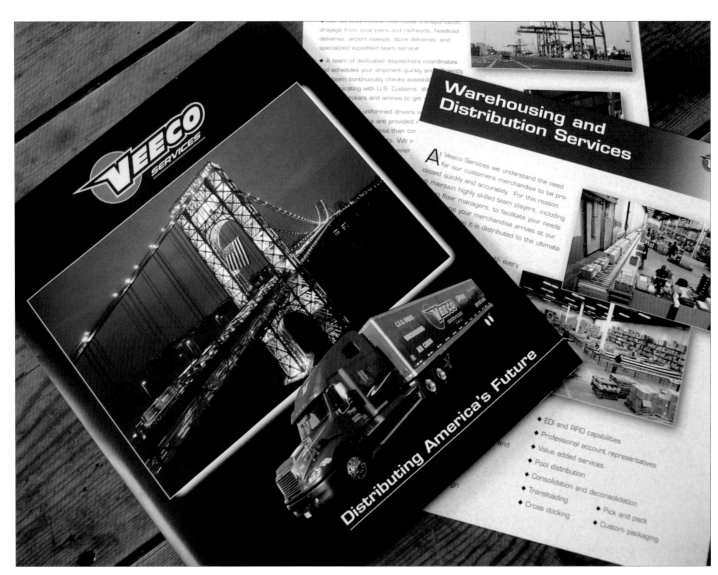

CLIENT
Veeco Services
CREATIVE FIRM
Ted DeCagna Graphic Design
www.tdgraphicdesign.net
DESIGNER, PHOTOGRAPHER
Ted DeCagna

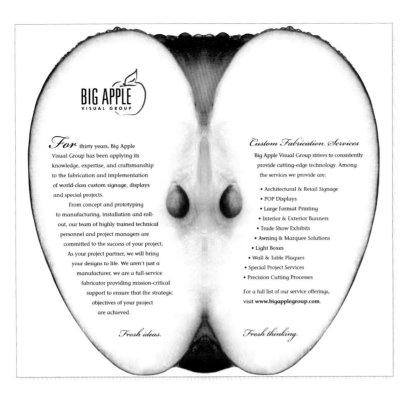

BIG APPLE
VISUAL GROUP

For thirty years, Big Apple
Visual Group has been applying its
knowledge, expertise, and craftsmanship
to the fabrication and implementation
of world-class custom signage, displays
and special projects.

From concept and prototyping
to manufacturing, installation and roll-
out, our team of highly trained technical
personnel and project managers are
committed to the success of your project.
As your project partner, we will bring
your designs to life. We aren't just a
manufacturer, we are a full-service
fabricator providing mission-critical
support to ensure that the strategic
objectives of your project
are achieved.

Fresh ideas.

Custom Fabrication Services

Big Apple Visual Group strives to consistently
provide cutting-edge technology. Among
the services we provide are:

• Architectural & Retail Signage
• POP Displays
• Large Format Printing
• Interior & Exterior Banners
• Trade Show Exhibits
• Awning & Marquee Solutions
• Light Boxes
• Wall & Table Plaques
• Special Project Services
• Precision Cutting Processes

For a full list of our service offerings,
visit **www.bigapplegroup.com**.

Fresh thinking.

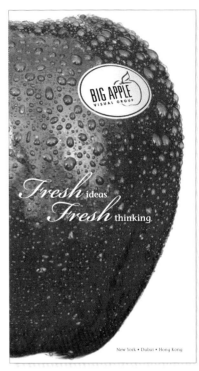

BIG APPLE
VISUAL GROUP

Fresh ideas.
Fresh thinking.

New York • Dubai • Hong Kong

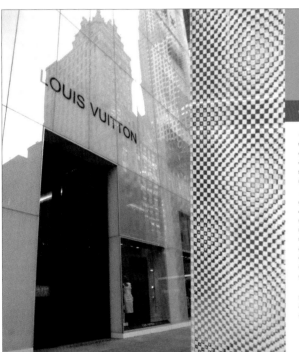

SUCCESS STORY: **Louis Vuitton**

Louis Vuitton came
to us with an innovative design
concept to create a continuous
distraction pattern on the glass
façade of their Fifth Avenue
flagship store in New York.

Given the enormous
scale of the façade, our techni-
cal team prototyped a solution
that created the effect that the
Louis Vuitton
to achieve. Th
application c
CAD/CAM f
technology c
the entire fac

This proje
Big Apple Vi
dedication t
technology a

CLIENT
Big Apple Visual Group
CREATIVE FIRM
Zero Gravity Design Group
www.zerogny.com
DESIGNERS
Jennifer Mariotti, Chuck Killorin

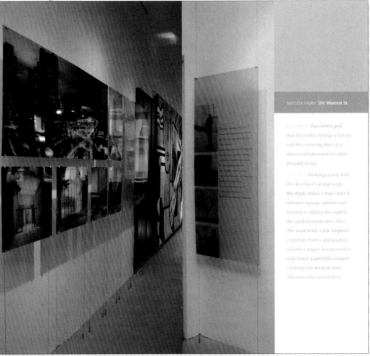

SUCCESS STORY: **101 Warren St.**

Our client's goal
was too jointly develop a luxury
exhibit conveying the conve-
nience and pleasures of condo-
minium living.

Working closely with
the developer's design team,
Big Apple Visual Group created
different signage systems and
exhibits to display throughout
the condominium sales office.
The multi-level, cable suspend-
ed picture frames and graphics
created a unique luxury exhibit
experience. Light boxes mount-
ed within the window areas
enhanced the overall effect.

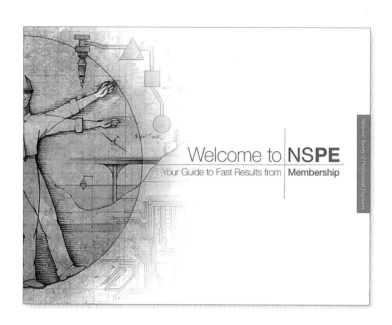

Welcome to **NSPE**
Your Guide to Fast Results from | Membership

National Society of Professional Engineers

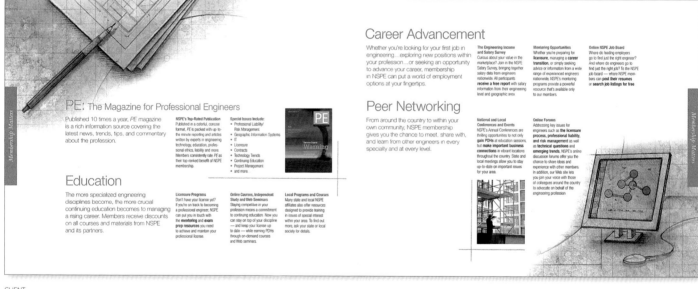

Membership Matters

PE: The Magazine for Professional Engineers

Published 10 times a year, *PE* magazine is a rich information source covering the latest news, trends, tips, and commentary about the profession.

NSPE's Top-Rated Publication
Published in a colorful, concise format, *PE* is packed with up-to-the-minute reporting and articles written by experts in engineering technology, education, professional ethics, liability and more. Members consistently rate *PE* as their top-ranked benefit of NSPE membership.

Special Issues Include:
- Professional Liability/ Risk Management
- Geographic Information Systems
- IT
- Licensure
- Contracts
- Technology Trends
- Continuing Education
- Project Management
- and more.

Education

The more specialized engineering disciplines become, the more crucial continuing education becomes to managing a rising career. Members receive discounts on all courses and materials from NSPE and its partners.

Licensure Programs
Don't have your license yet? If you're on track to becoming a professional engineer, NSPE can put you in touch with the **mentoring** and **exam prep resources** you need to achieve and maintain your professional license.

Online Courses, Independent Study and Web Seminars
Staying competitive in your profession means a commitment to continuing education. Now you can stay on top of your discipline — and keep your license up to date — while earning PDHs through on-demand courses and Web seminars.

Local Programs and Courses
Many state and local NSPE affiliates also offer resources designed to provide training in issues of special interest within your area. To find out more, ask your state or local society for details.

Career Advancement

Whether you're looking for your first job in engineering...exploring new positions within your profession...or seeking an opportunity to advance your career, membership in NSPE can put a world of employment options at your fingertips.

The Engineering Income and Salary Survey
Curious about your value in the marketplace? Join in the NSPE Salary Survey, bringing together salary data from engineers nationwide. All participants **receive a free report** with salary information from their engineering level and geographic area.

Mentoring Opportunities
Whether you're preparing for **licensure**, managing a **career transition**, or simply seeking advice or information from a wide range of experienced engineers nationwide, NSPE's mentoring programs provide a powerful resource that's available only to our members.

Online NSPE Job Board
Where do leading employers go to find just the right engineer? And where do engineers go to find just the right job? To the NSPE job board — where NSPE members can **post their resumes** or **search job listings for free**

Peer Networking

From around the country to within your own community, NSPE membership gives you the chance to meet, share with, and learn from other engineers in every specialty and at every level.

National and Local Conferences and Events
NSPE's Annual Conferences are thrilling opportunities to not only **gain PDHs** at education sessions, but **make important business connections** in vibrant locations throughout the country. State and local meetings allow you to stay up-to-date on important issues for your area.

Online Forums
Addressing key issues for engineers such as **the licensure process, professional liability, and risk management** as well as **technical questions** and **emerging trends**, NSPE's online discussion forums offer you the chance to share ideas and experience with other members. In addition, our Web site lets you join your voice with those of colleagues around the country to advocate on behalf of the engineering profession.

Membership Matters

CLIENT
National Society of Professional Engineers
CREATIVE FIRM
TGD Communications
www.tgdcom.com
DESIGNERS
Mark Pepperdine, Kirk Caldwell

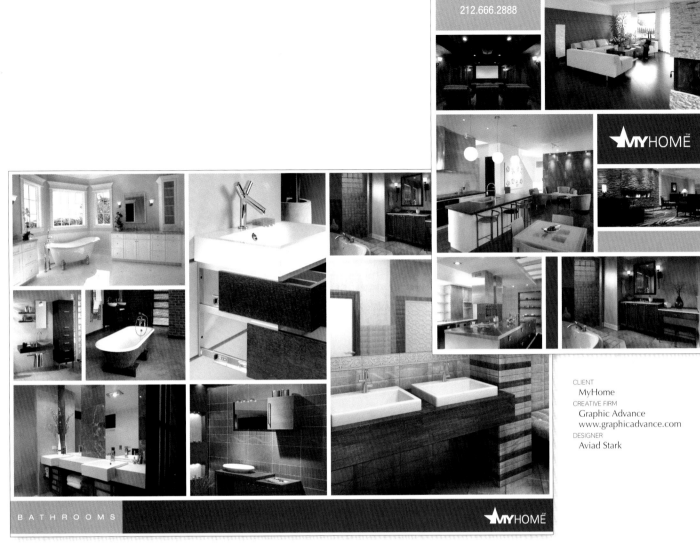

212.666.2888

BATHROOMS

CLIENT
MyHome
CREATIVE FIRM
Graphic Advance
www.graphicadvance.com
DESIGNER
Aviad Stark

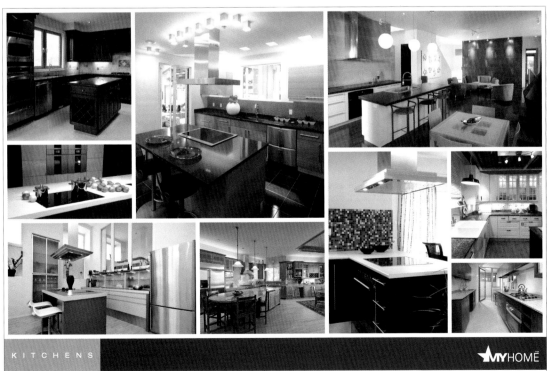

KITCHENS

CLIENT
Rainier Investment Management
CREATIVE FIRM
Hornall Anderson Design Works
www.hadw.com
DESIGNERS
Michael Connors, Vu Nguyen
PHOTOGRAPHER
Nancy Levine
COPYWRITER
Sally Bergesen

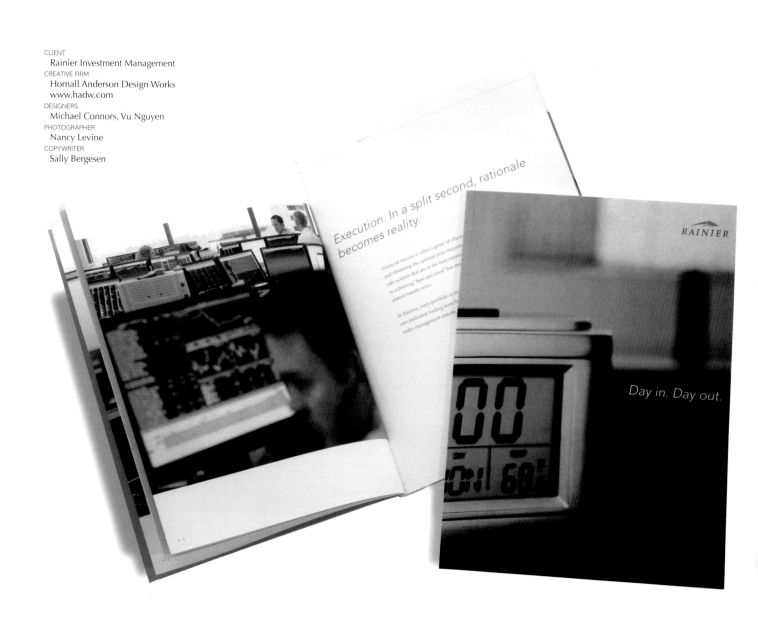

Execution. In a split second, rationale
becomes reality.

Day in. Day out.

RAINIER

Savor the **Flavor** of Fame.

The Claim to Fame Challenge!

CLIENT
 Susquehanna University
CREATIVE FIRM
 Sire Advertising
 www.sireadvertising.com
DESIGNERS
 Shawn Felty, Jordan Chappell,
 Sumer Buttorff

Dior
The New Look

CLIENT
Chicago History Museum
CREATIVE FIRM
SGDP
www.sgdp.com
ART DIRECTOR, DESIGNER
Albena Ivanova

The New Look Debuts

Paris was extremely cold the morning of February 12, 1947, as Christian Dior presented his first collection to the public in his packed salon. When the first model appeared, wearing a dress with padded hips accentuating a tiny cinched waist, her rustling voluminous skirt knocked over a freestanding ashtray, and excitement rose to cheers. Christian Dior had indeed created a New Look that would place a beleaguered Paris back on the fashion map.

After the show, *Harper's Bazaar* editor Carmel Snow told Dior, "It's quite a revolution, dear Christian. Your dresses have such a new look." Snow's term caught on and was used to describe any clothing of the era that followed the New Look silhouette. Seen in the poodle skirts sported at high-school sock hops and formal gowns worn by Chicago socialites, the New Look quickly became the style most fashion-conscious women embraced.

Cocktail Dress, c. 1947
BLACK WOOL CREPE AND SILK VELVET
GIFT OF MRS. HENRY D. PASCHEN
(MARIA TALLCHIEF)
CI.1974.483

Cocktail Dress, c. 1950
BLACK SILK FAILLE
GIFT OF MRS. GARDNER STERN
1982.69.10

Ballerina Maria Tallchief donated this dress, the Museum's only piece from Dior's historic first collection. Tallchief was prima ballerina of the New York City Ballet for eighteen years and later became the artistic director of Chicago's Lyric Opera Ballet. Tallchief and her then-husband, George Balanchine, attended the New Look opening, where Christian Dior himself escorted them to their seats. Maria Tallchief wore this dress—named "Maxim," after Dior's favorite Parisian restaurant—when she received the 1953 Woman of the Year award from President Dwight D. Eisenhower.

Silk was difficult to obtain during the lean years of World War II. Many countries restricted the amount of fabric for clothing production to make sure the military had enough for uniforms, tents, and other needs. The four-plus yards of luxurious, hand-pleated silk in this dress would not have been 'legal' in many parts of the world just five years earlier.

6

7

Themes of Fashion

By 1954, Christian Dior felt he had exhausted all the possibilities of the New Look and created three subsequent collections based on the letters H, A, and Y. The H collection so departed from the curvaceous New Look that many called it the Flat Look. Perhaps one of the most important features of this collection was a more natural waistline; although many women still wore girdles, the emphasis for this style was not an exceptionally small waist. The hems of the H line would eventually flare out to form the A-line collection, which still can be seen today in A-line skirts.

Vogue called the A line the "prettiest triangle since Pythagoras." The A line evolved into the Y line in fall 1955: a slender body with emphasis on large collars and wraps creating the arms of the Y. Beyond the alphabet, Dior also created collections that featured the shapes of flowers or geometric themes.

Of the spring 1956 collection — the Tulip line — *Vogue* reported, "Not since 1947 and Dior's famous first Collection have Paris fashions had such a rush of femininity — nor have there been so many bravos at the dramatic end of an opening." The small jacket cut high to reveal the waist of the skirt, called a "Caraco," was a common element of the Tulip line.

Cocktail Dress without Collar

Cocktail Dress without Jacket

Cocktail Dress, 1956
BLUE SILK TAFFETA
GIFT OF MRS. LAREN L. LONG
WORN BY RUTH PAGE
1975.166.14+c
SPONSORED BY KENNETH
GREENSACK STEPPEL

Cocktail Dress, c. 1954
RED SILK TAFFETA
GIFT OF MRS. THOMAS H. FISHER
(RUTH PAGE)
1989.94510
SPONSORED BY SOREN AND RICH UNGARETTI

Cocktail Dress, c. 1954
BLACK SILK FAILLE
GIFT OF MRS. HENRY D. PASCHEN
(MARIA TALLCHIEF)
1980.14.10
SPONSORED BY DOROTHY FULLER

Features of the H line can be found in both of the above cocktail dresses, which have high flat chests, elongated torsos, and focus on the lower hips. The black dress's original tax seal is still sewn to the designer label, which means that import tax probably was paid when the dress was brought back into the United States. Many women removed designer labels from garments to avoid paying a high import tax and rarely replaced them.

16

17

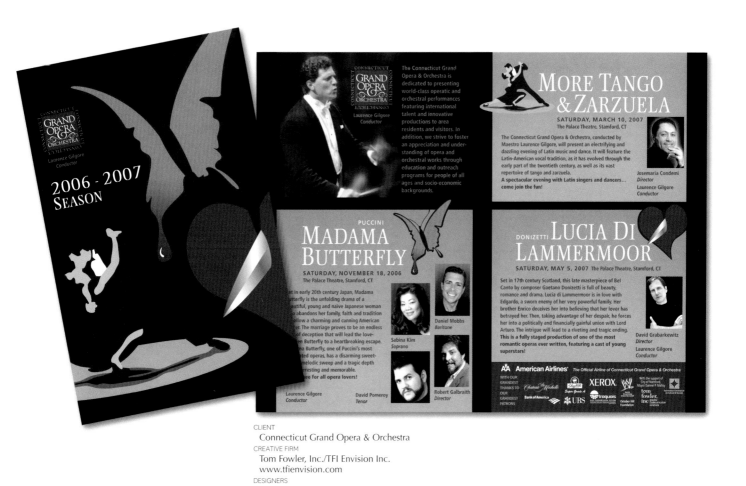

CLIENT
Connecticut Grand Opera & Orchestra
CREATIVE FIRM
Tom Fowler, Inc./TFI Envision Inc.
www.tfienvision.com
DESIGNERS
Elizabeth P. Ball, Phillip Doherty

CLIENT
Brodart Contract Library Furniture
CREATIVE FIRM
Sire Advertising
www.sireadvertising.com
DESIGNERS
Shawn Felty, Jordan Chappell,
Sumer Buttorff

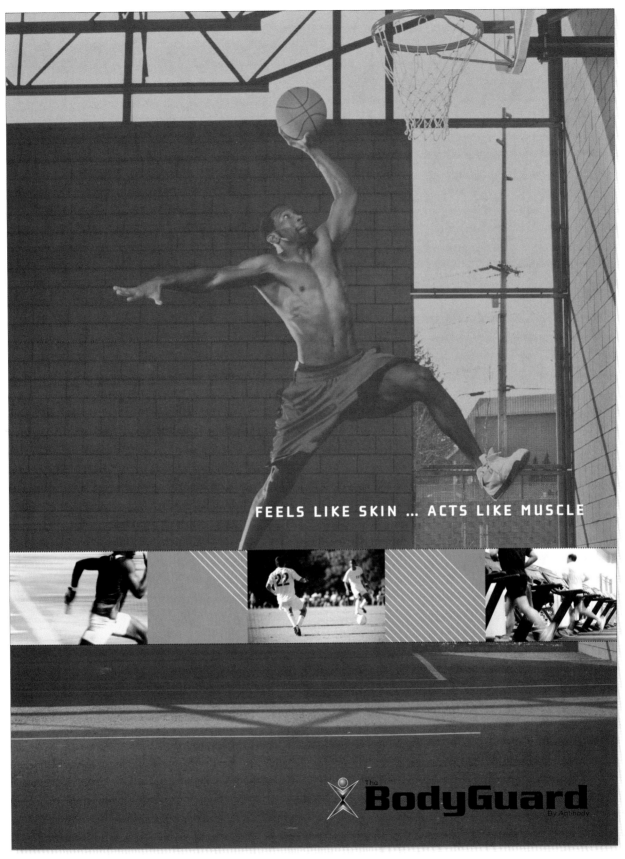

FEELS LIKE SKIN ... ACTS LIKE MUSCLE

The BodyGuard
By Antibody

CLIENT
Antibody, Inc.
CREATIVE FIRM
Octavo Designs
www.8vodesigns.com
DESIGNER
Sue Hough

FOREST CORPORATION

An Introduction

FOREST BOOKMAN PRESIDENT

Forest represents the Bookman family's third-generation at Forest Corporation. Prior to joining Forest Corporation, Forest sold commercial printing for a small sheet-fed company in Portland, Oregon. Aside from growing up around the business, Forest has also served Forest Corporation as the production scheduler, customer service manager and vice president of operations. Forest is strategically focused on aligning the ever-changing demands of the marketplace with the dynamic nature of the supply chain. Forest strongly believes that the value Forest Corporation provides is one of their greatest factors of differentiation in the promotional printing industry. Forest can be contacted at 330.425.3805 ext. 255 or forest@forestcorporation.com

JOHN K. HAMMOND GENERAL MANAGER

John Hammond joined Forest Corporation in 1990 as the sales and marketing manager. John successfully ran the sales organization from 1990–1994 when he was promoted to the general manager. John is currently responsible for overseeing all production and operational activities within the organization. John served as graphic marketing manager at General Electric Company and managed the commercial printing division at Xerox Corporation prior to joining the Forest team. John can be contacted at 330.425.3805 ext. 223 or hammond@forestcorporation.com

JOHN T. TKAC VP SALES & MARKETING

John Tkac joined Forest Corporation in September 2005. John has brought to the Forest team over 25 years of qualified printing and sales management experience. John previously held sales management positions at both Custom Graphics and Austin Printing prior to Forest Corporation. John is thrilled to be putting his years experience to work at a place he calls a "spot match" for his philosophy. John can be contacted at 330.425.3805 ext.232 forestcorporation.com

Leadership Team continues on reverse

CLIENT
Forest Corporation
CREATIVE FIRM
Crawford Design
www.crawford-design.com
DESIGNER
Alison Crawford

Founded in 1949 by the Bookman family, Forest Corporation has grown to become a leading supplier of litho, screen, and digital printing for large-format POP promotional materials. Our in-house capabilities for printing, fabrication, finishing, kit packing, and fulfillment—*coupled with our flexibility to package these services into cost-effective solutions*—have made us the single-source supplier of choice for an impressive list of local, regional and national clients.

A GREATER RETURN ON IMAGE

LITHO

LITHO PRINTING TRANSFERS INK FROM A PLATE TO A BLANKET MOUNTED ON AN IMPRESSION CYLINDER AND THEN FROM THE BLANKET TO THE SUBSTRATE OF CHOICE.

CHARACTERISTICS
Accepts a wide range of materials from 80 lb. text to 28 point board stock.
Compatible with synthetic substrates such as polyethylene from 7 mil to 28 mil.
Large format (see the equipment list for detailed specifications).

EQUIPMENT
Six color + aqueous coating (2)
Five color + aqueous coating
Four color + aqueous coating

PROJECT SCOPE
We offer national distribution for 1000+ pieces

BENEFITS
High resolution
High volume efficiencies

DIGITAL PRINTING OFFERS HIGH QUALITY, FULL COLOR GRAPHICS THROUGH A SYSTEM THAT ELIMINATES SEVERAL STEPS FROM THE PRE-PRESS PROCESS, MAKING IT A COST-EFFECTIVE CHOICE FOR SHORTER RUN LENGTHS.

CHARACTERISTICS
Accessible via a web-driven, individualized, template-based system at www.pinpointpop.com
Ideal for a variety of indoor and outdoor products.
Large format (see equipment list for detailed specifications).

EQUIPMENT
VUTEk® PV200 6-Channel UV, convertible flatbed
Idanit Novo, sheet-fed
HP Design Jet, roll-fed (4)

PROJECT SCOPE
Niche distribution offered for up to 250+ pieces

BENEFITS
Local and regional marketing
Test marketing
Prototypes

CLIENT
Saint Stanislaus Church
CREATIVE FIRM
Marcia Herrmann Design
www.her2man2.com

Advance
the Lives of People

ENOCH PRATT
free LIBRARY

CLIENT
Enoch Pratt Free Library
CREATIVE FIRM
Bremmer & Goris
goris.com
DESIGNER
Lara Dalinsky

Equip
Citizens for Success

YOUR BEST INVESTMENT

The Pratt's informational and educational
resources include:
• Live homework help
• Dedicated job and career center services
• In-depth guides on how to research a
 particular topic
• Information on small business, investing,
 marketing and more
• Resources for foundations and non-
 profit organizations, grant and proposal
 writing, general fundraising and more

The Enoch Pratt Free Library houses and showcases some
of America's most valuable collections, from images of
African American history to letters, books and clippings
by Edgar Allan Poe and other notable authors. The Pratt,
however, is much more than a repository of past treasures;
it's an evolving, dynamic classroom helping to shape
Baltimore's future. Its programs teach children how to
read and think creatively, while helping adults start small
businesses, nonprofit organizations and other enterprises.

CENTRAL LIBRARY /
STATE LIBRARY
RESOURCE CENTER
RENOVATION AND
COLLECTIONS

The Central Library is
embarking upon a major
expansion and renovation
project. Significant infrastructure changes will enhance
its heating, cooling, lighting and fire safety functions, and
provide the backbone for future information technology
uses. Commitment from the City and State will pay for these
structural improvements ($67.5 million total). Charitable
funds are needed to provide for amenities, technology
and furnishings necessary to ensure the educational and
community developmental needs of future generations.

TECHNOLOGY
AND BRANCH
IMPROVEMENTS

For many, the public library
is their only access to the
global world of electronic
information. Information
technology, however, presents
extraordinary challenges. The Pratt is highly regarded
nationwide in technology because of its Web resources,
high-speed, wide-area network, integrated and automated
library system, digital media archive service and staff
intranet. It requires a continuous source of funding to
provide resources and technical support, upgrade computer
hardware, software and Internet connections, and keep
pace with ever-evolving technological advances.

A safe, welcoming environment is also critical to attracting
and serving customers, a significant part of the Campaign
initiative is to transform branch locations into highly
visible, colorful, comfortable destinations-of-choice for
children and their families. Primary goals include
reorganizing public and staff areas, refreshing physical
environments to increase public access and creating
inviting, stimulating public spaces. Capital improvements
to branch facilities are key to providing optimal customer
service throughout the Pratt Library System.

SOUTHEAST ANCHOR
LIBRARY / EQUIPMENT
AND COLLECTIONS

The new Southeast Anchor
Library, the City's first
major construction and new
branch in 35 years, is at the
corner of Eastern Avenue and
Conkling Street in the Highlandtown section of Baltimore.
It incorporates the most contemporary, innovative library
resources available to best serve this diverse, revitalized
neighborhood. With 27,000 square feet of space, the
new Southeast Anchor Library houses community space
and expanded collections, and will provide community
development services for the surrounding neighborhoods
not available at other Pratt branches. Private philanthropic
support is needed to fund the collections and equipment
required for this new facility.

SYSTEM-WIDE
PROGRAMS

Baltimore City has a high
proportion of economically
and educationally challenged
residents. According to
Maryland's Literacy Works,
the city leads all 24 Maryland
jurisdictions in its 58% illiteracy rate — twice the
statewide and national statistics. Often the only source
for free educational and cultural programming, the Pratt
is a critical part of the family, school and community
partnership.

Last year, the Pratt's Family Literacy Initiative served
21,782 infants and their parents in a variety of special
programs designed to promote emergent literacy. The
Community Youth Corps (CYC) program is a nationally
acclaimed model that illustrates the Pratt's response and
outreach to teenagers. For adults and seniors, the Pratt
offers programs that include information access and
training for employment searches, as well as non-profit
management and fundraising workshops. Increased
Campaign funding will help us preserve and increase
these critical community programs and initiatives.

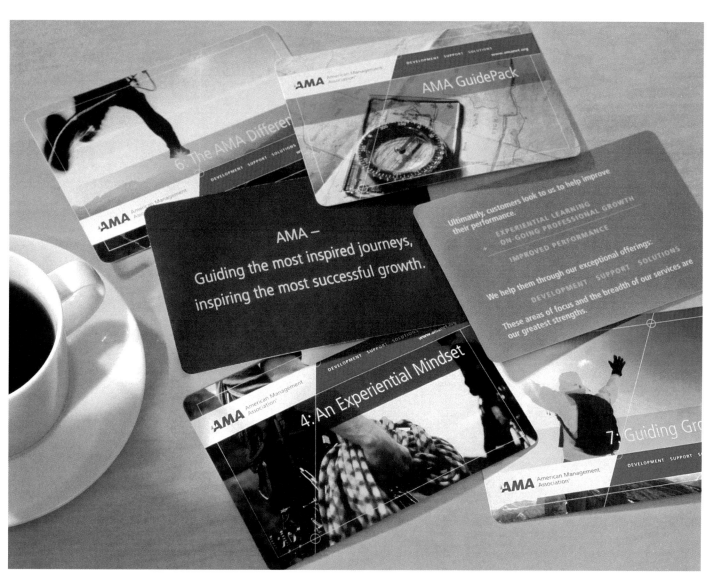

CLIENT
American Management Association
CREATIVE FIRM
Verse Group
versegroup.com
CREATIVE DIRECTORS
Michael Thibodeau, Sylvia Chu
DESIGNER
Marco Acevedo

Managing **Healthcare Costs**

Is this you?	Then, you might want to consider...	And, check out...
❏ Visit the doctor frequently	All Plans help you pay for office visits and lab tests—but each plan shares costs differently.	• WebMD CostCompare and PlanCompare
❏ Have daily prescription drugs	All Plans help you pay for prescription drugs. Review pages 5-7 of this guide to see how medical and prescription drugs apply differently to the deductible and out-of-pocket maximums in the Aetna plans.	• WebMD CostCompare and PlanCompare
❏ Planning for surgery	All medical plans help you pay for hospital stays (inpatient) or hospital procedures that allow you to go home the same day (outpatient)—but each plan shares costs differently. Review the out-of-pocket maximums for medical care.	• WebMD CostCompare, and PlanCompare • WebMD HospitalCompare • Aetna Cost of Care Estimator
❏ Planning for specific medical, dental or vision expenses in 2008	The Healthcare FSA lets you save money on eligible expenses you know you'll pay next year. Save up to $5,000 for the year through easy tax-free payroll deductions to pay for them. (Remember, unused balances are forfeited at year end, so estimate carefully.) OR FOR THOSE IN THE AETNA HEALTHFUND PLAN The health savings account lets you save up to $2,500 (individual) or $5,000 (family)—those are pre-tax dollars, with tax free earnings and withdrawals—for eligible medical expenses. If you don't use it, you keep it, and it … healthcare expenses. … spending account lets you … expenses like orthodontia or	• Aetna FSA Savings Calculator and HSA Estimator • WebMD CostCompare

Protection against **Unexpected Expenses This Year**

Is this you?	Then, you might want to consider...	And, check out...
❏ Like to pay for only what I need	The Aetna HealthFund Plan has the lowest payroll contribution, so you don't overpay for protection against unexpected expense. If you don't go to the doctor often, you may even have money left over in your HSA account in 2009.	• Aetna HSA Estimator • WebMD CostCompare • Last year's expenses
❏ Willing to pay more—just in case	Aetna Open Access or local plans let you pay more each paycheck in return for lower out-of-pocket expenses. You might pay more overall for your healthcare, but you can keep your expenses predictable throughout the year.	• WebMD CostCompare • Last year's expenses
❏ Want protection so an unexpected diagnosis doesn't hit my wallet hard	Most medical plans have a safety net—the out-of-pocket maximum—that limits what you'll spend each year. Compare the different levels under each plan to see what's right for you.	• WebMD CostCompare and PlanCompare
❏ Want the freedom to see any doctor and still have coverage	The Aetna Open Access plans and the Aetna HealthFund Plan help you cover the costs whether or not you see network doctors. Your local EPO or HMO options only cover in-network care.	• Aetna DocFind • WebMD PlanCompare

Protection from Unexpected Costs

When it comes to choosing healthcare insurance protection, your first instinct may be to buy the most expensive coverage you can get, thinking it's the safest option. You want enough health coverage to protect you and your family when you really need it, but you prefer not to buy more coverage than you'll need.

As you consider your medical plan choices, the good news is that Reed Elsevier medical plans have a safety net, protecting you against catastrophic expenses. The *out-of-pocket maximum* limits how much you might pay in a given year for medical expenses.

12 13

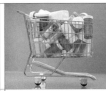
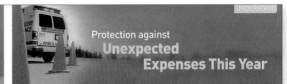

CLIENT
Reed Elsevier
CREATIVE FIRM
Tom Fowler, Inc./TFI Envision Inc.
www.tfienvision.com
DESIGNERS
Elizabeth P. Ball, Brien O'Reilly

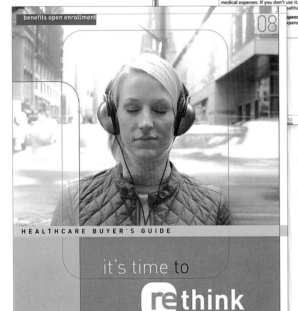

benefits open enrollment 08

HEALTHCARE BUYER'S GUIDE

it's time to
rethink
Your Benefits

re-sources
Your benefits envision at Reed Elsevier

Enroll from home or work at https://reibenefits.reed-elsevier.com

COMPARE

Help Is Here

COMPARE **YOUR OPTIONS USING ONLINE TOOLS**

ACCESS THESE TOOLS AND MORE at https://reibenefits.reed-elsevier.com. Or visit them directly using the directions below:

WEBMDHEALTH.COM/REEDELSEVIER
→You'll find these tools under Compare My Benefits

Compare Medical Plan Features
See all the features, including mental health, ER, chiropractic care, and more.
WebMD PlanCompare

Estimate Your Total Costs
First, compare your payroll contribution on the Get Started tab. Then, try a few scenarios—with higher than expected healthcare needs and lower than normal—and see where you come out ahead in the Costs by Plan tab.
WebMD CostCompare

Understand Hospital Costs
Compare quality and cost information for hospitals.
WebMD HospitalCompare

AETNA.COM
→Choose Members: Public Information at left center of page:

Check That Your Doctor Is In-Network
Or, find a new doctor near you.
Aetna DocFind or other medical plan website
– At left under Shortcuts → click Find a Doctor

Estimate your Out-of-Pocket Costs
See how fast the tax savings add up when you participate in an FSA.
Aetna FSA Savings Calculator
– Click Planning Resources tab at top, then click Flexible Spending Accounts

See What It's Worth to You
Estimate the long-term potential and tax advantages of the Aetna HealthFund Plan with HSA.
Aetna HSA Estimator
– From the top menu bar, click Health and Wellness, then Decision Support Tools, then Health Savings Calculation Tool
– Visit the special HealthFund website at REhealthfund.com

HTTPS://REIBENEFITS.REED-ELSEVIER.COM
→You'll find these tools in the Open Enrollment box

General Information
Find a recap of 2008 Benefits Open Enrollment information, frequently asked questions, links to tools and more.

Find the Plans Available in Your Area
Use the Zip Code Lookup to see the plans you're eligible for.

OTHER

Learn about the Aetna HealthFund Plan
Hear from people who chose the HealthFund Plan, calculate your HSA savings, and more.
Aetna HealthFund website → REhealthfund.com

Tally Last Year's Expenses
Get more than a gut check.
Your current medical plan website

Consider Serious Medical Issues
Ensure there are no bumps when you switch medical plans.
Call Health Advocate at 1-866-695-8622

FOLLOW UP WITH YOUR QUESTIONS

In Person
Find out from your HR representative if an Open Enrollment meeting will be offered at your location.

Online
Ask a question online using the RE Benefits Secure Message Center.
https://reibenefits.reed-elsevier.com
– Contact Us box → Online Service Center

Over the Phone
Speak to a Reed Elsevier Benefits Specialist Monday-Friday 9am – 5pm EST.
1-877-REI-1938

Don't Be Surprised
To avoid surprises about your doctor's bill or to comparison shop, check out Aetna's Cost of Care online tool. In many areas of the country, you'll be able to compare how much your doctor charges compared to other providers to see if you're getting the best deal.

21

Enroll from home or work at https://reibenefits.reed-elsevier.com

CLIENT
The National Center for Children & Families
CREATIVE FIRM
Very Memorable Design
www.vm.com
DESIGNER
Michael Pinto

PRODUCTION OF SOCIALLY RELEVANT, HIGH-QUALITY

children's cognitive and socio-emotional well-being. In this area, research spans transitions from home to school, from early to middle school years, and from school to community, including:
• Extra-curricular and School Achievement
• National Study of Children's Time Use in School

SYSTEMS/GOVERNANCE
In contrast to many other nations, America does not have an integrated, comprehensive system of early care and education for its youngest citizens. NCCF's work examines all the elements needed to create an early care and education system, including governance, workforce preparation, and financing. Systems/Governance projects include:
• Policy Matters: Early Childhood Planning In the Real World
• Early Care and Education Workforce Initiative

NEIGHBORHOOD/COMMUNITY
Healthy children can only develop in the context of healthy neighborhoods and communities. NCCF's projects in this area examine the influence of neighborhood processes on children of different ages and the effects of residential change on low-income families. Particular focus is given to the intersection of neighborhood and family resources and the opportunities and challenges they present for

enhancing the well-being
Community projects in
• Project on Human De
Chicago Neighborhood
• Children's Exposure to

INTERNATIONAL
Recognizing the impor
world, NCCF is committed to international work related to children and families. While respecting national and cultural differences, NCCF works with countries around the globe in the development, implementation, and evaluation of practices and policies that improve children's life chances. International projects include:
• Going Global with Indicators of Child Development (UNICEF)
• Pehelate Schools Project (with UNICEF India)

SCHOLARSHIP for SOCIAL ACTION

Production of
Socially Relevant,
High-Quality
Scholarship

Preparation of
Next
Generation
Leaders and
Scholars

Our Leadership

Welcome

Commitment to Our Customers

CLIENT
Cisco

CREATIVE FIRM
BSID Team/LWI
cisco.com/lwi.com

CREATIVE DIRECTOR
Gary McCavitt

ART DIRECTORS
Dennis Mancini, Gary Ferguson

PHOTOGRAPHY MANAGER
Vince Lindeman

PHOTOGRAPHERS
Achille Bigliardi, Doug Adesko,
Altaf Khan, Rob Delahanty,
Katerina Premfors

COPYWRITERS
Cindy Cloud, Mike Sanchez,
Karen Brighton

PROJECT MANAGER
Joan Banich

PREPRESS
XYZ Graphics

PRINTING
ColorGraphics, San Bruno, CA

PRINT BROKER
Cindy Cloud

PRODUCTION (LWI.COM)
Kathleen Coles, David Embrey

PROJECT MANAGER (LWI.COM)
Kathleen Coles

Together Than We Could Ever Be Apart

is not just a financial proposition, it is a commitment that all of our employees have
market, and sell the systems and solutions that help our customers make business transitions,
al programs, IT support, or talent resources, everyone at Cisco has a share in keeping us
as evidenced through our customer satisfaction survey. Our marketplace leadership comes
lobal efforts between technology groups and corporate business functions, and support
tively create and deliver the Cisco brand experience throughout their areas of expertise.

ot business as usual. Today's
w way of thinking and working
t and is more targeted than
ever before. There is value delivered to customers
when our marketing solutions are in alignment with their
business needs. This "better together" concept creates
solutions that helps us focus our efforts to increase
demand, growth, and brand awareness.

Research and Development
We see opportunities to innovate across our business
and the world. Cisco's long-term technology architec-
tural vision comes from our vision for our advanced tech-
nologies. Innovation is alive as we incubate emerging
technologies that hold the promise for future products.
And we continually optimize our core technologies of
routing and switching by innovating new processes
and reducing costs to keep the products valuable and
cost-effective for our customers.

Information Technology
We are Cisco's first and best customer, always at
the front lines of the latest technology. As a strategic
partner with our internal businesses we create the
enterprise network of the future. With over 2000
employees worldwide, we have a prominent role in
erasing barriers of distance, language, and culture
and extending that capability to customers.

Manufacturing
We take Cisco innovation from the drawing board to the
customer. Whether it's complex, high-end, configure-to-
order products or high-volume commercial goods, we
turn ideas into solutions. We have in many ways raised
the bar for supply chain excellence, but now a new and
even more challenging era has begun as we must con-
tinue to maintain delivery, improve quality, and accelerate
supply chain velocity, even as Cisco expands into new
technologies and geographies.

Human Resources
Advancing Cisco's global team of talented and diverse
individuals, attracting and developing diverse talent, and
cultivating a collaborative environment in which every-
one can contribute and grow their career are challenges
we can meet. We understand that multiple perspectives
are the key to creating the best, most innovative prod-
ucts and services for our customers.

Sales
Our team builds its success from a fierce commitment
to our customers' satisfaction. We have experienced
unparalleled growth over the decades. With unprec-
edented change in the marketplace, our effective ex-
ecution on delivering our products to our customers'
satisfaction will translate into significant opportunities
for Cisco to build on its leadership position in the world.

Finance
We provide insight and analysis to guide Cisco's strategic
positioning. Our team is valued as dynamic business
leaders that are catalysts taking Cisco to the next level of
excellence through unquestioned integrity, technology-
enabled productivity solutions, and management skills.
We are at the foundation of a company that generated
$35 billion in revenue for fiscal year 2007.

Cisco Services
We are the team that makes networks, applications, and
the people who use them work better together. We are
the advocates for Cisco customers and it is our goal to
accelerate our customer success through innovative
services and world-class people, processes, tools,
and partners.

CLIENT
Rainier Scholars
CREATIVE FIRM
Hornall Anderson Design Works
www.hadw.com
DESIGNERS
Jack Anderson, Michael Connors, Lee Ann Johnson,
Jana Nishi, Chang Ling Wu, Jeff Wolff
PHOTOGRAPHER
Nancy Levine
COPYWRITER
Evelyne Rozner

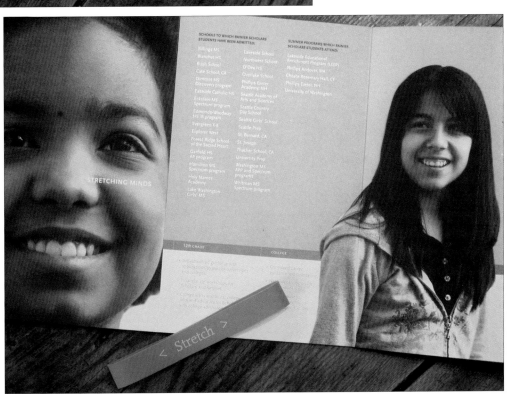

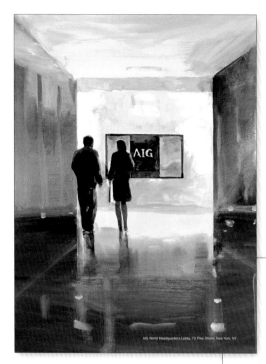

CLIENT
AIG Investments
CREATIVE FIRM
Paganucci Design, Inc.
www.paganucci.com
DESIGNER
Frank Paganucci

AIG World Headquarters Lobby, 70 Pine Street, New York, NY

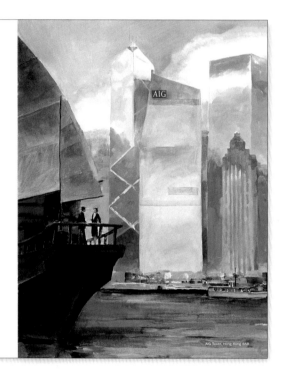

• *Regional:* United States, Asia, India,
 Latin America, Europe, Middle East and Africa
• *Property Type:* Office, Industrial, Multifamily
 Residential, Retail, Hospitality, Mixed-Use
• *Strategy:* Opportunistic, Value-Added, Core-Plus

Real Estate

Founded in 1987, AIG Global Real Estate offers a broad spectrum of investment solutions across strategies, risk profiles, and geographies in both developed and emerging markets. Having sponsored its first real estate fund in 1995, AIG Global Real Estate currently draws on the experience and expertise of approximately 550 real estate professionals in more than 30 locations around the world to access real estate opportunities for AIG investments.

"Our global real estate team not only applies its expertise to acquire high-potential properties around the world, but also creates value for these properties through in-house asset management, development, architecture and construction practices. Because of that high level of involvement, we are able to influence the outcomes."
– Kevin Fitzpatrick, President, AIG Global Real Estate

Operating for more than 20 years in markets worldwide has enabled AIG Global Real Estate to develop rigorous standards and proven processes to evaluate transactions, identify and quantify risks, and structure investments.

We believe that our funds benefit from our extensive access to deal flow, our comprehensive due diligence process, and the combined strengths we gain from other AIG and AIG Investments practice areas. A substantial portion of the capital used in the investment and development of our projects is our own, giving AIG Investments the perspective of not only a developer and investment manager, but also a co-investor.

In addition, AIG Global Real Estate is a world leader in environmentally sustainable development and design, and its projects have been recognized by the U.S. Green Building Council, the Sierra Club, the U.S. Environmental Protection Agency, and Audubon International.

AIG Tower, Hong Kong SAR

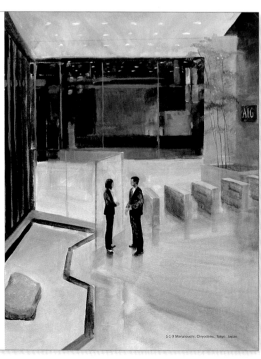

Defining Success From Your Perspective

We recognize that your goal in evaluating asset managers is not only to choose the right investment expertise on the basis of integrated global resources and exceptional performance, but to select a dedicated partner capable of personalizing its strengths to fit your unique needs.

That holds true whether you are managing a corporate or government pension plan ... directing the holdings for a foundation or endowment ... overseeing a family office ... investing your own portfolio ... or are seeking opportunities in alternative investments, including private equities, hedge funds or real estate.

As one of the world's Top 10 institutional asset managers, AIG Investments builds on more than 75 years of experience to manage more than half a trillion dollars for institutional, high net worth and individual investors. But even more importantly, we view our clients as individuals, and regard their diverse challenges as the proving ground for our long-standing commitment to investment excellence.

In meeting wide-ranging client objectives, AIG Investments leverages the skills and talents of more than 2,000 dedicated professionals across 44 offices, including fast-changing markets in Asia, the Eastern Bloc, South America and the Middle East.

1-1-3 Marunouchi, Chiyoda-ku, Tokyo, Japan

CLIENT
Huish Detergents, Inc.
CREATIVE FIRM
Summit Design Studio
summitdesignstudio@mac.com
DESIGNER
Lara Mullen

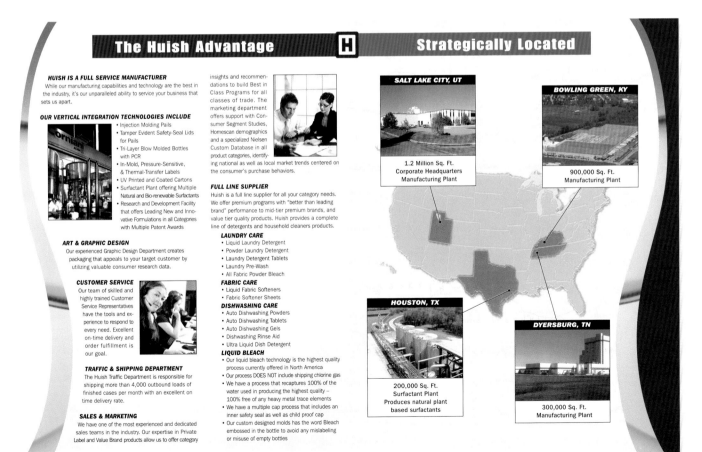

The Huish Advantage [H] Strategically Located

HUISH IS A FULL SERVICE MANUFACTURER
While our manufacturing capabilities and technology are the best in the industry, it's our unparalleled ability to service your business that sets us apart.

OUR VERTICAL INTEGRATION TECHNOLOGIES INCLUDE
- Injection Molding Pails
- Tamper Evident Safety-Seal Lids for Pails
- Tri-Layer Blow Molded Bottles with PCR
- In-Mold, Pressure-Sensitive, & Thermal-Transfer Labels
- UV Printed and Coated Cartons
- Surfactant Plant offering Multiple Natural and Bio-renewable Surfactants
- Research and Development Facility that offers Leading New and Innovative Formulations in all Categories with Multiple Patent Awards

ART & GRAPHIC DESIGN
Our experienced Graphic Design Department creates packaging that appeals to your target customer by utilizing valuable consumer research data.

CUSTOMER SERVICE
Our team of skilled and highly trained Customer Service Representatives have the tools and experience to respond to every need. Excellent on-time delivery and order fulfillment is our goal.

TRAFFIC & SHIPPING DEPARTMENT
The Huish Traffic Department is responsible for shipping more than 4,000 outbound loads of finished cases per month with an excellent on time delivery rate.

SALES & MARKETING
We have one of the most experienced and dedicated sales teams in the industry. Our expertise in Private Label and Value Brand products allow us to offer category

insights and recommendations to build Best in Class Programs for all classes of trade. The marketing department offers support with Consumer Segment Studies, Homescan demographics and a specialized Nielsen Custom Database in all product categories, identifying national as well as local market trends centered on the consumer's purchase behaviors.

FULL LINE SUPPLIER
Huish is a full line supplier for all your category needs. We offer premium programs with "better than leading brand" performance to mid-tier premium brands, and value tier quality products. Huish provides a complete line of detergents and household cleaners products.

LAUNDRY CARE
- Liquid Laundry Detergent
- Powder Laundry Detergent
- Laundry Detergent Tablets
- Laundry Pre-Wash
- All Fabric Powder Bleach

FABRIC CARE
- Liquid Fabric Softeners
- Fabric Softener Sheets

DISHWASHING CARE
- Auto Dishwashing Powders
- Auto Dishwashing Tablets
- Auto Dishwashing Gels
- Dishwashing Rinse Aid
- Ultra Liquid Dish Detergent

LIQUID BLEACH
- Our liquid bleach technology is the highest quality process currently offered in North America
- Our process DOES NOT include shipping chlorine gas
- We have a process that recaptures 100% of the water used in producing the highest quality – 100% free of any heavy metal trace elements
- We have a multiple cap process that includes an inner safety seal as well as child proof cap
- Our custom designed molds has the word Bleach embossed in the bottle to avoid any mislabeling or misuse of empty bottles

SALT LAKE CITY, UT
1.2 Million Sq. Ft.
Corporate Headquarters
Manufacturing Plant

BOWLING GREEN, KY
900,000 Sq. Ft.
Manufacturing Plant

HOUSTON, TX
200,000 Sq. Ft.
Surfactant Plant
Produces natural plant
based surfactants

DYERSBURG, TN
300,000 Sq. Ft.
Manufacturing Plant

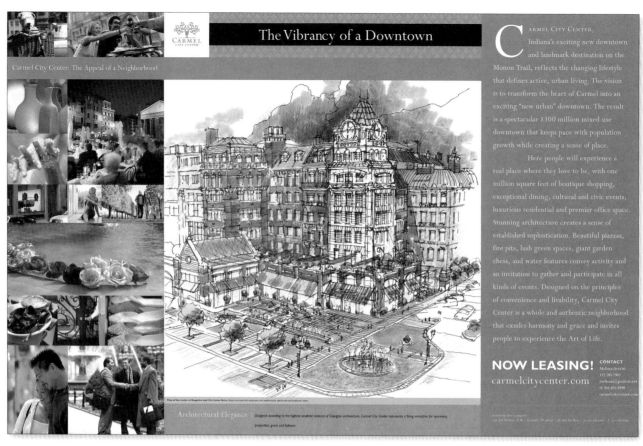

The Vibrancy of a Downtown

Carmel City Center: The Appeal of a Neighborhood

CARMEL CITY CENTER, Indiana's exciting new downtown and landmark destination on the Monon Trail, reflects the changing lifestyle that defines active, urban living. The vision is to transform the heart of Carmel into an exciting "new urban" downtown. The result is a spectacular $300 million mixed-use downtown that keeps pace with population growth while creating a sense of place.

Here people will experience a real place where they love to be, with one million square feet of boutique shopping, exceptional dining, cultural and civic events, luxurious residential and premier office space. Stunning architecture creates a sense of established sophistication. Beautiful piazzas, fire pits, lush green spaces, giant garden chess, and water features convey activity and an invitation to gather and participate in all kinds of events. Designed on the principles of convenience and livability, Carmel City Center is a whole and authentic neighborhood that exudes harmony and grace and invites people to experience the Art of Life.

NOW LEASING!
carmelcitycenter.com

Architectural Elegance | Designed according to the highest aesthetic tenets of Georgian architecture, Carmel City Center represents a living metaphor for symmetry, proportion, grace and balance.

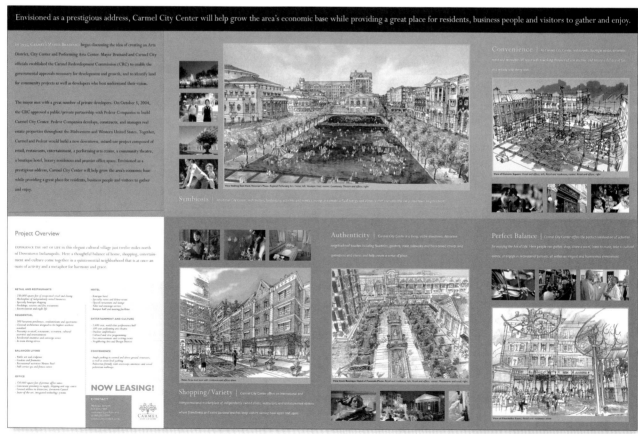

Envisioned as a prestigious address, Carmel City Center will help grow the area's economic base while providing a great place for residents, business people and visitors to gather and enjoy.

NOW LEASING!

CLIENT
Pedcor
CREATIVE FIRM
Kiku Obata + Company
www.kikuobata.com
DESIGNERS
Rich Nelson, Carole Jerome

CLIENT
Willits Footwear Worldwide
CREATIVE FIRM
PhaseOne Marketing & Design
www.phase-one.com
DESIGNERS
Michael Tobin, Nancy Ludes,
Thomas Forney

CLIENT
University of Portland
CREATIVE FIRM
Lightner Design
PROJECT & CREATIVE DIRECTOR
Rachel Barry-Arquit, University of Portland
ART DIRECTOR, DESIGNER
Connie Lightner, Lightner Design
COPYWRITERS
Amy Harrington, Rachel Barry—Arquit,
University of Portland
PRINTER
Bridgetown Printing

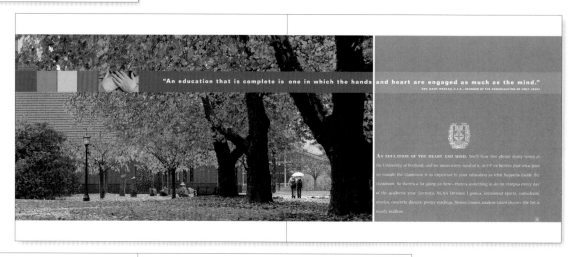

"An education that is complete is one in which the hands and heart are engaged as much as the mind."

REV. BASIL MOREAU, C.S.C., FOUNDER OF THE CONGREGATION OF HOLY CROSS

AN EDUCATION OF THE HEART AND MIND. You'll hear this phrase many times at the University of Portland, and we mean every word of it. At UP we believe that what goes on outside the classroom is as important to your education as what happens inside the classroom. So there's a lot going on here—there's something to do on campus every day of the academic year. Lectures, NCAA Division I games, intramural sports, comedians, movies, concerts, dances, poetry readings, fitness classes, student talent shows—the list is nearly endless.

live residence life

THE HEART OF CAMPUS LIFE really does involve living on campus. About 90 percent of freshmen live in the residence halls each year (six of the eight are open to freshmen), and they'll tell you that the benefits are many. Everything is right here—just steps away from you. You'll have easy access to the library, computer labs, dining hall, recreational facilities. You'll have no problem making friends, finding study partners, joining a pick-up basketball game. Quirky hall events include the roommate game, Waldschmidt 500 tricycle race, and the rock, paper, scissors tournament. And you might even see your grades improve: some studies have found that students who live on campus perform better academically.

HALL SPECS			
Mehling	375 women	Tallest building, biggest closets and the most spacious rooms on campus.	
Corrado	166 coed	Stunning views of Forest Park and the Willamette River; floor lounges.	
Villa Maria	198 men	Home of the Villa Drum Squad, unofficial band of the women's soccer team. Basketball court, headquarters of Army ROTC.	
Christie	161 men	Surround-sound big screen TV lounge, Muslim prayer room.	
Shipstad	368 coed	Two large lounges, pool table, sand volleyball court, and home of the University archives and museum.	
Kenna	212 coed	Only sauna on campus, pottery lab, headquarters of Air Force ROTC.	
Haggerty & Tyson	245 coed	Reserved for upper-class students, townhouse-style residences with common living areas and kitchenettes.	

play intramurals

YOU'LL STUDY HARD HERE, and you'll play hard, too. Howard Hall is our full-service recreational building with a pool, aerobics room, elliptical, treadmill, bike, and stair machines, tons of machine and free weights, and free rental equipment from bikes and helmets to tents and camping stoves. There are all kinds of aerobic, step, yoga, and pilates classes offered daily at no charge. Want to learn karate, scuba diving, or kayaking? A number of classes, such as these, are available for a small fee, and the offerings change each semester. If you're inspired by the on-court, on-field exploits of your Division I intercollegiate athlete classmates but aren't quite DI yourself, bring your A-game to one of our intramural sports competitions. We've got basketball, volleyball, softball, tennis, kickball, and ultimate Frisbee to name a few.

INTRAMURALS	From basketball, dodgeball, and futsal, to lacrosse, ultimate Frisbee, and softball.
OUTDOOR PURSUITS	Snowshoeing, hiking, indoor rock climbing, geocaching, orienteering, mountain biking, backpacking, kayaking, rock climbing, cross country skiing, camping.
CLASSES	Kickboxing, swimming, ab lab, yoga, hip hop, swing, clinics on tuning bikes or skis and running.

CLIENT
Southwest Corporate Federal Credit Union
CREATIVE FIRM
Pinnacle Graphics
www.pinnaclegraphics.com
CREATIVE DIRECTOR
Bob Tamura
DIRECTOR OF MARKETING, COPYWRITER
Terry Young, Southwest Corporate
Federal Credit Union

welcome

Welcome to Rainbow Valley Design and Construction, Oregon's unique, award-winning design-build company. For almost four decades we've been refining our design-build philosophy, working with hundreds of ... realize their ... turn your drea... inspires and ... aesthetic tast...

Top: The living and dining areas are defined by the repeating pattern of the ceiling beams. Above: The use of natural woods complement the custom cabinetry in the kitchen. Left: This newel post has detailing that continues the design theme of the home.

commercial

At Rainbow Valley we understand that creating an engaging, inviting building that is efficient, flexible and suited for its purpose is important to the success of your business. Well designed commercial buildings promote efficiency, increase consumer sales and communicate a company's brand. Whether it's tenant infill or new construction, Rainbow Valley has the experience, expertise and resources to make your business facility support a flourishing enterprise.

Top and Above: The reception area and lobby have been designed to create a comfortable, professional and interesting environment for visitors. Left: Even a company's most private places need a design that reflects the personality of the business.

CLIENT
Rainbow Valley Design & Construction
CREATIVE FIRM
Funk/Levis & Associates
funklevis.com
DESIGNER
Chris Berner

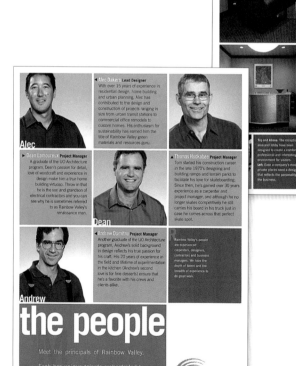

remodel

Remodeling your home usually starts out with a small idea, something you want to change to make a bit better. The idea grows and you realize you need some help. That's where we come in. We listen, help you evaluate your ideas, make suggestions, discuss materials and provide estimates. At the end of the work day, our skilled craftspeople take great care to minimize their impact by cleaning up their gear and construction debris. Our goal is to work to make your dream come true with as little disruption to you as possible.

Top: The clean design gives this interior space a feeling of grandeur. Above: The stair railing displays a calm, organic sculptural element. Left: This custom designed beam connection is both functional and beautiful.

Alec Oakers Lead Designer
With over 15 years of experience in residential design, home building and urban planning, Alec has contributed to the design and construction of projects ranging in size from urban transit stations to commercial office remodels to custom homes. His enthusiasm for sustainability has earned him the title of Rainbow Valley green materials and resources guru.

Alec

Dean Lamoureux Project Manager
A graduate of the UO Architecture program, Dean's passion for detail, love of woodcraft and experience in design make him a true home building virtuoso. Throw in that he is the son and grandson of electrical contractors and you can see why he is sometimes referred to as Rainbow Valley's renaissance man.

Thomas Huckabee Project Manager
Tom started his construction career in the late 1970's designing and building ramps and terrain parks to facilitate his love for skateboarding. Since then, he's gained over 30 years experience as a carpenter and project manager, and although he no longer skates competitively he still carries his board in his truck just in case he comes across that perfect skate spot.

Dean

Andrew Dumitru Project Manager
Another graduate of the UO Architecture program, Andrew's solid background in design reflects his true passion for his craft. His 20 years of experience in the field and lifetime of experimentation in the kitchen (Andrew's second love is for fine desserts) ensure that he's a favorite with his crews and clients alike.

Andrew

Rainbow Valley's people are experienced carpenters, designers, contractors and business managers. We have the depth of talent and the breadth of experience to do great work.

the people

Meet the principals of Rainbow Valley. Each has unique talents orchestrated to ensure that every Rainbow Valley project, large or small, is a success.

RAINBOW VALLEY
DESIGN AND CONSTRUCTION

EUGENE: 785 Grant Street • Eugene, OR 97402
PHONE: 541.342.4871

PORTLAND: 232 SE Oak Street, Suite 108
Portland, OR 97214
PHONE: 503.239.5958

www.rainbowvalleyinc.com

Firm: Arnold

Address: 101 Huntington Avenue,
Boston, MA

Phone: 617.587.8657

Web: arnoldworldwide.com

Project: Timberland's 10061 website
(10061.com)

Client: Timberland

Art Directors: Colin Jeffery,
John Kleophront, Paulo Lopez

Designers: Paulo Lopez,
Sara Rodriguez

Copywriter: Chris Carl

Why was it not just lucky that
this piece achieved its aims?

A lot of people put a lot of thought
into it, and then went out and did it.

Luck is never a product of hard
work and determination.

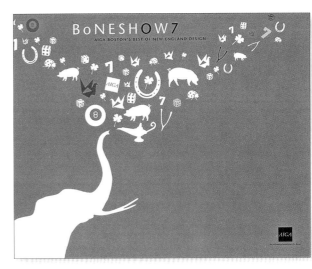

BoNESHOW7
AIGA BOSTON'S BEST OF NEW ENGLAND DESIGN

CLIENT
AIGA Boston
CREATIVE FIRM
Gill Fishman Associates
gill@gillfishmandesign.com
DESIGNERS
Tammy Torrey, Alicia Ozyjowski,
Michael Persons

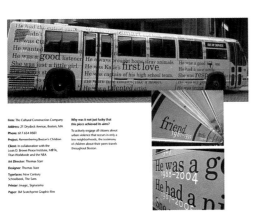

Firm: The Cultural Construction Company

Address: 21 Drydock Avenue, Boston, MA

Phone: 617.654.0501

Project: Remembering Boston's Children

Client: In collaboration with the
Louis D. Brown Peace Institute, MBTA,
Titan Worldwide and the NEA

Art Director: Thomas Starr

Designer: Thomas Starr

Typefaces: New Century
Schoolbook, The Sans

Printer: Imagic, Signarama

Paper: 3M Scotchprint Graphic Film

Why was it not just lucky that
this piece achieved its aims?

To actively engage all citizens about
urban violence that occurs in only a
few neighborhoods, the testimony
of children about their peers travels
throughout Boston.

Firm: Lemon

Address: 37 Fox Lane, Concord, MA

Phone: 781.254.9412

Web: lemonland.net

Project: Lemon Magazine

Art Director: Kevin Grady

Designers: Kevin Grady,
Adam Larson, Colin Metcalf

Copywriters: Robert Bundy,
Ashley Lynch-Mahone

Illustrators: Ronja Svenning Berge,
Colin Metcalf

Photographers: Dave Bradley,
Adam Larson, Guido Vitti

Others: Ryan Habbyshaw (assistant)
Ian Sattler (comic section editor),

Typefaces: Lemon Avant-Garde, Alias Union

Printer: West-Can, Winnipeg

Paper: Starbrite Gloss Coated
100 lb cover, 80 lb text

Why was it not just lucky that
this piece achieved its aims?

We at LEMON work too hard for luck to be
involved! LEMON achieves its aims because
it's a true labor of love, and our readers
recognize and appreciate that.

Firm: Weymouth Design

Address: 332 Congress Street,
6th Floor, Boston, MA

Phone: 617.542.2647

Website: weymouthdesign.com

Project: 2006 Annual Report

Client: Courier Corporation

Art Director: Robert Krivicich

Designers: Justin Gonyea,
Aaron Haesaert, Gary Pikovsky

Copywriter: John Temple

Photographers: Tim Llewellyn,
Michael Weymouth

Typefaces: Akzidenz Grotesk, Garamond

Printer: Kirkwood Printing

Paper: Sappi McCoy (cover/text), Fox River
Stipple (text), Mohawk Options (text)

Why was it not just lucky that
this piece achieved its aims?

Solid strategy led to a solid concept
and execution of design.

DUMB LUCK? FAT CHANCE.

As the miracle unfolds
Choose St. Vincent's Birthing Center

St.Vincent's
Family Birthing Center

As the miracle unfolds
Choose St. Vincent's Birthing Center

- Loving
- Caring
- Nurturing
- Supportive

St.Vincent's
Family Birthing Center

CLIENT
St. Vincent's Medical Center
CREATIVE FIRM
Pisarkiewicz Mazur & Co., Inc.
designpm.com
DESIGNERS
Mary Pisarkiewicz, Joy Whitley,
Julie Lange

who start out breastfeeding because they know it's best for baby, continue because they enjoy this special time with baby. There are so many ways dads and other family members can help too! Encourage mom. Help watch baby for cues of hunger. Change diapers. Bring baby to mom for feeding, and come to a prenatal breastfeeding class.

Prenatal Breastfeeding Class
Everything you need to know to get off to a great start...
To prepare mom and significant others (Dad, Grandma, Sister) for breastfeeding.

care and ho_____
good milk supply. Infor_____
and assistance on renting or purchasing breast pumps and related breastfeeding supplies will be reviewed.

We recommend that you keep baby with you as much as possible; this is called rooming in. Your comfort and confidence in caring for your new baby will grow with time. Especially if you are breastfeeding, keeping baby with you all day and night is recommended so you learn the baby's feeding cues and breastfeed often. Plan to attend the Care and Breastfeeding class that will be offered at 10 AM.

All of the staff in the FBC are Breastfeeding Support Specialists

Do you have questions about breastfeeding or pumping? One of our lactation consultants will assist you.

Call anytime:
203.576.6087
www.stvincents.org

Baby Care Class
Everything you need to know for caring for your new baby: Topics include first bath, feeding, burping, infant cues, diapers— what's normal, thermometer use, car seat information, sleep safety and when to call the doctor. Taking care of mom is also covered.

Childbirth Preparation Class
During this class, you will learn about the labor and delivery process, breathing/relaxation techniques, positioning/comfort measures, pain medication options/anesthesia and more. Classes held one Saturday every month, 12 PM - 6:30 PM, or two consecutive Mondays of each month from 6 PM - 9 PM. Advanced registration is required. There is a minimum of four couples required for this class. Fee: $150/couple.

Baby Care Class
This class offers information on baby care basics such as bathing, diapering, feeding, sleeping and safety. Classes held on the second Wednesday of each month from 7 PM - 9 PM. Advanced registration is required. Fee: $30/couple.

VBAC Class
This class is designed for moms and dads-to-be who are planning a vaginal birth, following a previous cesarean section. Class is scheduled upon request. Please call to sign up for this free class.

Prenatal Tour
Be prepared for the big day! Take a tour of our beautiful Family Birthing Center. Tours are conducted three times/month from 7 PM - 8:30 PM. Advanced registration is required.

Sibling Tour
The sibling tour makes the arrival of your new baby extra special for the big brother or sister. Designed especially for children ages two and older, tours are conducted three times a month from 5:30 PM - 6:30 PM. Advanced registration is required.

Sibling Attendance at Childbirth Classes
For children ages four and older, with approval from your obstetrician, big brother or sister can attend the birth. Class is given upon request. Please call to schedule for this free class.

Preparation for Breastfeeding
This class will teach you the basics of breastfeeding. Classes are held on the first Saturday of each month from 10 AM - 12 PM or the third Tuesday from 6:30 PM - 8:30 PM. Advanced registration is required. No fee.

Breast pump rental station for all your breastfeeding supplies is available. Call 203.576.6087 to sign up for a breastfeeding class or group, or for information on breastfeeding services.

Touchstone

REFLECTIONS ON OUR MISSION AND CORE VALUES

KOLIA O'CONNOR | HEAD OF SCHOOL

In his "Reflections" column published in *Under the Cupola*, our monthly newsletter, Head of School Kolia O'Connor explores how our Mission and Core Values are expressed in the lived experiences of students and adults alike at the Academy. Together, our Mission and Core Values serve as a touchstone so that, as we move forward and aspire to create vibrant and enriching possibilities for the future, we will not lose the distinct qualities that make Sewickley Academy the remarkable place it is. We are pleased to share Mr. O'Connor's reflections with you on the following pages.

CLIENT
Sewickley Academy
CREATIVE FIRM
Third Planet Communications
www.reinnov8.com
DESIGNER
Richard A. Hooper

Hearts, Minds, & Hands

Sewickley Academy inspires and educates students to engage their hearts, minds, and hands to cultivate their full individual and collective potential in the service of a greater good.

Sewickley Academy inspires and educates students to engage their hearts, minds, and hands to cultivate their full individual and collective potential in the service of a greater good. This is our mission. This is why we are here. This is why faculty gather and students return in September.

As we launch a new school year, it is, perhaps, worth pausing to reflect on what the words of the Academy's mission mean, what they are intended to suggest about what we do and why we do it.

We begin deliberately with inspiration, which suggests that the work in which our students engage is not merely the rote memorizing of facts or the labored acquisition of skills, but an igniting of passion for learning. What we hope for our students is that they will discover areas of interest that will command their attention, that will excite them in ways that promote their natural desire to know more and expand the limits of their world.

What follows is the idea of "hearts, minds, and hands," meaning that we acknowledge the primacy of the heart, of character, integrity, compassion, empathy, kindness, which is so vital to the maintenance of a civil society. Of course the heart cannot be disconnected from the mind, and it is the training of the capabilities of the mind that take up much of our time in schools. What we seek, however, is a mind whose capabilities are guided by character. In "hands," we see not only the athletic, artistic, and kinesthetic elements that are so important to a complete education, but the need to do, to act, to serve, that is implicit in the work of the hands. Fine character and formidable intellect and creative talent are not of much value if they are not employed to contribute to the advancement of society.

"Cultivate" suggests the organic nature of growth and education, as well as the idea that such growth takes time and must be nurtured through developmental stages until it is ready to blossom. It also implies the importance of attention to individual needs, for ours is not a garden with a single variety of flower but an array requiring slightly different care to grow and flourish.

While we acknowledge importance of "individual" potential, we also recognize the vital importance of "collective potential." Ours is not a community of zero-sum competition or survival of the fittest. We recognize that people live and work in groups and that civilization is predicated upon the ability of individuals to be able to work well with others and by doing so advance both their individual interests, as well as those of society.

Finally, "a greater good" acknowledges that there exists a higher, and more noble, reason for the pursuit of individual and collective accomplishment. We, as individuals and as a community, need to look beyond ourselves and remain mindful of the needs of others. By contributing to the welfare of others, to the enrichment of our own community as well as those communities beyond our borders, and to the protection of the natural environment which sustains life itself, we may take comfort in having added to rather than detracted from the greater good.

The Academy's mission is grounded in four core values, "Character," "Educational Vigor," "Diversity," and "Community," each of which will be the subject of future "Reflections". Taken with these values, our mission determines our course and directs all that we do. Parents may want to consider the connections between the Academy's values and their family's own so that the lessons we impart here may be reinforced at home. As we begin this, the Academy's one hundred and sixty-sixth year, let us rededicate ourselves, as we do each fall, to serving our children and one another so that we may achieve our lofty goals.

Character

Sewickley Academy upholds the highest ideals of honor, integrity, responsibility, respect, empathy, and kindness and the actions that flow from them.

1600 on the SATs, 5s on APs, a 100 on a spelling test, a smiley face on homework well done: such signs of scholastic success are impressive. Such signs also seem to have special value because they are measurable, all but the last, that is (unless we start to quantify smiley faces). While we are right to value and celebrate outstanding achievement, we should be somewhat cautious about the allure of numbers. Albert Einstein, himself, said that "Not everything that can be counted counts, and not everything that counts can be counted." Please do not misunderstand me, however; grades do count. They are the yardstick by which we measure academic progress and achievement. But they do not represent all that we do at Sewickley Academy, where our primary core value is character.

"Sewickley Academy upholds the highest ideals of honor, integrity, responsibility, respect, empathy, and kindness and the actions that flow from them" reads our Mission. We all recognize these values and understand that they are the bedrock upon which character is formed. They are not easy to measure, yet we as a school place them in the position of primacy among those core values that define who we are. And this is for good reason. The brilliant mind without exemplary character is not particularly appealing and might even be dangerous. Let's frankly admit that the less brilliant mind, if it comes with sterling character, is preferable. The ideal, of course, is brilliance together with character.

The Academy's commitment to character is one that is not for its own sake, however. In referring to the actions that follow from good character, we emphasize that it is not enough merely to be good; one has to "do good" as well, so we build opportunities for students to do good into our programs at every level.

Some might say that such values are anachronistic in the modern world, but I would submit that, especially today, where the power and reach of single individuals is almost beyond imagination, the promotion of these values is vital to the successful continuance of our civil society. All too soon we forget about Watergate, the savings and loan

scandals of the 1980s; the Orange County, California, debacle, as well as Enron, WorldCom, Tyco International, and other corporate imbroglios that not only stand as monuments to individual corruption and greed, but also negatively impacted tens of thousands if not millions of innocent individuals.

Character counts, and not just on the large stages of public and private life, but in the small mostly invisible transactions that take place daily among us. I often tell students that character might simply be defined as what you do when no one is looking, when there are no witnesses. Character is not doing right so that you won't get caught; it's doing right even if you could never be caught.

In Arthur Miller's masterful play *The Crucible*, the protagonist John Proctor, when agonizing about telling a lie to save his life, vacillates, first telling the lie and then quickly recanting, saying, "Because it is my name! Because I cannot have another in my life!" In the end, Proctor is condemned to death in the Salem witch trials for refusing to offer the court a lie that would have saved his life. He is a man of extraordinary principle, flawed as we all are, but nevertheless devoted to an adamantine idea of character.

Thankfully, very few of us will ever face as dramatic a choice as John Proctor, but to have our students understand the fundamental importance of personal integrity must be paramount among our commitments. And so, through our work on the playgrounds and in the classrooms, in school and at home, wherever and whenever we interact with our students, regardless of their age, we must, teachers and parents alike, both through direct instruction and through our own behavior, teach the lesson that character counts.

CLIENT
Urban Trends Salonspa
CREATIVE FIRM
McDill Design
www.mcdilldesign.com
DESIGNERS
Brenda Skibinski,
Rosana Lazcano

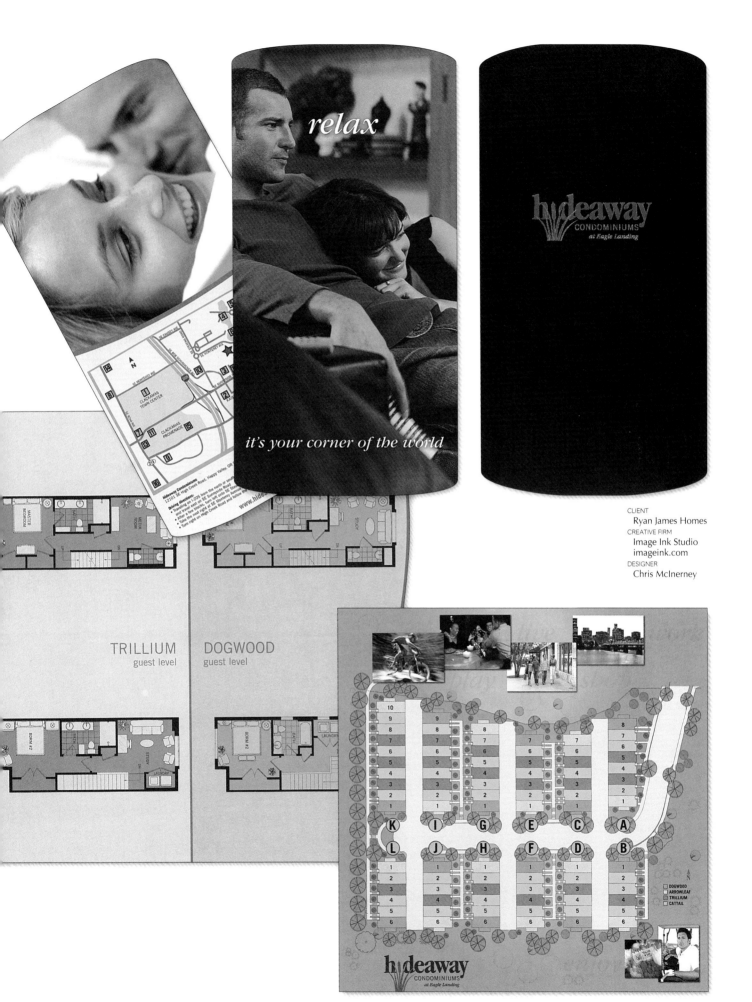

relax

it's your corner of the world

hideaway
CONDOMINIUMS
at Eagle Landing

CLIENT
Ryan James Homes
CREATIVE FIRM
Image Ink Studio
imageink.com
DESIGNER
Chris McInerney

TRILLIUM
guest level

DOGWOOD
guest level

hideaway
CONDOMINIUMS
at Eagle Landing

CLIENT
Sharp Electronics
CREATIVE FIRM
Paganucci Design, Inc.
www.paganucci.com
DESIGNER
Frank Paganucci

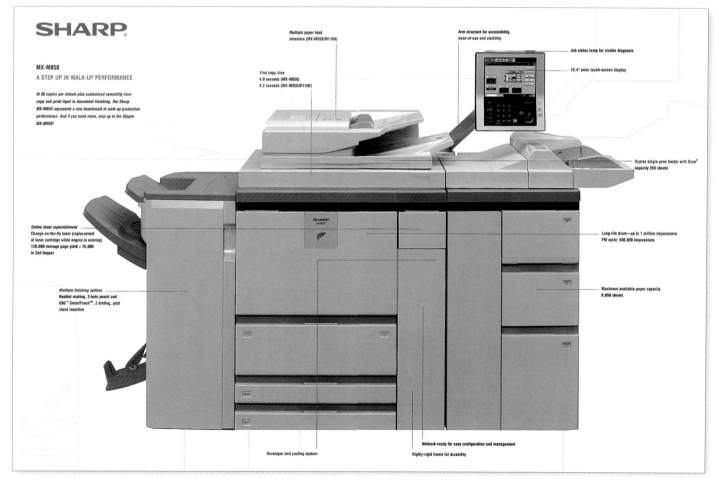

epiq
achievements

innovative technology solutions for litigation, bankruptcy and financial transactions

epiq
reach

the challenge: 6.2 MILLION NOTICES SERVED 103,083 CLAIMS SETTLED

CLIENT
Epiq
CREATIVE FIRM
Greenfield Belser
gbltd.com
DESIGNERS
Burkey Belser,
Mark Ledgerwood

epiq
recovery

the challenge: 7.6 MILLION FILES

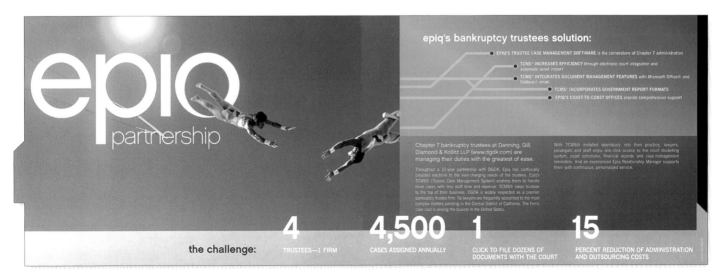

epiq
partnership

epiq's bankruptcy trustees solution:

- EPIQ'S TRUSTEE CASE MANAGEMENT SOFTWARE is the cornerstone of Chapter 7 administration
- TCMS® INCREASES EFFICIENCY through electronic court integration and automatic asset import
- TCMS® INTEGRATES DOCUMENT MANAGEMENT FEATURES with Microsoft Office® and Outlook® email
- TCMS® INCORPORATES GOVERNMENT REPORT FORMATS
- EPIQ'S COAST-TO-COAST OFFICES provide comprehensive support

Chapter 7 bankruptcy trustees at Danning, Gill, Diamond & Kollitz LLP (www.dgdk.com) are managing their duties with the greatest of ease.

Throughout a 10-year partnership with DGDK, Epiq has continually provided solutions to the ever-changing needs of the trustees. Epiq's TCMS® (Trustee Case Management System) enables them to handle more cases with less staff time and expense. TCMS® takes trustees to the top of their business. DGDK is widely respected as a premier bankruptcy trustee firm. Its lawyers are frequently appointed to the most complex matters pending in the Central District of California. The firm's case load is among the busiest in the United States.

With TCMS® installed seamlessly into their practice, lawyers, paralegals and staff enjoy one-click access to the court docketing system, asset schedules, financial records and case management reminders. And an experienced Epiq Relationship Manager supports them with continuous, personalized service.

the challenge: 4 TRUSTEES—1 FIRM 4,500 CASES ASSIGNED ANNUALLY 1 CLICK TO FILE DOZENS OF DOCUMENTS WITH THE COURT 15 PERCENT REDUCTION OF ADMINISTRATION AND OUTSOURCING COSTS

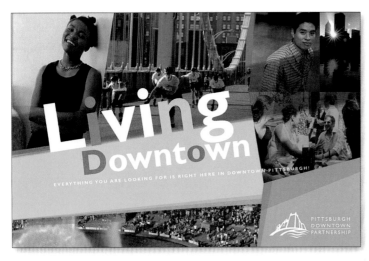

CLIENT
Pittsburgh Downtown Partnership
CREATIVE FIRM
FSC Marketing Communications
www.fscmc.com
CREATIVE DIRECTOR
Bryan Brunsell
DESIGNER
Dan Bretthole

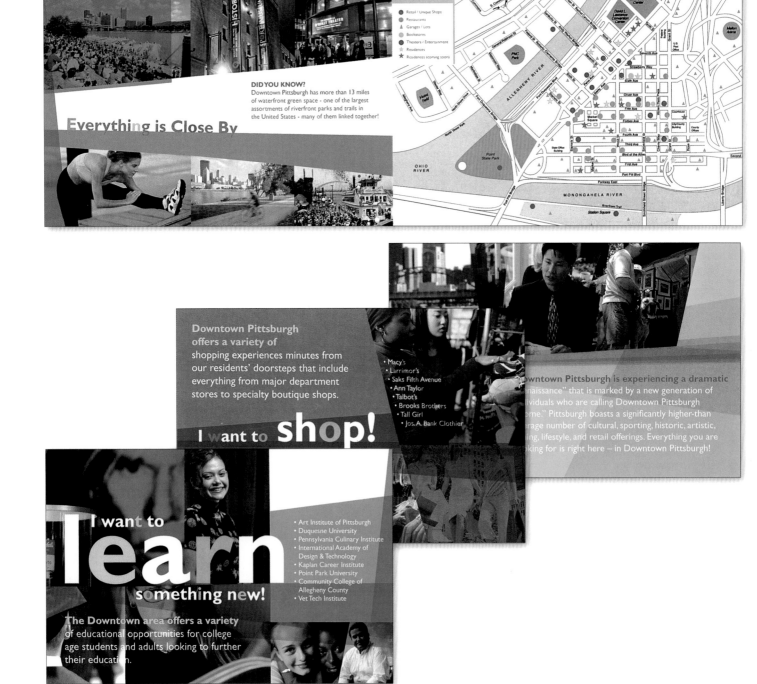

DID YOU KNOW?
Downtown Pittsburgh has more than 13 miles of waterfront green space - one of the largest assortments of riverfront parks and trails in the United States - many of them linked together!

Everything is Close By

Downtown Pittsburgh offers a variety of shopping experiences minutes from our residents' doorsteps that include everything from major department stores to specialty boutique shops.

• Macy's
• Larrimor's
• Saks Fifth Avenue
• Ann Taylor
• Talbot's
• Brooks Brothers
• Tall Girl
• Jos. A. Bank Clothier

I want to shop!

...wntown Pittsburgh is experiencing a dramatic ...naissance" that is marked by a new generation of ...ividuals who are calling Downtown Pittsburgh ...ome." Pittsburgh boasts a significantly higher-than ...rage number of cultural, sporting, historic, artistic, ...ing, lifestyle, and retail offerings. Everything you are ...king for is right here – in Downtown Pittsburgh!

I want to learn something new!

• Art Institute of Pittsburgh
• Duquesne University
• Pennsylvania Culinary Institute
• International Academy of Design & Technology
• Kaplan Career Institute
• Point Park University
• Community College of Allegheny County
• Vet Tech Institute

The Downtown area offers a variety of educational opportunities for college age students and adults looking to further their education.

CLIENT
Rhode Island Philharmonic & Music School
CREATIVE FIRM
Im-aj Communications & Design, Inc.
www.imajcommunications.com
DESIGNERS
Jami Ouellette, Carolynn Lowe,
Chris Basso

Congo Basin
Sustaining a valley of life

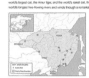

What makes the Amur-Heilong extraordinary

The vast tracts of the Amur-Heilong's temperate forests are one of the last places harboring the world's largest cat, the Amur tiger, and the world's rarest cat, the Amur leopard. Its river is one of the world's longest free-flowing rivers and winds through a remarkable fabric of forest, steppe grassland and taiga landscapes.

The Amur-Heilong may seem distant and isolated, but its natural splendor is not beyond the reach of globalization. Today, rapid growth in human population, international demands for natural resources, agricultural conversions, wildlife poaching, logging and development projects are straining the ecological integrity of one of nature's greatest masterpieces.

WWF delivers lasting results

At its core, the Amur-Heilong is a land of hope. The majestic Amur tiger—the largest cat on Earth—numbered fewer than 50. WWF and its partners, through decades of collaboration, helped bring the tiger back from the brink of extinction. We have pioneered conservation here, and we continue to improve management of the region's protected areas and forests to aid the resurgence of Amur-Heilong wildlife.

Notable Accomplishments

1990s
Initiated a number of initiatives and action-policy initiatives that helped slow the Amur tiger, once freed from population to near 500 or more.

2000s
Partnered with the government of Mongolia, established the Onon-Balj National Park—a sixteen-million-acre reserve in the headwaters of the Amur-Heilong.

Launched the Ussurian Poppyberry Program in fostering conservation to protect neglect animals in the preserving, far-endangered Amur cats and leopards. Since then, 19 core-area nurturing communities living among the Amur area of tiger leopards have aided the extinction approach.

Assisted in obtaining protected park for the Eastern Siberia Pacific Ocean pipeline so vital riverine habitat would not be disturbed.

WWF is committed to making our vision a reality

Lasting conservation of the Amur-Heilong requires bringing together the global conservation community, the governments of China, Russia and Mongolia, local communities, industry and international lending institutions. WWF has developed multinational conservation strategies where we are training local communities to manage their natural resources and prevent trade in illegal timber and wildlife. WWF aggressively supports antipoaching activities and works to save the remaining Amur leopards from extinction.

WWF is focused on four areas that present the best opportunities for altering the global forces that challenge the future of this place.

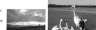
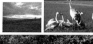
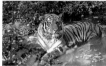

Restoring habitats and protecting species
Habitat loss and depletion of vital prey species have driven near-extinctions of the Amur tiger and leopard. WWF's work includes creating a multitude of protected area in Russia and northeastern China for leopards; establishing national parks in Russia's Primorksy Krai province; and expanding tiger habitats in China. We restore damaged forests, bolster populations of deer and wild boar that sustain big cats, and enhance enforcement of China's ban on wildlife trade.

Promoting sustainable forestry
Uncontrollable and illegal logging practices are devastating habitats for endangered leopards and tigers. With the help of WWF's Global Forest and Trade Network, we work globally and locally to facilitate trade between companies committed to responsible forestry practices. We also work with American and Japanese purchasers of wood products from the Amur-Heilong to educate them about their power to create change by choosing responsibly-sourced timber products.

Ensuring the river's natural flow
The increasing international demand for energy has prompted plans to dam the Amur-Heilong River, the longest free-flowing river in the Eastern Hemisphere. We are working with local, national and international governments to urge adoption of a WWF proposal for hydropower energy development that strikes a sustainable balance between the needs of humans and the region's ecological integrity.

Protecting the river's headwaters
Mining, forest fires, poaching and overfishing threaten the headwaters of the Amur-Heilong in northeastern Mongolia. WWF works with local communities and industry, the Mongolian government, and global environmental groups to improve land automation and restoration practices, and implement ecotourism programs that encourage conservation while infusing local economies with revenue.

"Reversing the trend toward extinction is difficult but not impossible. We helped bring the tiger back from the brink of extinction and now it's the Amur leopard's turn."

Dr. Darron Collins
Managing Director, Amur-Heilong

What makes the Congo Basin extraordinary

Deep in the heart of the African continent, the tropical forests of the Congo Basin are a haven for forest elephants, gorillas and other amazing wildlife. The indigenous people of the forest gather and hunt for food, just as their ancestors have done for thousands of years. Under towering canopies of ancient trees, their lives—and the survival of nature here—depend on the forests.

The Congo Basin holds up to one-quarter of the world's tropical forests. Its mosaic of ecosystems—rivers, forests, savannas, swamps and flooded forests—are teeming with life. These forests regulate local climate and the flow of water, protect and enrich soils, control diseases and safeguard water quality. They also make up one of the most important wilderness areas left on Earth.

WWF delivers lasting results

WWF has worked for more than 30 years to protect the forests of the Congo Basin. By tapping our global network, we have addressed a vast array of challenges facing nature, including the timber industry, mineral and oil extraction, energy production and wildlife poaching. We partner at every level—global, national, regional and local—to achieve lasting conservation.

Notable Accomplishments

1980s
Launched conservation efforts to protect pygmy habitats and to preserve vital indigenous BaAka pygmies.

1990s
Assisted in establishing the Sangha Tri Nationale Reserve Park—the first trans-border protection of a park complex in Central Africa.

Brought together six African nations at the historic Yaoundé Summit to conserve more than one million acres of Kaysa National's crucial multinational policymaking strategy, and established key collaborative conservation management among laws.

2000s
Championed Moropela for regional conservation that joined the efforts of scientists to explore future business and economic reference.

Convened the Brazzaville Summit of the African nations that resulted in Africa's first conservation treaty.

Successfully advanced the Northern completions to join WWF's Central Africa Forest & Trade Network (CAFTN).

"Science is at the heart of all our activities — from sophisticated satellite mapping to muddy-boots wildlife surveys — and we have proven to be a viable partner in protecting this unique place for future generations."

Dr. Richard Carroll
Managing Director, Congo Basin

WWF is committed to making our vision a reality

Central Africa's forests are being logged at a rate that could wipe out more than 70 percent of its trees by 2040. These activities threaten highly-localized endemic species and significantly reduce the region's natural resiliency to climate change. Wildlife trade continues unabated with the poaching of elephants, great apes, tropical birds and fish.

WWF is working to restore ecological processes, reduce the human footprint and support local economies in the Congo Basin. We are focused on four areas that present the best opportunities for altering the global forces that challenge the future of this magical place.

Creating sustainable forestries
The Congo Basin provides essential global ecological services by absorbing and storing carbon dioxide—a process that can slow the rate of global climate change. WWF is collaborating with local governments, timber companies and international lending institutions to open constructive dialogue and encourage best environmental practices. We are combining our fieldwork and policy work to promote adoption of Forest Stewardship Council certification standards.

Preventing wildlife trade
More than one million tons of wild animal meat—known as bushmeat—are consumed annually across the Congo Basin. The consumption rate is projected to double over the next 25 years, which threatens extinction for great apes and elephants. WWF is working to reduce the demand for bushmeat by partnering with logging companies, air companies, transporters and local communities to develop community-based fisheries and sustainable hunting practices and limit access to illegal wildlife trade.

Providing education and job training
The recent designation of national parks in the Congo Basin has altered traditional ways of life for local communities that have relied on the forests for generations. With the added challenges of a growing population and an increased frequency of armed conflict, WWF is educating local communities about environmental stewardship, providing job training for sustainable management of natural resources, and establishing collaborative ecotourism ventures.

Promoting sustainable development
Plans to finance and develop a large new oil mine in northern Gabon threaten intact rain forests that harbor elephants, leopards, gorillas and chimpanzees. WWF is working with governments, mining companies and financial backers to open constructive dialogue, provide technical support and encourage mitigation measures. We are also coordinating a worldwide response to address the ecological impact of a growing human footprint in the region.

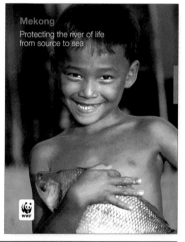

Mekong
Protecting the river of life from source to sea

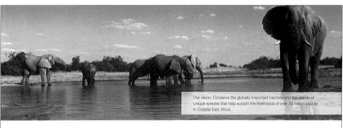

Our vision: Conserve the globally-important habitats and thousands of unique species that help sustain the livelihoods of over 30 million people in Coastal East Africa.

What makes Coastal East Africa extraordinary

Few places on Earth can match the abundance and diversity of life found in Coastal East Africa. From the shores of Lake Malawi—home to nearly 1,000 endemic species of fish—and the Eastern Arc Mountains and Marine landscapes—where humans act alongside the highest collection of endemic and threatened species in all of Africa—to the Indian Ocean and the East African marine ecoregion, Coastal East Africa stretches for 2,300 miles, from southern Somalia to the shores of South Africa.

The coastlines here are among the poorest in the world. Livelihoods and human health are directly connected to the natural resources. Over the past 50 years, human activity has significantly altered this once-pristine paradise.

The place, harboring the largest, intriguing and largest intriguing reef in the world and a rich tapestry of mangroves and sea-grass beds, Coastal East Africa spans 190 million acres, including the mountains, grasslands, and woodlands in Kenya, Tanzania and Mozambique. The terrestrial region is also the source of fresh waters and fertile soil for local communities.

The species, With the highest concentration of abalone species in Africa—18,570 species of plants and animals—the region's waters sustain of the species of sea turtles in the Indian Ocean and 36 species of marine mammals, such as whales, dolphins and the white-spined dugong. Its terrestrial habitat provides refuge for wild crops, black rhinos, red-colobus monkeys and African elephants.

The people, Although impoverished, the communities in this region have a strong cultural heritage with rich traditions. Because their livelihoods and health are directly connected to natural resources, empowering them to be ethically involved in conservation will preserve their ecosystems and create alternate income sources.

Our vision: Establish a sustainable relationship between people and the environment to ensure a future that includes healthy wildlife populations, plentiful natural resources and lasting change for local livelihoods.

What makes the Eastern Himalayas extraordinary

Few places on Earth can match the breathtaking splendor of the Himalayas. Its towering peaks and snowbelt valleys have inspired naturalists, adventure seekers and spirit-seekers for centuries. Its diverse landscapes harbor exotic creatures such as red pandas, snow leopards and one-horned rhinos.

The place, The Himalayan mountain range forms a 1,500-mile-long barrier that separates the Indian subcontinent from the high, dry Tibetan Plateau. Located in Nepal, Bhutan, northern Myanmar, southeast Tibet and northeast India, the region is comprised of temperate forests, the world's highest mountain peaks and tallest grasslands, savannas and rich alpine meadows.

The species, The Eastern Himalayas harbor 10,000 plant species, 300 mammal species and 750 bird species. Its grasslands are home to the densest population of Bengal tigers, living alongside Asian elephants and one-horned rhinos. Bhutan offers refuge for snow leopards, red pandas and bears. The region's freshwater forests sustain Himalayan black bears and golden langurs.

The people, The region is a rich cultural mosaic of Buddhists, Hindus, Christians and animists, all of whom have lived closely with nature for centuries. Many communities live in isolation, and their livelihoods and traditions directly depend on natural resources, making conservation an integral part of their lives.

U.S. Southeast Rivers and Streams
Safeguarding America's richest source of freshwater

What makes the Chihuahuan Desert extraordinary

In the Chihuahuan Desert, roadrunners scurry after collared lizards, while golden eagles search the desert brush from high above for black-tailed jackrabbits. Forests of yucca and agave display unearthly beauty. Here, nearly one fifth of the world's cactus species thrive. Hundreds of bird species—including the seemingly ever-present and ephemerally falcon—find food and shelter while helping to maintain the region's delicate and imperiled natural balance.

Covering an area so large it rivals Texas, the Chihuahuan Desert is challenged by an increasing human population, agricultural expansion and unsustainable management of water and land resources.

WWF delivers lasting results

The United States and Mexico share a long tradition of working together on cross-border issues. WWF builds on that tradition in four offices in both Chihuahua City, Mexico and Las Cruces, New Mexico in 1997. WWF launched our program here with a focus on solutions that benefit both people and nature.

Notable Accomplishments

1990s

Conservation from experts combined with technology. In the Chihuahuan Desert, WWF employs a host of conservation plan.

Catherine Plume
Managing Director, Chihuahuan Desert

WWF is committed to making our vision a reality

This magnificent desert landscape is threatened by population growth, poor water management, agricultural expansion, invasive species, illegal wildlife trade, and a lack of understanding about the desert's ecological importance. Extraction of copper, gypsum, salt, lime and sand have degraded the region. An overtaxed 30 percent of the Rio Grande is regularly diverted for irrigation—in fact, in 2001 the river dried up for the first time in recent history, failing to reach the Gulf of Mexico.

WWF is focused on five areas that present the best opportunities for changing the global forces that challenge the future of this special place.

Promoting best management practices in Big Bend
The Big Bend region of Texas and northern Mexico is a 1.6 million-acre landscape that contains a multitude of protected and private lands. WWF is collaborating with ranchers, governments and conservation organizations to promote sustainable grazing and wildlife management practices that benefit both nature and the ranching communities.

Restoring freshwater ecosystems
WWF is working to ensure the return of healthy river flows to the Rio Grande. We are collaborating with governments, communities and organizations to restore water conservation practices and ensure adequate flows to support the ecosystems and communities that depend on this vital river.

Conserving grasslands and wetlands
WWF is working to conserve the region's grasslands and wetlands, which provide critical habitat for many species. We collaborate with landowners and communities to promote sustainable land management practices that protect these fragile ecosystems.

Halting illegal wildlife trade
WWF is working to combat the illegal trade of wildlife in the Chihuahuan Desert. We collaborate with law enforcement agencies and local communities to reduce demand and protect endangered species.

Protecting large predators
WWF is working to protect large predators such as black bears and mountain lions in the Chihuahuan Desert. We collaborate with governments and communities to promote coexistence and reduce conflicts between predators and humans.

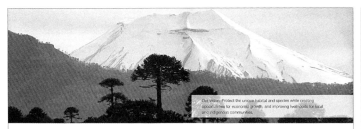

Our vision: Protect the unique habitat and species while creating opportunities for economic growth, and improving livelihoods for local and indigenous communities.

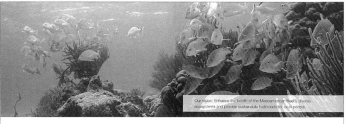

Our vision: Enhance the health of the Mesoamerican Reef's diverse ecosystems and provide sustainable livelihoods for local people.

What makes Southern Chile extraordinary

Flanked by snowcapped volcanoes and Andean mountain peaks, the Valdivian temperate forests run in a narrow band along the southwest shore of South America through Chile. The region contains some of the world's largest and oldest trees, and the Gulf of Corcovado is the prime feeding and nursing grounds for blue whales—the world's largest mammal.

Accelerated rates of economic development in Chile threaten the Valdivian temperate forests' environment and human quality of life—unsustainable logging, forest conversion, aquaculture, infrastructure projects, and weak regulatory and government enforcement capacity endanger the future of the region.

The place. The Valdivian temperate forests cover nearly 80 million acres in Chile. As South America's only temperate rain forest—second in size only to the forests of the Pacific Northwest—the region contains some of the world's largest and oldest trees. Of the estimated 35 million acres of original Valdivian forest, only 40 percent remains intact.

The species. The forests of Valdivia are home to the endangered pudú, the world's smallest deer; the magellanic woodpecker; and the mountain monkey, considered to be a "living fossil." The alerce tree found here can live for more than 3,000 years, making it the second-longest living organism on Earth. The Gulf of Corcovado features a dazzling abundance of sea birds and other marine life.

The people. Southern Chile is home to a population of more than five million people, including indigenous groups such as the Pehuenche and Huilliche, who have lived here for thousands of years. Today, the lifestyles and local economies of many communities in the region rely heavily on the area's native forests and marine life.

What makes the Mesoamerican Reef extraordinary

The jewel of the Caribbean Sea, the Mesoamerican Reef is a rich tapestry of fringing reefs, atolls, patch reefs, sea grass pastures, and mangrove forests. An ancient natural system dating back 2½ million years, it acts as a natural barrier against severe storms for Mexico, Guatemala, Belize and Honduras, and its presence is vital to the survival of many plants and animals as well as humans.

As the most important marine reef in the Western Hemisphere and the second-largest in the world, the Mesoamerican Reef provides shelter for fascinating species, such as the mammoth whale shark and the endangered split water crocodile. It is also home to one of the world's largest populations of manatees.

The place. A large mosaic of ecosystems, the Mesoamerican Reef covers nearly 11½ million acres—from the northern end of the Yucatán Peninsula in Mexico and the Caribbean coasts of Belize and Guatemala, to the Bay Islands in northern Honduras. It includes ocean habitats, coastal zones, tropical and cloud forests, and wetlands that drain the Caribbean slope.

The species. The Mesoamerican Reef hosts more than 60 species of stony coral and more than 500 species of fish—including commercially vital grouper, snapper and spiny lobster. It also provides refuge for sea turtles that feed and nest along the shoreline. Its watershed is home to jaguars, howler monkeys and birds such as the quetzal.

The people. More than two million people live in the coastal communities that span four countries. This population of great cultural and ethnic diversity depends on economic activities linked to coastal and marine resources, such as fishing and tourism. The region is also experiencing rapid population growth and increased exploitation of land and resources.

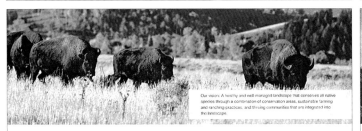

Our vision: A healthy and well-managed landscape that conserves all native species through a combination of conservation areas, sustainable farming and ranching practices, and thriving communities that are integrated into the landscape.

Our vision: Conserve the Amazon through local and national action in priority landscapes and aquatic systems; region-wide efforts in planning, leadership and coordination; and global influence of market forces.

What makes the Northern Great Plains extraordinary

Two hundred years ago, Lewis and Clark traversed through the Northern Great Plains and found an abundance of life rivaling the African savanna. Millions of bison, pronghorn and elk grazed an endless sea of grass, watched by prairie wolves, grizzlies and other predators in the distance while immense flocks of birds colored the big open sky.

Today, large swaths of the mixed-grass prairie remain, but the sights and sounds of its native species are largely gone. With less than 2 percent of the region's 180 million acres managed for wildlife conservation, the Northern Great Plains is one of the least protected places on Earth. There is, however, an opportunity to restore this remarkable landscape and the wildlife that call it home.

The place. In the heart of North America, the Northern Great Plains stretches across soils built up over millennia. Its untilled prairies, diverse grasses, magnificent wildflowers, and meandering streams and rivers span five states within the United States and two Canadian provinces.

The species. The region is home to more than 1,500 species of plants like blue grama, sagebrush and coneflowers; 300 birds, including the greater sage grouse, golden eagle and sandhill crane; and 220 species of butterfly. It harbors more than 90 mammals, including the American bison, the prairie dog and the black-footed ferret—the most endangered mammal in North America.

The people. Many people living on the prairie can trace their roots back generations; centuries for Native Americans. The virtues of cultural pride, hard work and tight-knit communities shape much of the culture of the Northern Great Plains and figure prominently in how Americans see themselves today.

What makes the Amazon extraordinary

The Amazon is a mosaic of landscapes and ecosystems—from lowland tropical forests to flooded savannas dotted with palm trees and bamboo forests. It is the world's largest river basin and the source of one fifth of all fresh water on Earth. The Amazon contains one third of the planet's remaining rain forests, sustaining millions of species.

In the last decades, scientific research has established a clear link between the health of the Amazon and the integrity of the global environment, but still only a fraction of its biological richness has been revealed. Today, rapid deforestation threatens the Amazon's forests. At current rates, 25 percent of its original forests are projected to be destroyed by 2020—a looming disaster not only for the region's plants and animals, but for the world.

The place. The Amazon spans the borders of eight South American countries. The region's high levels of rainfall, diverse topography and meandering rivers sustain its amazing variety and abundance of life. The Amazon contains vast stores of carbon—its rain forests are key to stabilizing local and global climate.

The species. Containing nearly 40,000 plant species, the Amazon is a land of the world's richest diversity of birds, freshwater fish and butterflies. One of the world's last refuges for jaguars, harpy eagles and pink dolphins, its thousands of tree species are home to southern two-toed sloths, pygmy marmosets, saddleback and emperor tamarins and Goeldi's monkeys.

The people. More than 350 indigenous and ethnic groups have lived in the Amazon for thousands of years, tapping native life for agriculture, clothing and traditional medicines. Today, more than 30 million people live in the region. Although most live in large urban centers, all residents remain dependent on the Amazon's ecosystem services for food, shelter and livelihoods.

WWF sets the standard for sound conservation

At conservation work at WWF is grounded in science. WWF's Conservation Science Program (CSP) draws on powerful insights from biology, hydrology, oceanography and the social sciences to create new and effective approaches for protecting biodiversity. Our scientists track emerging issues and lead regional and global analysis to identify and set priorities for conserving the world's valuable habitats and species.

The results of CSP's endeavors inform and direct all WWF programs. The innovative ideas generated and the knowledge acquired—communicated through scientific articles, books, the internet and computer-based tools—contribute to strengthening the scientific integrity of conservation efforts around the world. Many of CSP's innovations and tools have been adopted by other conservation organizations, government agencies and academic researchers.

Our vision: Advance biodiversity conservation worldwide through the development and application of innovative scientific principles, tools and information.

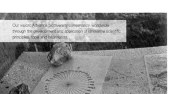

WWF delivers lasting results

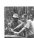

Creating a framework for ocean conservation

Challenge:

Solution:

Preparing the next generation of conservation scientists

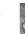

Challenge:

Solution:

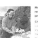

Establishing values for natural resources

Challenge:

Solution:

Measuring meaningful results and charting progress

Challenge:

Solution:

Collecting data to protect and restore freshwater systems

Challenge:

Solution:

The Galápagos
The world's most treasured islands

Dr. Eric Dinerstein

Gulf of California
The world's aquarium

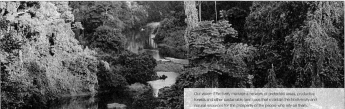

Our vision: Effectively manage a network of protected areas, productive forests and other sustainable land uses that maintain the biodiversity and natural resources for the prosperity of the people who rely on them.

What makes Borneo and Sumatra extraordinary

From the hot, humid lowlands to the rocky, misty uplands, the rain forests of Borneo and Sumatra teem with extraordinary life. The cries of gibbons can be heard through the early morning mist. Orangutans dwell in trees, elephants, tigers and rhinos roam freely over the dense forest floor, and hornbills soar through the skies.

Logging and oil palm plantation expansion are causing one of the worst rates of deforestation in the world. But once pristine, today, Sumatra's forests have been nearly wiped out and Borneo's forests, once protected by their remoteness, face an ever-growing threat.

WWF is making a difference here. We have a bold conservation vision to protect this land in place on Earth.

The place. Located on the equator, the islands harbor some of the world's most diverse rain forests and Southeast Asia's last intact forests. Borneo is the world's third-largest island, covering an area slightly larger than Texas. Sumatra is the world's sixth-largest island. The islands' tropical climate and diverse ecosystems have created habitats for an array of life.

The species. This is the only place where tigers, rhinos, orangutans and elephants live together. It is home to the sun bear, the world's smallest bear; the clouded leopard; and flying fox bat. There are more than 15,000 known plant species with many more species yet to be discovered—since 1995, more than 400 new species have been identified.

The people. The cultural diversity of Borneo and Sumatra is as distinct and varied as its nature. The region's 56 million people are a mix of indigenous peoples and immigrants from mainland Indonesia and other Asian countries.

CLIENT
World Wildlife Fund
CREATIVE FIRM
Crabtree + Company
www.crabtreecompany.com
DESIGNERS
Susan Angrisani,
Lisa Suchy,
Rod Vera,
William Weinheimer,
Rob Harlow

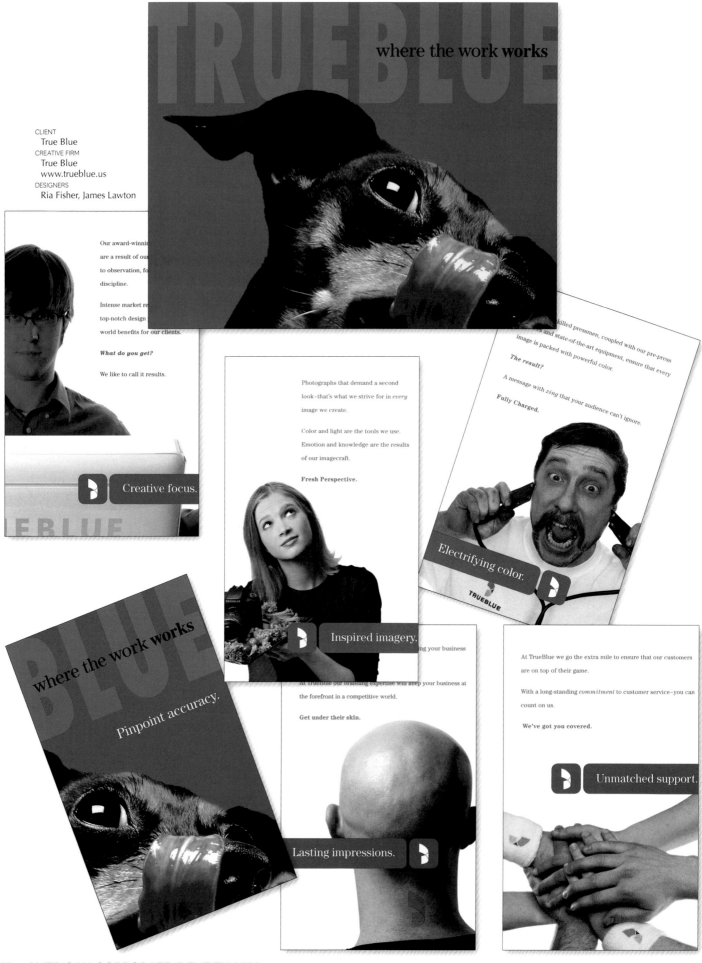

where the work works

TRUEBLUE

CLIENT
True Blue
CREATIVE FIRM
True Blue
www.trueblue.us
DESIGNERS
Ria Fisher, James Lawton

Our award-winni...
are a result of our...
to observation, fo...
discipline.

Intense market re...
top-notch design ...
world benefits for our clients.

What do you get?

We like to call it results.

Creative focus.

Photographs that demand a second
look–that's what we strive for in *every*
image we create.

Color and light are the tools we use.
Emotion and knowledge are the results
of our imagecraft.

Fresh Perspective.

Inspired imagery.

...killed pressmen, coupled with our pre-press
...es and state-of-the-art equipment, ensure that every
image is packed with powerful color.

The result?

A message with *zing* that your audience can't ignore.

Fully Charged.

Electrifying color.

TRUEBLUE

where the work **works**

Pinpoint accuracy.

...ng your business

At TrueBlue our branding expertise will keep your business at
the forefront in a competitive world.

Get under their skin.

Lasting impressions.

At TrueBlue we go the extra mile to ensure that our customers
are on top of their game.

With a long-standing *commitment* to customer service–you can
count on us.

We've got you covered.

Unmatched support.

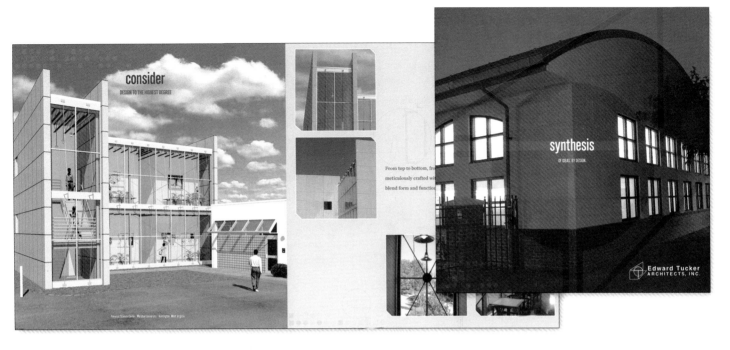

consider
DESIGN TO THE HIGHEST DEGREE

synthesis
OF IDEAS, BY DESIGN.

From top to bottom, fr[...]
meticulously crafted wi[...]
blend form and function[...]

Edward Tucker
ARCHITECTS, INC.

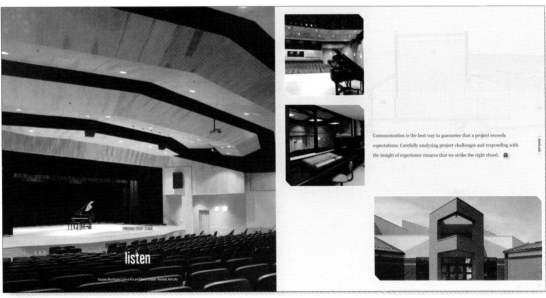

Communication is the best way to guarantee that a project exceeds
expectations. Carefully analyzing project challenges and responding with
the insight of experience ensures that we strike the right chord.

listen

THROUGH EVERY STAGE

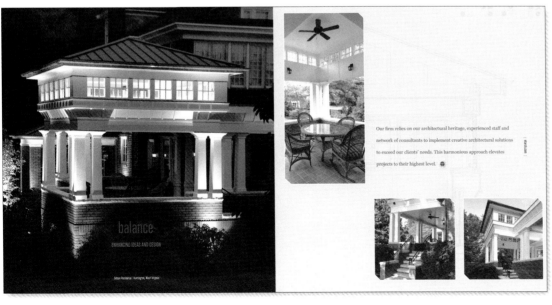

Our firm relies on our architectural heritage, experienced staff and
network of consultants to implement creative architectural solutions
to exceed our clients' needs. This harmonious approach elevates
projects to their highest level.

balance
ENHANCING IDEAS AND DESIGN

JUDGE'S WORK
CLIENT
Edward Tucker Architects, Inc.
CREATIVE FIRM
Maple Creative
maplecreative.com
DESIGNER
Thomas White
COPYWRITERS
Justin Hylbert,
Phoebe Patton Randolph,
Edward W. Tucker

Convenience | Comfort | Cutting-Edge Care | Innovative Technology

Our interdisciplinary, patient-centered team uses the most highly advanced treatment technologies that are unique to our area. Providing the highest level of cancer care to each and every patient is our top priority, and offering an atmosphere that is caring and compassionate is our utmost concern. What does this mean for our patients? It means that you can feel confident that you are receiving the absolute best radiation oncology treatment possible in a warm and nurturing environment.

A Top-Notch Team
Our experienced radiation oncologists combine compassionate care with exceptional qualifications. They are specialty-trained and extremely knowledgeable in providing the most innovative methods of radiation oncology in the region and have received their training at some of the best cancer centers in the United States.

Together with our physicians, our highly-skilled support staff works tirelessly to coordinate your care. Our team of experts – including oncology nurses, radiation therapists, physicists, dosimetrists, and support staff – collaborates to review your case and develop a comprehensive treatment plan.

Accredited by the American College of Radiology (ACR), we adhere to the most rigorous national standards and strive to exceed them. We realize that every patient is unique, and through this collaborative model, we can ensure that you receive the best possible care, specifically tailored to your particular circumstance and disease.

Exceptional Technology
Our center offers the most innovative, highly advanced technologies and treatments in cancer care including four-dimensional CT simulation and image guided radiation technology (IGRT). We are the first community-based radiation oncology center in the area to use these modalities. Additional state-of-the-art technologies include:

Brachytherapy

Respiratory Gating

Electronic Medical Records (EMR)

Diagnostic Fusion Technology (MRI/CT/PET)

Convenience and Comfort
We strive to combine state-of-the-art treatment in a warm, nurturing environment where you'll feel comfortable and at home – right near your home. You won't have to travel far or to an unfamiliar large city to receive the best possible cancer care. We've brought the best to you. Our convenient community location is just a short drive from home with ample free parking, so you can avoid the stress of a long and slow commute into the city for your treatments. We know you have things to do, people to see and life to live, and our goal is making sure you do just that!

From the moment you walk through our door, we want you to feel cared for and welcome. Spend time in our relaxing resource center learning about the latest cancer research and modalities; rejuvenate with complimentary refreshments and snacks in our snack bar; and feel free to ask any one of our staff members for assistance or information. We are here to help.

While you are visiting, you will notice other features we've provided to help you relax including flat screen televisions in every treatment room with a selection of relaxing DVDs and soothing music; blanket warmers and separate changing and waiting areas for male and female patients.

We also work with the American Cancer Society to coordinate rides with a number of local organizations, including The Ride, so that you never have to worry about getting to your appointments.

Partnering to Provide Better Care
Shields Radiation Oncology Center Mansfield is a joint venture of Sturdy Memorial Hospital, Morton Hospital and Shields Health Care Group, the state's largest provider of medical imaging services. By working together, we have combined strengths to provide better, more convenient care to patients in the surrounding communities. You can rest assured knowing that this collaboration has been specifically designed to provide the best possible care and treatment to you, our patient, and that together, we are committed to helping you to fight your disease so that you can live life to the fullest.

For a referral to the Shields Radiation Oncology Center Mansfield, please ask your physician to call 508-261-2000.

CLIENT
Shields Radiation Oncology Center
CREATIVE FIRM
Im-aj Communications & Design, Inc.
www.imajcommunications.com
DESIGNERS
**Jami Ouellette, Leslie Emert,
Chris Basso**

Frequently Asked Questions

What to Expect

Amenities: Make Yourself at Home

Patient Resources

The following organizations offer medical information, treatment decision tools, news updates and support resources.

American Cancer Society
800-ACS-2345

**Answers to Your
Radiation Therapy Questions**
800-962-7876
www.rtanswers.org

Cancer Care, Inc.
800-813-HOPE
www.cancercare.org

Cure for Lymphoma Foundation
212-213-9595

**G&P Foundation
for Cancer Research**
212-486-2575

International Myeloma Foundation
800-452-CURE
www.myeloma.org

The Leukemia & Lymphoma Society
800-955-4572
914-949-0084
www.leukemia-lymphoma.org

**Multiple Myeloma
Research Foundation**
203-972-1250
914-949-0084
www.multiplemyeloma.org

National Breast Cancer Coalition
www.stopbreastcancer.org
800-622-2838

National Cancer Institute
800-4-CANCER
www.cancernet.nci.nih.gov

**National Coalition for
Cancer Survivorship**
877-NCCS-YES
www.canceradvocacy.org

National Kidney Foundation
800-622-9010
www.kidney.org

National Ovarian Cancer Coalition
888 OVARIAN
www.ovarian.org

National Prostate Cancer Coalition
888-245-9455
www.fightprostatecancer.org

Patient Advocate Foundation
800-532-5274
www.patientadvocate.org

**Susan G. Komen
Breast Cancer Foundation**
800 I'M AWARE
www.komen.org

US TOO!
800 808-7866
www.ustoo.com

**Y-ME National
Breast Cancer Organization**
800-221-2141
www.Y-ME.org

www.srocmansfield.com | 1-508-261-2000

Skin Care Products

The following are approved skin care products for people receiving radiation therapy.

Moisturizers
Eucerin
Nivea
Lubriderm
Shea Butter
Calendula Cream

Redness
Aquaphor
Hydrogel/Radiacare Gel
Burn Block Lotion
Shea Butter

Itchy Skin
Hydrocortisone 1%
Alternate Hydrocortisone 1%
(with any of the above products)

Deodorants – for patients who are having their breast or underarm treated
Cornstarch
Herbal Magic Roll-On (order at www.barr.com)
Tom's of Maine, original unscented

Most of these products can be purchased at local pharmacies, hospital pharmacies, or occasionally at department stores. Use only unscented products.

Do not apply any skin care products in the radiation field less than four hours before treatment.

www.srocmansfield.com | 1-508-261-2000

Elder Resources

The following communities offer a range of services and support including counseling, adult family care, family caregiver support, and personal care attendants.

American Cancer Society
800-ACS-2345

Attleboro
508-223-2235

Bridgewater
508-697-0929

Brockton
508-580-7811

Canton
781-828-1323

Easton
508-230-0540

Franklin
508-520-4945

Foxboro
508-543-1252

Mansfield
508-261-7368

Norfolk
508-528-4430

Norton
508-285-0235

Norwood
781-762-1201

Plainville
508-699-7384

Stoughton
781-344-8882

Taunton
508-821-1425

Walpole
508-668-3330

Wrentham
508-384-5425

www.srocmansfield.com | 1-508-261-2000

Shields Radiation Oncology Center · Mansfield
A SHIELDS | STURDY | MORTON PARTNERSHIP
combining strengths to provide better care

From This Day Forward

CLIENT
(on behalf of IMI for)
Interstate Hotels
CREATIVE FIRM
Sellier Design
sellierdesign.com
DESIGNER
Connie Guess

As Our Marriage
Brings New Meaning To Love,

So Our Love
Brings New Meaning To Life.

CLIENT
Vivendi Development
CREATIVE FIRM
Helena Seo Design
www.helenaseo.com
CREATIVE DIRECTOR, DESIGNER
Helena Seo
COPYWRITER
Nancy Tomkins
PHOTOGRAPHER
Bill Fleming, others

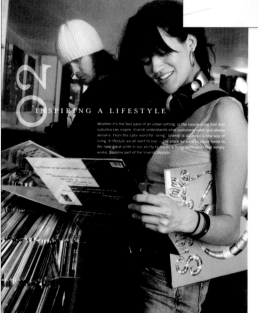

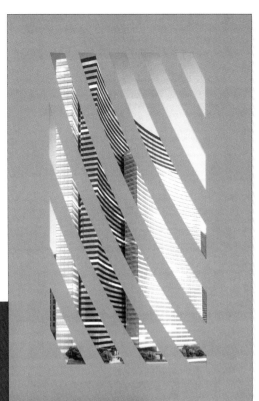

RESPITE. RHYTHM. REMARKABLE.
VDARA CONDO HOTEL - An urban retreat masterfully
designed within CityCenter™ that offers a full complement
of services and amenities to inspire, pamper and indulge.

CREATE YOUR ESCAPE.
From its distinctive shape and unique silhouette of
patterned glass to the interior of each residence,
Vdara Condo Hotel delivers the ideal balance of
access and escape.

MGM MIRAGE. A LEADER YOU CAN TRUST.
Few companies can match the high expectations set
by MGM MIRAGE in design excellence, service and
sustainable living. And few have the vision, the depth
of talent and the experience to make it happen.

CLIENT
City Center
CREATIVE FIRM
Brand, Ltd.
brandltd.com
DESIGNERS
Virginia Martino,
Anne Bonds

Recognize Engineering Excellence

The 2007 NAE Awards

Charles Stark Draper Prize

Fritz J. and Dolores H. Russ Prize

Bernard M. Gordon Prize

Grainger Challenge Prize

Founders Award

Arthur M. Bueche Award

CLIENT
National Academy of Engineering
CREATIVE FIRM
TGD Communications
www.tgdcom.com
DESIGNERS
Jennifer Cedoz, Rory Mach, Bill Truslow,
Bruce Hershey, Jeff Wojtaszek, Scott Braman

NAE AWARDS

The 2007 Charles Stark Draper Prize
Timothy J. Berners-Lee

"Professor Fung is a giant among scholars of this century, and he is without doubt the most eminent bioengineer in the world today."

– Don Giddens
Georgia Institute of Technology

Yuan-Cheng B. Fung

Widely recognized as the father of biomechanics, Dr. Fung established the biomechanical properties and the behaviors of virtually every organ and tissue in the body.

Among the first to move from "traditional" engineering into the emerging field of bioengineering, Dr. Fung was recruited by the University of California, San Diego (UCSD), in 1966 to establish a bioengineering program, with biomechanics and microcirculation as central research themes. By applying his profound knowledge and elegant analytical methods of mechanics to the study of biological tissues, he literally created the new field of biomechanics.

In subsequent years, Dr. Fung went on to establish the foundation of biomechanics in bodily tissues, including the lung, heart, blood vessels, blood cells, ureter, intestine, muscle, and skin. By using "models" to explain and predict biological phenomena, Dr. Fung single-handedly opened new horizons for biomedical and engineering research and provided the cornerstones of research in many institutions in this country and abroad.

In the 1980s, he initiated a new direction for bioengineering and coined the term "tissue engineering," which became a new, integrative

research theme at UCSD. Today tissue engineering is a focus of nearly all major bioengineering programs in the country.

Dr. Fung's innovative research has provided a foundation for industrial applications in a variety of fields, including tissue engineering of cardiovascular, urinary, musculoskeletal, and cutaneous systems. His studies have contributed to the development of skin substitutes to treat burn patients. And he has worked with Advanced Tissue Sciences Inc. on a project to develop a tissue-engineered vascular graft.

Dr. Fung has built superb graduate and undergraduate programs at UCSD, whose graduates have made important contributions in their fields. His several authoritative books are widely used as textbooks in this country and abroad.

He has received numerous awards and honors, including the NAE Founders Award in 1998 and the National Medal of Science in 2000. He is also one of the very few who has been elected to membership in all three national academies: National Academy of Sciences, National Academy of Engineering, and Institute of Medicine.

Arthur W. Winston

Dr. Arthur W. Winston, director of the MSEM Program and Research Professor of Electrical Engineering at Tufts, has been an integral part of the program since it was founded in 1984 and was instrumental in the design and development of the innovative MSEM curriculum.

Dr. Winston is also the 2009 past-president of the Institute of Electrical and Electronic Engineers (IEEE) and was IEEE president in 2004. An IEEE and IEE (UK) fellow, he is a recognized expert in the fields of instrumentation and measurement and other areas. He also received the IEEE Major Educational Innovation Award in 1995.

Besides his 35 years of academic experience, Dr. Winston has more than 40 years of experience in the development of instrumentation. He has worked for leading technology-driven organizations, including the Bell Telephone Company of Canada, Radio and Electrical Engineering Division of the National Research Council of Canada, Massachusetts Institute of Technology,

Schlumberger, National Research Corporation, and Allied Research Corporation (Boeing). He co-founded several companies, including Space Sciences and IKOR (Omniscience), and has served in a variety of high-level corporate and technical positions.

During his career in industry, Dr. Winston is as personally responsible for the development of the Apollo heat shield Temperature Measurement System, which monitored the head shield upon re-entry, and the development and implementation of a worldwide nuclear test monitoring system that permitted the U.S. to participate in the SALT talks. He has produced more than 100 papers and presentations and holds three patents.

Dr. Winston received a B.A.Sc. from the University of Toronto, where he specialized in engineering physics. He was first in his class of 800 engineering students and received numerous academic scholarships and awards. He earned his doctorate in physics from MIT.

"I give much of the credit for the significant advancement in my career over the past few years to the Tufts program and Dr. Arthur Winston."

– Sean P. Hemingway
Wyeth BioPharma

Harold S. Goldberg

Since graduating from The Cooper Union with a BEE in 1944 and receiving his MEE from the Brooklyn Polytechnic Institute, Harold S. Goldberg has had a career of more than 60 years. He devoted his early professional life to product engineering, developing both military and commercial products and systems as an analog circuit and systems designer, and then as a project engineer.

In 1959, Mr. Goldberg was recruited by EPSCO Corporation, first as a section head at the Systems Division, then as chief engineer of the division. In 1962, he moved on to co-found Lexington Instruments where, as vice president for engineering, he developed cardiovascular test instruments and monitoring systems. Then, in 1966, he joined Avco Bioteech Labs, where he designed the electronics for the first bedside pumping cardiac system, which is still in use today.

In 1971, he and Bernard Gordon founded Data Precision Corporation. Mr. Goldberg

was president throughout the company's rise to the third largest instrumentation company in the industry.

Mr. Goldberg played a key role in founding what was to become the Tufts MSEM Program, serving as associate dean and then Teaching Professor for the past ten years. As he has taught a popular course, Engineering Project Methodology. He feels strongly that the concepts taught in the MSEM program will be essential to the future of the electronics industry in the United States.

Mr. Goldberg has received many awards and prizes. Among them are Distinguished Alumnus from Polytechnic Institute, the John Fluke Memorial Pioneer Award from the instrumentation industry, the Alan Pless Award from Electro, the Citation of Honor from the IEEE's Activities Board, the Haraden Pratt Award from IEEE, and the Career Achievement Award from the I&M Society, where he also recently became a Director Emeritus.

Jerome E. Levy

Jerome E. Levy began his seven-decade career in education in 1938 as a teacher of mathematics and physics at the Preparation School of the College of the City of New York. Assigned to teach remedial math to the "failed" academic students at DeWitt Clinton in New York City, he discovered that thinking—and teaching—outside the box could reawaken in his students an interest in, and even a love of, mathematics.

During World War II, Mr. Levy served as Officer-in-Charge of the Pacific Fleet Radar School Under his command, more than 6,000 Navy, Army, and Marine electronics technicians were trained for assignments in the repair technicians in all theaters of the war. Mr. Levy was awarded the Legion of Merit with a Presidential citation that included the following: "Lieutenant Commander Levy established a curriculum and training technique which facilitated the technical training of radar personnel of the Pacific Fleet and, by his contribution to the field of electronics, greatly furthered the progress of radar development."

After serving an additional five years as a civilian training expert and fire-control analyst with the Navy Department Bureau of Ordnance, Mr. Levy was recruited in 1957 as a consultant to the Instrumentation Laboratories at MIT to manage the preparation and control of the design documentation being prepared for the guidance systems of Polaris and Apollo.

As a teacher and developer of the innovative MSEM Program curriculum, Mr. Levy worked with Harold Goldberg to prepare the school for its initial accreditation by the New England Association of Schools and Colleges.

Mr. Levy was inducted into Phi Beta Kappa in 1997. He received his B.S. in mathematics, Magna Cum Laude from CCNY in 1938. Awarded a Harden scholarship, he received his M.A. in education and mathematics from New York University in 1940.

Abul Hussam

Abul Hussam, an associate professor in the Department of Chemistry and Biochemistry at George Mason University, Fairfax, Va., has been awarded the Grainger Challenge Gold Award of $1 million for his SONO filter, a household water treatment system that removes arsenic from drinking water. Hussam was born in Kushtia, Bangladesh. He earned a B.S. (Honors) and M.S. both in chemistry from the University of Dhaka and a Ph.D. in analytical chemistry from the University of Pittsburgh. He has presented and published more than 90 scientific papers in international journals, proceedings, and books. Hussam was instrumental in establishing an environmental research laboratories in Kushtia and is actively engaged in educating the public on the nature of present and future environmental crises. The arsenic filter based on his research is already being used by thousands of people in Bangladesh.

The Gold Award-winning SONO filter is a point-of-use method of removing arsenic from drinking water. A top bucket is filled with locally available coarse river sand and a composite iron matrix (CIM). The sand filters coarse particles and imparts mechanical stability while the CIM removes inorganic arsenic. The water then flows into a second bucket where it is again filtered through coarse river sand, then wood charcoal to remove organic contaminants. Finally, the water flows through fine river sand and wet brick chips to remove fine particles and stabilize water flow. The SONO filter is manufactured in Bangladesh.

Arup K. SenGupta, John E. Greenleaf, Lee M. Blaney, Owen E. Boyd, Arun K. Deb, and Water For People

Arup K. SenGupta, John E. Greenleaf, Lee M. Blaney, Owen E. Boyd, Arun K. Deb, and the nonprofit organization Water For People are sharing the Grainger Challenge Silver Award of $200,000 for their community water-treatment system. SenGupta is the Bossin Senior Professor and professor of chemical engineering and civil and environmental engineering at Lehigh University in Bethlehem, Pa. Boyd is chief executive officer of Solmetex Co. in Northborough, Mass. Deb is a retired vice president of Roy F. Weston Inc. (now Weston Solutions Inc.) in West Chester, Pa. Greenleaf, a Ph.D. candidate in civil and environmental engineering, and Blaney, who recently earned a bachelor's degree in environmental engineering, conducted

laboratory research under SenGupta at Lehigh University. Water for People helps people in developing countries improve their quality of life by supporting the development of locally sustainable drinking water resources, sanitation facilities and health and hygiene education programs.

The system developed by the Silver Award-winning team is installed at a community wellhead. Each arsenic-removal unit serves about 300 households. Water is hand-pumped into a fixed-bed column, where it passes through activated alumina or hybrid anion exchanger (HAIX) to remove the arsenic. After passing through a chamber of graded gravel to remove particulates, the water is ready to drink. This system has been used in 100 locations in West Bengal, India.

The water-treatment units, including the activated alumina sorbent, are manufactured in India and villagers are responsible for their upkeep and day-to-day operation. The active media are regenerated for reuse, and arsenic-laden sludge is contained in an environmentally safe way that allows minimum leaching.

Children's Safe Drinking Water Program, Procter & Gamble

accept the prize for P&G. He has a Ph.D. in toxicology from North Carolina State University and an M.S. in public health from the University of North Carolina Chapel Hill, where he did water research. He has a background in research and development and has published numerous papers and made many presentations on radiation, gastrointestinal health, and safe drinking water.

The PUR™ technology combines chemicals for disinfection, coagulation, and flocculation in a sachet that can treat small batches of water in the home. The system is simple, portable, and capable of treating water from any source. First, the sachet contents are stirred for five minutes into a 10-liter bucket of water. The water is then allowed to rest for another five minutes, during which arsenic and other contaminants separate out. The water is then poured through a clean cloth to filter out contaminants. After another 20 minutes to complete the disinfection process, the water is safe to drink. The Children's Safe Drinking Water Program, part of P&G's Fixed Philanthropy Program, has worked with partners to provide 57 million sachets in more than 50 countries in the past three years, enough to purify more than 570 million liters of drinking water. Each sachet costs about as much as one egg.

The Children's Safe Drinking Water Program at Procter & Gamble Co. (P&G), Cincinnati, has been awarded the Grainger Challenge Bronze Award of $100,000 for the PUR™ Purifier of Water, a coagulation and flocculation water-treatment system. The Children's Safe Drinking Water Program consists of emergency relief work and the establishment of not-for-profit markets to provide P&G's safe drinking-water technology to children and their families in the developing world. Greg Allgood, director of the program, will

History is made by those
who see the future.

CITYCENTER

CLIENT
CityCenter
CREATIVE FIRM
Brand, Ltd.
brandltd.com
DESIGNERS
Virginia Martino, Anne Bonds

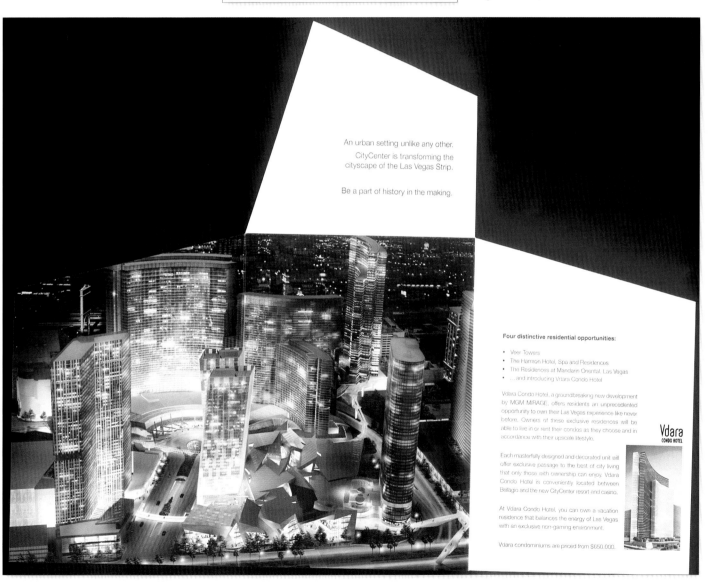

An urban setting unlike any other.
CityCenter is transforming the
cityscape of the Las Vegas Strip.

Be a part of history in the making.

Four distinctive residential opportunities:

- Veer Towers
- The Harmon Hotel, Spa and Residences
- The Residences at Mandarin Oriental, Las Vegas
- ...and introducing Vdara Condo Hotel

Vdara Condo Hotel, a groundbreaking new development by MGM MIRAGE, offers residents an unprecedented opportunity to own their Las Vegas experience like never before. Owners of these exclusive residences will be able to live in or rent their condos as they choose and in accordance with their upscale lifestyle.

Each masterfully designed and decorated unit will offer exclusive passage to the best of city living that only those with ownership can enjoy. Vdara Condo Hotel is conveniently located between Bellagio and the new CityCenter resort and casino.

At Vdara Condo Hotel, you can own a vacation residence that balances the energy of Las Vegas with an exclusive non-gaming environment.

Vdara condominiums are priced from $650,000.

Vdara
CONDO HOTEL

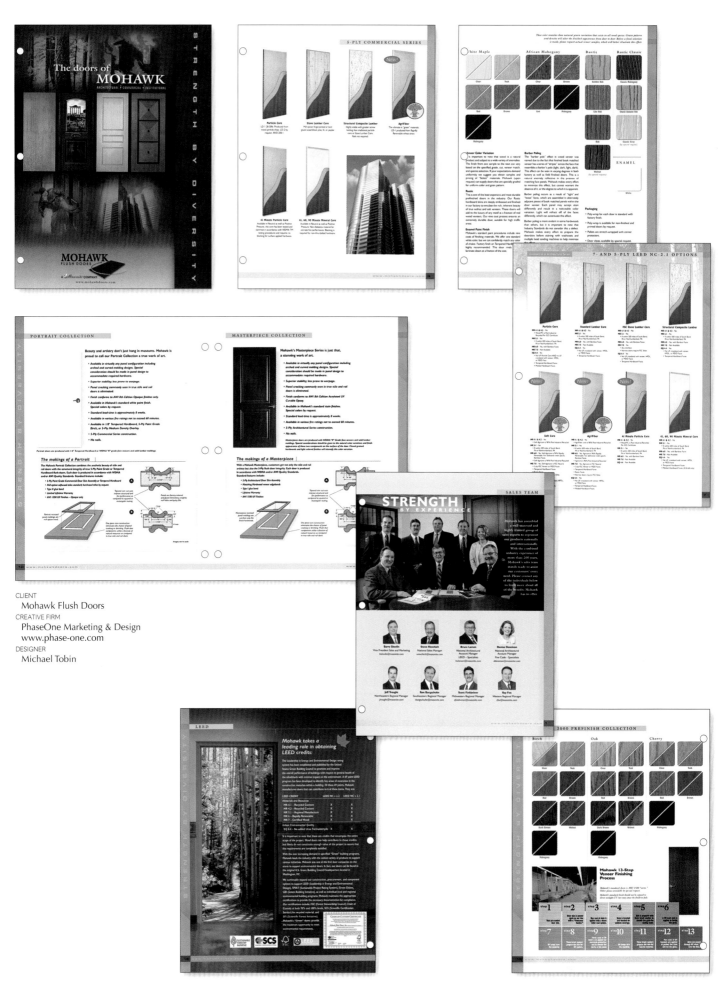

CLIENT
Mohawk Flush Doors
CREATIVE FIRM
PhaseOne Marketing & Design
www.phase-one.com
DESIGNER
Michael Tobin

The Art of the Ask™
A Field Guide for Fundraisers

Prospero

The Meeting
Face-to-Face Tips

The Ask
...nk the donor for past support
(...ppropriate)
...mon bond through building
...upport
...donor's story
...tory to project elements
...se for support
...unt

Know Your Prospect
What is their association with your
...organization?
...is their prior giving record?
...t is their giving potential?
...their special areas of interest?
...involvement do they have?
...her charitable interests?

Who Are Your Best
Prospects?
• People who give
• People who volunteer
• People who have benefited from
 the organization's services
• ...people who have previously asked

Why People Give
• Appreciate the organization's work
• To help solve a problem
• Desire to get involved
• To belong or be recognized
• Sense of community
• ...person who is asking

Why People Don't Give
...y're not asked
...on't and won't give to anything
...t feel connected to the cause

CLIENT
Prospero Group
CREATIVE FIRM
Gill Fishman Associates
gill@gillfishmandesign.com
DESIGNER
Michael Persons

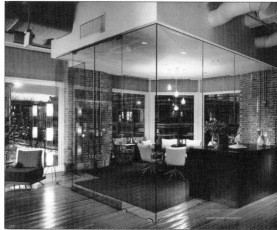

CLIENT
GHT Limited
CREATIVE FIRM
Grafik Marketing Communications
www.grafik.com
DESIGNERS
Michael Marcos, John Vitrovich,
Hal Swetnam

CLIENT
 Foley Hoag Foundation
CREATIVE FIRM
 Right Hat, LLC
 www.righthat.com
DESIGNERS
 Charlyne Fabi, Charlene Wong

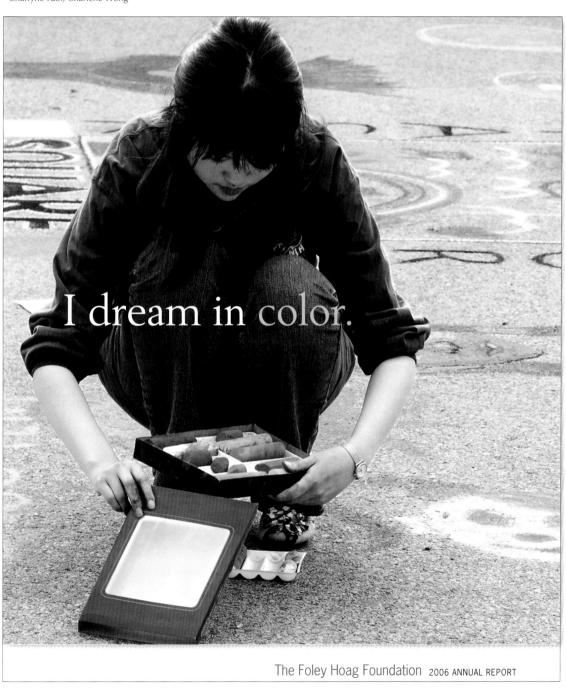

I dream in color.

The Foley Hoag Foundation 2006 ANNUAL REPORT

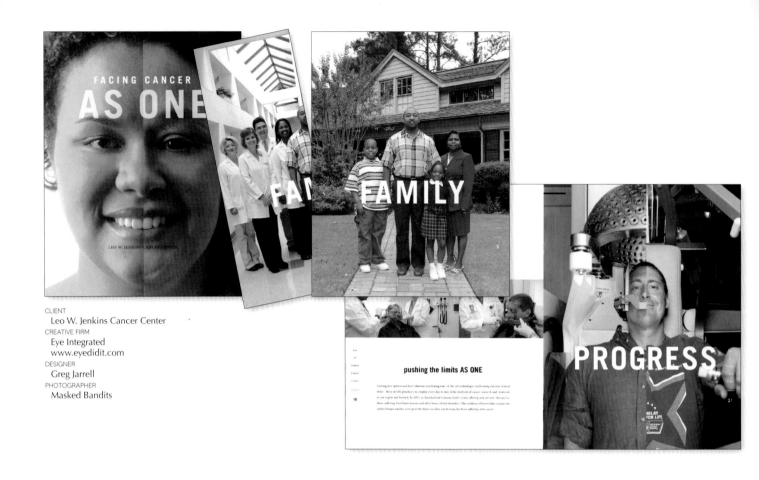

CLIENT
Leo W. Jenkins Cancer Center
CREATIVE FIRM
Eye Integrated
www.eyedidit.com
DESIGNER
Greg Jarrell
PHOTOGRAPHER
Masked Bandits

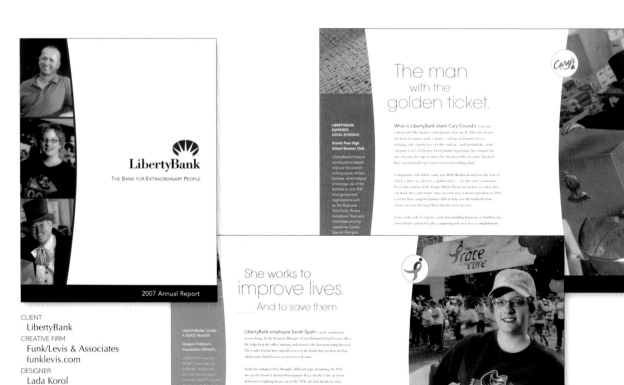

CLIENT
LibertyBank
CREATIVE FIRM
Funk/Levis & Associates
funklevis.com
DESIGNER
Lada Korol

REPORT FROM THE PRESIDENT

(body text illegible)

REVOLUTIONIZING SCIENCE. ENHANCING OUR LIVES.
INSTITUTE FOR SYSTEMS BIOLOGY 2006 ANNUAL REPORT

PREDICTIVE

(body text illegible)

"My DNA will be a crystal ball,
allowing me to see into my health future."

(body text illegible)

PARTICIPATORY

(body text illegible)

"One day my DNA could reveal that I'm highly
likely to die young of heart disease. If it does, I'll
work with my doctors to create a different future."

CLIENT
Institute for Systems Biology
CREATIVE FIRM
GA Creative, Inc.
www.gacreative.com
DESIGNERS
Jeff Welsh, Karen Axtell

2x
10,200 illegal dumper sites were cleaned
in 2006 double the number from 2005

2,550,000
scrap tires collected for recycling

Many Small Actions
KEEP AMERICA BEAUTIFUL, INC. 2006 ANNUAL REVIEW

Solid Green: Keep Clemson Clean

PROJECT 2006 PROFILE

AFFILIATE Keep South Carolina Beautiful/PalmettoPride
LOCATION Clemson, S.C.
PARTNERS Clemson University, City of Clemson,
Keep South Carolina Beautiful/Palmetto Pride

(body text illegible)

CLIENT
Keep America Beautiful
CREATIVE FIRM
Taylor Design
taylordesign.com
DESIGNER
Mark Barrett

Annual Reports • 213

CLIENT
Volunteers of America
CREATIVE FIRM
Grafik Marketing Communications
www.grafik.com
DESIGNERS
Arthur Hsu, Kristin Moore, Melissa Willets

CLIENT
Circor International
CREATIVE FIRM
Gill Fishman Associates
gill@gillfishmandesign.com
DESIGNER
Alicia Ozyjowski

CLIENT
Encore
CREATIVE FIRM
GCG
gcgadvertising.com
DESIGNER
Brian Wilburn

CLIENT
International Youth Foundation
CREATIVE FIRM
Levine & Associates
www.levinedc.com
CREATIVE DIRECTOR
Monica Snellings
ART DIRECTOR, DESIGNER
Greg Sitzmann
COPYWRITER
Garfinkel + Associates

CLIENT
Mid Iowa Health Foundation
CREATIVE FIRM
Sayles Graphic Design
www.saylesdesign.com
DESIGNER
John Sayles

CLIENT
K.I.D.S.
CREATIVE FIRM
WestGroup Creative
www.westgp.com
DESIGNERS
Chip Tolaney, Marvin Bork

"My music, my pictures, my way."

Welcome to the Human Network at Work

Cisco Systems, Inc. 2007 Annual Report

CISCO

"Our store is your store."

CLIENT
Cisco
CREATIVE FIRM
BSID Team/Tolleson Design
cisco.com/tolleson.com
CREATIVE DIRECTOR
Gary McCavitt
ART DIRECTORS
Art Kilinski, Gary Ferguson
PHOTOGRAPHY MANAGER
Vince Lindeman
PHOTOGRAPHERS
Achille Bigliardi, Doug Adesko,
Altaf Khan, Jordan Reeder
COPYWRITERS
Ethan Place, Mike Sanchez,
Karen Brighton
PROJECT MANAGER
Linda Mayer
PREPRESS
XYZ Graphics
PRINTING
ACME Printing, Boston, MA
PRINT BROKER
Bill Littell
CREATIVE DIRECTOR (TOLLESON DESIGN)
Steve Tolleson
DESIGNERS (TOLLESON DESIGN)
Steve Tolleson, Craig Clark,
Boramee Seo
PRODUCTION (TOLLESON DESIGN)
Rene Rosso
PROJECT MANAGER (TOLLESON DESIGN)
Christy Brand

The Growth Priority

CLIENT
LaBarge Inc.
CREATIVE FIRM
Stan Gellman Graphic Design Inc.
www.sggdesigninc.com
DESIGNERS
Britni Eggers, Barry Tilson

CLIENT
Essex Property Trust
CREATIVE FIRM
Hausman Design
www.hausmandesign.com
DESIGNER
Joan Hausman
COPYWRITER
Nancy Tomkins
PHOTOGRAPHER
Alan Blaustein

CLIENT
Board of Pharmaceutical Specialties
CREATIVE FIRM
Dever Designs
www.deverdesigns.com
ART DIRECTOR
Jeffrey L. Dever
DESIGNER
Fatima Ameen

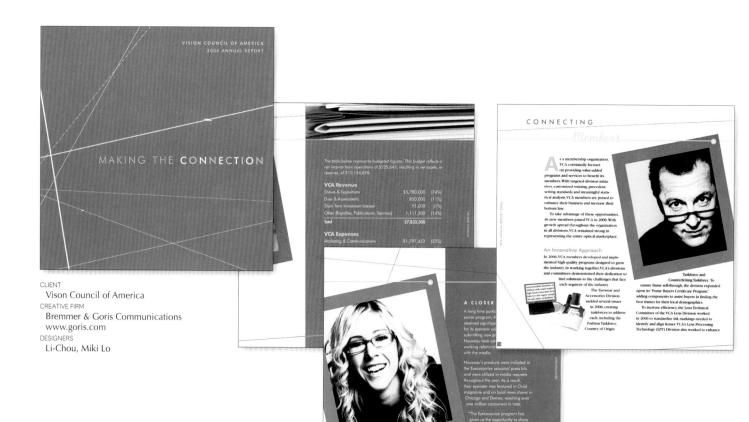

CLIENT
Vison Council of America
CREATIVE FIRM
Bremmer & Goris Communications
www.goris.com
DESIGNERS
Li-Chou, Miki Lo

CLIENT
American Chemical Society
CREATIVE FIRM
Levine & Associates
www.levinedc.com
CREATIVE DIRECTOR
John Vance
ART DIRECTOR, DESIGNER
Megan Riordan
COPYWRITER
Doug Dollemore

CLIENT
The Maritime Aquarium at Norwalk
CREATIVE FIRM
Tom Fowler, Inc./TFI Envision Inc.
www.tfienvision.com
DESIGNERS
Elizabeth P. Ball, Brien O'Reilly

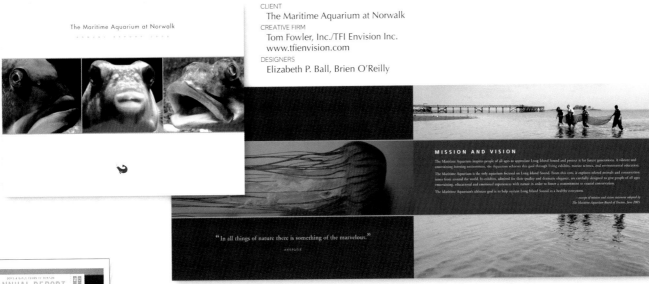

CLIENT
Boys & Girls Club of Boston
CREATIVE FIRM
Gill Fishman Associates
gill@gillfishmandesign.com
DESIGNER
Tammy Torrey

Financial Highlights:

CLIENT
Haverty Furniture Companies, Inc.
CREATIVE FIRM
Eye Integrated
www.eyedidit.com
DESIGNER
Greg Jarrell
PHOTOGRAPHER
Louis Cahill

CLIENT
Cash America
CREATIVE FIRM
GCG
gcgadvertising.com
DESIGNERS
Bill Buck, Jim Frazier

CLIENT
Rockefeller Philanthropy Advisors
CREATIVE FIRM
art270
www.art270.com
DESIGNERS
Alexis Van Saun, Carl Mill

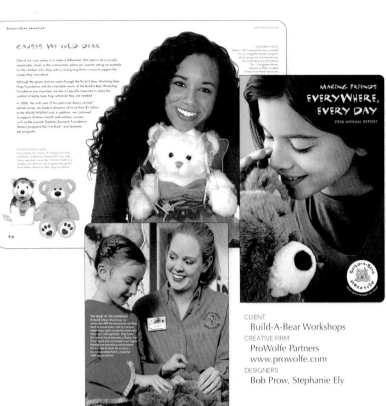

CLIENT
Build-A-Bear Workshops
CREATIVE FIRM
ProWolfe Partners
www.prowolfe.com
DESIGNERS
Bob Prow, Stephanie Ely

CLIENT
Southern Education Foundation
CREATIVE FIRM
Jones Worley Design, Inc.
www.jonesworley.com
DESIGNERS
Cynthia Jones Parks, Eric Key

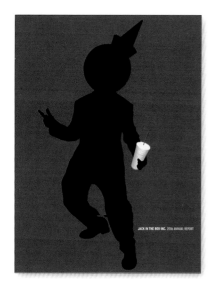

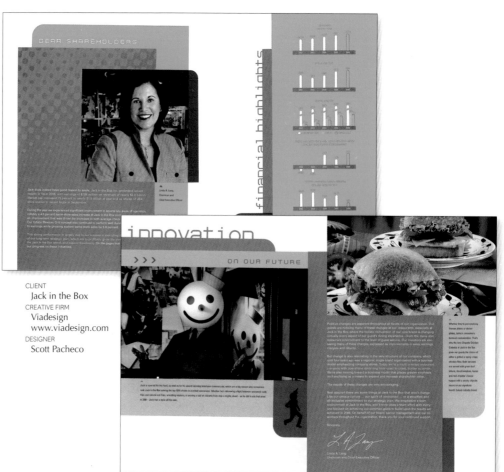

CLIENT
Jack in the Box
CREATIVE FIRM
Viadesign
www.viadesign.com
DESIGNER
Scott Pacheco

CLIENT
Morris Animal Foundation
CREATIVE FIRM
SGDP
www.sgdp.com
DESIGNER
Augusta Toppins
COPYWRITER
Claudine Guertin

CALENDARS

CLIENT
TrueBlue
CREATIVE FIRM
True Blue
www.trueblue.us
DESIGNERS
Ria Fisher, Zach Hobbs

CLIENT
Brandman's Paint & Decorating
CREATIVE FIRM
Dixon Schwabl
dixonschwabl.com
DESIGNERS
Corinne Clar, Roger Winkler,
Dana Denberg, Kara Painting

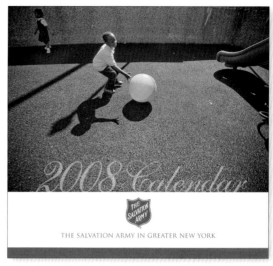

CLIENT
The Salvation Army/Greater New York
CREATIVE FIRM
brown stone studio
brown-stone-studio.com
DESIGNERS
Amy Hecht, Axel Öberg

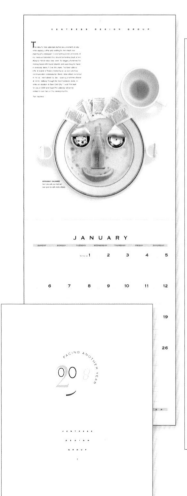

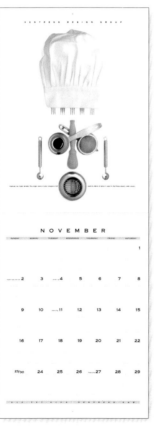

CLIENT
Ventress Design Group
CREATIVE FIRM
Ventress Design Group
www.ventress.com
DESIGNERS
Tom Ventress, Woodie Knight

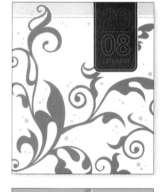

CLIENT
Cecily Ink
CREATIVE FIRM
Defteling Design
www.defteling.com
DESIGNER
Alex Wijnen

CLIENT
Consolite Corporation
CREATIVE FIRM
Sabingrafik, Inc.
http://tracy.sabin.com
DESIGNER, ILLUSTRATOR
Tracy Sabin

CLIENT
City of Bridgeton, MO.
CREATIVE FIRM
Stan Gellman Graphic Design Inc.
www.sggdesign.com
DESIGNERS
Britni Eggers, Barry Tilson

CLIENT
Graphics West/Nationwide
CREATIVE FIRM
eurie creative
www.euriecreative.com
DESIGNERS
Victor Rodriguez, Carri Hall

CLIENT
US Navy
CREATIVE FIRM
Slice
www.slice-works.com
ART DIRECTOR
Dick Rabil
DESIGNER
Greg Aylsworth

CLIENT
Graphics West/Nationwide
CREATIVE FIRM
eurie creative
www.euriecreative.com
DESIGNERS
Victor Rodriguez, Carri Hall

CLIENT
Internal Revenue Service
CREATIVE FIRM
RCW Communication Design Inc.
www.rcwinc.com
DESIGNERS
Michele Thomas, Rodney C. Williams,
Eric Westbrook

CLIENT
Belyea
CREATIVE FIRM
Belyea
belyea.com
DESIGNERS
Ron Lars Hansen,
Nicholas Johnson,
Aaron Clifford

CLIENT
University Galleries
CREATIVE FIRM
Connie Hwang Design
www.conniehwangdesign.com
DESIGNER
Connie Hwang

CDs

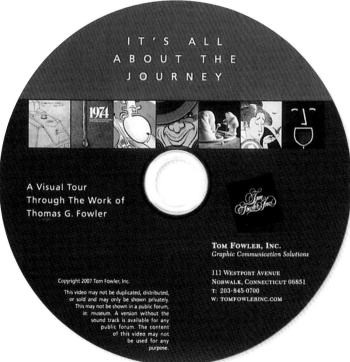

CLIENT
Tom Fowler, Inc./TFI Envision Inc.
CREATIVE FIRM
Tom Fowler, Inc./TFI Envision Inc.
www.tfienvision.com
DESIGNER
Elizabeth P. Ball

CLIENT
Raspberry Records/Paul Lippert
CREATIVE FIRM
Higgins Design
www.jhigginsdesign.com
DESIGNER
Jane Higgins
PHOTOGRAPHERS
Teri Dixon/Getty Images,
Yoshiki Nakamura, Julie Beckman,
Sophie Lippert

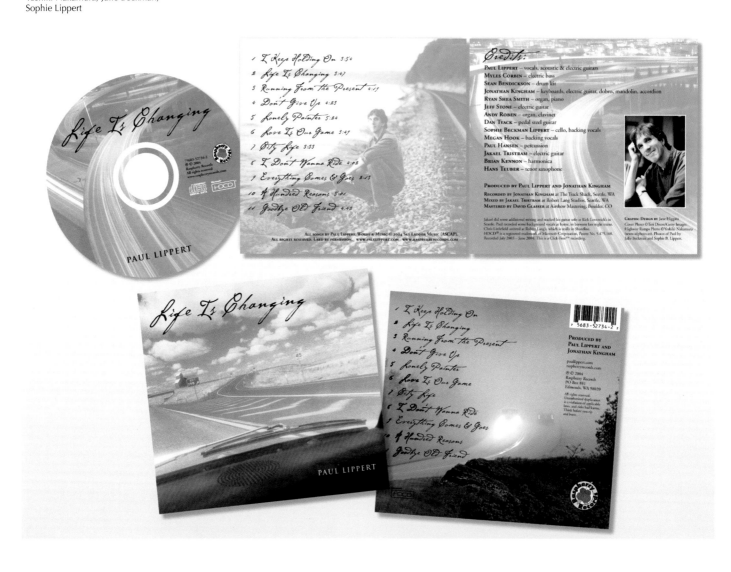

WEBSITES

COMPANY HISTORY PORTFOLIO ROOM DOCTORS MEDIA CUSTOM FURNITURE ANTIQUES CONTACT US

Bartolomei & Company is a full service interior design firm providing interior and architectural design services, custom furniture design and specialty antiques located in Washington, DC, serving national and international clientele.

Bartolomei & Company
INTERIOR DESIGN

CLIENT
Bartolomei & Company
www.bartolomeiandcompany.com
CREATIVE FIRM
Lomangino Studio Inc.
www.lomangino.com
DESIGNER
Betsy Martin

Bartolomei & Company

COMPANY HISTORY PORTFOLIO ROOM DOCTORS MEDIA CUSTOM FURNITURE ANTIQUES CONTACT US

CONTEMPORARY

ZOOM 1 2 3 4 5 6 7 8 9 10 >>

TRADITIONAL ▶

COMMERCIAL ▶

CLIENT
BSC Group
CREATIVE FIRM
Fathom
www.fathom.com
ART DIRECTOR
Brent Robertson
DEVELOPER
Joe Philippan
COPYWRITER
Louisa Handle
WEB PROGRAMMER
Wojciech Pirog

CLIENT
Museum World
museumworld.com
CREATIVE FIRM
Beth Singer Design
info@bethsingerdesign.com
PRINCIPAL
Beth Singer
DESIGNER
Suheun Yu

CLIENT
Soltazza
CREATIVE FIRM
CramerSweeney
www.cramersweeney.com
DESIGNERS
Susan Hammell,
Dave Girgenti

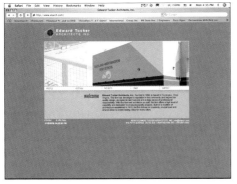

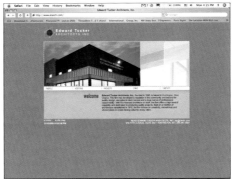

JUDGE'S WORK

CLIENT
Edward Tucker Architects, Inc.
CREATIVE FIRM
Maple Creative
maplecreative.com
DESIGNERS
Thomas White,
Kim S. Gayton,
Marc Lewis
WEB PROGRAMMER
Thomas White
COPYWRITERS
Phoebe Patton Randolph,
Edward W. Tucker

CLIENT
Strategic Building Solutions
CREATIVE FIRM
Fathom
www.fathom.com
DESIGNER
Adrian Kecki

CLIENT
Connecticut Grand Opera & Orchestra
www.ctgrandopera.com
CREATIVE FIRM
Tom Fowler, Inc./TFI Envision Inc.
www.tfienvision.com
DESIGNERS
Elizabeth P. Ball, Brien O'Reilly,
Chris Plaisted

CLIENT
Magiquest
CREATIVE FIRM
Verse Group
versegroup.com
CREATIVE DIRECTOR
Michel Thibodeau
DESIGNER
Marco Acevedo

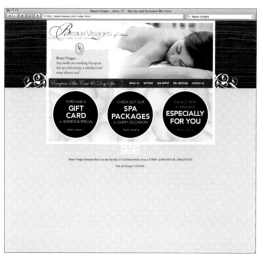

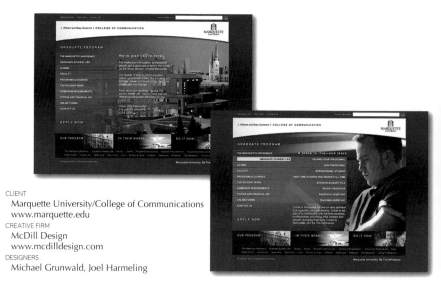

CLIENT
Marquette University/College of Communications
www.marquette.edu
CREATIVE FIRM
McDill Design
www.mcdilldesign.com
DESIGNERS
Michael Grunwald, Joel Harmeling

CLIENT
Kieran Murphy
www.kieranmurphymusic.com
CREATIVE FIRM
Zero Gravity Design Group
www.zergny.com
DESIGNERS
Chuck Killorin, Jennifer Mariotti

CLIENT
Beaux Visages
CREATIVE FIRM
Fathom
www.fathom.com
DESIGNER
Michelle Guilmette

CLIENT
Frederick Wine Trail
www.frederickwinetrail.com
CREATIVE FIRM
Octavo Designs
www.8vodesigns.com
DESIGNERS
Mark Burrier, Sue Hough

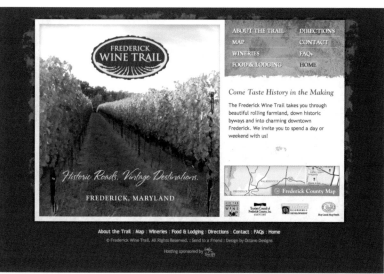

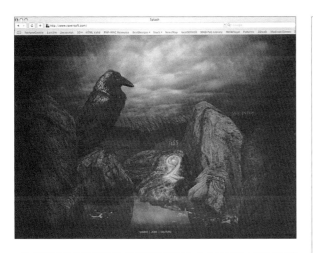

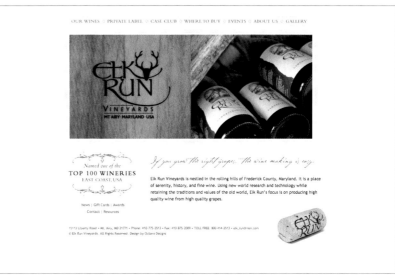

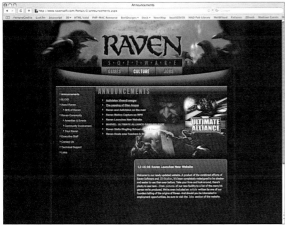

CLIENT
Raven Software
www.ravensoft.com
CREATIVE FIRM
ZD Studios
www.zebradog.com
DESIGNERS
Mark Schmitz, Rasheild Atlas,
Evan Schultz

CLIENT
Elk Run Vineyards
www.elkrun.com
CREATIVE FIRM
Octavo Designs
www.8vodesigns.com
DESIGNERS
Seth Glass, Sue Hough

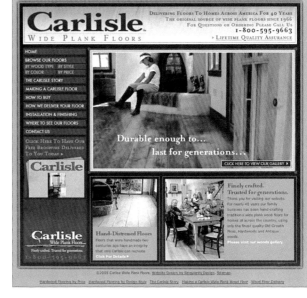

CLIENT
Carlisle Wide Plank Floors
www.wideplankflooring.com
CREATIVE FIRM
Singularity Design
www.singularitydesign.com
DESIGNERS
Chris Counter, Joshua Cohen,
Jeff Greenhouse

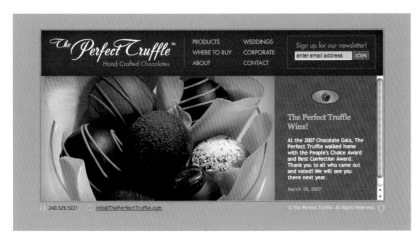

CLIENT
The Perfect Truffle
CREATIVE FIRM
Octavo Designs
www.8vodesigns.com
DESIGNERS
Mark Burrier, Sue Hough

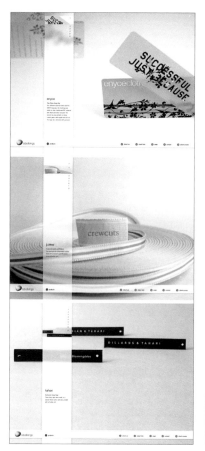

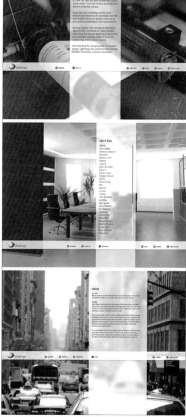

CLIENT
Label Kings
www.labelkings.com
CREATIVE FIRM
Helena Seo Design
www.helenaseo.com
CREATIVE DIRECTOR, DESIGNER
Helena Seo

CLIENT
Helms Mulliss Wicker
hmw.com
CREATIVE FIRM
Greenfield Belser
gbltd.com
DESIGNERS
Burkey Belser, Mark Ledgerwood

CLIENT
Sergio Vega
www.paradiseinthenewworld.com
CREATIVE FIRM
Connie Hwang Design
www.conniehwangdesign.com
DESIGNERS
Connie Hwang, Jarrod Ryhal

CLIENT
UNX, Inc.
www.unx.com
CREATIVE FIRM
Cullinane Inc.
www.cullinane.com
DESIGNER
Jia Kang Sung

CLIENT
Heavenly Hydrangeas
www.heavenlyhydranges.com
CREATIVE FIRM
Octavo Designs
www.8vodesigns.com
DESIGNERS
Mark Burrier, Sue Hough

CLIENT
Fairytale Fashion
www.fairytalefashion.com
CREATIVE FIRM
Zero Gravity Design Group
www.zerogny.com
DESIGNERS
Chuck Killorin,
Jennifer Mariotti

CLIENT
Harwood Feffer
www.hfesq.com
CREATIVE FIRM
Fathom
www.fathom.net
DESIGNER
Bil Jenak
DEVELOPER
Brent Robertson
COPYWRITER
Louisa Handle
WEB PROGRAMMER
Wojciech Pirog

CLIENT
Berenter Greenhouse & Webster
CREATIVE FIRM
Berenter Greenhouse & Webster
www.bgwad.com
ASSOCIATE CREATIVE DIRECTOR, ART DIRECTOR, DESIGNER
Sharon Occhipinh
ASSOCIATE CREATIVE DIRECTOR, COPYWRITER
Dan Trink
PRODUCER
Heather Eynch
DIGITAL PRODUCTION
AMP

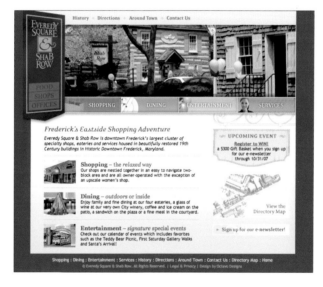

CLIENT
Everedy Square & Shab Row
everedysquare.com
CREATIVE FIRM
Octavo Designs
www.8vodesigns.com
DESIGNERS
Mark Burrier, Sue Hough

CLIENT
CineGraphic Studios
www.cinegraphicstudios.com
CREATIVE FIRM
Octavo Designs
www.8vodesigns.com
DESIGNERS
Mark Burrier, Sue Hough

CLIENT
Kramer Carton Company
www.kramercarton.com
CREATIVE FIRM
Hellbent Marketing
www.hellbentmarketing.com
DESIGNERS
Deb Shea, Shanan Valente

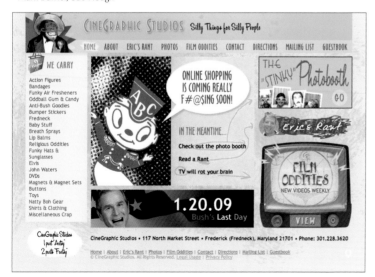

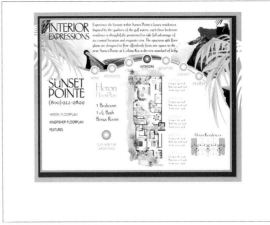

CLIENT
Sunset Pointe at Collany Key
www.collanykey.com
CREATIVE FIRM
JM DesignHaus, Inc.
jmdesignhaus.com
CREATIVE DIRECTOR
Jodi Myers

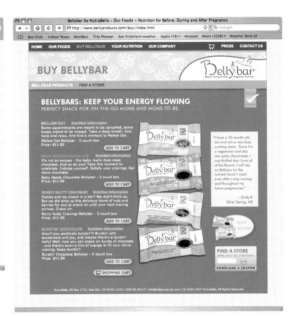

CLIENT
Nutrabella
www.bellyproducts.com
CREATIVE FIRM
Studio Picotee
www.studiopicotee.com
DESIGNER
Heather Landers
PRODUCTION
Lucinda Brown-Trillamar

CLIENT
Ditalia
www.ditalia.com
CREATIVE FIRM
Paragon Design Group
www.iamparagon.com
DESIGNER
Andrew Davies

CLIENT
Tommy Bahama
www.tommybahama.com
CREATIVE FIRM
Hornall Anderson Design Works
www.hadw.com
DESIGNERS
Jamie Monberg, Nathan Young, Joe King,
Gordon Mueller, Matt Frickelton, Erica Goldsmith

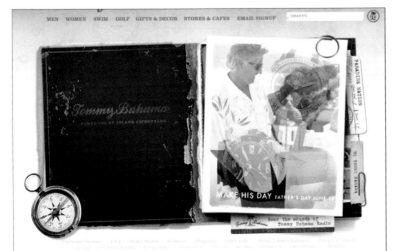

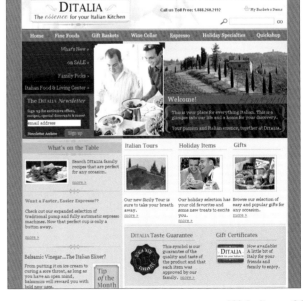

CLIENT
Rockrose Development Corp.
www.eastcoastlic.com
CREATIVE FIRM
Silver Creative Group
silvercreativegroup.com
DESIGNERS
Suzanne Petrow, Paul Zullo,
Dave Rodman

CLIENT
Schum & Associates
CREATIVE FIRM
Schum & Associates
www.schum.com
ART DIRECTOR, DESIGNER, DEVELOPER
Ephraim Schum

CLIENT
Space Needle
CREATIVE FIRM
Hornall Anderson Design Works
www.hadw.com
DESIGNERS
Jamie Monberg, Nathan Young, Joe King, Hans Krebs,
Adrien Lo, Corey Paganucci, Chris Monberg

CLIENT
Perseus Realty
www.argentcondos.com
CREATIVE FIRM
Pensaré Design Group
www.pensaredesign.com
DESIGNER
Amy E. Billingham
WEB PROGRAMMER, ANIMATION
Spur Communications

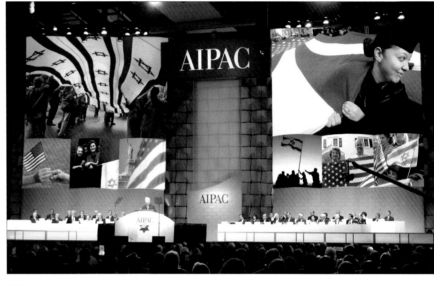

CLIENT
American Israel Public Affairs Committee
CREATIVE FIRM
Beth Singer Design
info@bethsingerdesign.com
PRINCIPAL
Beth Singer
DESIGNERS
Sucha Snidvongs,
Suheun Yu

CLIENT
NBC
CREATIVE FIRM
Curio Design LLC
curiodesign.com
DESIGNERS
Carrie Chatterson, Tamiko Hershey,
Kris Chatterson

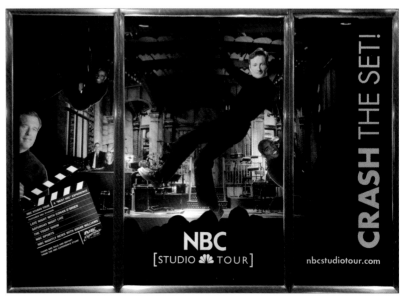

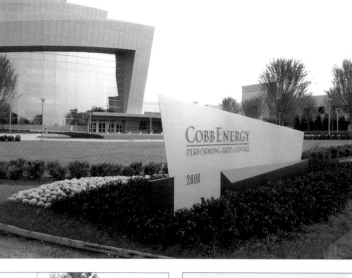

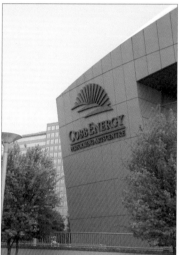

CLIENT
University of Wisconsin Athletic Department
CREATIVE FIRM
ZD Studios
www.zebradog.com
DESIGNERS
Mark Schmitz, Matt Tedore, Louis Cole Scott,
Loren Zemlicka, Mel Kranz

CLIENT
Smallwood, Reynolds, Stewart,
Stewart, Architects
CREATIVE FIRM
Jones Worley Design, Inc.
www.jonesworley.com
DESIGNERS
Cynthia Jones Parks, Barry Nation

CLIENT
University of Cincinnati
CREATIVE FIRM
Kolar Design and Marcia Shortt Design
www.kolardesign.net
DESIGNERS
Kelly Kolar, Marcia Shortt, Donald Carson, Becky Ruehl,
Mary Dietrich, Brent Beck, TJ Schmidlin, Ric Snodgrass

CLIENT
University of Wisconsin Athletic Department
CREATIVE FIRM
ZD Studios
www.zebradog.com
DESIGNERS
Mark Schmitz, Matt Tedore, Louis Cole Scott,
Loren Zemlicka, Mel Kranz

CLIENT
Marina Tae Kwon Do
CREATIVE FIRM
Evenson Design Group
www.evensondesign.com
DESIGNERS
Stan Evenson,
Mark Sojka,
Melanie Usas

CLIENT
Highland Downtown Association
CREATIVE FIRM
Keyword Design
www.keyworddesign.com
DESIGNER
Judith Mayer

CLIENT
Popeyes Louisiana Kitchen
CREATIVE FIRM
Berry Design Inc.
berrydesign.com
DESIGNERS
Bob Berry, Chip Waller

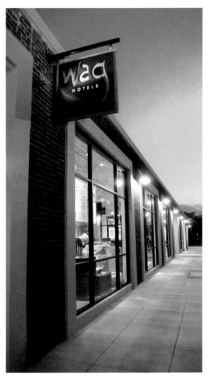

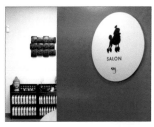

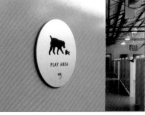

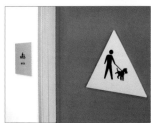

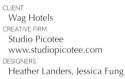

CLIENT
Wag Hotels
CREATIVE FIRM
Studio Picotee
www.studiopicotee.com
DESIGNERS
Heather Landers, Jessica Fung

CLIENT
Eat Unique
CREATIVE FIRM
Mona MacDonald Design
DESIGNER
Mona MacDonald

CLIENT
Rockrose Development Corp.
CREATIVE FIRM
Silver Creative Group
silvercreativegroup.com
DESIGNERS
Suzanne Petrow, Bill Melin, Paul Zullo

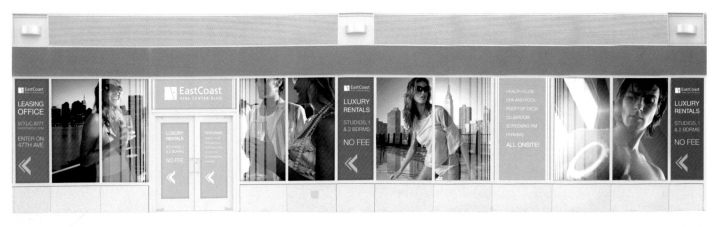

CLIENT
Environmental Action Comm. of West Marin County
CREATIVE FIRM
Deutsch Design Works
www.DDW.com
DESIGNERS
Barry Deutsch, Lori Wynn

CLIENT
The North Face
CREATIVE FIRM
Studio Picotee
www.studiopicotee.com
DESIGNER
Heather Landers

CLIENT
Parker Hannifin Corporation
CREATIVE FIRM
Karen Skunta & Company
www.skunta.com
DESIGNERS
Karen A. Skunta, Jamie L. Finkelhor,
Felix Lee, Jen Maxwell, Kristal Ernst,
Martin L. Spicuzza, Becky Ralich Spak

CLIENT
TrueBlue
CREATIVE FIRM
TrueBlue
www.trueblue.us
DESIGNERS
Ria Fisher, James Lawton

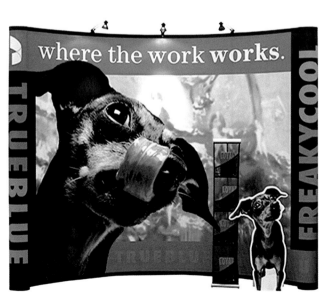

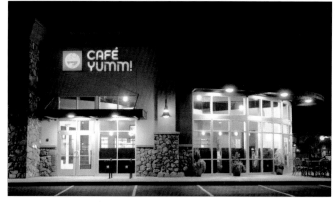
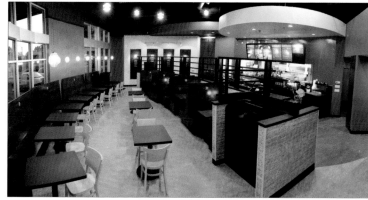

CLIENT
Cafe' Yumm!
CREATIVE FIRM
Hornall Anderson Design Works
www.hadw.com
DESIGNERS
Larry Anderson, Bruce Branson-Meyer,
Jay Hilburn, Kathleen Gibson,
Greg Arhart, Ashley Arhart

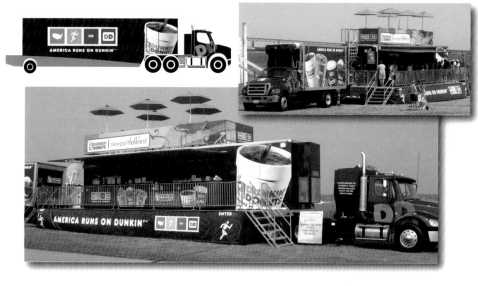

CLIENT
Parker Hannifin Corporation
CREATIVE FIRM
Karen Skunta & Company
www.skunta.com
DESIGNERS
Karen A. Skunta, Jamie L. Finkelhor,
Felix Lee, Jen Maxwell, Kristal Ernst
Martin L. Spicuzza, Becky Ralich Spak

CLIENT
Dunkin' Donuts
CREATIVE FIRM
Berry Design Inc.
berrydesign.com
ART DIRECTOR
Bob Berry, Chip Waller

CLIENT
Sub Zero
CREATIVE FIRM
ZD Studios
www.zebradog.com
DESIGNERS
Mark Schmitz, Amy Beyler, Chris Moore

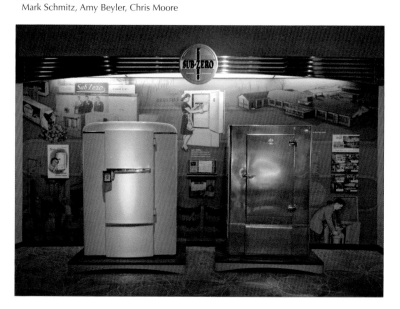

it's about time

nails done on the run

fast is beautiful

CLIENT
:10 Minute Manicure
CREATIVE FIRM
Goldforest
www.goldforest.com
DESIGNERS
Michael Gold, Bibiana Pulido,
Lauren Gold, Sid Hoeltzell

CLIENT
T-Mobile
CREATIVE FIRM
Hornall Anderson Design Works
www.hadw.com
DESIGNERS
James Tee, Mark Popich, Andrew Well,
Jon Graeff, Ethan Keller, Javas Lehn,
Kalani Gregoire, Brenna Pierce

CLIENT
Popeyes Louisiana Kitchen
CREATIVE FIRM
Berry Design Inc.
berrydesign.com
DESIGNERS
Bob Berry, Chip Waller

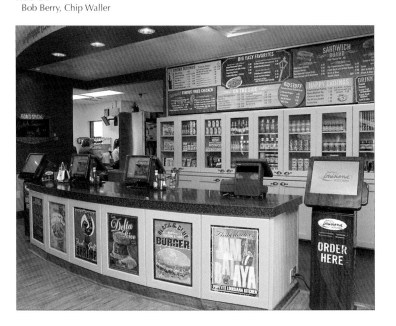

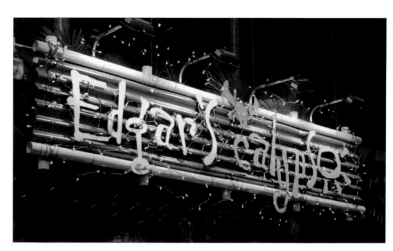

CLIENT
Ekko Restaurant
CREATIVE FIRM
Stephen Longo Design Associates
DESIGNER
Stephen Longo

CLIENT
Edgar's Calypso
CREATIVE FIRM
McDill Design
www.mcdilldesign.com
CREATIVE DIRECTOR
Michael Dillon
DESIGNER
Joel Harmeling

CLIENT
The p.i.n.k. Spirits Company
CREATIVE FIRM
The Bailey Group
www.baileygp.com
DESIGNERS
Steve Perry, Jessica Glebe

CLIENT
Brooklyn Public Library
CREATIVE FIRM
Pisarkiewicz Mazur & Co., Inc.
designpm.com
DESIGNERS
Mary F. Pisarkiewicz, Jimmy D. Reeves,
Julie Lange, Dom Marino

CLIENT
Plaza Las Américas
CREATIVE FIRM
ID Group
idgroup@caribe.net
DESIGNERS
Abner Gutiérrez, Jorge Colón,
Mayra Maldonado

CLIENT
 The Richard E. Jacobs Group
CREATIVE FIRM
 Herip Design Associates, Inc.
 heripdesign.com
DESIGNERS
 Walter M. Herip, John R. Menter, Jen Hollo Crabtree

CLIENT
 DSM Biologies
CREATIVE FIRM
 Eye Integrated
 www.eyedidit.com
DESIGNER
 Jason Crain

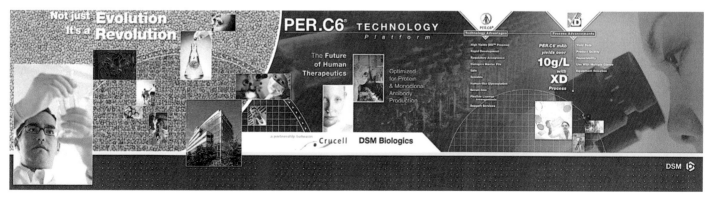

CLIENT
Gulf Chemical & Metallurgical Co.
CREATIVE FIRM
FSC Marketing Communications
www.fscmc.com
DESIGNERS
Bryan Brunsell, Tim Frost

CLIENT
PSAV
CREATIVE FIRM
Conry Design
www.conrydesign.com
DESIGNER
Rhonda Conry

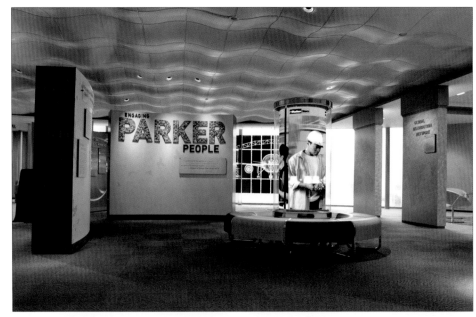

CLIENT
Parker Hannifin Corporation
CREATIVE FIRM
Karen Skunta & Company
www.skunta.com
CREATIVE DIRECTOR
Karen A. Skunta
EXHIBIT DESIGNERS
Jamie L. Finkelhor, Felix Lee,
Jen Maxwell, Kristal Ernst
INTERIOR DESIGNERS
Martin L. Spicuzza, Becky Ralich Spak
X-RAY PHOTOGRAPHER
Nick Veasey

CLIENT
Inquisite
CREATIVE FIRM
Hoopla Headquarters
www.hooplahq.com
BOOTH DESIGN
Ivy Oliver
BANNER DESIGN
Chris Visit,
Josh Finto
COPYWRITER
Stacy Stroud
PHOTOGRAPHER
Eric Hegwen

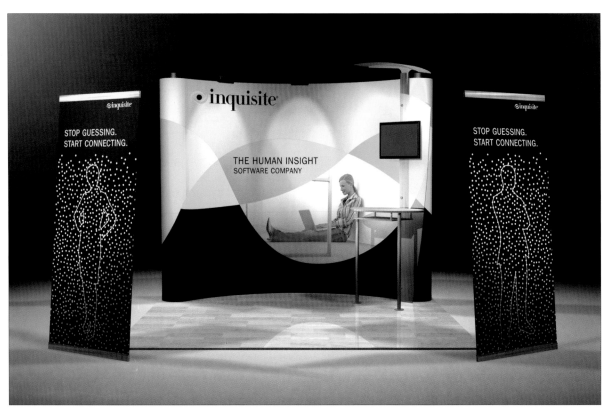

CLIENT
Marshall Erdman & Associates
CREATIVE FIRM
ZD Studios
www.zebradog.com
DESIGNERS
Mark Schmitz, Amy Beyler, Chris Moore,
Eric Dorgan, Kris Marconnet, Rasheid Atlas

CLIENT
Stora Enso
CREATIVE FIRM
Alexander Isley Inc.
www.alexanderisley.com
CREATIVE DIRECTOR
Alexander Isley
MANAGING DIRECTOR
Aline Hilford
DESIGNER
Sara Bornberger

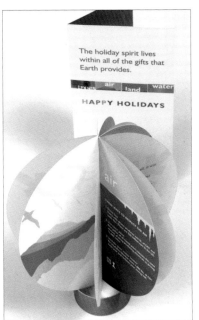

CLIENT
Crabtree + Company
CREATIVE FIRM
Crabtree + Company
www.crabtreecompany.com
DESIGNERS
Susan Angrisana, Lisa Suchy,
Rod Vera, Joe Valasquez

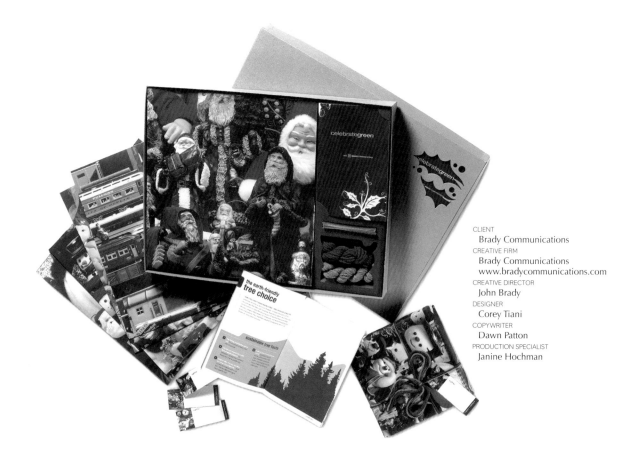

CLIENT
Brady Communications
CREATIVE FIRM
Brady Communications
www.bradycommunications.com
CREATIVE DIRECTOR
John Brady
DESIGNER
Corey Tiani
COPYWRITER
Dawn Patton
PRODUCTION SPECIALIST
Janine Hochman

CLIENT
DELL, Inc.
CREATIVE FIRM
Hoopla Headquarters
www.hooplahq.com
DESIGNERS
Ivy Oliver, Paige Neagle, Stacy Stroud,
Jeff Vavrek, Angela Oliver
PHOTOGRAPHERS
Kyle Chesser, Kevin Terwilliger

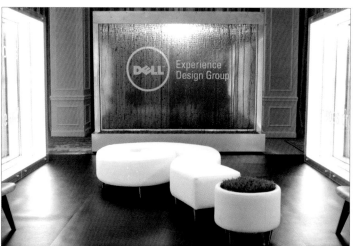

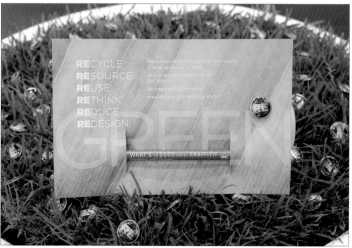

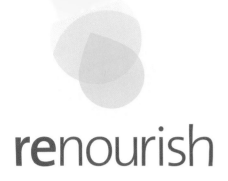

CLIENT
Renourish
CREATIVE FIRM
Renourish
www.re-nourish.com
DESIGNER
Eric Benson

CLIENT
Green Joy
CREATIVE FIRM
Evenson Design Group
www.evendesigngroup.com
CREATIVE DIRECTOR
Stan Evenson, Mark Sojka
DESIGNER
Dallas Duncan

CLIENT
SSRD
CREATIVE FIRM
EAT Advertising & Design
DESIGNERS
Patrice Jobe, Rachel Eilts

CLIENT
King Biofuel
CREATIVE FIRM
EAT Advertising & Design
DESIGNERS
Patrice Jobe, Rachel Eilts

CLIENT
Teens for Safe Cosmetics
CREATIVE FIRM
Axion Design
axiondesign.com
DESIGNER
Axion Design Team

CLIENT
In Harmony
CREATIVE FIRM
Belyea
belyea.com
DESIGNERS
Ron Lars Hansen, Kara Mealy

GOING GREEN ✈

MINIMIZING AVIATION'S ENVIRONMENTAL
FOOTPRINT AT AIRPORTS

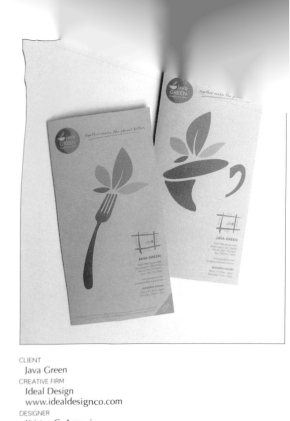

CLIENT
Java Green
CREATIVE FIRM
Ideal Design
www.idealdesignco.com
DESIGNER
Kristen C. Argenio

CLIENT
Airports Council International—North America
CREATIVE FIRM
Bremmer & Goris Communications
www.goris.com
DESIGNER
Carolyn Belefski

CLIENT
Bennett Homes
CREATIVE FIRM
Image Ink Studio
imageink.com
DESIGNER
Tom Hession-Herzog

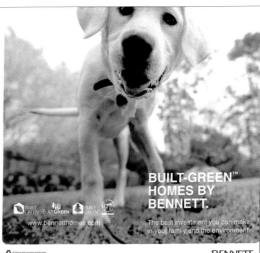

**BUILT-GREEN™
HOMES BY
BENNETT.**

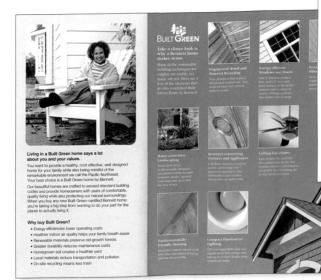

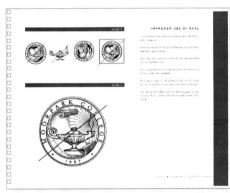

CLIENT
Moorpark College
CREATIVE FIRM
BBM&D
bbmd-inc.com
DESIGNERS
Mia Bortolussi, Suzette Brown,
Elizabeth McKee

CLIENT
Parker-Hannifin
CREATIVE FIRM
Addison Whitney
www.addisonwhitney.com
DESIGNERS
Kimberlee Davis, Nick Irwin, Kristin Everidge,
Trey Walsh, David Grager, Sharon Dunlap

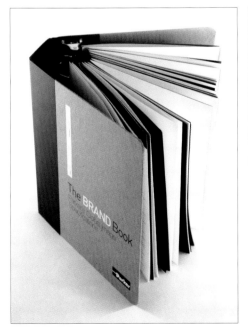

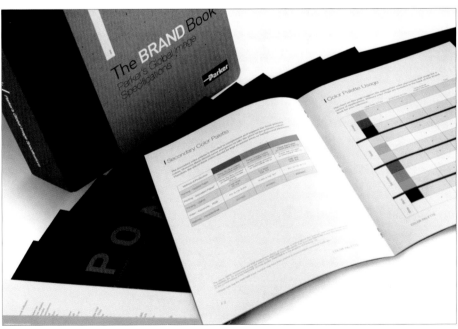

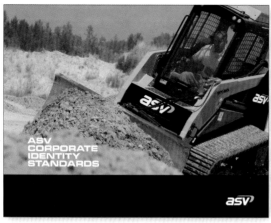

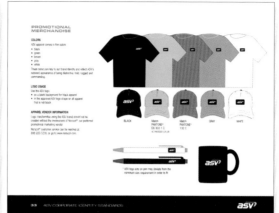

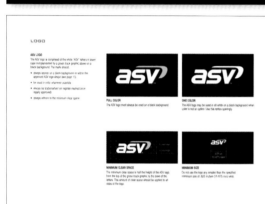

CLIENT
ASV
CREATIVE FIRM
Franke + Fiorella
www.frankefiorella.com
CREATIVE DIRECTOR
Craig Franke
DESIGNER
Todd Monge

CLIENT
Travelers
CREATIVE FIRM
Brandlogic
brandlogic.com
DESIGNERS
Pete Lewis,
Joan Palm (Travelers)

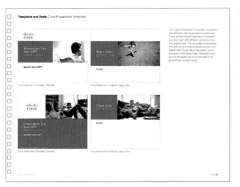

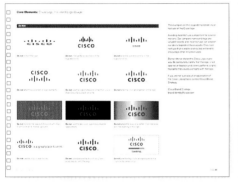

CLIENT
Cisco
CREATIVE FIRM
Cisco
cisco.com
CREATIVE DIRECTOR, COPYWRITER
Gary McCavitt
ART DIRECTOR, PRODUCTION,
COPYWRITER, DESIGNER
Art Kilinski
DESIGNERS
Ronn Harsh, Alex Pista,
Gary Ferguson, Dennis Mancini,
Jeff Brand, Mike Needham
PHOTOGRAPHERS
Achille Bigliardi, Doug Adesko
PHOTOGRAPHY MANAGERS
Vince Lindeman, Kevin Prentice
COPYWRITERS
Mike Sanchez, Joan Banich,
Louis Arreola
PROJECT MANAGER
Linda Mayer
PREPRESS
XYZ Graphics
PRINTING
Moquin Press, Belmont, CA
PRINT BROKER
Bill Littell

CLIENT
College of Engineering &
Comp Science, Syracuse University
CREATIVE FIRM
stressdesign
www.stressdesign.com
DESIGNERS
Renee Stevens, Marc V. Stress,
Christine Walker

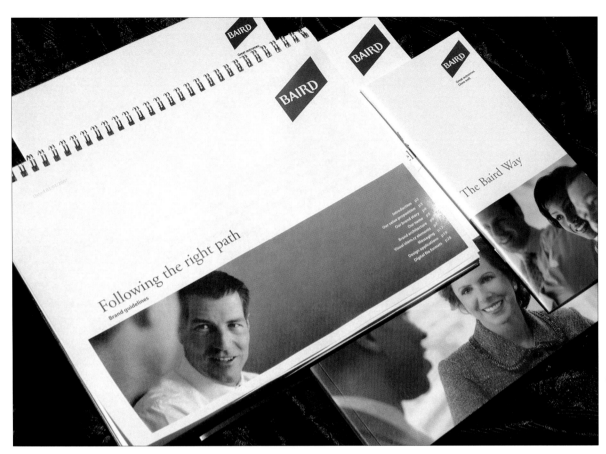

CLIENT
Baird
CREATIVE FIRM
Interbrand NY
www.interbrand.com
CREATIVE DIRECTOR
Kurt Munger
ASSOCIATE CREATIVE DIRECTOR
Carlyn Schlecter
DIRECTOR
Ronan Tiongson
DESIGN DIRECTOR
Van Rals
SENIOR DESIGNER
Marc Bernauer

CLIENT
MedTech
CREATIVE FIRM
stressdesign
www.stressdesign.com
DESIGNERS
Renee Stevens, Marc V. Stress,
Christine Walker

CLIENT
Seattle Seahawks
CREATIVE FIRM
Hornall Anderson Design Works
www.hadw.com
DESIGNERS
Jack Anderson, Andrew Wicklund,
Elmer dela Cruz, Peter Anderson,
Nathan Young

CLIENT
Itzhaki Properties
CREATIVE FIRM
Liska + Associates
www.liska.com
DESIGNERS
Tanya Quick,
Erin Buchanan

MODERN **23**

CLIENT
Moorpark College
CREATIVE FIRM
BBM&D
bbmd-inc.com
DESIGNER
Barbara Brown

MOORPARK COLLEGE

CLIENT
Space Needle
CREATIVE FIRM
Hornall Anderson Design Works
www.hadw.com
DESIGNERS
Jack Anderson,
David Bates,
Javas Lehn

SKY Q

CLIENT
Bananafish for Betesh Group
CREATIVE FIRM
Design Trends
tree52@optonline.net
CREATIVE DIRECTOR
David Un
DESIGNER
Tree Trapanese

Bananafish

CLIENT
Boot Headquarters
CREATIVE FIRM
Paragon Design Group
www.iamparagaon.com
DESIGNER
Andrew Davies

CLIENT
Schnitzer West
CREATIVE FIRM
Hornall Anderson Design Works
www.hadw.com
DESIGNERS
John Anicker,
Larry Anderson,
Jay Hilburn,
Yuri Shvets,
Andrew Wicklund,
Bruce Branson-Meyer

CLIENT
Frederick Wine Trail
CREATIVE FIRM
Octavo Designs
www.8vodesigns.com
DESIGNERS
Mark Burrier,
Sue Hough

CLIENT
Emily Valentine
CREATIVE FIRM
Jack Nadel International
www.nadel.com
SENIOR ART DIRECTOR
Jack Mongkolkasetarin

CLIENT
Set in Your Way Event Planning
CREATIVE FIRM
The Wecker Group
weckergroup.com
DESIGNER
Robert Wecker

CLIENT
Halo Models & Talent Group
CREATIVE FIRM
Paragon Design Group
www.iamparagon.com
DESIGNER
Andrew Davies

CLIENT
Willow Tree Manor
CREATIVE FIRM
Octavo Designs
www.8vodesigns.com
DESIGNERS
Sue Hough, Seth Glass

CLIENT
Hoover& Strong
CREATIVE FIRM
Martin Branding Worldwide
martinbranding.com
CREATIVE DIRECTOR
Dave Martin
ART DIRECTOR
G. Lee Wall

CLIENT
MogoMedia
CREATIVE FIRM
Evenson Design Group
www.evensondesign.com
CREATIVE DIRECTOR
Stan Evenson
DESIGNER
Dallas Duncan

CLIENT
Hill Baptist Church
CREATIVE FIRM
Church Logo Gallery
churchlogogallery.com
DESIGNER
Michael Kern

CLIENT
In Harmony
CREATIVE FIRM
Belyea
belyea.com
DESIGNER
Ron Lars Hansen

CLIENT
Kirkwood Electric
CREATIVE FIRM
Dittmar Design
dittmardesign.com
DESIGNER
Greg Dittmar

CLIENT
Solaria Corporation
CREATIVE FIRM
Factor Design Inc
www.factordesign.com
DESIGNERS
Jeff Zwerner, Tim Guy,
Cindy Steinberg,
Nicholas Davidson

CLIENT
Soltazza
CREATIVE FIRM
CramerSweeney
www.cramesweeney.com
DESIGNER
Dave Girgenti

JUDGE'S WORK
CLIENT
Ferrell Photographics
CREATIVE FIRM
Maple Creative
maplecreative.com
DESIGNER
Thomas White

CLIENT
Tom Fowler, Inc./TFI Envision Inc.
CREATIVE FIRM
Tom Fowler, Inc./TFI Envision Inc.
www.tfienvision.com
DESIGNERS
Elizabeth P. Ball, Mary Ellen Butkus, Brien O'Reilly, Thomas G. Fowler

CLIENT
Smugglers Run Plantation
CREATIVE FIRM
Pierre Rademaker Design
www.rademakerdesign.com
DESIGNERS
Pierre Rademaker,
Debbie Shibata

CLIENT
Clippinger Investment Properties
CREATIVE FIRM
Vince Rini Design
vincerinidesign.com
DESIGNER
Vince Rini

CLIPPINGER
INVESTMENT
PROPERTIES
INCORPORATED

CLIENT
David W. May,
General Contractor, LLC
CREATIVE FIRM
Erin N. May
DESIGNER
Erin N. May

David W. May
GENERAL CONTRACTOR, LLC

CLIENT
Lifeline Food Company, Inc.
CREATIVE FIRM
The Wecker Group
weckergroup.com
DESIGNER
Robert Wecker

CLIENT
Santa Rita Hills Growers
Alliance
CREATIVE FIRM
Mark Oliver, Inc.
www.markoliverinc.com
CREATIVE DIRECTOR
Mark Oliver
ILLUSTRATOR
Tom Hennessy

CLIENT
Purevana
CREATIVE FIRM
Axion Design
axiondesign.com
DESIGNERS
Axion Design Team

CLIENT
JDRF—Nevada Chapter
CREATIVE FIRM
Bridge
DESIGNERS
Victor Rodriguez, Matt Jones,
Patty Mar, Adrian Campuzano

CLIENT
Oregon Garden Resort
CREATIVE FIRM
Pierre Rademaker Design
www.rademakerdesign.com
DESIGNERS
Sara Schultz,
Pierre Rademaker

CLIENT
Orsus—real estate management
CREATIVE FIRM
Eye Integrated
www.eyedidit.com
DESIGNERS
Eva Roberts,
Jason Crain,
Stanton
Blakeslee

CLIENT
La Cornue
CREATIVE FIRM
Factor Design Inc.
www.factordesign.com
DESIGNERS
Jeff Zwerner,
Tim Guy,
Todd Schulte,
Lily Lin

CLIENT
Hadsten House
CREATIVE FIRM
Pierre Rademaker Design
www.rademakerdesign.com
DESIGNERS
Pierre Rademaker,
Debbie Shibata

CLIENT
Lifelike Botanicals
CREATIVE FIRM
Brand, Ltd.
brandltd.com
DESIGNERS
Virginia Martino,
Sandy Schiff

CLIENT
Neighborhood Notes
CREATIVE FIRM
Defteling Design
www.defteling.com
DESIGNERS
Alex Wijnen,
Michelle Fortner

CLIENT
Trupanion
CREATIVE FIRM
Hornall Anderson Design Works
www.hadw.com
DESIGNERS
Michael Martinez, Katie Phipps,
Oliver Hutton

CLIENT
Des Moines East Village
CREATIVE FIRM
Sayles Graphic Design
www.saylesdesign.com
DESIGNER
John Sayles

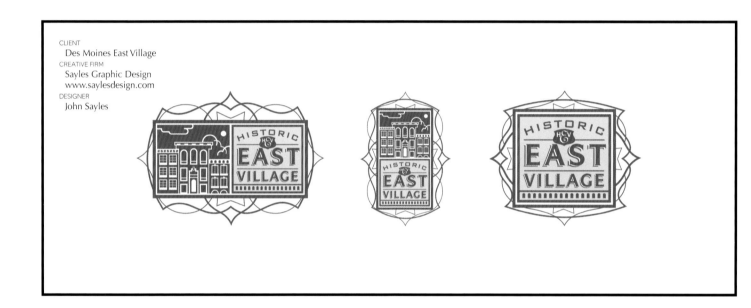

CLIENT
Radiation Oncology Institute
CREATIVE FIRM
Seth Joseph & Co., LLC
www.sethjoseph.com
DESIGNERS
Seth J. Katzen, Amy Bernard

CLIENT
Kinnelon Design
CREATIVE FIRM
Kinnelon Design

CLIENT
Western Image Communications, Inc.
CREATIVE FIRM
Chris Corneal
DESIGNER
Chris Corneal

CLIENT
Bryant Blueberry Farm
CREATIVE FIRM
Higgins Design
www.jhigginsdesign.com
DESIGNER
Jane Higgins

CLIENT
Proclivity
CREATIVE FIRM
Matthew Schwartz Design Studio
www.ms-ds.com
DESIGNER
Matthew Schwartz

CLIENT
Farmers House
CREATIVE FIRM
EAT Advertising & Design
www.eatinc.com
DESIGNERS
Patrice Jobe,
Rachel Eilts,
DeAnne Dodd

CLIENT
OSPAC
CREATIVE FIRM
Stephen Longo Design Associates
DESIGNER
Stephen Longo

CLIENT
Emeraude
CREATIVE FIRM
McMillian Design
www.mcmilliandesign.com
DESIGNER
William McMillian

CLIENT
DCM
CREATIVE FIRM
Gee + Chung Design
www.geechungdesign.com
DESIGNER
Earl Gee

CLIENT
Island Time Clothing
CREATIVE FIRM
Roskelly Inc.
www.roskelly.com
DESIGNER
Thomas C.
Roskelly

CLIENT
Amazon Millworks
CREATIVE FIRM
Z promotion & design, Inc.
www.kitchenmarketing.com
DESIGNER
Philip D. Zaleon

CLIENT
The Vision Council of America
CREATIVE FIRM
Bremmer & Goris Communications
www.goris.com
DESIGNERS
Li-Chow, Miki Lo

CLIENT
Sound Mind Music
CREATIVE FIRM
Evenson Design Group
www.evensondesign.com
CREATIVE DIRECTORS
Stan Evenson,
Mark Sojka
DESIGNER
Dallas Duncan

CLIENT
Zeus Rooster
CREATIVE FIRM
Peterson Ray & Company
www.peterson.com
DESIGNERS
Miler Hung,
Carl Peterson

CLIENT
Success Capital
CREATIVE FIRM
Never Boring Design Associates
www.neverboring.com
DESIGNERS
David Boring,
Julie Orona

CLIENT
Worthington Hotel
CREATIVE FIRM
GCG
gcgadvertising.com
DESIGNERS
Brian Wilburn,
Steve Noble

O'TOOLE + COMPANY

CLIENT
Hula Hut
CREATIVE FIRM
Pierre Rademaker Design
www.rademaker.com
DESIGNERS
Pierre Rademaker,
Debbie Shibata

CLIENT
Richmond Community Services
CREATIVE FIRM
Pisarkiewicz Mazur & Co., Inc.
designpm.com
DESIGNERS
Mary F. Pisarkiewicz,
Stephanie Werthman

CLIENT
Monterey Culinary Arts Foundation
CREATIVE FIRM
The Wecker Group
weckergroup.com
DESIGNER
Robert Wecker

CLIENT
Whitfield Development Group
CREATIVE FIRM
Eye Integrated
www.eyedidit.com
DESIGNERS
Greg Jarrell,
Stanton Blakeslee

CLIENT
Camp Piankatank
CREATIVE FIRM
Church Logo Gallery
churchlogogallery.com
DESIGNER
Michael Kern

CLIENT
Temple Sinai
CREATIVE FIRM
Pisarkiewicz Mazur & Co., Inc.
designpm.com
DESIGNER
Mary F. Pisarkiewicz

CLIENT
Pop N Fold Papers
CREATIVE FIRM
Stephen Longo Design Associates
DESIGNER
Stephen Longo

CLIENT
National Association of Counties
CREATIVE FIRM
Dever Designs
www.deverdesigns.com
DESIGNER
Jeffrey L. Dever

CLIENT
ACS Log Build
CREATIVE FIRM
EAT Advertising & Design
www.eatinc.com
DESIGNERS
Patrice Jobe,
DeAnne Dodd,
Rachel Eilts,
Davin Watne

CLIENT
LaGrange County Community
Foundation
CREATIVE FIRM
MillerWhite, LLC
www.millerwhite.com
DESIGNER
Atsu Kpotufe

CLIENT
St. Paul's Episcopal Church
CREATIVE FIRM
Graves Fowler Creative
www.gravesfowler.com
ART DIRECTOR
Victoria Q. Robinson
DESIGNER
Kristen
Braaten
McPeak

CLIENT
St. Paul Chamber Orchestra
CREATIVE FIRM
Rubin Cordaro Design
ww.rubincordaro.com
DESIGNERS
Jim Cordaro, Bruce Rubin

{ INTERSECTION } { INTERSECTION } { INTERSECTION }

retailocity

AAIM

FUNDACIÓN ÁNGEL RAMOS

MARKET SQUARE

taste of the bay
A CULTURAL GUIDE TO THE AREA'S BEST

CLIENT
Barron & Homesley Orthopedic Specialists
CREATIVE FIRM
Mountain Laurel Advertising, inc.
www.mountainlaureladv.com
DESIGNERS
Russ Dymond, Mark Biller

CLIENT
Hanley Road Church
CREATIVE FIRM
Grizzell & Co.
DESIGNER
John H. Grizzell

CLIENT
PL8SCAN.COM
CREATIVE FIRM
Jack Nadel International
www.nadel.com
SENIOR ART DIRECTOR
Jack Mongkolasetarin

CLIENT
Peterson + Collins Builders
CREATIVE FIRM
The Design Channel
www.thedesignchannel.com
DESIGNERS
David Franek, Jonathan Bruns

CLIENT
American Express
CREATIVE FIRM
Taylor Design
tayordesign.com
DESIGNER
Kristin Shunway

CLIENT
TT W Realty LLC
CREATIVE FIRM
Liska + Associates
www.liska.com
DESIGNERS
Tanya Quick,
Jenn Cash

CLIENT
Phillips Communications
CREATIVE FIRM
Roskelly Inc.
www.roskelly.com
DESIGNER
Thomas C. Roskelly

CLIENT
Sensei Marc Unger
CREATIVE FIRM
Latrice Graphic Design
DESIGNER
Vicki L.
Meloney

CLIENT
New Jersey Ironmen/Newark Arena
CREATIVE FIRM
FAI Design Group
www.faidesigngroup.com
ART DIRECTOR
Robert Scully
DESIGNERS
Robert Scully,
Joshua Dillard

CLIENT
Contemporary Healthcare Capital
CREATIVE FIRM
CramerSweeney
www.cramersweeney.com
DESIGNER
Dave Girgenti

CLIENT
The Alliance for Nonprofit Growth and Opportunity—TANGO
CREATIVE FIRM
Fathom
www.fathom.com
DESIGNER
Ben Callaghan

CLIENT
Integrated Wellness
CREATIVE FIRM
Sayles Graphic Design
www.saylesdesign.com
DESIGNER
John Sayles

CLIENT
Old, Fat, Bald Guys Sports
CREATIVE FIRM
Octavo Designs
www.8vodesigns.com
DESIGNERS
Seth Glass,
Sue Hough

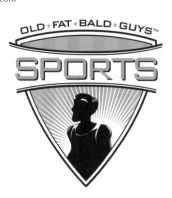

CLIENT
Welcome to Wellness
CREATIVE FIRM
Fleury Design
fleurydesign.com
DESIGNER
Ellen Fleury

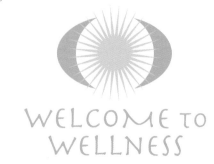

CLIENT
Sipping Dreams
CREATIVE FIRM
Funk/Levis & Associates
funklevis.com
DESIGNERS
Claudia Villegas,
David Funk, Lada Korol

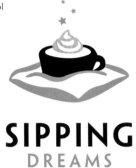

CLIENT
Dilu Entertainment
CREATIVE FIRM
Evenson Design Group
www.evensondesign.com
CREATIVE DIRECTOR
Stan Evenson
DESIGNER
Mark Sojka
ILLUSTRATOR
Wayne Watford

CLIENT
City of North Richland Hills
CREATIVE FIRM
GCG
gcgadvertising.com
DESIGNER
Brian Wilburn

CLIENT
Contemporaine
CREATIVE FIRM
Liska + Associates
www.liska.com
DESIGNER
Steve Liska

CLIENT
Wish Upon A Hero
CREATIVE FIRM
CramerSweeney
www.cramersweeney.com
DESIGNER
Dave Girgenti

CLIENT
American Advertising Federation
CREATIVE FIRM
GCG
gcgadvertising.com
DESIGNER
Brian Wilburn

CLIENT
Wisconsin Historical Society
CREATIVE FIRM
ZD Studios
www.zebradog.com
DESIGNERS
Mark Schmitz,
Louis Cole Scott,
Matt Tedore

CLIENT
Right Hat, LLC
CREATIVE FIRM
Right Hat, LLC
www.righthat.com
DESIGNER
Charlyne Fabi

CLIENT
University of Minnesota
CREATIVE FIRM
ZD Studios
www.zebradog.com
DESIGNERS
Mark Schmitz,
Kris Marconnet

CLIENT
Magnolia Consulting
CREATIVE FIRM
JM DesignHaus, Inc.
jmdesignhaus.com
CREATIVE DIRECTOR
Jodi Myers

CLIENT
Worship Center Community Church
CREATIVE FIRM
Church Logo Gallery
churchlogogallery.com
DESIGNER
Michael Kern

CLIENT
Chocolaterre
CREATIVE FIRM
McDill Design
www.mcdilldesign.com
DIRECTOR
Michael Dillon
CREATIVE
Dave Burkle

CLIENT
Small Farm Training Center
CREATIVE FIRM
Sabingrafik, Inc.
http://tracysabin.com
ILLUSTRATOR, DESIGNER
Tracy Sabin

CLIENT
Flower Creation
CREATIVE FIRM
Keng's Designs
www.kengsdesigns.com
DESIGNER
Robert Keng

CLIENT
creek & co
CREATIVE FIRM
Brohard Design Inc.
www.brohard.com
DESIGNER
William Brohard

CLIENT
The Loyola Foundation
CREATIVE FIRM
Graves Fowler Creative
www.gravesfowler.com
DESIGNER
Jeffrey Everett

CLIENT
San Diego Food Bank
CREATIVE FIRM
ParkerWhite
http://www.parkerwhite.com
ART DIRECTOR
Cindy White
ILLUSTRATOR
Tracy Sabin

CLIENT
Sequim Lavender Growers Association
CREATIVE FIRM
Laurel Black Design
www.laurelblack.com
DESIGNER
Laurel Black

CLIENT
Prodigy Partnership
CREATIVE FIRM
Martin Branding
martinbranding.com
CREATIVE DIRECTOR
Dave Martin
ART DIRECTOR
Glee Wall

CLIENT
Cultural Elements
CREATIVE FIRM
Chip Tolaney
www.culturalelements.com
DESIGNER
Chip Tolaney

JUDGE'S WORK
CLIENT
Sur la Table
CREATIVE FIRM
Lemley Design
www.lemleydesign.com
DESIGNERS
David Lemley, Ensi Mofasser, Coventry Jankowski

CLIENT
Paella Alfresco
CREATIVE FIRM
Roskelly Inc.
www.roskelly.com
DESIGNER
Thomas C. Roskelly

CLIENT
Art Directors Club of New Jersey
CREATIVE FIRM
Stephen Longo Design Associates
DESIGNER
Stephen
Longo

CLIENT
Banner Pharmacaps
CREATIVE FIRM
Addison Whitney
www.addisonwhitney.com
DESIGNERS
Kristin Everidge, Nick Irwin,
Trey Walsh, Kimberlee Davis

CLIENT
1st Lathrop Dental
CREATIVE FIRM
Prographic Design Inc.
prographicdesign.com
DESIGNER
Vanitha Alagirisamy

CLIENT
New Life Management
CREATIVE FIRM
Crowley Webb and Associates
crowleywebb.com
DESIGNERS
Katie Hazel, Kelly Gambino

CLIENT
Chrysler LLC
CREATIVE FIRM
Iconix Inc.
www.iconixinc.com
DESIGNER
Renée LeClair

CLIENT
Gluten Free Foundation
CREATIVE FIRM
Conry Design
www.conrydesign.com
DESIGNER
Rhonda Conry

CLIENT
Teach to Fish
CREATIVE FIRM
Brohard Design Inc.
www.brohard.com
DESIGNER
William Brohard

CLIENT
Schools of Promise, Syracuse University
CREATIVE FIRM
stressdesign
www.stressdesign.com
DESIGNERS
Christine Walker,
Marc V. Stress

CLIENT
Covenant House
CREATIVE FIRM
Verse Group
versegroup.com
CREATIVE DIRECTORS
Michael Thibodeau,
Sylvia Chu
DESIGNERS
Marina Binns,
Marco Acevedo

CLIENT
Robinson Home Products
CREATIVE FIRM
Michael Orr + Associates, Inc.
michaelorrassociates.com
DESIGNERS
Michael R. Orr,
Thomas Freeland

CLIENT
Charles Stinson Archtects
CREATIVE FIRM
Rubin Cordaro Design
www.rubincordaro.com
DESIGNERS
Jim Cordaro,
Bruce Rubin

CLIENT
Tracy Urgent Care
CREATIVE FIRM
Prographic Design
prographicdesign.com
DESIGNER
Vanitha Alagirisamy

CLIENT
National Association of School Psychologists
CREATIVE FIRM
Octavo Designs
www.8vodesigns.com
DESIGNERS
Seth Glass,
Sue Hough

CLIENT
Yogali—fun yoga for kids
CREATIVE FIRM
Niza Hanany Design
DESIGNER
Niza Hanany

CLIENT
Splender Financial
CREATIVE FIRM
Factor Design Inc.
www.factordesign.com
DESIGNERS
Jeff Zwerner, Tim Guy,
Chris Swenson,
James Songcayawon

CLIENT
Odyssey Lifestyle
CREATIVE FIRM
Brand, Ltd.
brandltd.com
DESIGNERS
Virginia
Martino,
Anne
Bonds

CLIENT
The East-West Center
CREATIVE FIRM
Very Memorable Design
http://www.vm.com
DESIGNER
Michael
Pinto

CLIENT
Three Rivers Rowing Assoc.
CREATIVE FIRM
Elias/Savion Adv.
elias-savion.com
DESIGNER
Ronnie
Savion

CLIENT
David Bebon
CREATIVE FIRM
Roskelly Inc.
www.roskelly.com
DESIGNER
Thomas C. Roskelly

CLIENT
Café Yumm!
CREATIVE FIRM
Hornall Anderson Design Works
www.hadw.com

DESIGNERS
Larry Anderson,
Bruce Branson-Meyer,
Jay Hilburn, Kathleen Gibson

CLIENT
Seattle Waldorf School
CREATIVE FIRM
Higgins Design
www.jhigginsdesign.com
DESIGNER
Jane Higgins

CLIENT
Brands United
CREATIVE FIRM
Roskelly Inc.
www.roskelly.com
DESIGNER
Thomas C. Roskelly

CLIENT
PEMCO Insurance
CREATIVE FIRM
Belyea
belyea.com
DESIGNER
Ron Lars
Hanen

CLIENT
Days Inn
CREATIVE FIRM
Verse Group
versegroup.com
CREATIVE DIRECTORS
Michael Thibodeau,
Sylvia Chu
DESIGNERS
Marina Binns,
Doris Dell,
Marco
Acevedo

CLIENT
Hudner Oncology Center
CREATIVE FIRM
Roskelly Inc.
www.roskelly.com
DESIGNER
Thomas C. Roskelly

CLIENT
Y.S. Raj Global Mission
CREATIVE FIRM
Dever Designs
www.deverdesigns.com
DESIGNER
Jeffrey L. Dever

CLIENT
Robbins Bros.
CREATIVE FIRM
Zero Gravity Design Group
www.zerogny.com
DESIGNERS
Jennifer
Mariotti,
Chuck
Killorin

CLIENT
Imag'in Greeting Cards
CREATIVE FIRM
Marqium
www.marqium.com
DESIGNER
Fadi Yaacoub

CLIENT
Honest Foods
CREATIVE FIRM
Mark Oliver, Inc.
www.markoliverinc.com
DESIGNER
Mark Oliver
ILLUSTRATOR
Steve Bjorkman

CLIENT
Brown's Landing
CREATIVE FIRM
Markatos | Moore
http:mm-sf.com.com
ART DIRECTOR
Peter Markatos
ILLUSTRATOR
Tracy Sabin

CLIENT
Vinotéque
CREATIVE FIRM
Evenson Design Group
www.evensondesign.com
CREATIE DIRECTORS
Stan Evenson,
Mark Sojka
DESIGNERS
Mark Sojka,
Nicole Splater

CLIENT
Sena Kean Manor
CREATIVE FIRM
Momentum Communications
DESIGNER
Laurie Klein Westhafer

CLIENT
InnerBanks Capital
CREATIVE FIRM
Eye Integrated
www.eyedidit.com
DESIGNER
Stanton Blakeslee

CLIENT
Steve Schulman
CREATIVE FIRM
The Wecker Group
weckergroup.com
DESIGNER
Robert Wecker

CLIENT
The Stables at Millennium
CREATIVE FIRM
Roskelly Inc.
www.roskelly.com
DESIGNER
Thomas C. Roskelly

CLIENT
Sports Village Reality
CREATIVE FIRM
GCG
gcgadvertising.com
DESIGNER
Kris Copeland

CLIENT
Luna Roasters Gourmet Coffee & Tea
CREATIVE FIRM
Evenson Design Group
www.evensondesign.com
CREATIVE DIRECTOR
Stan Evenson
DESIGNER, ILLUSTRATOR
Mark Sojka

JUDGE'S WORK
CLIENT
Twin Branch
CREATIVE FIRM
Maple Creative
maplecreative.com
DESIGNER
Thomas White

CLIENT
Rivenrock Capital LLC
CREATIVE FIRM
Evenson Design Group
www.evensondesign.com
CREATIVE DIRECTORS
Stan Evenson,
Mark Sojka
DESIGNER
Katja Loesch

CLIENT
Deb Catering
CREATIVE FIRM
EAT Advertising & Design
www.eatinc.com
DESIGNERS
Patrice Jobe,
DeAnne Dodd,
Rachel Eilts

CLIENT
A.W. Shucks
CREATIVE FIRM
The Wecker Group
weckergroup.com
DESIGNERS
Matt Gnibus,
Robert Wecker

CLIENT
U.S. Navy
CREATIVE FIRM
Slice
www.slice-works.com
ART DIRECTOR
Dick Rabil
DESIGNER
Juana Merlo

CLIENT
Earth First Farms
CREATIVE FIRM
Richard Zeid Design
www.rzdesign.com
DESIGNER
Richard Zeid

Earth First Farms

CLIENT
MND Media
CREATIVE FIRM
McMillian Design
www.mcmilliandesign.com
DESIGNERS
William McMillian,
Lindsay Giuffrida, Bill McDevitt

CLIENT
Uniglory Studio
CREATIVE FIRM
Uniglory Studio
www.uniglorystudio.com
DESIGNER
Lauren Castady

CLIENT
Newport Orthopedic Institute
CREATIVE FIRM
Vince Rini Design
vincerinidesign.com
DESIGNER
Vince Rini

CLIENT
Chrysler LLC—Dodge
CREATIVE FIRM
Iconix Inc.
www.iconixinc.com
DESIGNER
Mary Kay Gill

DODGE RAM MEGA CAB®
musical chairs

CLIENT
posh + funk Couture
CREATIVE FIRM
Tamar Graphics
www.tamargraphics.com
DESIGNER
Tamar Wallace

CLIENT
Prodigy Partnership
CREATIVE FIRM
Martin Branding Worldwide
martinbranding.com
CREATIVE DIRECTOR
Dave Martin
ART DIRECTOR
G. Lee Wall

CLIENT
Cisco
CREATIVE FIRM
GSID team
cisco.com

CREATIVES
Gary McCavitt, Ronn Harsh, Bob Jones, Jerry Kuyper,
Joe Finnochiaro, Gary Ferguson, Dennis Mancini,
Alex Pista, Jeff Brand, Art Kilinski, Mike Needham,
Johnny Thompson, Linda Mayer

CLIENT
Guck Boats
CREATIVE FIRM
Roskelly Inc.
www.roskelly.com
DESIGNER
Thomas C. Roskelly

CLIENT
White Horse Farm
CREATIVE FIRM
Little
www.littleonline.com
DESIGNER
Joe Chaffee

CLIENT
Extraordinary Interiors
CREATIVE FIRM
Prographic Design Inc.
prographicdesign.com
DESIGNER
Vanitha
Alagirisamy

CLIENT
Al Minicola General Insurance Agency
CREATIVE FIRM
Jack Nadel International
www.nadel.com
SENIOR ART DIRECTOR
Jack Mongkolkasetarin

CLIENT
The Campus Theatre
CREATIVE FIRM
MFDI
DESIGNER
Mark Fertig

CLIENT
Qubica AMF
CREATIVE FIRM
Martin Branding Worldwide
martinbranding.com
CREATIVE DIRECTOR
Dave Martin

CLIENT
Culture Advertising Design
CREATIVE FIRM
Culture Advertising Design
www.culture-ad.com
ART DIRECTOR
Craig Brimm

CLIENT
Northway Community Church
CREATIVE FIRM
FSC Marketing Communications
www.fscmc.com
CREATIVE DIRECTOR, DESIGNER
Bryan Brunsell

CLIENT
Seviche
CREATIVE FIRM
Elias/Savion Adv.
elias-savion.com
DESIGNER
Ronnie Savion

CLIENT
Adirondack Plowing
CREATIVE FIRM
Kinnelon Design

CLIENT
PLATO Learning
CREATIVE FIRM
Peggy Lauritsen Design Group
www.pldg.com
ART DIRECTOR, DESIGNER
Brian Danaher

CLIENT
Teens for Safe Cosmetics
CREATIVE FIRM
Axion Design
axiondesign.com
DESIGNERS
Axion Design Team

CLIENT
Praxis
CREATIVE FIRM
Crowley Webb and Associates
crowleywebb.com
DESIGNER
Kelly Gambino

CLIENT
Susan Oldrid Interior Design
CREATIVE FIRM
Roskelly Inc.
www.roskelly.com
DESIGNER
Thomas C. Roskelly

CLIENT
The Vineyard
CREATIVE FIRM
Chris Corneal
DESIGNER
Chris Corneal

CLIENT
Sparkles—Auto & Pet Wash
CREATIVE FIRM
Marcia Herrmann Design
www.her2man2.com

CLIENT
Paulinskill Poetry Project
CREATIVE FIRM
Stephen Longo Design Associates
DESIGNER
Stephen Longo

CLIENT
Readers Make Leaders
CREATIVE FIRM
Culture Advertising Design
www.culture-ad.com
ART DIRECTOR
Craig Brimm

CLIENT
City of North Richland Hills
CREATIVE FIRM
GCG
gcgadvertising.com
DESIGNER
Bill Buck

CLIENT
Earth Mothers
CREATIVE FIRM
GCG
gcgadvertising.com
DESIGNER
Brian Wilburn

CLIENT
NASA
CREATIVE FIRM
Crabtree + Company
www.crabtreecompany.com
DESIGNERS
Susan Angrisani,
Lisa Suchy,
Rod Vera,
Forrest Dunnavant,
Rob Harlow

CLIENT
SDG Architects Inc.
CREATIVE FIRM
Pierre Rademaker Design
ww.rademakerdesign.com
DESIGNERS
Pierre Rademaker, Debbie Shibata

CLIENT
Rodah Maxwell
CREATIVE FIRM
Culture Advertising Design
www.culture-ad.com
ART DIRECTOR
Craig Brimm

CLIENT
Tealeaf
CREATIVE FIRM
Connie Hwang Design
www.conniehwangdesign.com
DESIGNER
Connie Hwang

CLIENT
American Academy of
Optometry
CREATIVE FIRM
Graves Fowler Creative
www.gravesfowler.com
DESIGNER
Jeffrey Everett

CLIENT
Green Bay East High Soccer Booster Club
CREATIVE FIRM
Daniel Green Eye-D Design
DESIGNER
Daniel Green

CLIENT
Red Dog Spa and Boutique
CREATIVE FIRM
Studio Picotee
www.studiopicotee.com
DESIGNERS
Heather Landers,
Maura Houston

CLIENT
Pittsburgh Cultural Trust
CREATIVE FIRM
Robert Meyers Design
robertmeyersdesigns.com
DESIGNER
Robert Meyers

CLIENT
Copeland Properties
CREATIVE FIRM
Pierre Rademaker Design
www.rademakerdesign.com
DESIGNERS
Pierre Rademaker,
Sara Schultz

CLIENT
Altair Engineering
CREATIVE FIRM
Visual Syntax/Design
DESIGNERS
Daniel Kidwell, Peter Megert

CLIENT
Humanitri
CREATIVE FIRM
ProWolfe Partners
www.prowolfe.com
DESIGNER
Doug Wolfe

CLIENT
Chrysler LLC—Jeep
CREATIVE FIRM
Iconix Inc.
www.iconixinc.com
DESIGNER
Mary
Kay Gill

CLIENT
215 Secure
CREATIVE FIRM
Singularity Design
www.singularitydesign.com
DESIGNER
Chris Counter

CLIENT
Sterner Consulting
CREATIVE FIRM
Mona MacDonald Design
DESIGNER
Mona MacDonald

CLIENT
New Life Management
CREATIVE FIRM
Crowley Web and Associates
crowleywebb.com
DESIGNER
Katie Hazel

CLIENT
Boston Book Festival
CREATIVE FIRM
Gill Fishman Associates
DESIGNER
Alicia
Ozjowski

CLIENT
Asparagus
CREATIVE FIRM
Richard Zeid Design
www.rzdesign.com
DESIGNER
Richard Zeid

CLIENT
Visiting Nurses Association
CREATIVE FIRM
Fathom
www.fathom.net
DESIGNER
Ben
Callaghan

CLIENT
Ecotope
CREATIVE FIRM
Roskelly
www.roskelly.com
DESIGNER
Thomas
C. Roskelly

CLIENT
Green Store
CREATIVE FIRM
Funk/Levis & Associates
funklevis.com
DESIGNERS
Chris Berner,
Claudia Villegas

CLIENT
Bill Zbaren
CREATIVE FIRM
Liska + Associates
www.liska.com
DESIGNERS
Steve Liska, Vanessa Rue

CLIENT
TrueNicks
CREATIVE FIRM
Roskelly Inc.
www.roskelly.com
DESIGNER
Thomas C. Roskelly

CLIENT
San Luis Obispo County Historical Society
CREATIVE FIRM
Pierre Rademaker Design
www.rademakerdesign.com
DESIGNERS
Pierre Rademaker,
Debbie
Shibata

CLIENT
Eat Unique Cafe + Catering
CREATIVE FIRM
Mona MacDonald Design
DESIGNER
Mona MacDonald

CLIENT
National Steinbeck Center
CREATIVE FIRM
The Wecker Group
weckergroup.com
DESIGNERS
Robert Wecker,
Matt Gnibus

CLIENT
Gypsy Voice Overs
CREATIVE FIRM
Evenson Design Group
www.evensondesign.com
CREATIVE DIRECTORS
Stan Evenson,
Mark Sojka
DESIGNER
Angela Kim

CLIENT
Victor & Antonio Ayala
CREATIVE FIRM
MXGraphics
DESIGNER
Jorge Flores-Vallejo

CLIENT
O'Connor House Museum
CREATIVE FIRM
Addison Clark
www.addison-clark.com
CREATIVE DIRECTOR, DESIGNER
Andy Matznick

CLIENT
Skeleton Coast Imports
CREATIVE FIRM
The Wecker Group
weckergroup.com
DESIGNERS
Robert Wecker,
Matt Gnibus

CLIENT
Baja 1000 Development Group LLC
CREATIVE FIRM
Phinney Bischoff Design House
www.pbdh.com
DESIGNERS
David Cole, Dean Hart

CLIENT
City Avenue Special Services District
CREATIVE FIRM
Roskelly
www.roskelly.com
DESIGNER
Thomas C. Roskelly

CLIENT
Wauwatosa School District
CREATIVE FIRM
Catral Doyle creative
cdcreative.com

CLIENT
Oakes Coffee & Bottled Water
CREATIVE FIRM
Sire Advertising
www.sireadvertising.com
DESIGNERS
Shawn Felty,
Jessica Varner,
Sumer Buttorff

CLIENT
Three Dog Creative
CREATIVE FIRM
Robert Meyers Desgn
robertmeyersdesign.com
DESIGNERS
Douglas Goldsmith,
Robert Meyers

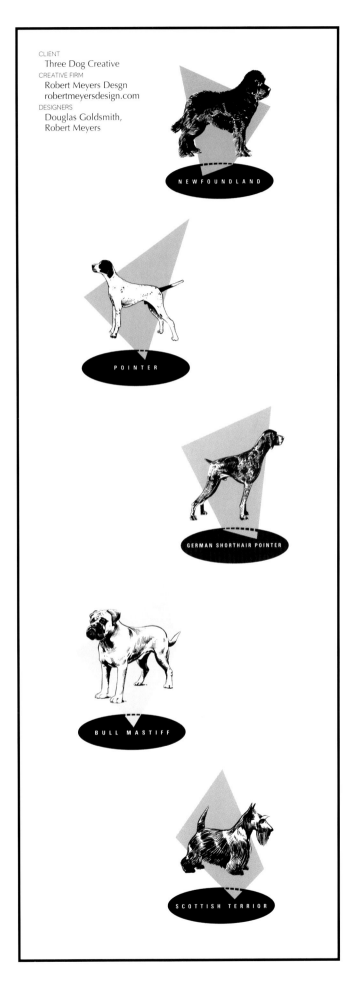

CLIENT
Vh1 Save the Music Foundation
CREATIVE FIRM
Alexander Isley Inc.
www.alexanderisley.com
CREATIVE DIRECTOR
Alexander Isley
MANAGING DIRECTOR
Aline Hilford
DESIGNER
George Kokkinidis

CLIENT
IT Direct
CREATIVE FIRM
Fathom
www.fathom.com
DESIGNERS
Ben Callaghan, Brent Robertson

CLIENT
Guiding Eyes for the Blind
CREATIVE FIRM
Tom Fowler, Inc./TFI Envision Inc.
www.tfienvision.com
DESIGNERS
Elizabeth P. Ball, Mary Ellen Butkus

CLIENT
PSI—five and alive
CREATIVE FIRM
Group T Design
www.grouptdesign.com
DESIGNER
Tom Klinedinst

CLIENT
Park Community Church
CREATIVE FIRM
Christopher Gorz Design
www.studiochris.com
DESIGNER
Christopher Gorz

CLIENT
Agency Access
CREATIVE FIRM
Matthew Schwartz Design Studio
www.ms-ds.com
DESIGNER
Matthew Schwartz

CLIENT
Calvary Baptist Church
CREATIVE FIRM
Church Logo Gallery
churchlogogallery.com
DESIGNER
Michael Kern

CLIENT
New Hampshire Network of Child Advocacy Centers
CREATIVE FIRM
Pensaré Design Group
www.pensaredesign.com
CREATIVE DIRECTOR
Mary Ellen Vehlow

DESIGNER
Amy E. Billingham
ILLUSTRATOR
Robin Zingone

CLIENT
E3 Communications
CREATIVE FIRM
Crowley Webb and Associates
crowleywebb.com
DESIGNER
Katie Hazel

CLIENT
Select Door and Window
CREATIVE FIRM
Church Logo Gallery
churchlogogallery.com
DESIGNER
Michael Kern

CLIENT
Valence Edge
CREATIVE FIRM
Fathom
www.fathom.net
DESIGNERS
Ben Callaghan, Bil Jenak

CLIENT
Urban Land Institute
CREATIVE FIRM
Phoenix Creative Group
www.phoenixcreative group.com
DESIGNERS
Nick Lutkins,
Sean Mullins,
Nicole Kassolis,
Dan Cosgrove

CLIENT
American Institute of Architects Minnesota
CREATIVE FIRM
Rubin Cordro Design
www.rubincordaro.com
DESIGNERS
Jim Cordaro, Bruce Rubin

CLIENT
Art Guard
CREATIVE FIRM
Frank D'Astolfo Design
DESIGNER
Frank D'Astolfo

CLIENT
Circle Seven Radio
CREATIVE FIRM
Peterson Ray & Company
www.peterson.com
DESIGNER
Miler Hung

CLIENT
Christopher Martins
CREATIVE FIRM
Silver Creative Group
silvercreativegroup.com
DESIGNERS
Suzanne Petrow,
Donna Bonato

CLIENT
Tailz 'Er Waggin'
CREATIVE FIRM
Oh Frenzy!
www.ohfrenzy.com
DESIGNERS
Charlie Honold,
Tara Langley

CLIENT
Make-A-Wish Foundation of Southern Florida
CREATIVE FIRM
Goldforest
www.goldforest.com
CREATIVE DIRECTOR, COPYWRITER
Lauren Gold
ART DIRECTOR, DESIGNER
Bibiana Pulido

STUDENT WORK

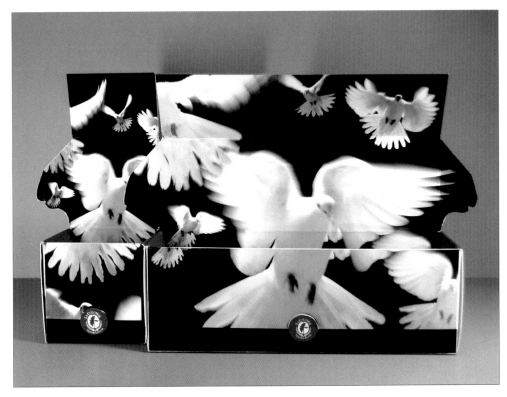

PROJECT
Tags, Bags, Labels, & Boxes
SCHOOL
Drexel University Antoinette Westphal College
of Media Arts & Design
INSTRUCTOR
Jody Graff
DESIGNER
Bob O'Mara

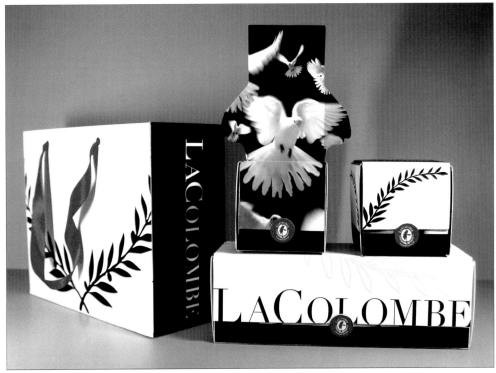

PROJECT
Trademark/Logo Design
SCHOOL
Susquehanna University
INSTRUCTOR
Mark Fertig
DESIGNER
Tim Storck

SUBTERRANEAN
· B O O K S ·

PROJECT
Trademark/Logo Design
SCHOOL
Michigan State University
INSTRUCTOR
Chris Corneal
DESIGNER
Design Center of
Michigan State University

outdoor
expressions

PROJECT
Trademark/Logo Design
SCHOOL
Susquehanna University
INSTRUCTOR
Mark Fertig
DESIGNER
Jessica Oswald

SUBTERRANEAN
BOOK COMPANY

PROJECT
Trademark/Logo Design
SCHOOL
Pennsylvania College of
Art and Design
INSTRUCTOR
Pam Barby
DESIGNER
Ismael Padilla

ZOOBAR

PROJECT
Trademark/Logo Design
SCHOOL
Drexel University Antoinette Westphal College
of Media Arts & Design
INSTRUCTOR
E. June Roberts-Lunn
DESIGNER
Kevin Dietrich

berry & homer
LARGE FORMAT DIGITAL PRINTING

PROJECT
Trademark/Logo Design
SCHOOL
Susquehanna University
INSTRUCTOR
Mark Fertig
DESIGNER
Allison Kratzer

INDIA
SPICE
COMPANY

PROJECT
Trademark/Logo Design
SCHOOL
Susquehanna University
INSTRUCTOR
Mark Fertig
DESIGNER
Christine Ottley

CANNON RIVER CONSULTING
program evaluation . institutional research . statistical analysis

PROJECT
Trademark/Logo Design
SCHOOL
Susquehanna University
INSTRUCTOR
Mark Fertig
DESIGNER
Stephanie Rohde

BESSO'S
Coffee • Pastries • Gelato

PROJECT
Trademark/Logo Design
SCHOOL
University of Hartford
INSTRUCTOR
John Nordyke
DESIGNER
Mike Dionne

sakurair

PROJECT
Trademark/Logo Design
SCHOOL
Illinois State University
INSTRUCTOR
Julie Johnson
DESIGNER
Sean Roosevelt

INTERNATIONAL FLYING FARMERS

PROJECT
Trademark/Logo Design
SCHOOL
Susquehanna University
INSTRUCTOR
Mark Fertig
DESIGNER
Kelly Ely

Heartland
P A S T A

PROJECT
Trademark/Logo Design
SCHOOL
Monmouth University
INSTRUCTOR
Karen Bright
DESIGNER
Lacey Ackerman

PROJECT
Trademark/Logo Design
SCHOOL
Susquehanna University
INSTRUCTOR
Mark Fertig
DESIGNER
Katrina Sprague

BESSO'S
COFFEE • PASTRIES • GELATO

PROJECT
Trademark/Logo Design
SCHOOL
Susquehanna University
INSTRUCTOR
Mark Fertig
DESIGNER
Jessica Oswald

PROJECT
Trademark/Logo Design
SCHOOL
Susquehanna University
INSTRUCTOR
Mark Fertig
DESIGNER
Christine Ottley

Friends of New Orleans

PROJECT
Trademark/Logos
SCHOOL
Pennsylvania College of
Art and Design
INSTRUCTOR
James Bubb
DESIGNER
Shaun Hartley

EcoSmart
CONSUMER PRODUCTS

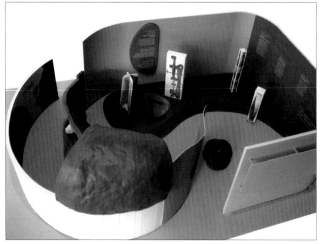

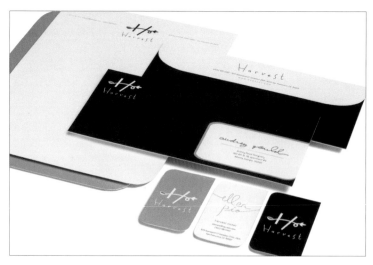

PROJECT
Signage & Environmental Graphics
SCHOOL
Drexel University Antoinette Westphal
College of Media Arts & Design
INSTRUCTOR
Jody Graff
DESIGNERS
Ruslan Khaydarov, Bradley Breneisen,
Maria-Nefeli Stavrinidi

PROJECT
Stationery
SCHOOL
Portfolio Center
DESIGNER
Audrey Gould

PROJECT
Brochures
SCHOOL
Pennsylvania College of Art and Design
INSTRUCTOR
James Bubb
DESIGNER
Kevin Harder

PROJECT
Packaging
SCHOOL
Susquehanna University
INSTRUCTOR
Mark Fertig
DESIGNER
Kyle Nalls

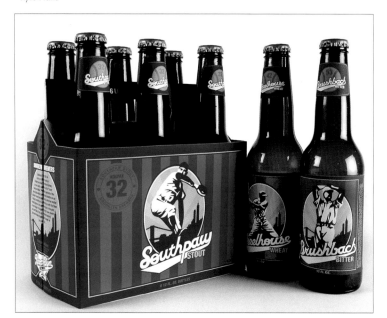

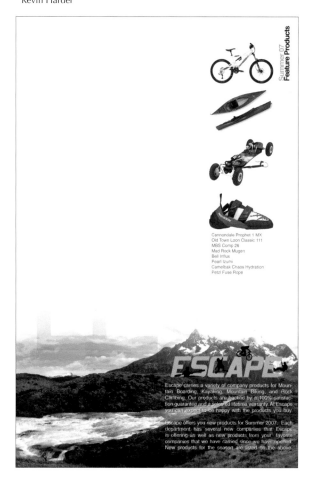

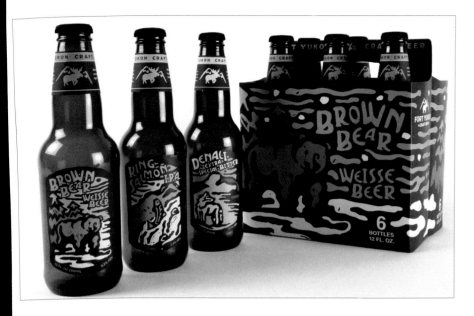

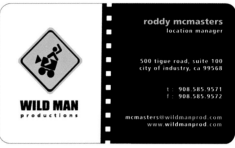

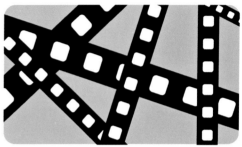

PROJECT
 Packaging
SCHOOL
 Susquehanna University
INSTRUCTOR
 Mark Fertig
DESIGNER
 Anne Toal

PROJECT
 Business Cards
SCHOOL
 Susquehanna University
INSTRUCTOR
 Mark Fertig
DESIGNER
 Joe Pilcavage

PROJECT
 Packaging
SCHOOL
 Susquehanna University
INSTRUCTOR
 Mark Fertig
DESIGNER
 Jenelle Anthony

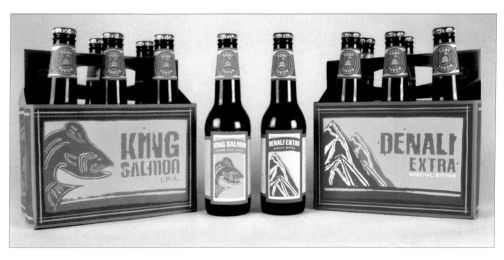

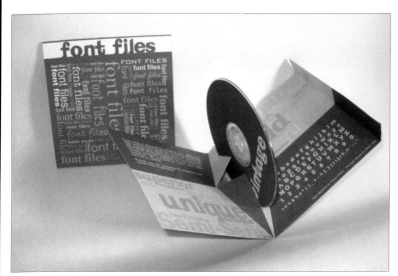

PROJECT
 CDs & DVDs
SCHOOL
 Pennsylvania College of Art and Design
INSTRUCTOR
 Christina Hess
DESIGNER
 Elaine Leer

PROJECT
Trademarks/Logos
SCHOOL
Susquehanna University
INSTRUCTOR
Mark Fertig
DESIGNER
Kelly Ely

PROJECT
Trademarks/Logos
SCHOOL
Portfolio Center
DESIGNER
Larry Luk

PROJECT
Trademarks/Logos
SCHOOL
Portfolio Center
DESIGNER
Maria Zafft

PROJECT
Trademarks/Logos
SCHOOL
Portfolio Center
DESIGNER
Banu Soyturk

PROJECT
Trademarks/Logos
SCHOOL
Portfolio Center
INSTRUCTOR
Hank Richardson
DESIGNERS
Larry Luk,
Britton Stewart

PROJECT
Trademarks/Logos
SCHOOL
Portfolio Center
DESIGNER
Greg Meyers

PROJECT
Trademarks/Logos
SCHOOL
Susquehanna University
INSTRUCTOR
Mark Fertig
DESIGNER
Anne Toal

PROJECT
Trademarks/Logos
SCHOOL
Portfolio Center
DESIGNER
Georgios Saliaris

PROJECT
Trademarks/Logos
SCHOOL
Susquehanna University
INSTRUCTOR
Mark Fertig
DESIGNER
Katrina Sprague

PROJECT
Trademarks/Logos
SCHOOL
Portfolio Center
DESIGNER
Maria Bisso

PROJECT
Trademarks/Logos
SCHOOL
Drexel University Antoinette Westphal College
of Media Arts & Design
INSTRUCTOR
E. June Roberts-Lunn
DESIGNER
Allison Fegan

PROJECT
Trademarks/Logos
SCHOOL
Portfolio Center
DESIGNER
Larry Luk

PROJECT
Packaging
SCHOOL
Portfolio Center
INSTRUCTOR
Heather Kase
DESIGNER
Amanda Babcock

PROJECT
Brochures
SCHOOL
Illinois State University
INSTRUCTOR
Julie Johnson
DESIGNER
Shawn Prokes

PROJECT
Promotions
SCHOOL
Portfolio Center
INSTRUCTOR
Hank Richardson
DESIGNER
Larry Luk

PROJECT
Packaging
SCHOOL
Susquehanna University
INSTRUCTOR
Mark Fertig
DESIGNER
Robert Prall

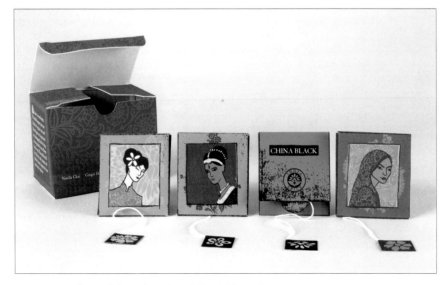

PROJECT
CDs & DVDs
SCHOOL
Susquehanna University
INSTRUCTOR
Mark Fertig
DESIGNER
Kelly Ely

PROJECT
Announcements, Cards, & Invitations
SCHOOL
Illinois State University
INSTRUCTOR
Julie Johnson
DESIGNER
Sean Roosevelt

PROJECT
Stationery
SCHOOL
Susquehanna University
INSTRUCTOR
Mark Fertig
DESIGNER
Tracy Brauner

PROJECT
Business Cards
SCHOOL
Susquehanna University
INSTRUCTOR
Mark Fertig
DESIGNER
Kelly Ely

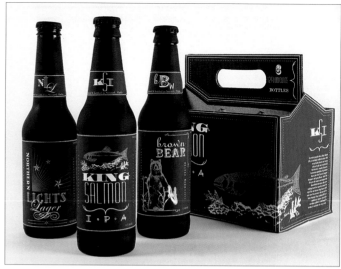

PROJECT
CDs & DVDs
SCHOOL
Susquehanna University
INSTRUCTOR
Mark Fertig
DESIGNER
Andrew Goodsell

PROJECT
Packaging
SCHOOL
Susquehanna University
INSTRUCTOR
Mark Fertig
DESIGNER
Allison Kratzer

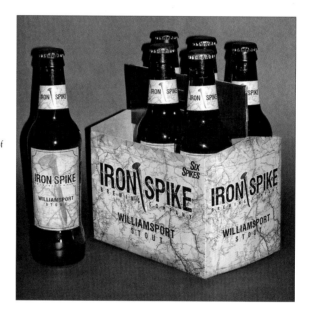

PROJECT
Packaging
SCHOOL
Pennsylvania College of
Art and Design
INSTRUCTOR
Jim Bubb
DESIGNER
Chad Campbell

PROJECT
Packaging
SCHOOL
Drexel University Antoinette Westphal
College of Media Arts & Design
INSTRUCTOR
Sandy Stewart
DESIGNER
Patrick McKeever

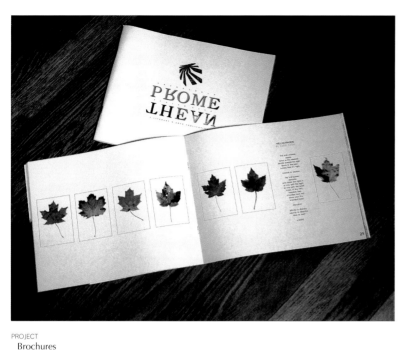

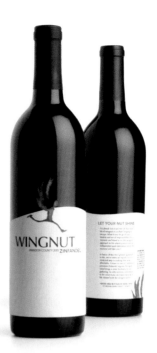

PROJECT
Packaging
SCHOOL
Portfolio Center
INSTRUCTOR
Hank Richardson
DESIGNER
Amanda Babcock

PROJECT
Brochures
SCHOOL
County College of Morris
INSTRUCTOR
Stephen Longo
DESIGNERS
Jennifer Bassora, John Farischon,
Christopher Warzocha

PROJECT
Packaging
SCHOOL
Susquehanna University
INSTRUCTOR
Mark Fertig
DESIGNER
Courtney Thibeault

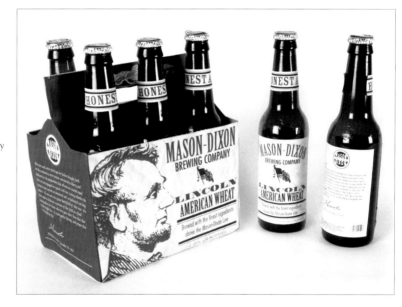

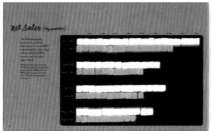

PROJECT
Annual Reports
SCHOOL
Drexel University Antoinette Westphal
College of Media Arts & Design
INSTRUCTOR
Jody Graff
DESIGNER
Julia Fiorello

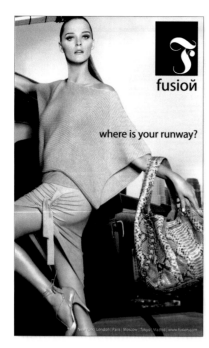

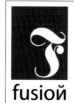

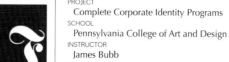

PROJECT
Complete Corporate Identity Programs
SCHOOL
Pennsylvania College of Art and Design
INSTRUCTOR
James Bubb
DESIGNER
Yelizaveta S. Semerik

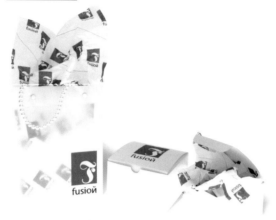

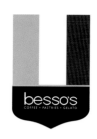 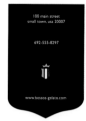

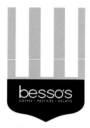

PROJECT
Business Cards
SCHOOL
Susquehanna University
INSTRUCTOR
Mark Fertig
DESIGNER
Joe Pilcavage

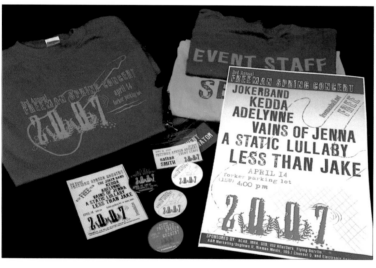

PROJECT
Promotions
SCHOOL
Iowa State University
INSTRUCTOR
Alan Mickelson
DESIGNER
Kelly Leaman

PROJECT
Packaging
SCHOOL
Susquehanna University
INSTRUCTOR
Mark Fertig
DESIGNER
Stevie Long-Blyler

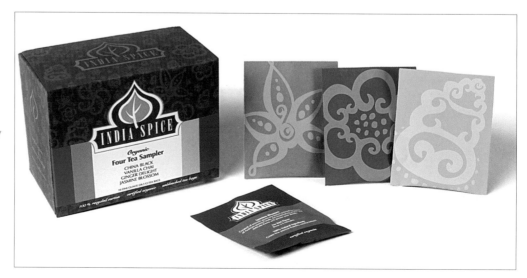

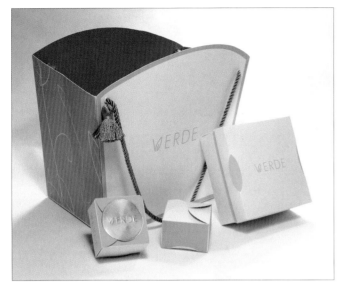

PROJECT
 Tags, Bags, Labels, & Boxes
SCHOOL
 Drexel University Antoinette Westphal
 College of Media Arts & Design
INSTRUCTOR
 Sandy Stewart
DESIGNER
 Julia Dobbins

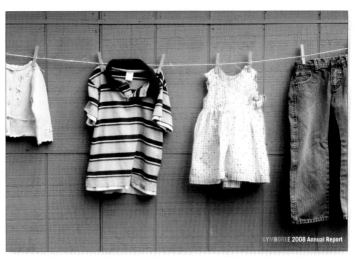

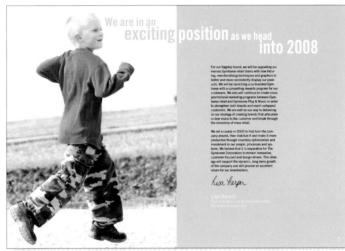

PROJECT
 Annual Reports
SCHOOL
 Illinois State University
INSTRUCTOR
 Julie Johnson
DESIGNER
 Shawn Prokes

PROJECT
 Business Cards
SCHOOL
 Susquehanna University
INSTRUCTOR
 Mark Fertig
DESIGNER
 Tracy Brauner

PROJECT
 Packaging
SCHOOL
 Susquehanna University
INSTRUCTOR
 Mark Fertig
DESIGNER
 Tim Storck

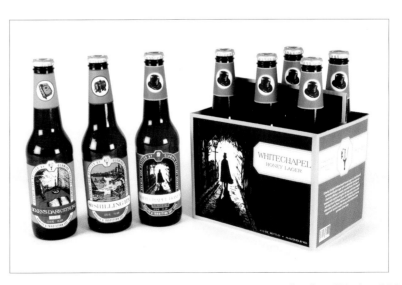

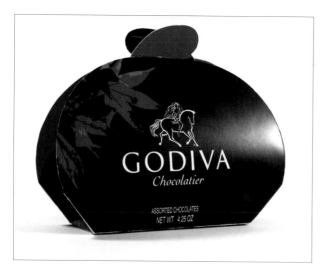

PROJECT
Packaging
SCHOOL
Pennsylvania College of Art and Design
INSTRUCTOR
Pam Barby
DESIGNER
Nikki Ziegler

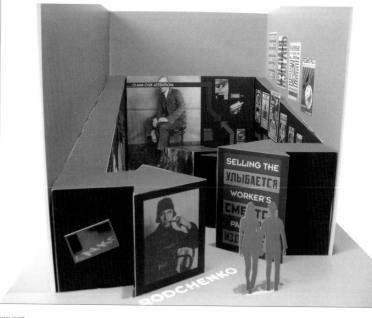

PROJECT
Signage & Environmental Graphics
SCHOOL
Drexel University Antoinette Westphal
College of Media Arts & Design
INSTRUCTOR
Jody Graff
DESIGNERS
Dan Steinberg, Julia Dobbins

PROJECT
Promotions
SCHOOL
Portfolio Center
INSTRUCTOR
Melissa Kuperminc
DESIGNER
Amanda Babcock

PROJECT
Complete Corporate Identity Programs
SCHOOL
The Design Center
Western Michigan University
INSTRUCTOR
Tricia Hennessy
DESIGNERS
Steve Sayler, Eric Kasprowicz,
Matt Frank, Oscar Garcia

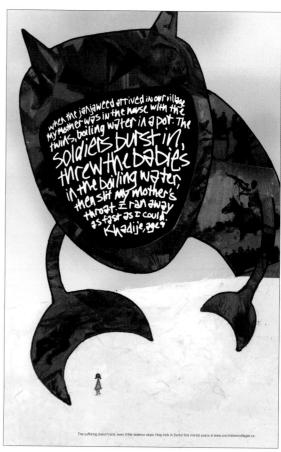

PROJECT
Stationery
SCHOOL
Marshall University
DESIGNER
Zeynep Ozturk

PROJECT
Business Cards
SCHOOL
Susquehanna University
INSTRUCTOR
Mark Fertig
DESIGNER
Tim Storck

PROJECT
Tags, Bags, Labels, & Boxes
SCHOOL
Drexel University Antoinette Westphal
College of Media Arts & Design
INSTRUCTOR
Sandy Stewart
DESIGNER
Jess Hetzel

PROJECT
Packaging
SCHOOL
Pennsylvania College of Art and Design
INSTRUCTOR
Pam Barby
DESIGNER
Alex Nielsen

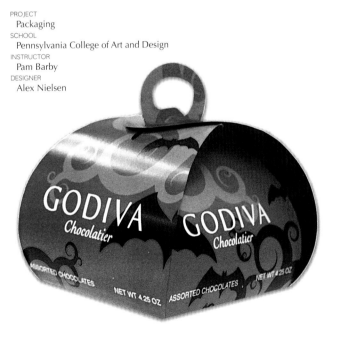

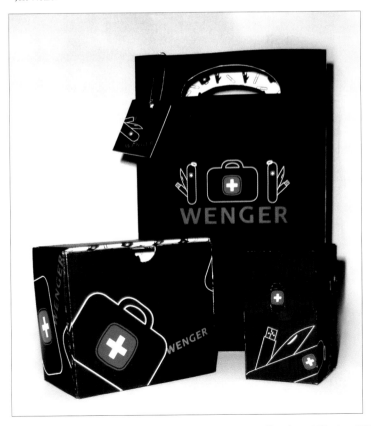

PROJECT
Announcements, Cards & Invitations
SCHOOL
Marshall University
DESIGNER
Zeynep Ozturk

PROJECT
Business Cards
SCHOOL
Susquehanna University
INSTRUCTOR
Mark Fertig
DESIGNER
Stephanie Rohde

PROJECT
Annual Reports
SCHOOL
Susquehanna University
INSTRUCTOR
Mark Fertig
DESIGNER
Steve Semanchik

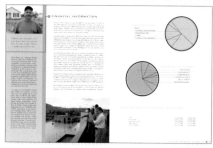

PROJECT
Complete Corporate Identity Programs
SCHOOL
Drexel University Antoinette Westphal College of
Media Arts & Design
INSTRUCTOR
Mark Willie
DESIGNER
Jess Hetzel

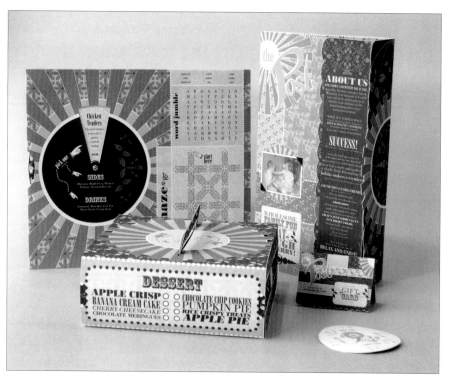

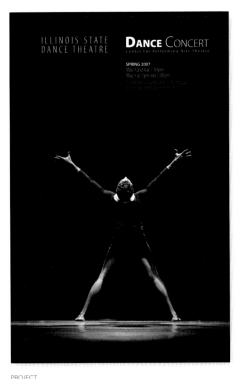

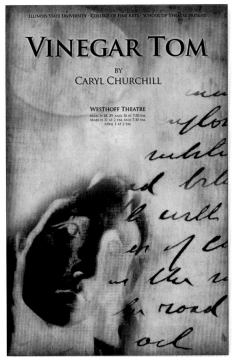

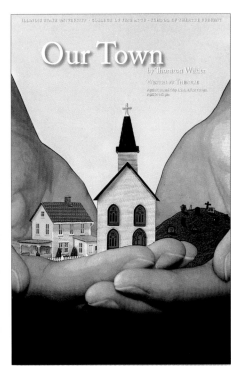

PROJECT
 Promotions
SCHOOL
 Illinois State University
INSTRUCTOR
 Julie Johnson
DESIGNER
 Sean Roosevelt

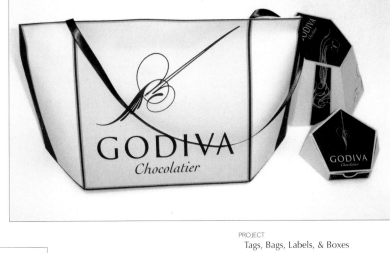

PROJECT
 Tags, Bags, Labels, & Boxes
SCHOOL
 Drexel University Antoinette Westphal
 College of Media Arts & Design
INSTRUCTOR
 Sandy Stewart
DESIGNER
 Olga Filipava

PROJECT
 Tags, Bags, Labels, & Boxes
SCHOOL
 Drexel University Antoinette Westphal
 College of Media Arts & Design
INSTRUCTOR
 Sandy Stewart
DESIGNER
 Steve Nunes

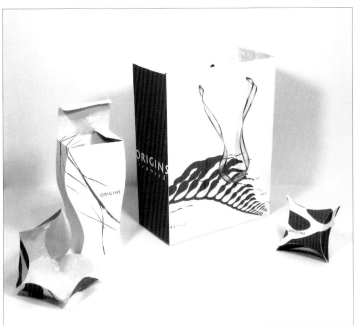

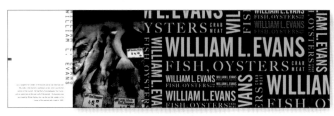

PROJECT
Brochures
SCHOOL
Drexel University Antoinette Westphal College of
Media Arts & Design
INSTRUCTOR
E. June Roberts-Lunn
DESIGNER
Marcy Zuczek

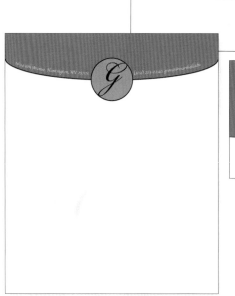

PROJECT
Stationery
SCHOOL
Marshall University
DESIGNER
Molly Grove

PROJECT
Promotions
SCHOOL
Portfolio Center
DESIGNER
Georgios Saliaris

PROJECT
Tags, Bags, Labels, & Boxes
SCHOOL
Drexel University Antoinette Westphal
College of Media Arts & Design
INSTRUCTOR
Sandy Stewart
DESIGNER
Michele Kopec

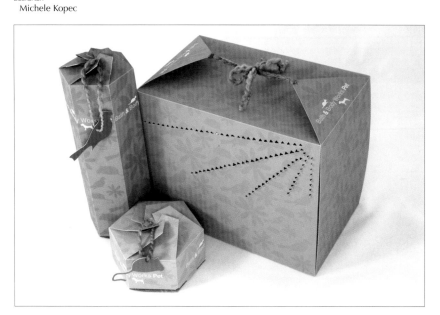

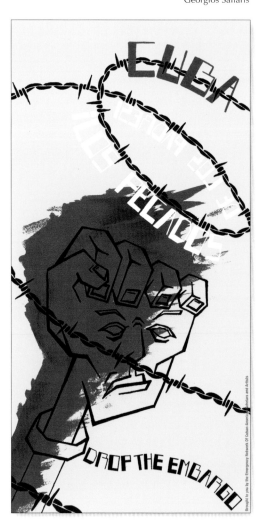

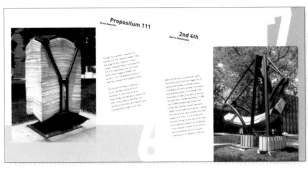

PROJECT
Brochures
SCHOOL
The Design Center
Western Michigan University
INSTRUCTOR
Tricia Hennessy
DESIGNERS
Jamie Georges,
Josh Morey

PROJECT
Packaging
SCHOOL
Susquehanna University
INSTRUCTOR
Mark Fertig
DESIGNER
Jessica Oswald

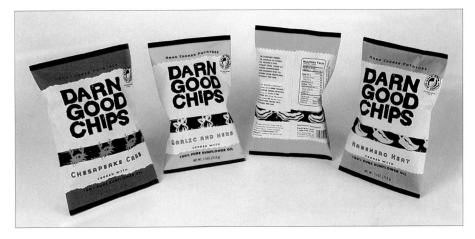

PROJECT
Packaging
SCHOOL
Susquehanna University
INSTRUCTOR
Mark Fertig
DESIGNER
Joe Pilcavage

PROJECT
Announcements, Cards & Invitations
SCHOOL
Marshall University
DESIGNER
Molly Grove

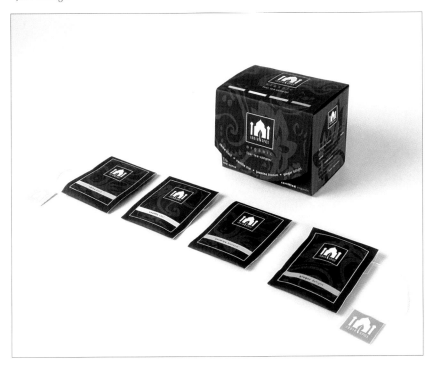

Student Work • 315

INDEX